WILD WORLD

PHOTOGRAPHING ICONIC WILDLIFE

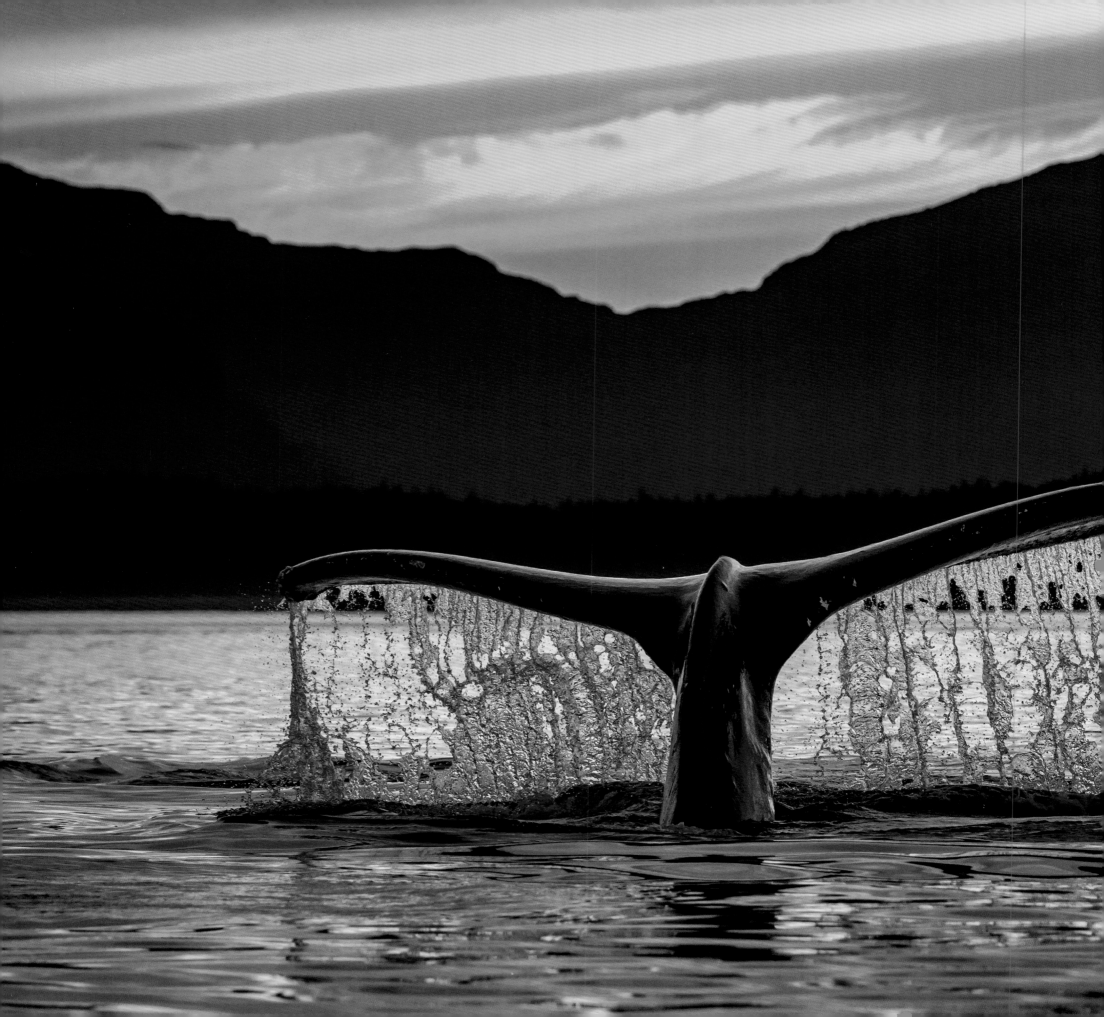

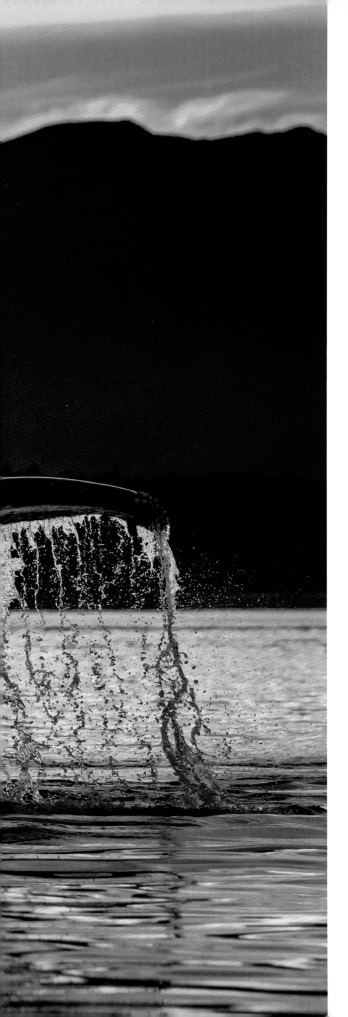

WILD WORLD
PHOTOGRAPHING ICONIC WILDLIFE

Richard Barrett

Dedication

To all those helping to protect
our planet's wildlife

First published in Great Britain by Merlin Unwin Books 2021

Photographs and text © Richard Barrett 2021
www.wildandwonderful.org

Merlin Unwin Books Ltd
Palmers House, 7 Corve Street
Ludlow, Shropshire SY8 1DB. U.K.

www.merlinunwin.co.uk

Edited by Anna Levin
Designed by Simon Bishop
Printed by IMAK

ISBN 978-1-913159-27-6

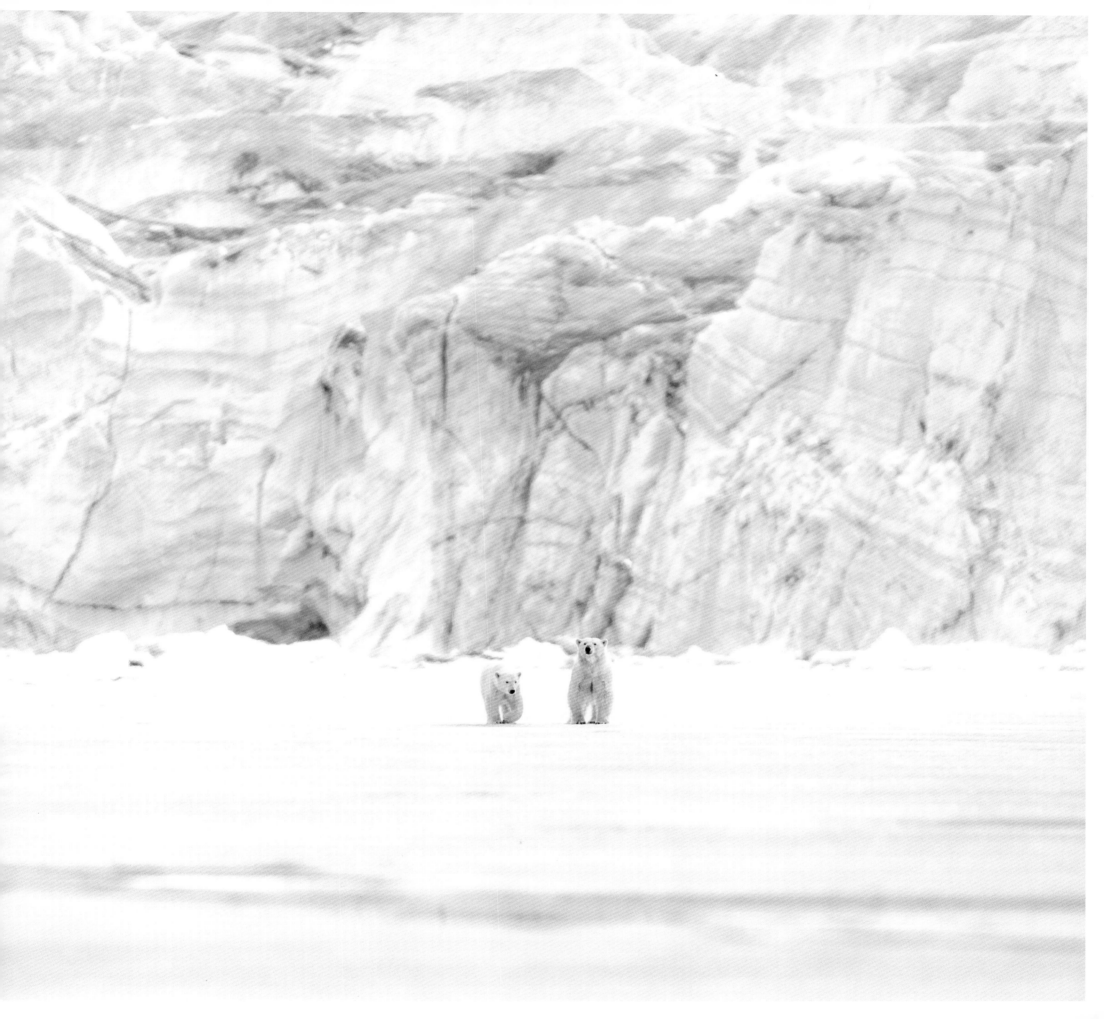

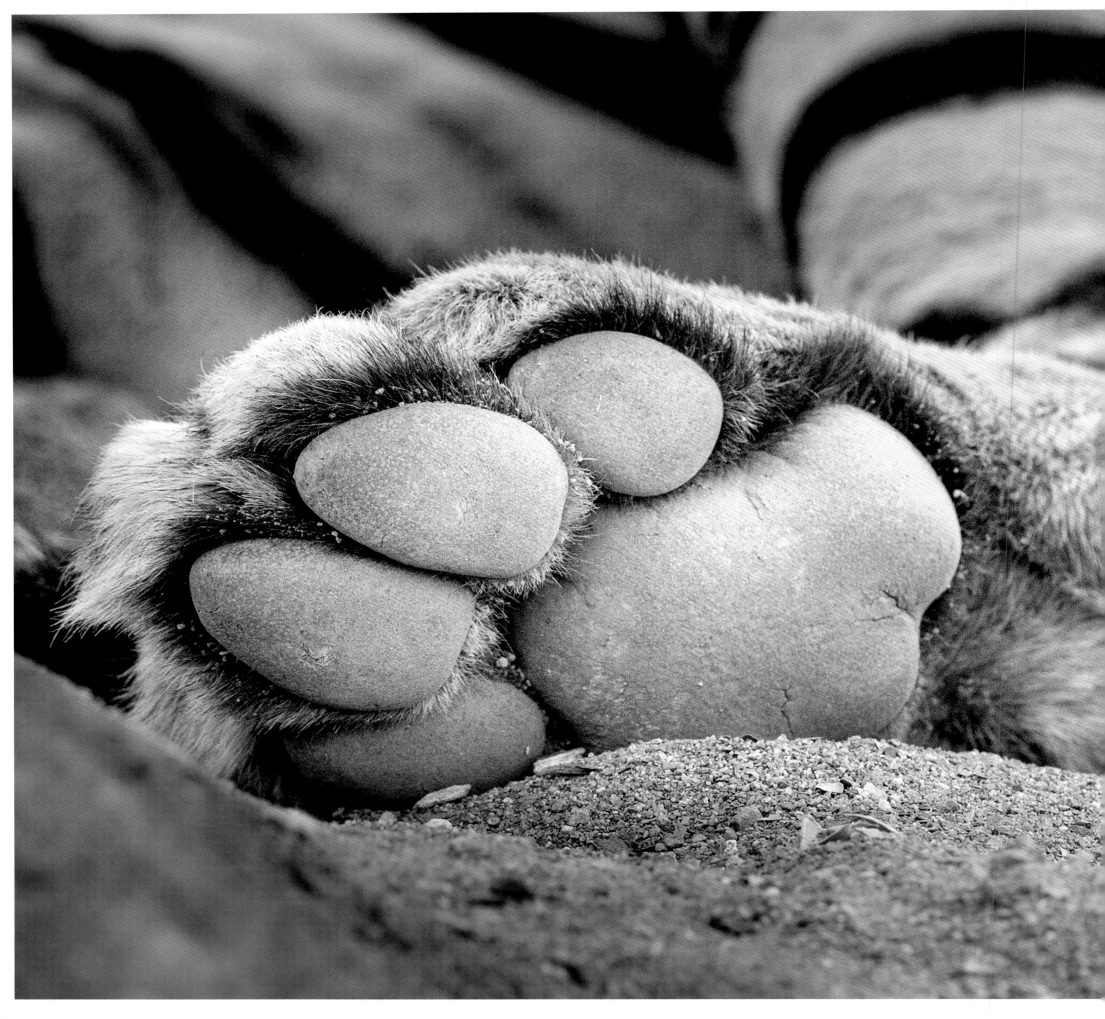

Contents

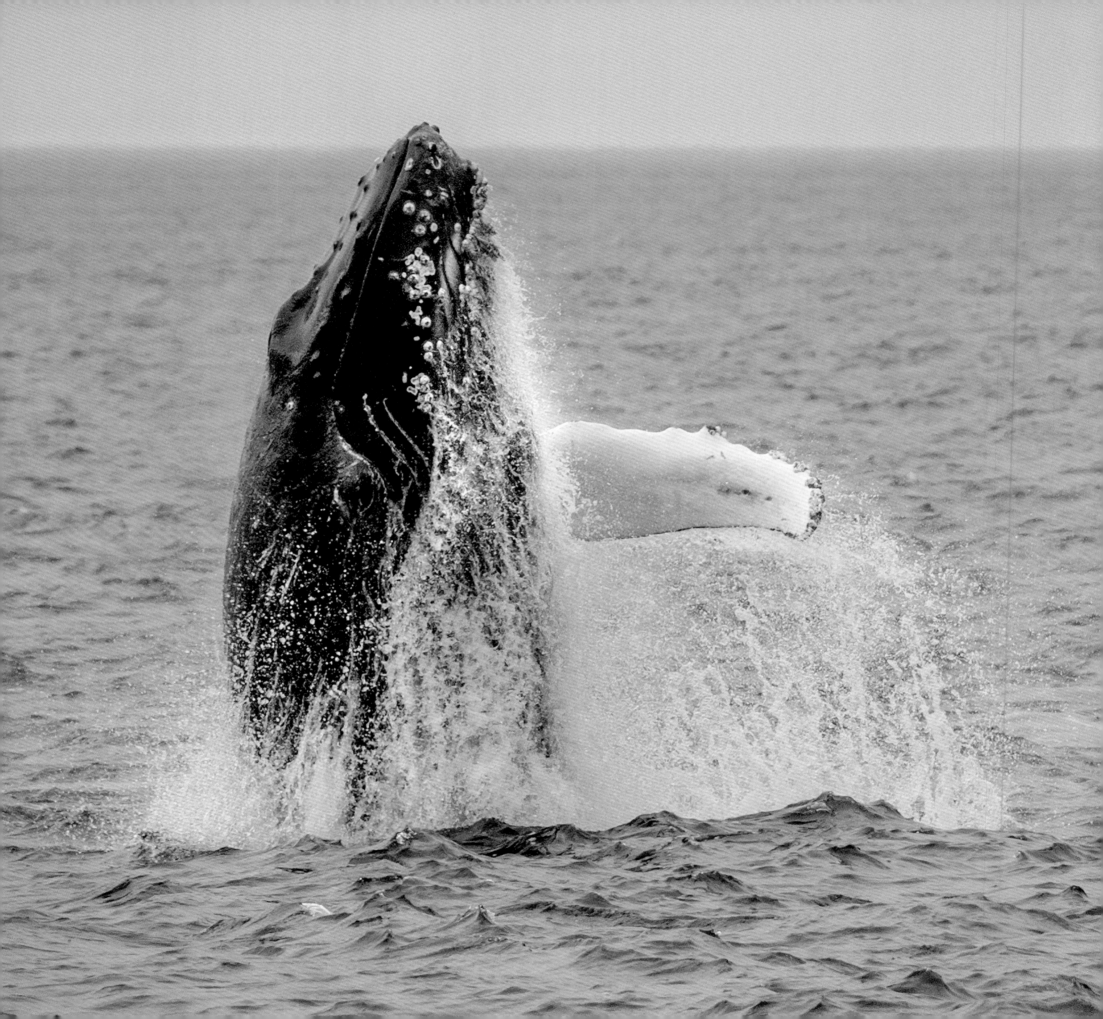

Foreword **Mark Carwardine**

Zoologist, environmental activist, writer,
TV and radio presenter and wildlife photographer

This terrific book is the product of countless thousands of hours in the field, spent sitting in uncomfortable hides, bobbing up and down in small boats, clambering over mountains, wading through rivers, bouncing about in safari vehicles, crawling around on hands and knees... and waiting. Hours and hours of waiting: for an animal to appear, for a moment of unusual behaviour, for a better angle, or for exactly the right light.

It isn't the first book to have been written about the best places around the world to photograph wildlife, and it won't be the last. But what makes *Wild World – Photographing Iconic Wildlife* stand out from the crowd is that it is based on first-hand experience. Richard has been there, done that, experienced all the trips himself. And it shows. He knows what he's talking about.

I have travelled with him many times over the years. In fact, I was standing or sitting or lying right next to him when he took some of the spectacular photographs in this book (I won't show you mine – or you'll compare).

Richard makes an enthusiastic and inspiring travel companion. He's the man resolutely standing outside on deck in all weathers, waiting long after everyone else has given up, doggedly ignoring sub-zero temperatures, hiking that extra mile. He is out at dawn and doesn't stop until the last, last ray of light has disappeared at dusk (or the animals have died of old age). He is never without a camera and a long lens around his neck, and never without a broad smile on his face.

The spectacular results speak for themselves. Tigers, for example, have been photographed a million times — but just look at that gem of a chapter opener. What an absolutely stunning shot. And look at the fabulous variety of shots in the grizzly bear chapter, for example. Almost anyone can take a technically competent image (although, I have to admit, I do know a few who can't). With modern equipment, it's not too difficult to get a sharp subject that fills the frame. But good images are ten-a-penny. Richard's are better than that. He shoots pictures that go beyond technical perfection — beyond the countless millions of wildlife photographs already taken.

Then there are the stories behind them. The personal anecdotes and insights, the descriptions of what happened at the time and how the shots were taken. There are loads of tips and tricks, too: why it's better to photograph chimpanzees in the rainy season, what equipment to leave behind when the miserable airline gives you a miserly luggage allowance, the best kind of boat for photographing humpback whales, and so on.

So here is everything you need to plan your ultimate photographic safari. Richard has done it all for you – he suggests where to go and what to photograph, provides heaps of inspiration with his own magnificent imagery, and reveals all the necessary information to go and do it yourself.

Whether or not your pictures are as good as his is entirely down to you! ●

Introduction **Richard Barrett**

Photographing the world's most charismatic animals has become a passion for me. It's quite a change from when I started out on my photographic journey, back at school during the Apollo Moon landings. Space travel was always in the news, I was intrigued and determined to try to photograph astronomical subjects, in particular the Moon and the Sun. I remember working out how to attach an old-fashioned plate camera to a telescope, and then rushing to the darkroom to develop and process the black and white photographic plates, exploring what worked and what didn't. There were no automatic exposure modes, histograms or auto-focus in those days! The Sun was a particular challenge — elaborate contraptions of angled half-silvered mirrors were needed to lose most of that intense light. In the end I got things to work, and I still have those images of the Moon's craters, sunspots, and even the northern lights taken from my parent's home in northern England.

Then work intervened and I had a structural steelwork business to run. Time didn't permit me to continue this hobby and my photography fell by the wayside. But a bit like riding a bicycle, although my skills became rusty, the main learning was retained. A few years ago, after I had sold the business and retired, one of the first things I did was get back into photography. It was no longer a world of plates and darkrooms, but a whole new digital realm. The basic principles were the same, but there was a lot of new stuff to learn.

After watching an episode of BBC's Big Cat Diary one evening, I booked a photographic tour to Kenya's Masai Mara in January 2009. On that first tentative trip I spent just five nights at Kicheche Mara Camp, and I have been hooked ever since! Seeing Africa's big cats close up was an overwhelming experience. I found that wildlife encounters,

particularly with large predators, involve an immediacy and intensity that I haven't experienced in any other photography. You can be just trundling along in a safari vehicle with nothing much happening, then you go around a corner and are suddenly launched into an amazing encounter where time is of the essence and where knowing your camera gear inside out is essential to enable you to react at lightning speed to events as they occur. Usually there is no second chance. It's quite an adrenaline rush and the joy of getting it right, nailing the shot, is what drives me on.

In the early days I often booked onto wildlife photography tours and I found that travelling in small groups was an education. Many of the other guests had been on previous tours and I would enjoy discovering lots of ideas for future trips from them — I always seemed to come home with a long list of places to visit, and a shopping list of new camera gear that I discovered I needed! Now I've reached the stage that it's often the other way around — I have been fortunate enough to visit many of the world's wildlife hotspots myself and people on trips quiz me for ideas of places to visit. In particular, the photo galleries on my website generate a lot of enquiries: What is best place to see a particular animal? When is the best time to visit? Where should we stay? I realised that there is a need for this sort of information from a non-commercial source, and so this book is my attempt to answer those questions.

Aren't we lucky? — there has never been a better time to be an amateur wildlife photographer. Modern digital camera equipment is superb, and for modest costs you can buy a camera better than the top-end gear of only a few years ago. Though we are also at time of unprecedented habitat degradation and concerns about wildlife loss,

fortunately there is still plenty out there if you know where to look for it. The tourist infrastructure of air travel and eco-tourism facilities has made many of the remote corners of the world accessible for the first time. Visiting wildlife hotspots may well be the best way to conserve them. If local people feel they have more to gain from preserving wildlife than destroying it, then it stands a chance. However, in some locations there is a danger that increasing tourist numbers may damage the habitat and impact on the welfare of the wildlife. I recommend booking all trips with a responsible and experienced operator — one who ensures that local staff are employed, tourist dollars are retained in local communities, and tourist operations are done in a sustainable manner without over-exploiting the habitat. In this way, eco-tourism ensures that the economic gains outweigh any perceived benefits from poaching and habitat encroachment, thereby preserving the wildlife for future generations.

I have visited all the locations in the detailed recommendations in the book, and so can personally recommend them. However, things never stay the same, and that is especially true of wildlife. While I hope that most of these locations will remain reliable for many years to come, it is always wise to check with your tour company or travel agent that the situation is still as I describe.

I hope this book inspires some of you to get out there and visit these wild and wonderful places for yourself, and to take your best experiences home with you by photographing some spectacular wildlife. And I hope that many more will enjoy these highlights of my own encounters with the wild world — exhilarating moments in time, which the medium of photography has enabled me to capture and bring back to share. ●

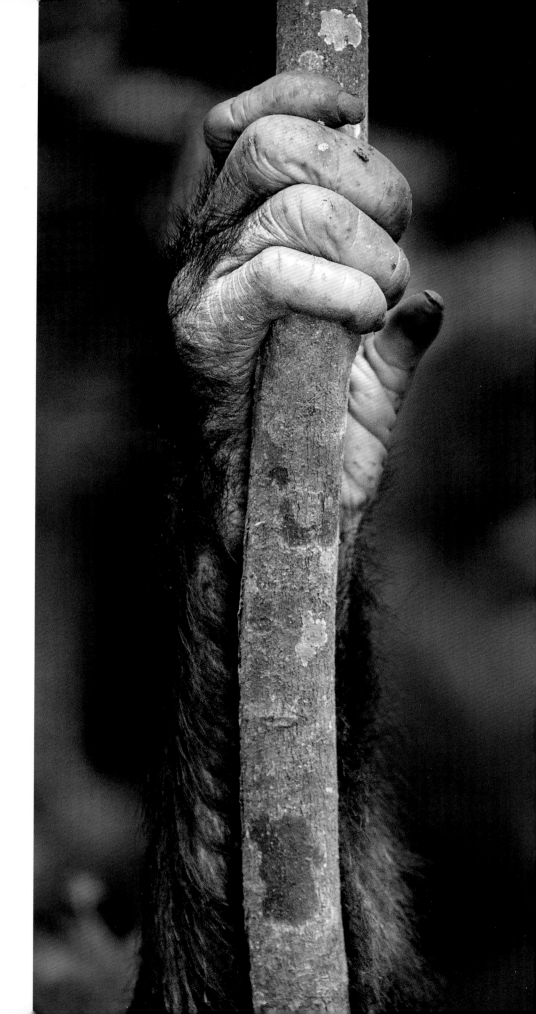

Tiger

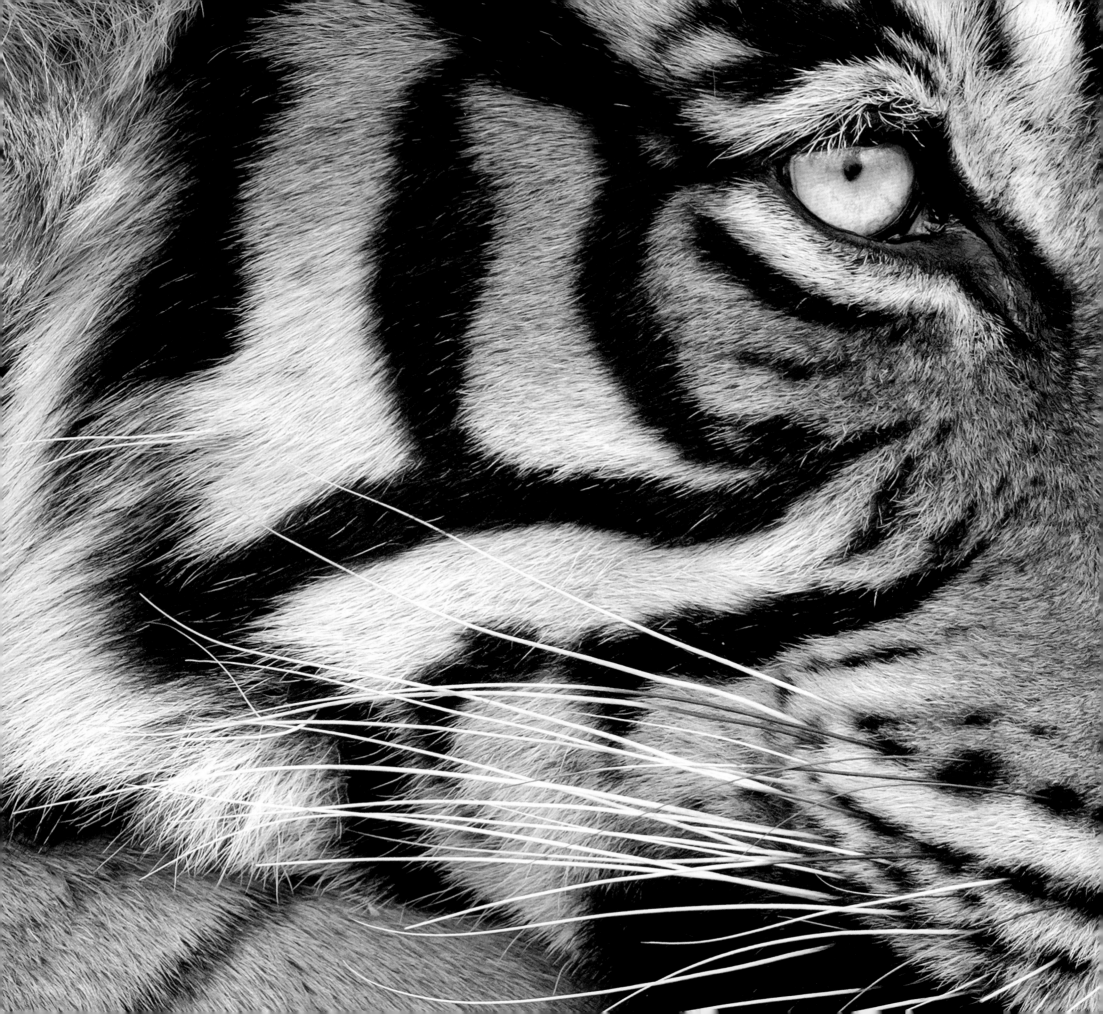

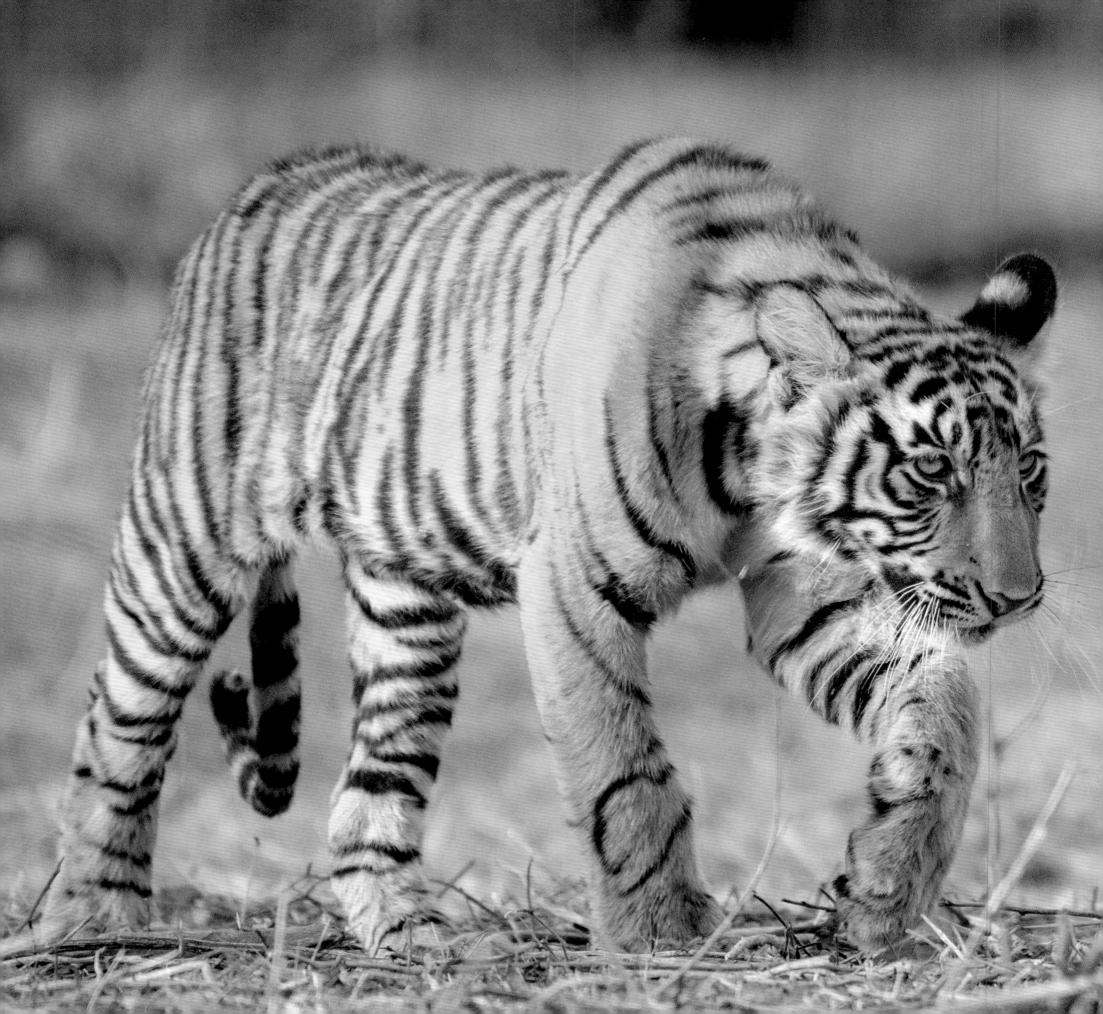

The tiger is the ultimate big cat and to my mind, one of the world's most beautiful creatures. The thrill of watching one of these magnificent apex predators in the wild takes some beating. To see at close quarters its sheer size and power is both awesome and humbling. When a tiger walks past your vehicle and looks straight at you, it can also be absolutely terrifying. I knew that to capture these emotions in photographs would be something very special.

Tigers once ranged widely from the frozen wastes of Russia right across Asia to Japan, Korea and the tropical rainforests of Indonesia. Clearly, it is a robust animal, a natural survivor: the various subspecies have successfully adapted to a huge variety of climatic conditions and it seems that if there is adequate prey, water and habitat, the tiger can thrive. But the future of the tiger is by no means certain. Due to poaching for skins and body parts, habitat loss, a diminishing prey base and continued conflict with humans, the tiger is classified as 'Endangered' by the global authority on the status of the natural world (IUCN).

My tiger travels focused on the Bengal tiger, the most numerous of the six remaining subspecies. Its highest population is in India, recorded at 2,967 individuals in 2018. There are also smaller populations of Bengal tigers in Nepal, Bhutan, Bangladesh and Myanmar. After strenuous conservation efforts, India's tiger numbers have recovered somewhat in recent years. However, there is a long way to go to assure their survival. Tiger numbers are still low: by comparison, in 1947 there were estimated to be more than 40,000 in India.

Visiting one of India's tiger reserves provides an economic benefit to the local area. I travelled to a number of reserves, particularly Ranthambore Tiger Reserve, and saw how the benefits of eco-tourism help to ensure that people living nearby regard tigers as a positive asset.

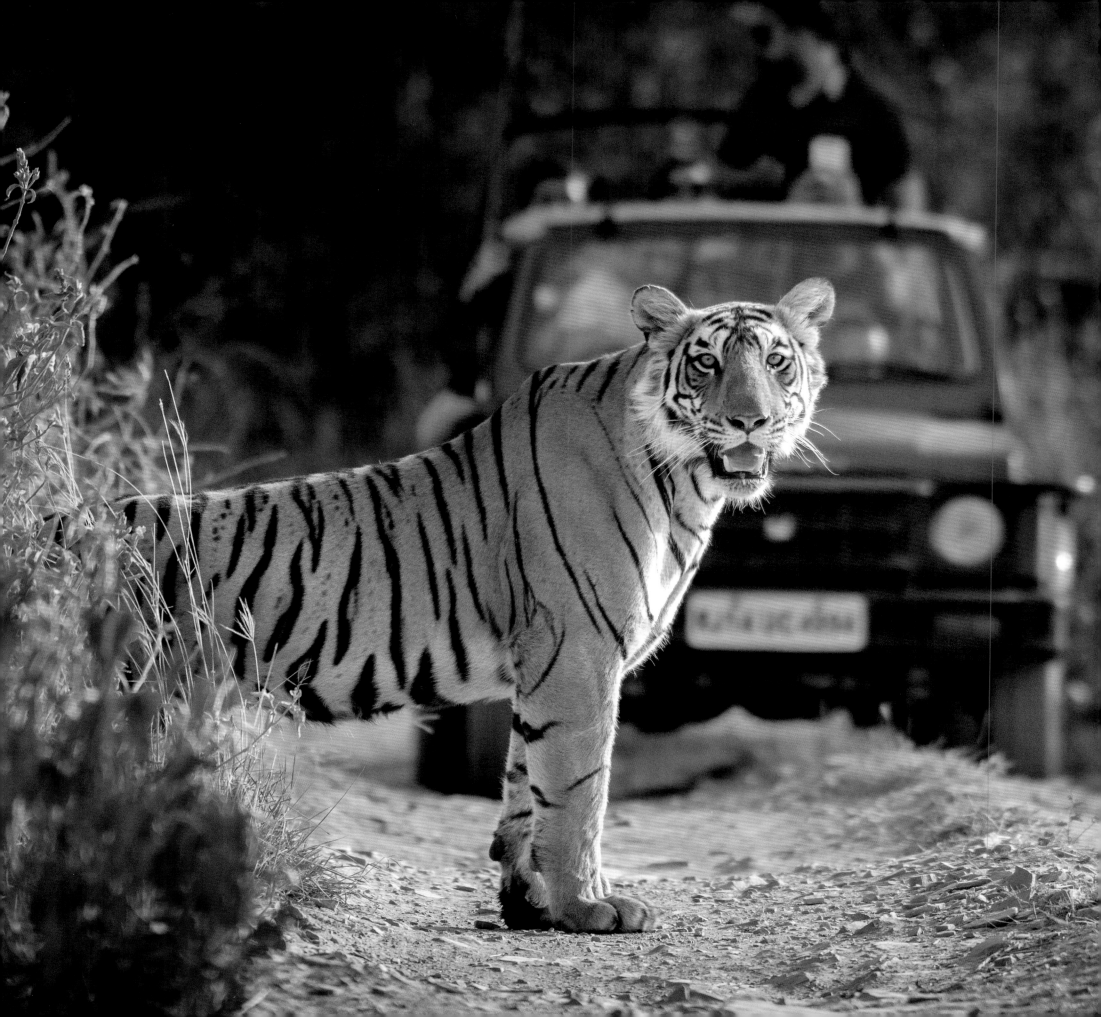

Unearthly hour

Blaring noise and blinding lights are bearing down on us. We swerve to avoid a gaudy tractor pulling a trailer-load of rocks as it looms out of the haze, coming towards us on our side of the road. For some reason the driver has his music playing at mega-decibel level, no doubt waking everyone in the whole area. It is still twilight as we hurtle amongst the traffic. I had just quickly gulped down a cup of coffee, munched on a couple of biscuits, and then we had pulled out of the hotel car park, bleary-eyed at 5:20am.

Now we are mingling with an amazing collection of vehicles, people, bikes and animals on the road to Ranthambore Tiger Reserve. What are all these people doing up at this unearthly hour? Just 20 minutes from our hotel to the Park, this drive has been a rude awakening every morning!

Blowing our horn, we pull out around a massive lorry, narrowly missing a cow wandering in the middle of the road. I shiver in the morning cold, pull my fleece tight, and hold onto my cap. It is surprising chilly in these open jeeps first thing each day, although I know that within a few hours we will be baking as the temperature rises to more than 35°C (95⁰F).

Reaching the turn-off, we dive right between oncoming vehicles, horns blaring, and bounce onto the cobbled road that leads up the steep hill towards the Mishrdarah Gate. Brightly dressed pilgrims, clothed in their best finery, are trudging alongside the track, heading up to the temple that is beside the gate. We reach a barrier; a few formalities are dealt with and now we are on the final leg of our short high-speed daily dash.

Will we be first today? That is our goal every day, much better to be first through the gate, rather than follow others in a cloud of dust. In the middle of the road we round the final blind bend. Phew, we made it! And yes, we are in pole position. It is now 5:40am, the gate is firmly closed; we have twenty minutes before the day's action begins. Can't wait. ●

Left:
Ranthambore Tiger Reserve, Rajasthan, India
Nikon D5 + 200-500mm f5.6 lens at 360mm;
1/2500 sec at f5.6; ISO 1000

Title pages:
Ranthambore Tiger Reserve, Rajasthan, India
Nikon D5 + 500mm f4 lens;
1/640 sec at f9; ISO 3200

Introduction pages:
Ranthambore Tiger Reserve, Rajasthan, India
Nikon D5 + 200-500mm f5.6 lens at 500mm;
1/2000 sec at f5.6; ISO 2800

Right: A tiger strolls along the road ahead, pausing to glance casually to the left. The raised back foot makes this picture for me! The sense of nonchalance makes tiger photography look easy, but in fact we had been in India for six days already and this was the first photograph I'd taken. I had visited the same reserve two years previously and had fantastic sightings. The difference was that this time the equilibrium of tiger society had been upset by the death of a dominant male, now the hierarchy was in flux, and the inhabitants edgier: the males battling, the females hiding. It was a reminder that India's tiger reserves are dependent upon a small number of habituated animals, and anything that causes upheaval can affect the chance of sightings.

Bandhavgarh Tiger Reserve, Madhya Pradesh, India
Nikon D3S + 200-400mm f4 lens at 400mm
1/500 sec at f4; ISO 3200

Photographic tip
Communicate!

Our needs as photographers differ greatly from the needs of most tourists. They normally want to get as close as possible to the tiger and unless you explain this to the driver, he will assume you want him to drive up right alongside it. The necessary manoeuvring of the vehicle for tiger photography requires excellent communication between you and the guide and driver. In the heat of the action, for this to work well, good communication through shared language is essential. Additionally, the guide needs to be really experienced, not only very familiar with the park but with a good understanding of tiger behaviour to be able to anticipate the tiger's next move. To find a suitable guide, I recommend that you book your trip through a specialist wildlife travel agent with an established track record of running photographic trips to India.

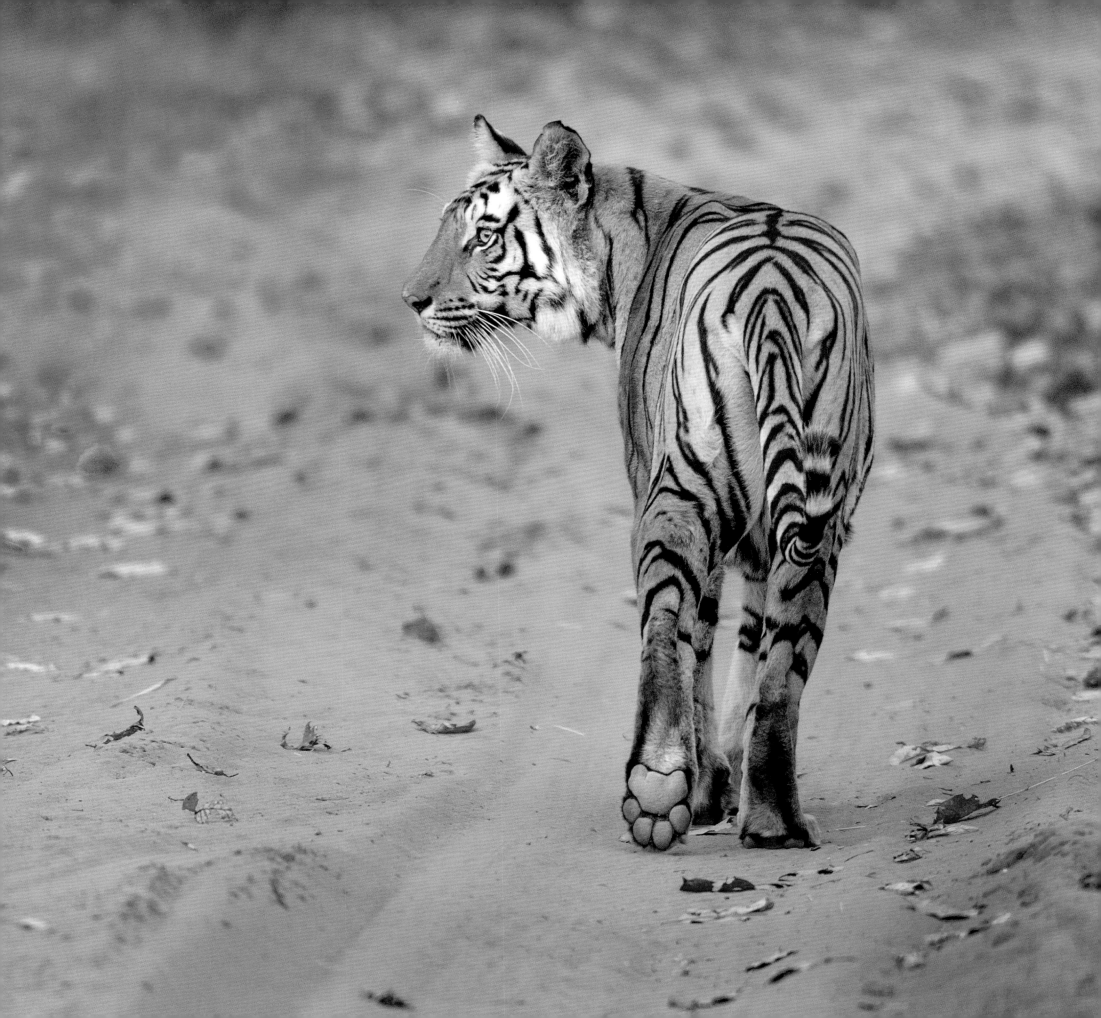

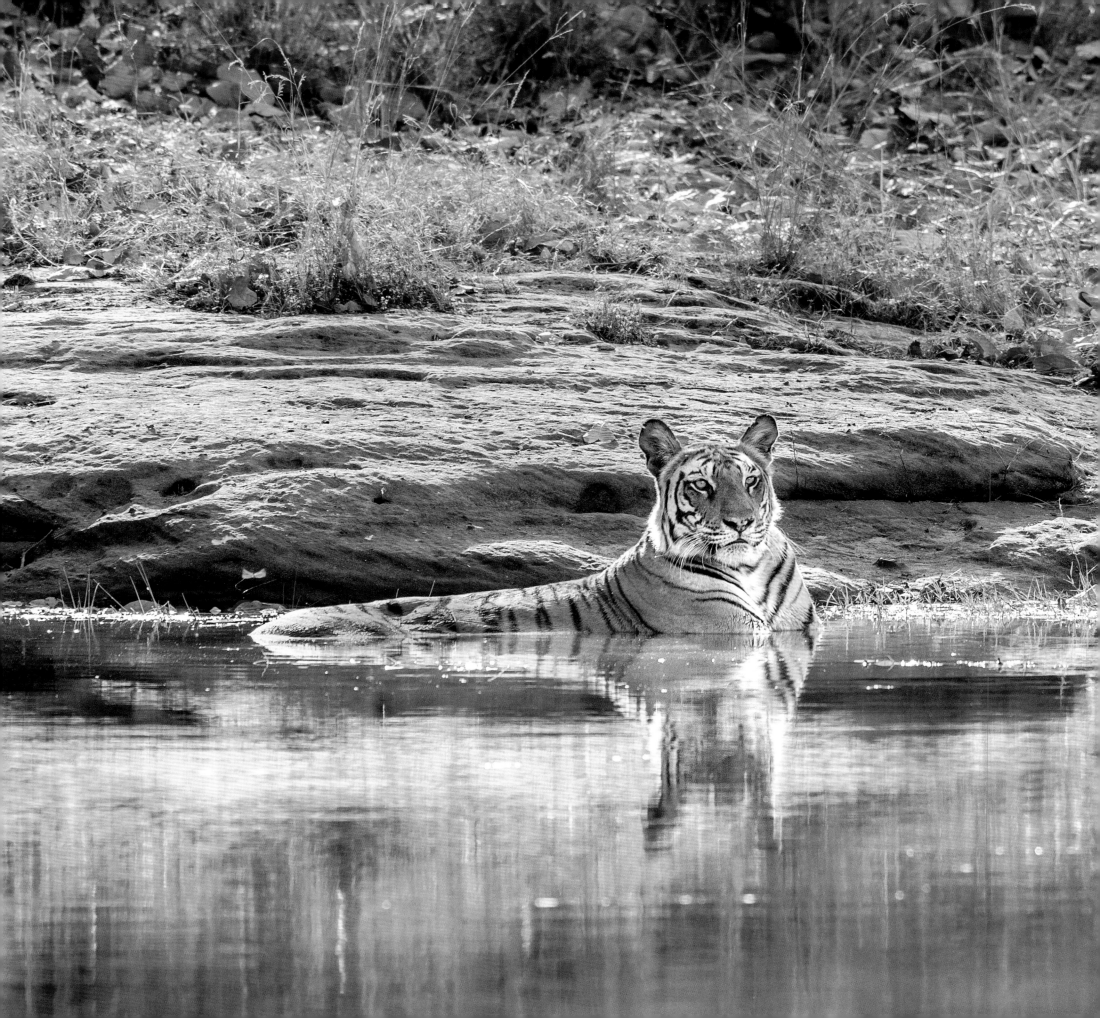

I saw a tiger!

As we bounce to a halt, a cloud of orange dust settles over us, dust of our own making. We had all heard the sound — 'Au-ou' — the shrill alarm call of a spotted deer. 'Au-ou', louder this time, off to our right, slightly behind us. This is a spotted deer telling its herd: 'I saw a tiger!' We wait, listening to the jungle: the alarms will tell us where the tiger is. Now a bark, a sort of rumbling, chuntering bark — that's a monkey, a Hanuman langur, also behind us. Keeping watch from the trees, their alarm calls are much more reliable than the spotted deer. Now we know for sure that something is there. We all turn to scan the road. More alarm calls, further back. Fear grips those in the jungle, excitement grips us in the jeep.

Suddenly, a tigress emerges from the bushes, strides across the road, and walks off into the undergrowth. Gone. Great to see, but really only a glimpse, certainly not a photographic opportunity! It was all too brief — but can we see her again?

She's definitely on the move, and although completely hidden from view, it seems from the direction of travel that she is heading up the steep hill on our left. The guide suggests she may be going to drink, as over the other side of the hill there is a large waterhole. A road goes around the hill, we can go and wait there if we want, maybe she will reappear at the waterhole? Yes, we all cry, and off we head.

We pull up to the large waterhole, it's more like a lake in reality, and we park up on the shoreline. The hill is now off to our left, the water in front and to our right. We're looking and listening intently, everyone is scanning the hillside for movement. Nothing. We wait. Still nothing, seconds become minutes, time passes. No alarm calls, it seems the trail has gone dead on us. It's now over twenty minutes since we arrived, and so we reluctantly start to put our gear down and prepare to move off.

Someone exclaims, 'Look!' A tigress has appeared on the far side of the lake. Not 'our' tigress, another one! How lucky is that? She's walking along the far shoreline, heading down towards the water. Gingerly she turns, and reverses into the water. She doesn't want a drink, but a bath to cool down! Sitting in the glistening lake, she takes her time. And so do we, taking lots and lots of lovely photos of a tigress chilling in a beautiful reflective lake. ●

Left: Bandhavgarh Tiger Reserve, Madhya Pradesh, India
Nikon D3X + 200-400mm f4 lens at 400mm;
1/320 sec at f4.5; ISO 200

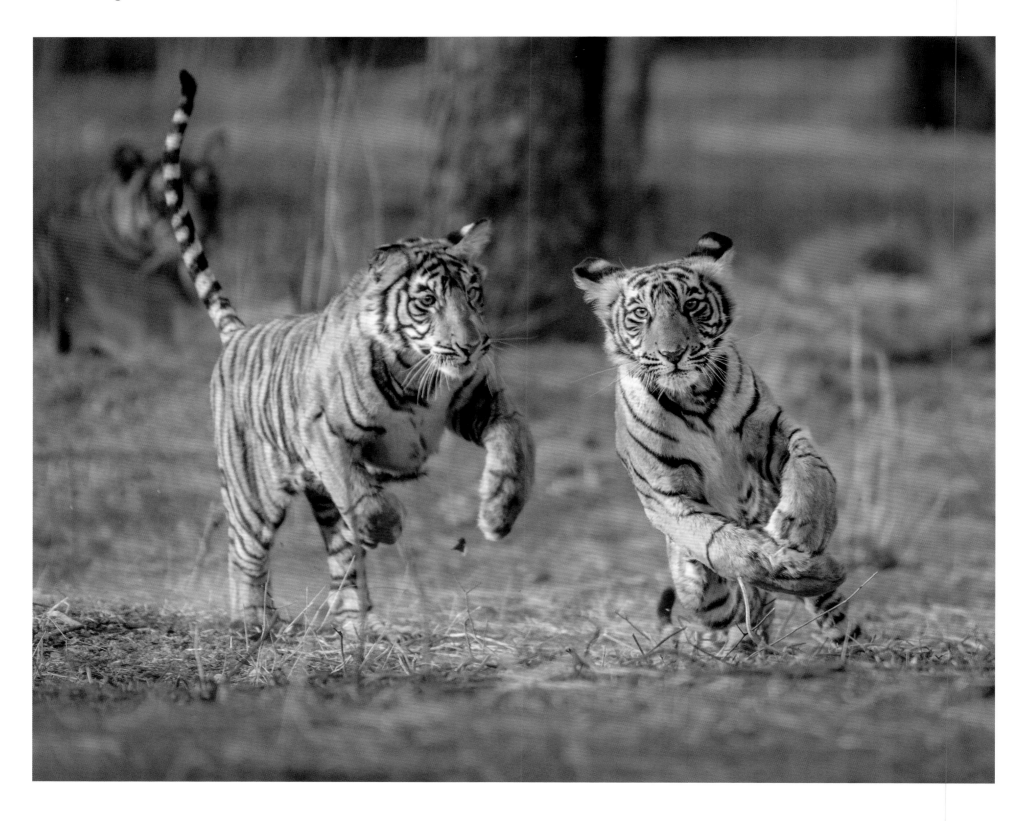

Above: Ranthambore Tiger Reserve, Rajasthan, India
Nikon D5 + 200-500mm f5.6 lens at 500mm;
1/1600 sec at f5.6; ISO 1100

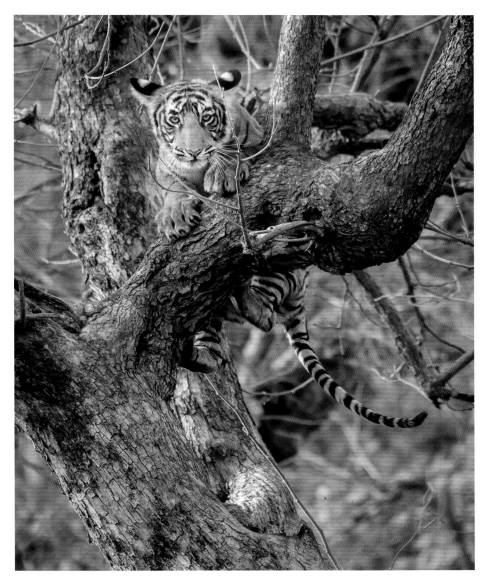

Above: Ranthambore Tiger Reserve, Rajasthan, India
Nikon D5 + 200-500mm f5.6 lens at 500mm;
1/2000 sec at f6.3; ISO 5600

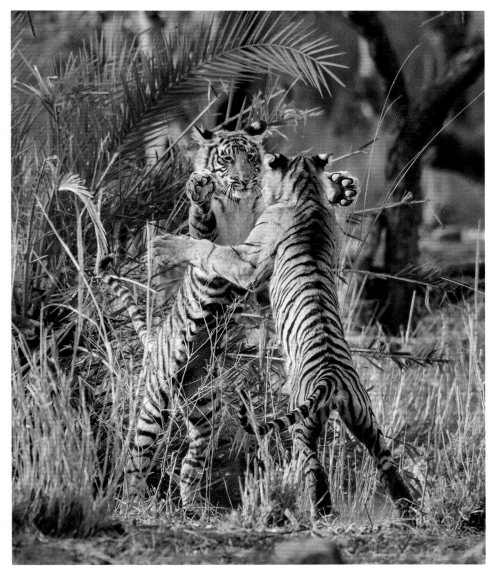

Above: Ranthambore Tiger Reserve, Rajasthan, India
Nikon D5 + 200-500mm f5.6 lens at 390mm;
1/2000 sec at f7.1; ISO 2000

Left and above: The mother was sitting quietly in the background, keeping an eye on her three cubs. We parked the vehicle nearby in a low position and watched in awe as the cubs chased and played, full of rough and tumble and exploration. It was a happy family scene and our encounter continued for more than an hour. Sometimes the cubs would return to their mum, but then one would get up to play again and another would soon follow. One cub exploring went up a nearby tree! You don't usually see tigers up a tree, but youngsters of most cats will play up trees, in fact they will play anywhere with anything, it's how they learn to hunt and fight and develop all the skills they will need as an adult tiger.

These cubs look about nine months old, they were big but still have some way to go to be fully grown and independent. Cubs stay with their mothers for more than two years.

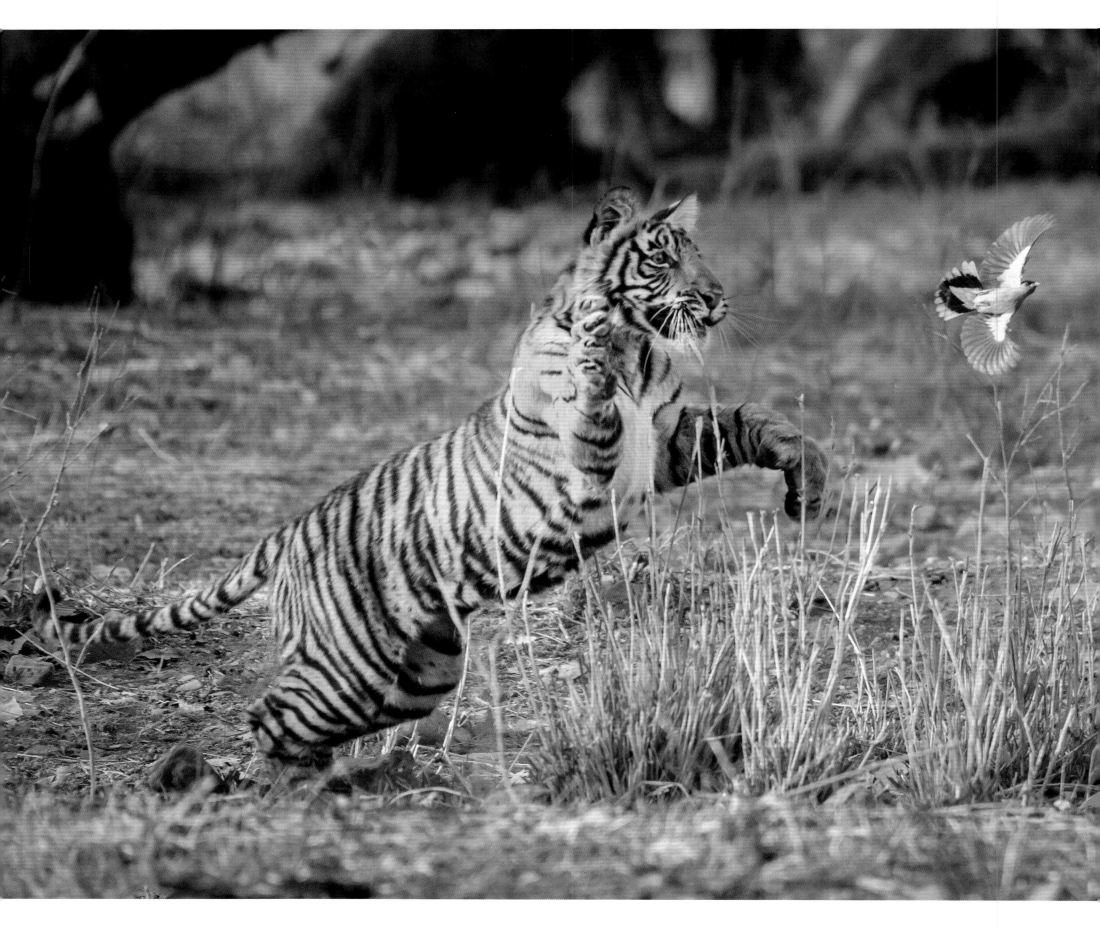

Photographic tip
Support matters

Method		
	●	Recommended
	○	Possible use
	●	Not recommended
Handheld	●	There is usually good light, allowing for fast shutter speeds. With good technique, this is a very practical option, particularly when action is hectic.
Beanbag	○	The sides of the vehicles are very low, making it difficult to use a beanbag. But in certain circumstances it is worth the effort of sprawling in the bottom of the vehicle to get really low.
Monopod	●	Often the best option, providing good stability without taking up much space.
Tripod	●	There is not enough space to use a tripod, although you could use it with all three legs together as an improvised monopod.

Left: I've never seen this behaviour before or since, but play is a crucial part of life for all young animals, and I suppose this tiger cub just plays with whatever it finds that happens to be there and especially if it's moving. The bird is a brahminy starling, it was on the ground and the tiger pounced and played, just like a puppy would. The bird got away!

Ranthambore Tiger Reserve, Rajasthan, India
Nikon D5 + 200-500mm f5.6 lens at 480mm;
1/2000 sec at f7.1; ISO 2500

Eye contact with a tiger

We have spent the whole day in Ranthambore National Park. It's now 4:30 in the afternoon, the light is just getting nice and soft, and we have found a tiger. It's a female known as 'Arrowhead' and we are told she is often seen in this section of the Park. She seems really calm with vehicles near her; in fact, she's completely ignoring them. Presently she is walking through quite dense vegetation; I can't get a decent shot where she is now. And there are loads of other vehicles around. This could be tricky.

If we get stuck behind her, we will be looking at her rear end and we will get mixed up with all these other vehicles. So, we definitely need to get ahead. And we don't want to be looking down on her, that's not going to work either. I want the image to engage through eye contact with the tiger. So, we want to be as low as possible, at eye level, or even a bit below. If we are close to her, we're bound to be looking down. Extra distance will help, and it will be no problem as I have a long telephoto lens.

Arrowhead is really mobile now, in and out of the vegetation, checking out various spots, working her territory. I keep asking the guide where she is likely to go next, so we can keep moving ahead to create opportunities for photographs as she moves towards us. He's doing an excellent job, this is a great location, nice and low with a good background. We are well ahead of the tiger, and we've been waiting a while, but now she's coming this way.

And suddenly all this manoeuvring pays off. One shot as she looks out into the road, and a second as she comes down the trail directly towards us. ●

Right: Ranthambore Tiger Reserve, Rajasthan, India
Nikon D5 + 200-500mm f5.6 lens at 360mm;
1/2500 sec at f5.6; ISO 1250

Photographic tip
Get low, get ahead

For an animal like a tiger, getting at eye level, or below, is almost always the best for photography. Looking down doesn't often work well, as you want the photo to engage through eye contact with the subject. On vehicle-based safaris this can be difficult to achieve.

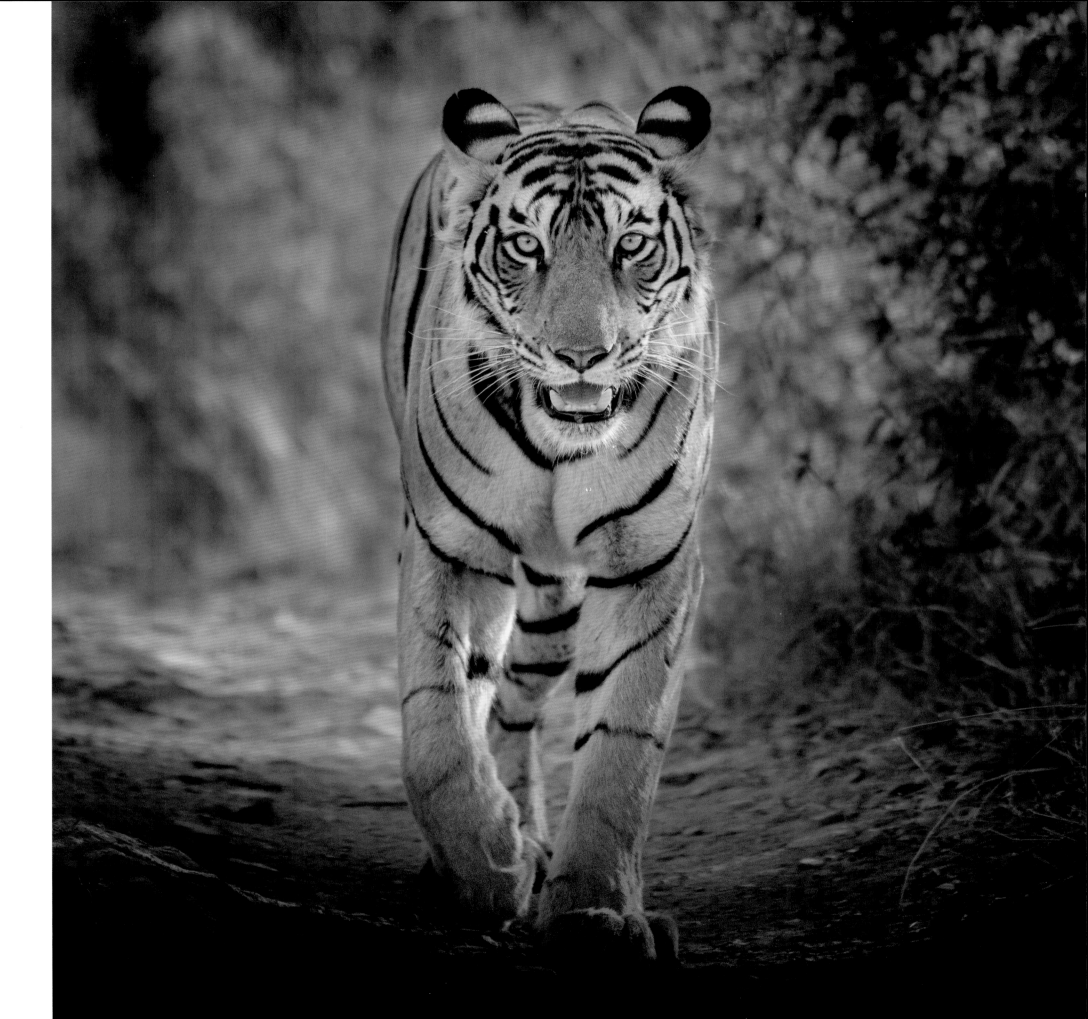

Previous page and right: All the roads in the reserve are very basic dirt tracks that wind through the forest, and vehicles have to stay on these roads. This is where it's important to have a good guide who knows the roads and the tigers — the guide will be able to second-guess where an animal will cut across through the trees, then scoot around and intercept it further along. It's a maze as the roads wind around and around and the animals meander between them, so local expertise makes all the difference.

These tigers are so relaxed around vehicles, they have clocked us in both photographs but then continued what they were doing: strolling along or having a back scratch (right). If a tiger wasn't used to vehicles it would hide, but these ones just completely ignore us. Many vehicles in Indian reserves create a lot of noise, with people shouting and pointing, but to the tigers you are just part of the landscape, neither a threat nor a food source.

Right: Ranthambore Tiger Reserve, Rajasthan, India
Nikon D5 + 200-500mm f5.6 lens at 480mm;
1/640 sec at f7.1; ISO 3200

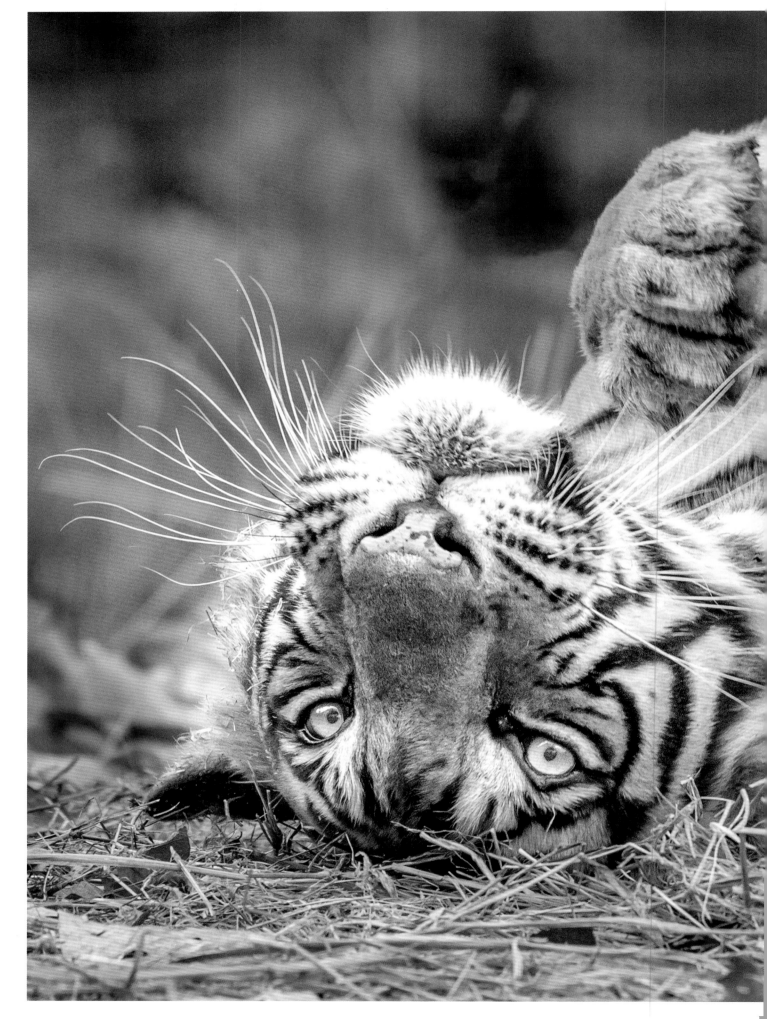

Right: This young cub was returning to its mother in the heat of the day. It looks alone in the expanse of forest but she wasn't far away — just the other side of the tree in the foreground. I wanted to capture the glare of sunlight and the sense of the dense forest habitat. There is only a relatively small amount of open ground and so catching them crossing it is the trick for tiger photography. In choosing to visit India at the hottest time of year, I traded comfortable temperatures for increased chances of sightings: the tigers are easier to spot in these clearings when the undergrowth has died down in the summer heat.

Ranthambore Tiger Reserve, Rajasthan, India
Nikon D5 + 200-500mm f5.6 lens at 220mm;
1/1000 sec at f8; ISO 720

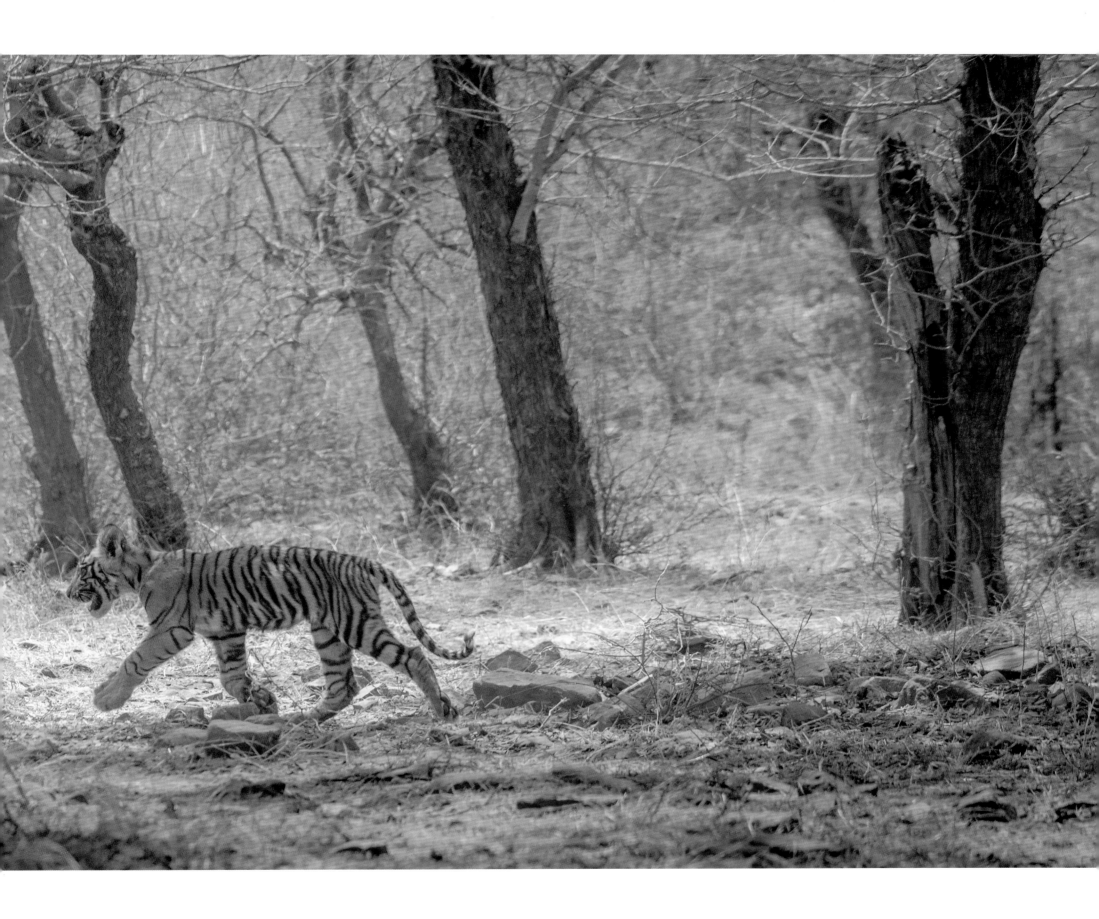

Optimism prevailed

My seriously unfashionable, but highly effective, silvered sun umbrella is at least keeping me shaded, as the sun blasts down from overhead. It is 40°C (104°F) in the shade, much more in the full sun. We have been parked here for hours. Off to our right, sitting under a shady bush about 100 metres (110 yards) away, there is a tigress and two tiny cubs. We are hoping they will come back over here sometime soon.

We arrived here at noon, and as the only vehicle around, we had briefly enjoyed watching the mother and her cubs sitting under the tree in front of us. Earlier they had stashed a sambar deer kill off to our left but by midday it was too hot for tigers to do anything but sit quietly. And for us, the light was too harsh to do much useful photography either. After about half-an-hour the tigress and her cubs moved away to that bush, where they have been ever since. We knew they were unlikely to go far with that fresh kill nearby, and so we had a decision to make: Do we wait and hope they come back to their original tree a bit later in the day when the light is better? Or do we leave and go looking for something else, or even go back to the lodge to chill out for a few hours? It was a tough call, but optimism prevailed, and we had decided we should stay. We moved the vehicle to the best possible vantage point for our envisioned image, and we are still here, strategically placed with the tigers to our right, and the kill to our left. Sitting quietly, just waiting.

The silence is abruptly broken when lots of vehicles on the afternoon game drive start arriving — engines revving, people excitedly chattering 'Tiger, tiger!' Some are looking at us with some bemusement, even concern. Why are they over there? They can't see the tigers very well from there. Someone asks us if everything is OK? We reassure them that we are fine, just waiting.

Now it's 4pm. The light is now much softer, the temperature more bearable. The tigress gets up, walks slowly towards us and sits down by 'our' tree. The cubs join her. A dozen other vehicles now race across and position themselves as best they can around us. But we have the clear, uninterrupted view — our plan has come together. ●

Right: Ranthambore Tiger Reserve, Rajasthan, India
Nikon D5 + 200-500mm f5.6 lens at 350mm;
1/1600 sec at f6.3; ISO 1400

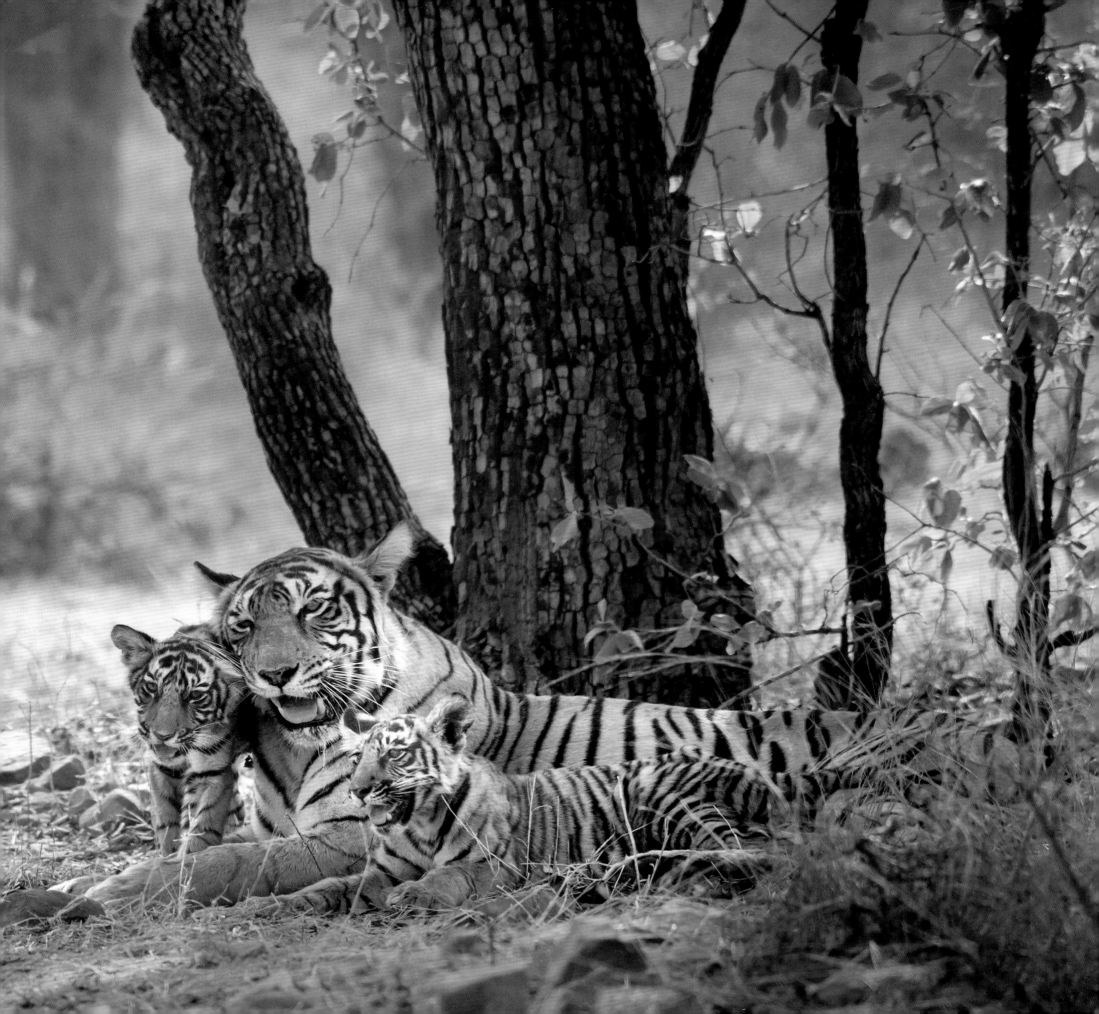

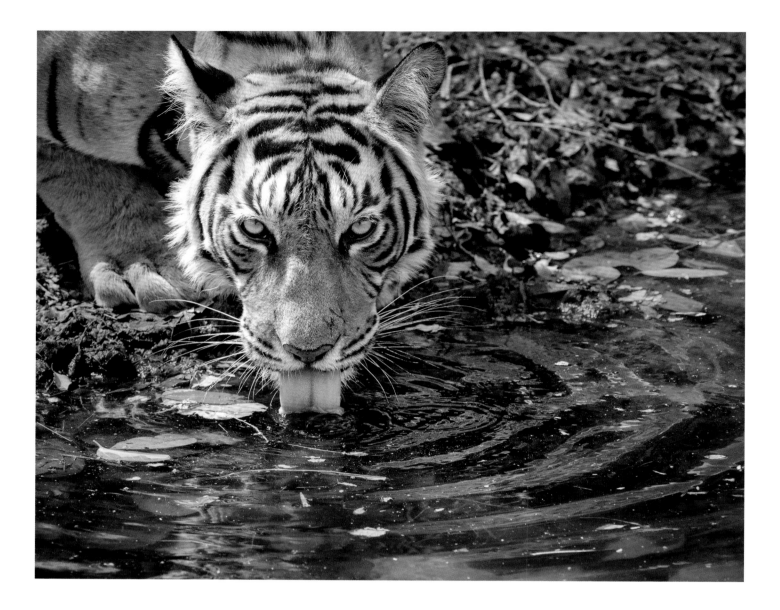

Above: I recommend undertaking a tiger safari in the hot, dry season. One of the advantages is that prey and predators congregate at water and so are easier to see — and to photograph. With limited water available, tigers come to the pools not just to locate prey but to drink, and their thirst is increased with the searing heat. It seems surprising to see a cat having a bath, but in the middle of day, tigers will find water and bathe to cool down. It's tiger 'air conditioning'. This is a familiar pattern: as morning warms up, they will find water and then maybe sit there for hours, just keeping cool.

Ranthambore Tiger Reserve, Rajasthan, India
Nikon D5 + 500mm f4 lens;
1/1000 sec at f8; ISO 1250

Right: This water source was just a puddle really, the tiger was lying across the width of it, but it doesn't seem to dry up. The terrain in the reserve has been enhanced to ensure there is water available. There is not much land left for tigers so it's vital that there is water in the reserves. In this heat, many animals have to stay near water, but once a tiger arrives everything else scarpers, so we don't see other animals there.

Ranthambore Tiger Reserve, Rajasthan, India
Nikon D5 + 200-500mm f5.6 lens at 240mm;
1/1250 sec at f8; ISO 1600

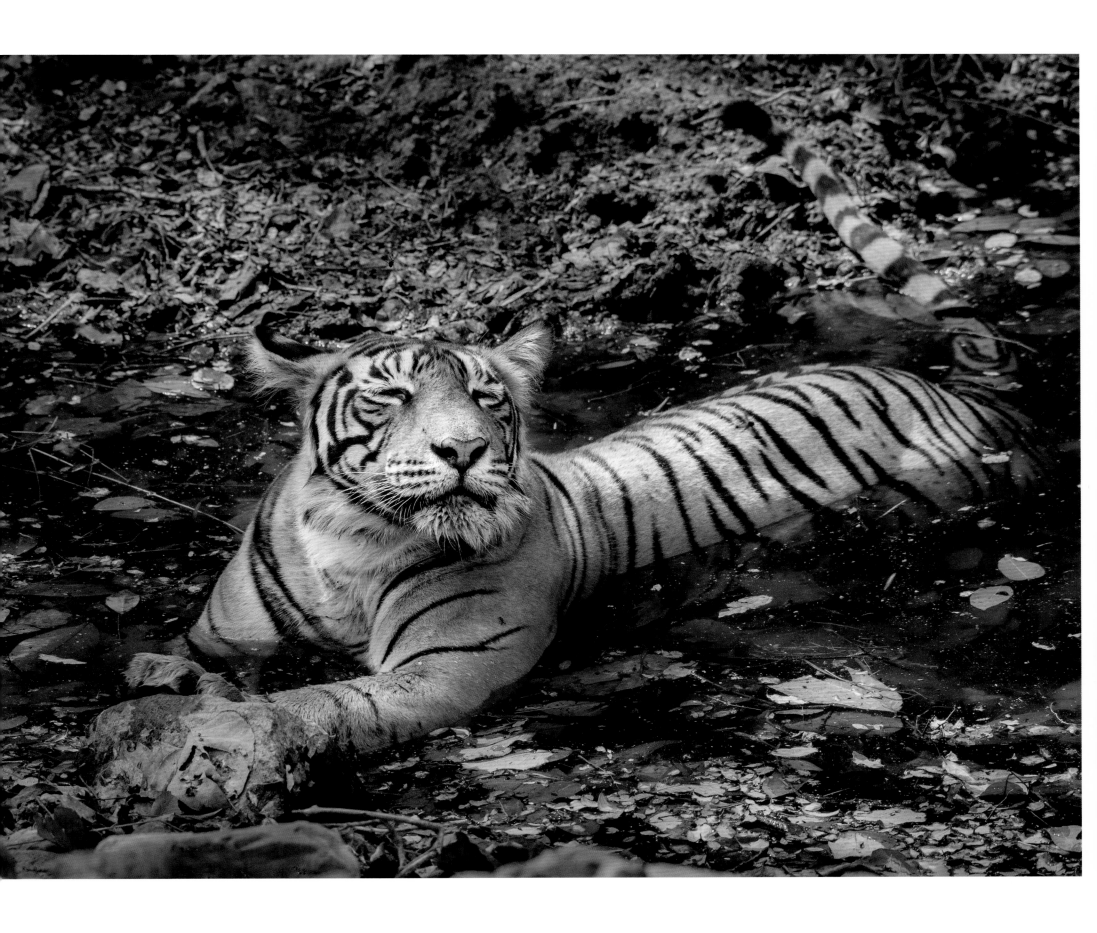

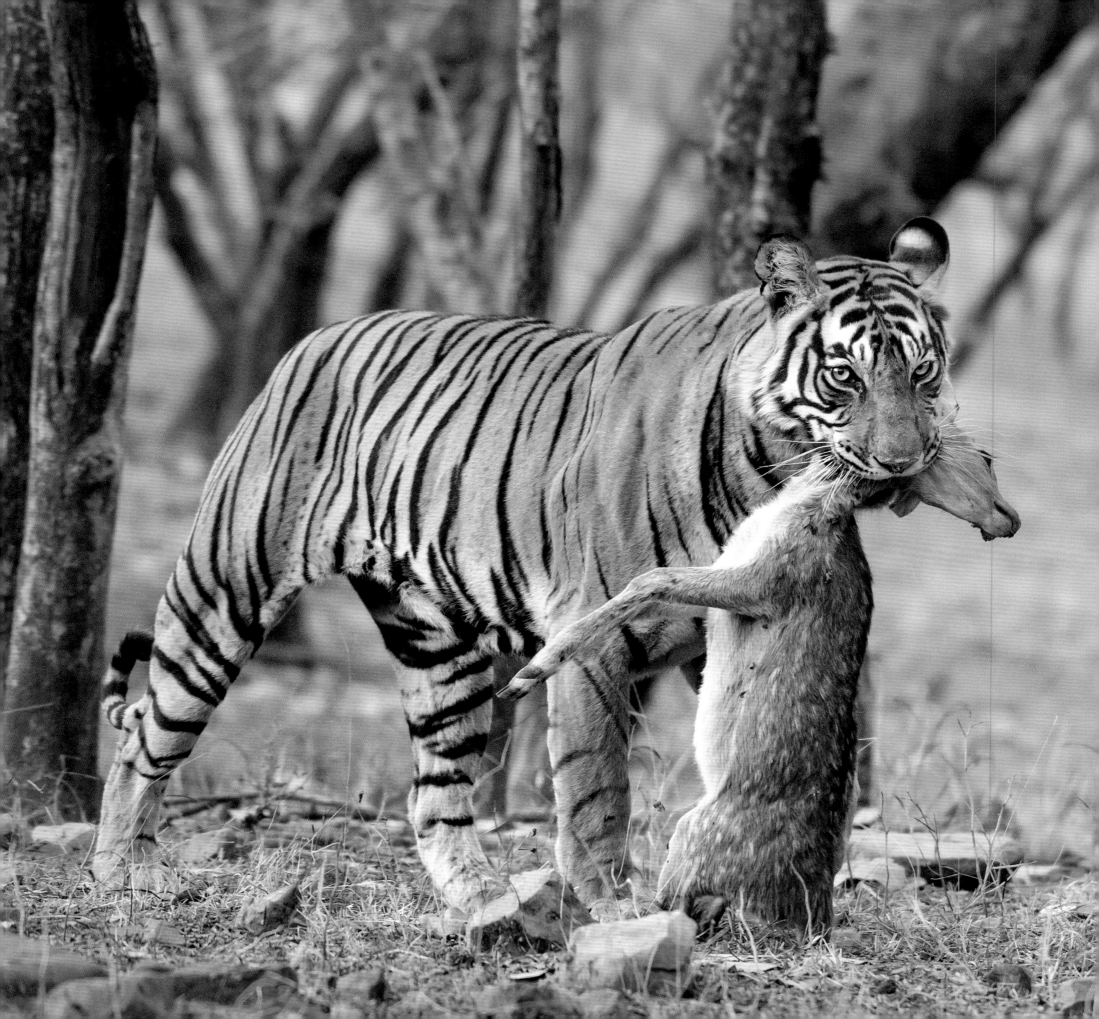

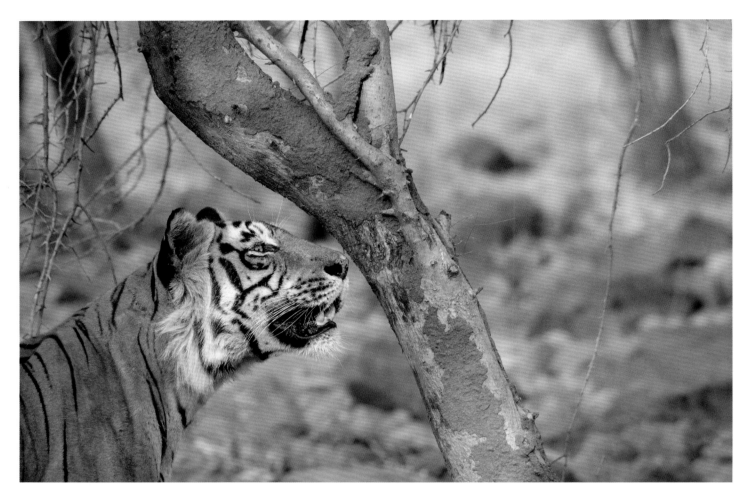

Above: This tiger is patrolling its territory, policing the boundaries by checking scent marks on trees to discover who has been there, who shouldn't have been? Tiger territories are a complex overlapping system; males have larger territories which may contain, or overlap with, a number of female territories. While females stay close to home when they leave their mother, males must move right out of the father's territory. This a difficult issue as the small size of reserves renders male tigers vulnerable and so mortality is high: they have to move out or they will get killed by the father, but moving can mean leaving the safety of the reserve. There is important work going on to create 'tiger corridors' to link the different reserves, but still the tiger may have a huge area of India to cross and many dangers to face beyond these corridor.

Ranthambore Tiger Reserve, Rajasthan, India
Nikon D5 + 200-500mm f5.6 lens at 290mm;
1/1000 sec at f6.3; ISO 2800

Right: I was watching the camouflage of the tiger's colouring against the russet tones of the dry foliage in dappled sunlight, and the dark stripes among the tree trunks of the forest. A sudden sunbeam broke through and happened to spotlight the moment the tiger was licking its nose.

Previous spread: We had seen cubs playing around, but noticed they were on their own and so we drove off to find the mother. We soon found her with this kill in her mouth — a spotted deer fawn, which she was carrying back to the cubs. The mother and cubs always seem to know where each other are and how to find each other. We followed her, repositioning the vehicle two or three times to get ahead, and she must have walked for more than 2 kilometres (1.2 miles), carrying her prey with relative ease.

Ranthambore Tiger Reserve, Rajasthan, India
Nikon D5 + 200-500mm f5.6 lens at 260mm;
1/800 sec at f5.6; ISO 3600

Ranthambore Tiger Reserve, Rajasthan, India
Nikon D5 + 500mm f4 lens + 1.4x converter;
1/1000 sec at 5.6; ISO 4000

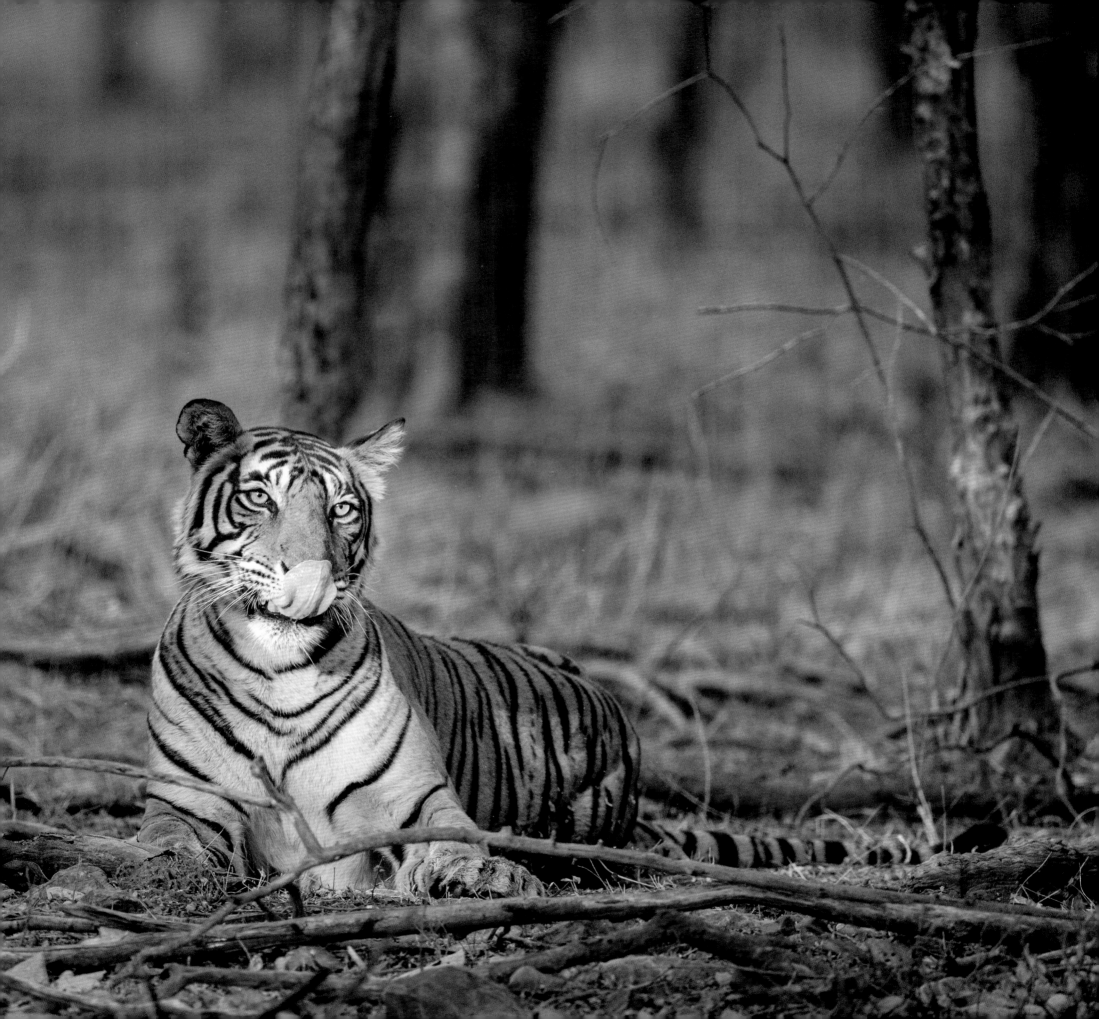

Right: We spotted this tiger resting in the shade, and I liked the sense that it was framed by a cathedral arch of trees. We parked up and watched and waited, the tiger occasionally moved but invariably looked the other way. I had this picture in my head: I wanted that depth of the soft background, so just waited for it to happen. After an hour or two, the tiger eventually glanced back towards us.

Ranthambore Tiger Reserve, Rajasthan, India
Nikon D5 + 200-500mm f5.6 lens at 500mm;
1/1600 sec at f5.6; ISO 1250

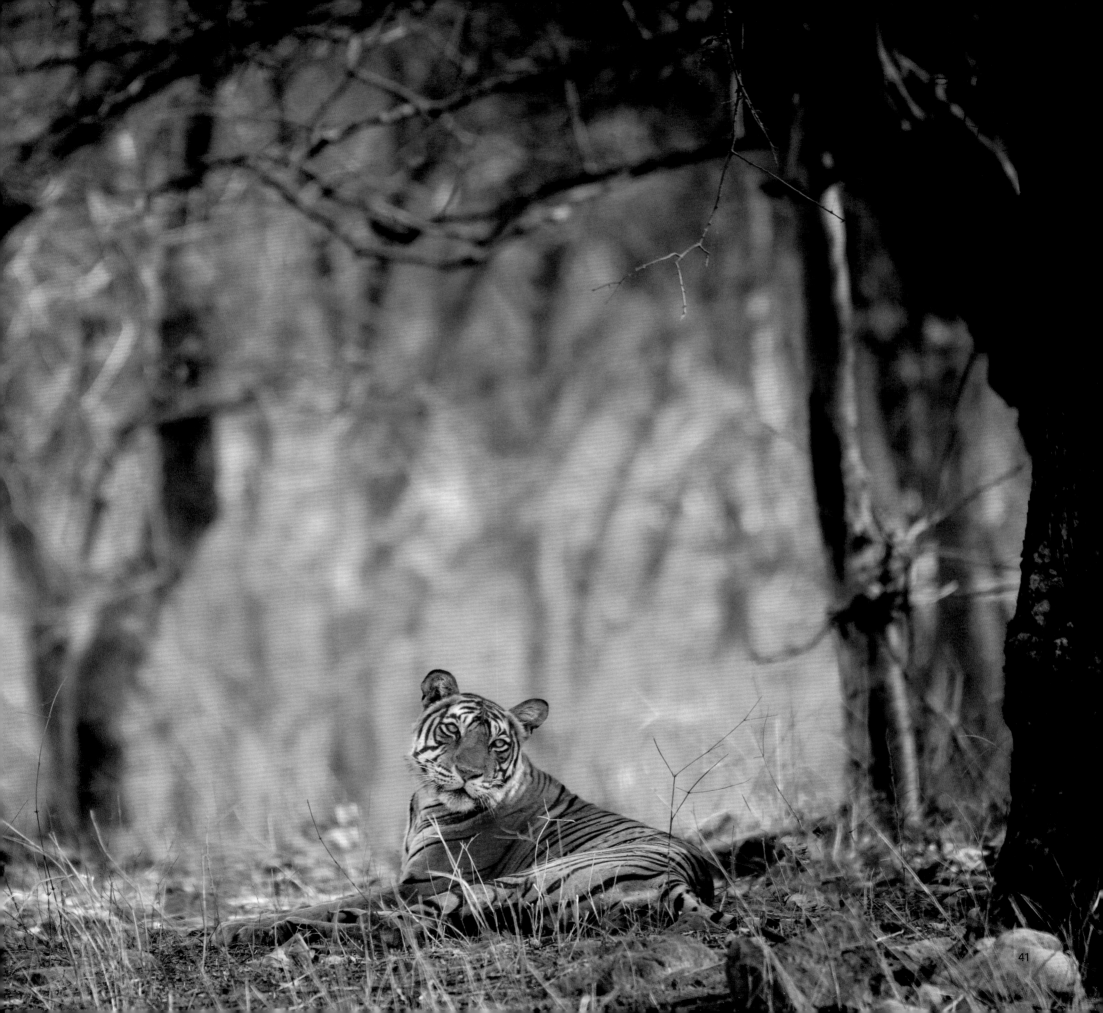

Planning your ultimate tiger safari

Where to go?
Choosing which reserve to visit is not easy. Tiger reserves in India are generally quite small, in comparison to many national parks in other parts of the world. Because of the relatively small numbers of tigers in each reserve, the quality of sightings can vary enormously over a few years, or even from year to year. One or two habituated tigers in the main tourist zone can make all the difference between a rewarding photographic trip and one with fleeting or even no sightings. Some reserves gained stellar reputations for excellent tiger encounters over a number of years, but things can change very suddenly as the dynamics of tiger society changes and photography can then become more difficult. Nothing is certain when looking for tigers.

Does the reserve have a route system?
Whilst some reserves allow you to drive freely, others have a rigorous route system allocated at the beginning of the game drive, you have to stick to it, usually moving in only one direction. This can be restrictive in looking for tigers, particularly when trying to find tigers by following alarm calls from prey animals.

Does the reserve have a zone system?
Most reserves have a zone system, and if free movement is allowed within the zone, this makes following alarm calls and tracking tigers much easier. Of course, some zones may not have a tiger present when you visit, so if there is an all-zone permit system available, taking this up will dramatically improve your chances.

What are the entry and exit times to the reserve?
For example, can you get in at first light to get 'golden hour' shots? While it is not essential, all day access is also worthy of consideration. Whilst the light may be harsh in the middle of the day, you will almost certainly get more sightings if you can stay all day.

How many vehicles are there likely to be at a sighting?
Generally, you have to expect quite a lot of vehicles at most sightings. It is useful to establish the number of vehicles allowed into the reserve or zone, as the quality of a sighting can be marred by jeeps jockeying for position.

What type of vehicles are available, and how many passengers will be in each?
As discussed in "Get low, get ahead", on page 26, the type of vehicle is a key decision when planning your safari. A low vehicle, like a Jeep, is best for photography.

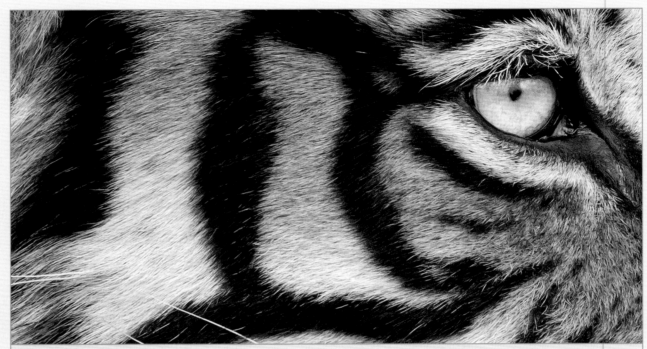

When to visit?

	Oct/Nov	Dec/Jan	Feb/March	April/June
Climate/ temperature	The monsoon season has just ended, and temperature will be cold in the early hours, but pleasantly warm once the sun comes up. Little chance of rain	First thing in the mornings it can be very cold in an open jeep, but temperatures will rise rapidly and by mid-morning it will be hot. Some areas suffer misty days in the early months of the year. Little chance of rain	Cool first thing in the day, but then getting quite hot from mid-morning onwards. Little chance of rain. Some areas may suffer mist, particularly early morning	Peak of the dry season. Temperatures soar in the morning. Highs of 35-40ºC (95-104ºF) Chance of afternoon thunderstorms
Background vegetation	Vivid green	Green	Beginning of autumnal colours	Golden brown
Tiger spotting	Can be difficult. Wildlife spread everywhere. Dense vegetation	Can be difficult. Wildlife spread everywhere. Dense vegetation	Moderate. Wildlife becoming more concentrated. Vegetation beginning to die back	Easiest. Wildlife concentrated near water. Vegetation has died back
Comfort	High. Comfortable temperatures	High. Comfortable temperatures	Moderate. Hot in the middle of the day	Uncomfortable. Very hot during the day

For my 'Ultimate Tiger Safari', in April I travelled by train from Delhi to stay 11 nights at the Ranthambhore Regency Hotel in Sawai Madhopur. Each day I visited Ranthambore Tiger Reserve on full day all-zone permits on a tour booked through UK-based wildlife tour specialists Reef and Rainforest.

Recommendation summary

Reserve: Ranthambore Tiger Reserve, Rajasthan, India.
Best time to visit: April and May.
Getting there: Fly to Delhi. It is five hours by train from Delhi to the Reserve.
Access: Full day all-zone permits.
Duration: Obviously the longer the better, but a minimum of six days.
Accommodation: There are many lodges in the area, choose one that is reasonably near to the Reserve and suits your budget.
How to book: Use a specialist wildlife travel agency with an established track record in India.

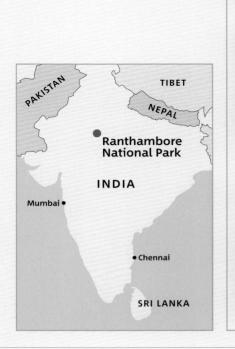

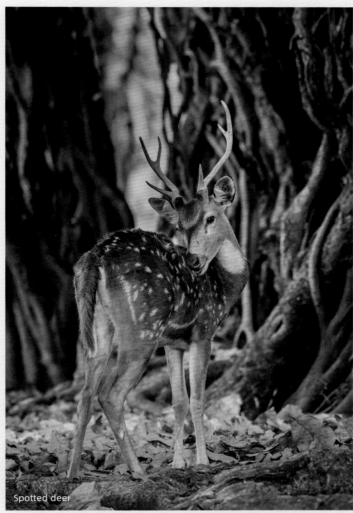

Spotted deer

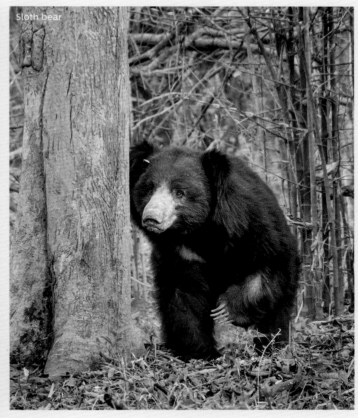

Sloth bear

What else might I see?

There is plenty of other wildlife to see in India's tiger reserves. In addition to many species of birds, you will see the tiger's prey species such as spotted deer and Hanuman langurs, and there is a reasonable chance of spotting other predators such as leopards and sloth bears.

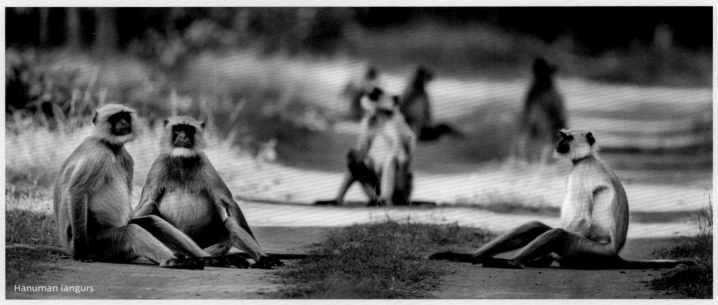

Hanuman langurs

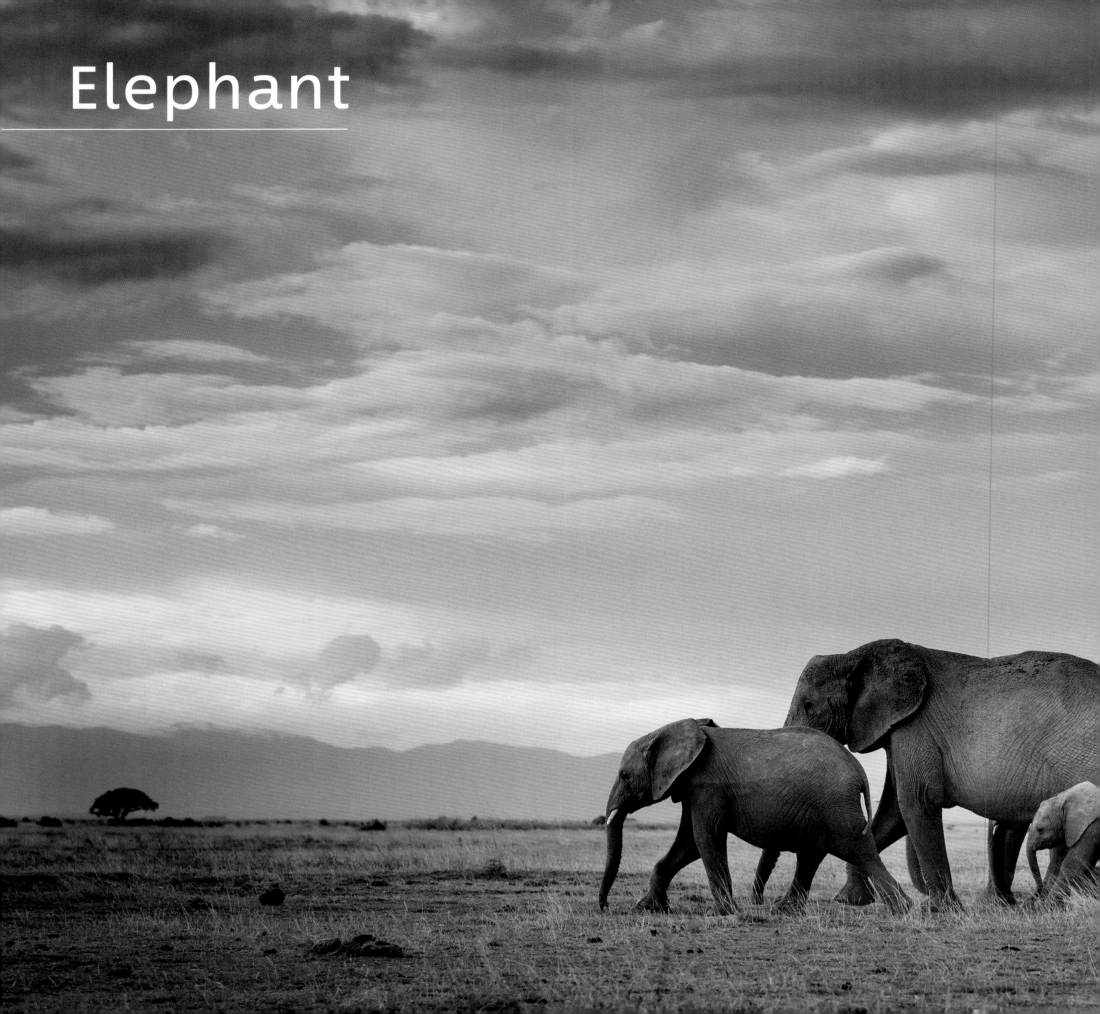

Elephant

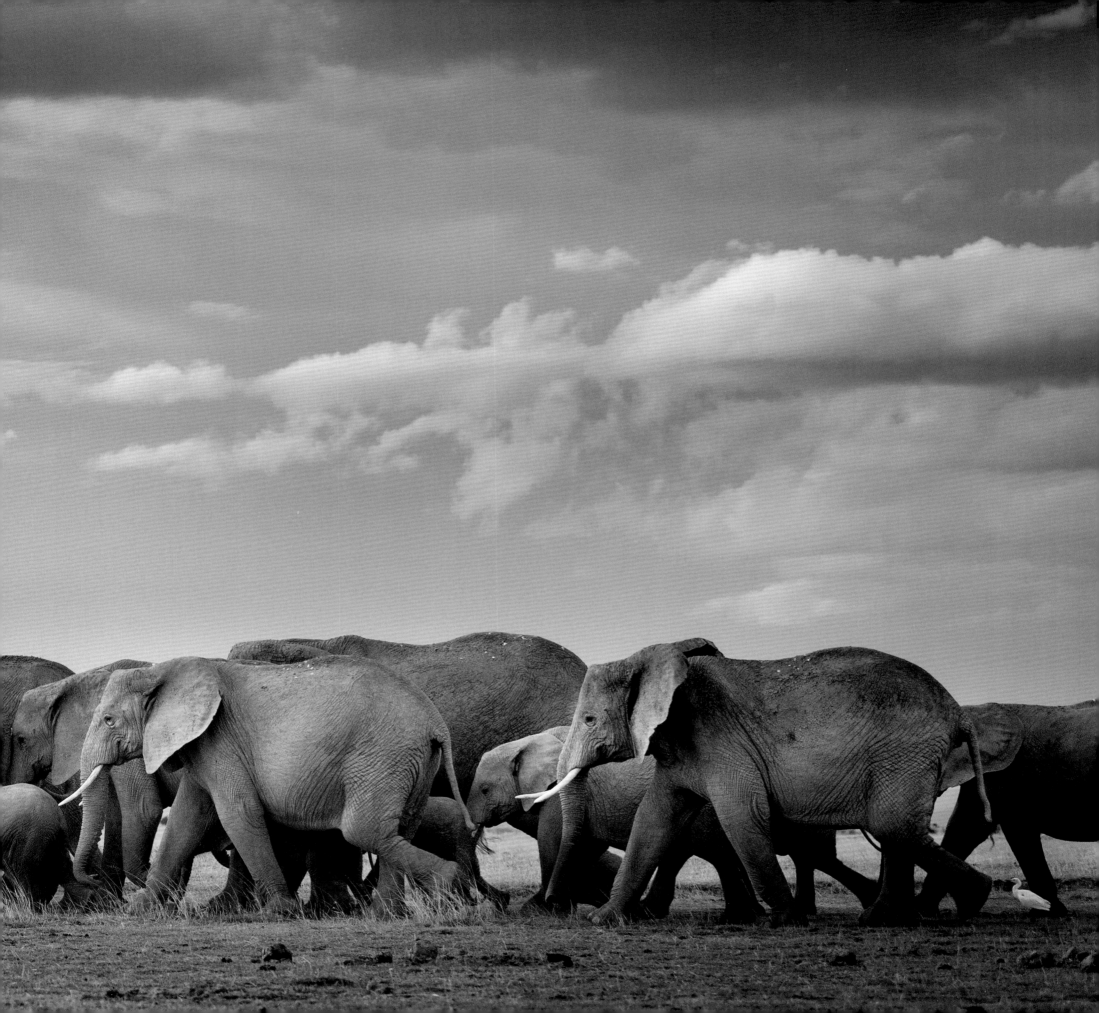

Everyone loves elephants! Even as small children we are able to identify this unique animal. Weighing up to 6 tonnes (6 tons), the African elephant is the largest land animal on the planet, and a species with which we generally feel a warm familiarity.

Elephants have a lot to offer the wildlife photographer. Who wouldn't want to try to capture in photos the appeal of a young calf, or the bond between the calf and its mother? Or the incredible shapes and textures that form the animal — trunk, tusks, pillar-like legs, huge feet, tiny eyes and rough, tough skin? It's a challenge to convey the awe-inspiring feeling of being close to such towering size and overwhelming power. Likewise to capture the complex interactions of the herd: the group of related adult females and their sub-adult offspring all led by the matriarch. And whether photographing a single individual or the wider herd, it is very rewarding to set elephants in the context of the dramatic environments in which they live.

Sadly, in recent years we have become all too well aware of the terrible toll that poaching for ivory has taken on the elephant populations in both Africa and Asia. Numbers have fallen dramatically in the last decade or so. National authorities and global conservation organisations are working hard to try to halt the slaughter. In some areas this has been more successful than in others, and thankfully there are still substantial numbers of elephants in some national parks. I visited a number of parks and reserves in Kenya, Zambia, Namibia and Botswana, and found many opportunities to encounter and photograph these magnificent giants.

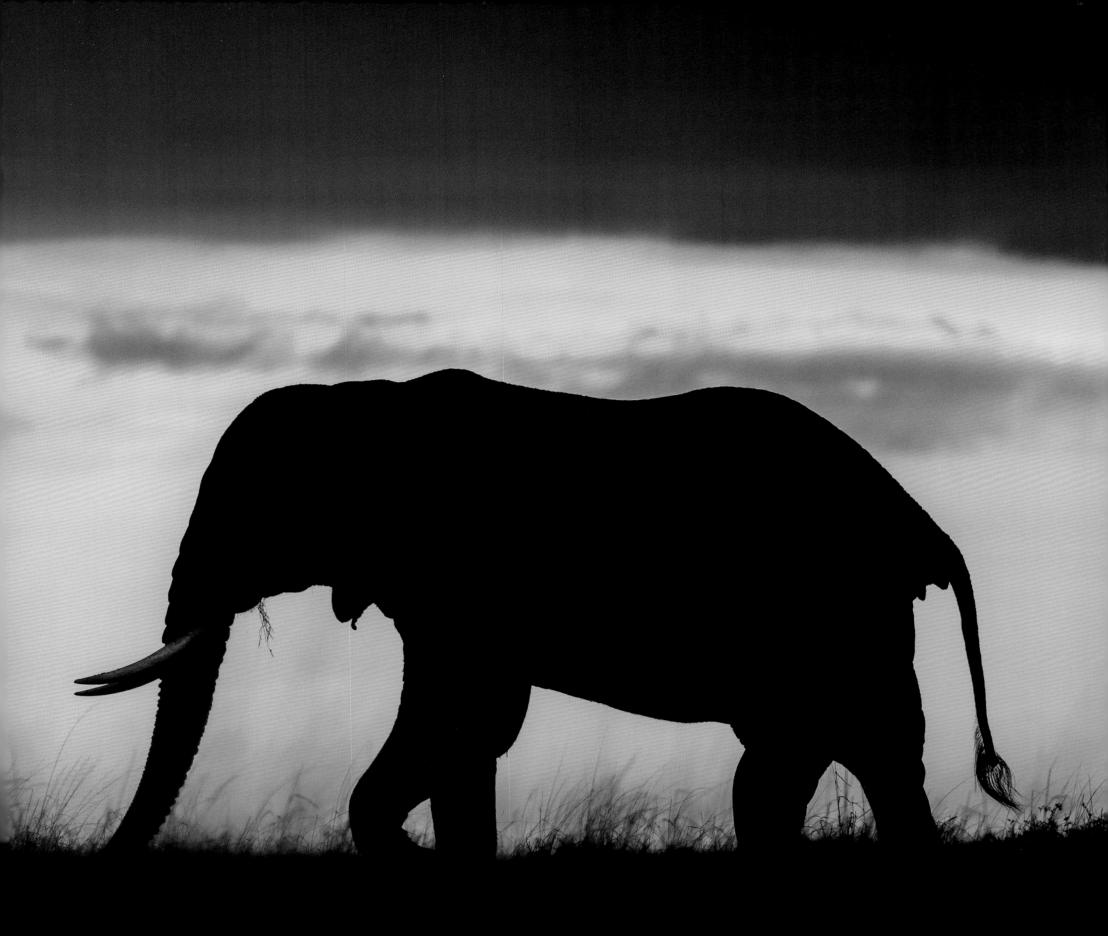

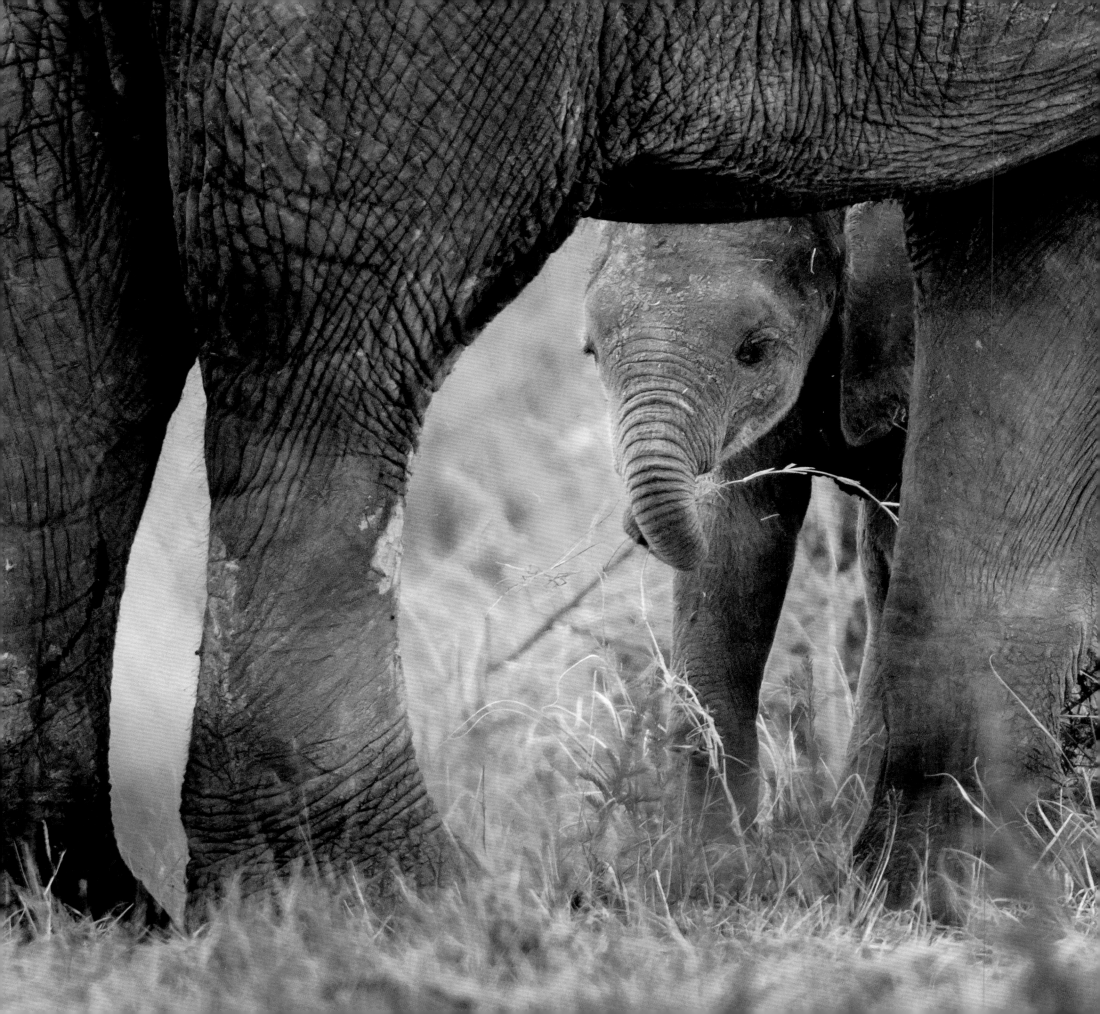

Lying on the ground with elephants towering above me

This is so uncomfortable! The grass is really prickly, it's piercing through my clothes at multiple points, and sticking into me. I shuffle to try and improve the situation, but it makes little difference. I am lying on the ground at the back of the safari vehicle underneath the spare tyre. This gives me a great camera angle on this herd of approaching elephants. The guide had explained that by lying close to the vehicle and beneath the tyre I appear to the elephants to be part of the vehicle. This means they will go about their business undisturbed. Hopefully, and more importantly in my opinion right now, it also means they won't see me as a threat. With youngsters in the herd, if the adults do perceive a threat, they may well charge.

I am in Kitirua Conservancy, which is adjacent to Kenya's Amboseli National Park. In the background is the mighty peak of Kilimanjaro, which dominates the skyline throughout the area.

I feel distinctly uneasy lying on the ground with these elephants towering above me, as I know from experience that elephants can be aggressive at times. Here in this Conservancy they seem really calm, but I am more than ready to jump quickly back into the vehicle if that changes, or if they come too close. It is also quite tricky keeping an eye on them all, as they are constantly wandering around in different directions. When photographing, I am absorbed with the scene through my viewfinder, concentrating on framing a shot. It is a very narrow, restricted field of view. I must keep remembering to look around me, there may be better photo opportunities elsewhere, or, more critically, an elephant may be moving dangerously close. These giant animals can approach almost silently. Fortunately, our guide is also keeping a watchful eye on them, and I trust his experience that he will notice any change in their mood or the situation, and alert me if necessary. ▶

Left: Kitirua Conservancy, Amboseli, Kenya
Nikon D5 + 180-400mm f4 lens + 1.4x extender at 560mm;
1/2000 sec at f5.6; ISO 1400

Title pages:
Kitirua Conservancy, Amboseli, Kenya
Nikon D5 + 70-200mm f2.8 lens at 75mm;
1/250 sec at f3.5; ISO 1800

Introduction pages:
Kitirua Conservancy, Amboseli, Kenya
Nikon D5 + 180-400mm f4 lens at 280mm;
1/2500 sec at f4; ISO 400

▶ I've spotted a tiny calf, probably only a couple of months old. He is very cute and seems to be enjoying his young life. Still a little stumbly when walking, he has not gained full mastery of his trunk. Most of the time he is keeping close to his mother, but occasionally he ventures further afield. I decide to concentrate on the calf, but just when it looks like I may get a nice clear view, the herd moves off into the bushes.

I clamber back into the vehicle, and we see if we can find another position. It looks hopeless, as the herd is now in a dense thicket of bushes and rapidly receding from view. However, the guide persists, and finds a way around and through the bushes into another clearing. I jump out of the vehicle again.

We have to do this a couple more times, as each time our quarry moves into another thicket. But eventually the guide's persistence pays off, as we end up in an open space, and very close to the elephants. This calf is a joy! One minute he is hiding behind his mother, the next he is testing out his trunk on a clump of grass. Now he's doing a 'mad puppy'-type dash. The Kitirua Conservancy is perfect for this kind of situation. Here you are allowed to get out of the vehicle, enabling a nice low-level camera angle to produce much more engaging shots of the elephants — a technique that's particularly effective with this endearing calf. ●

Right: Kitirua Conservancy, Amboseli, Kenya
Nikon D5 + 180-400mm f4 lens + 1.4x extender at 550mm;
1/2000 sec at f7.1; ISO 1100

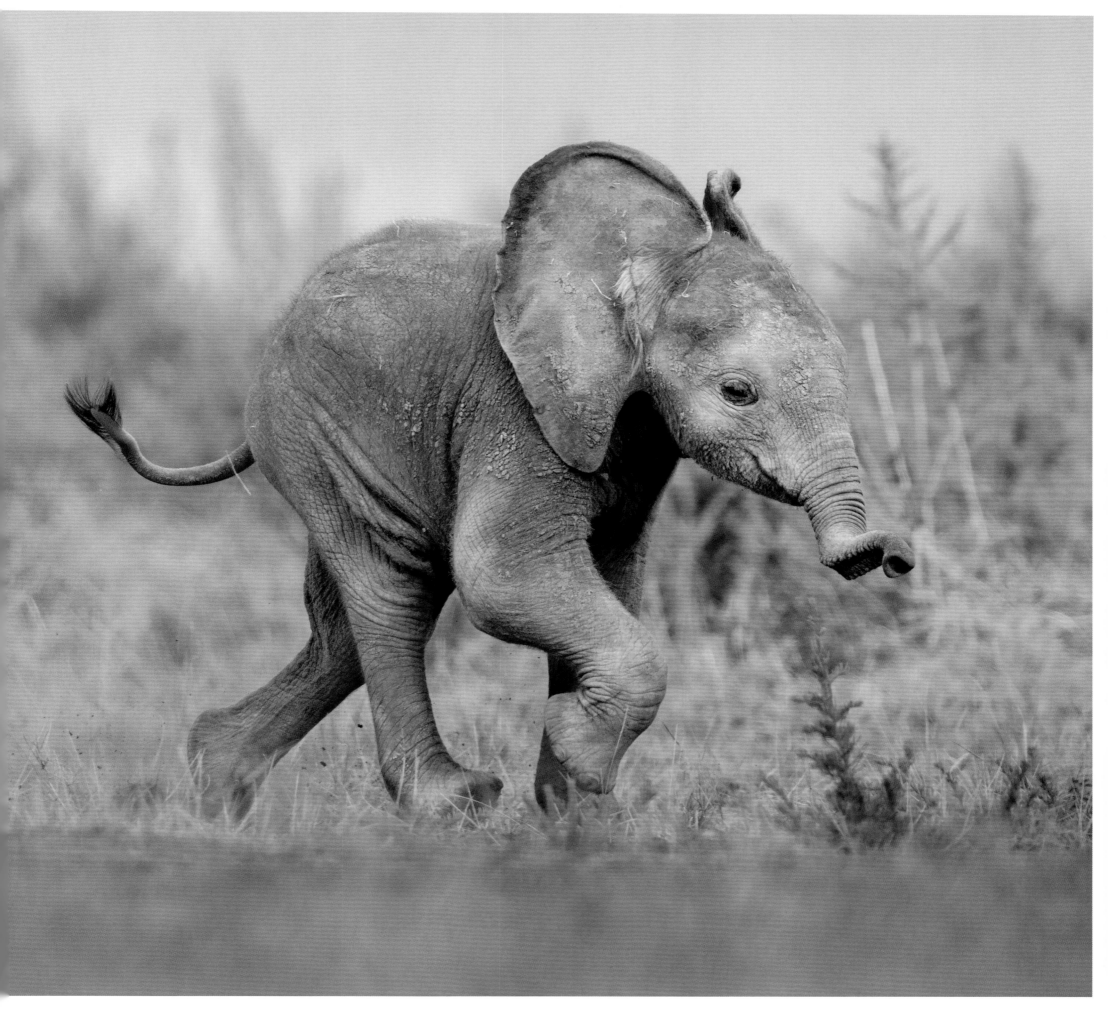

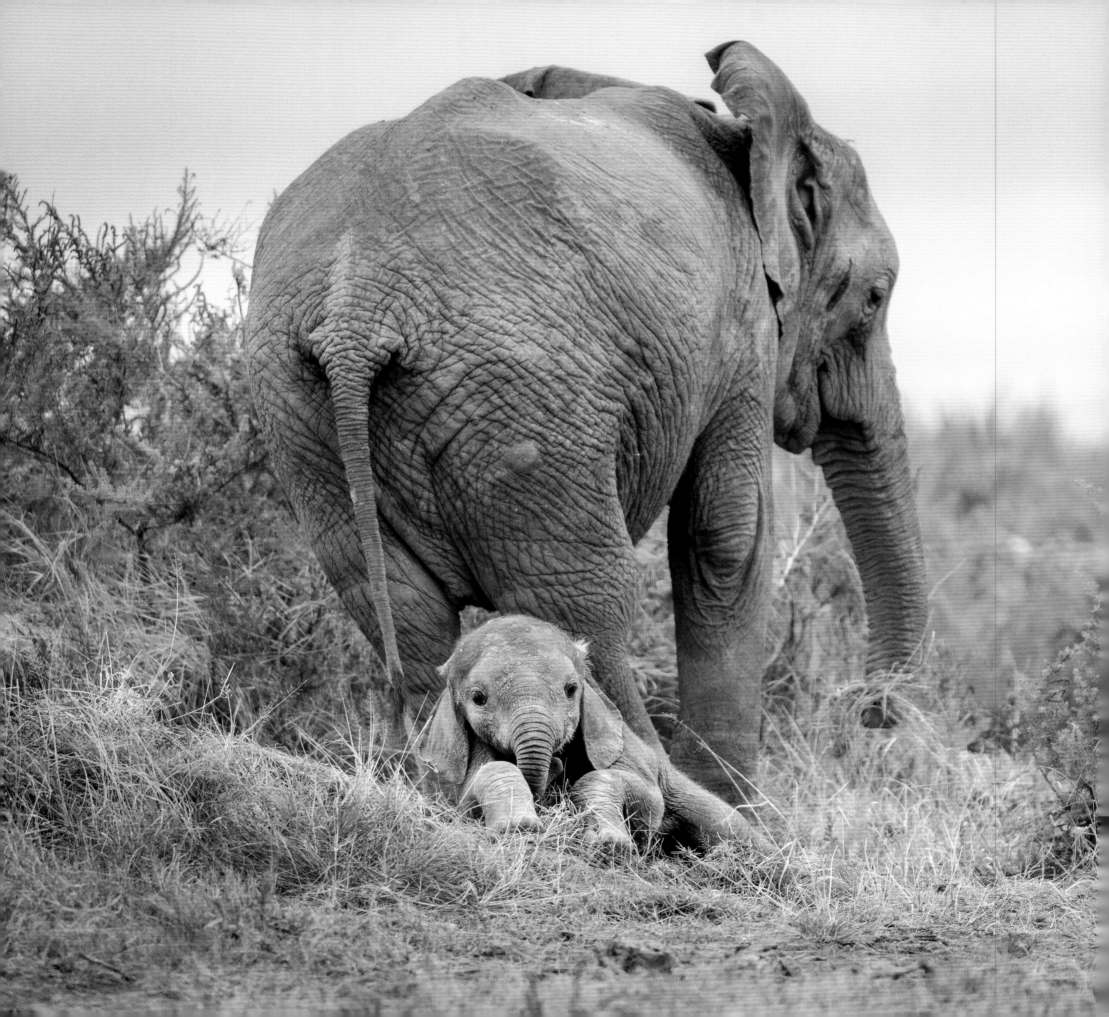

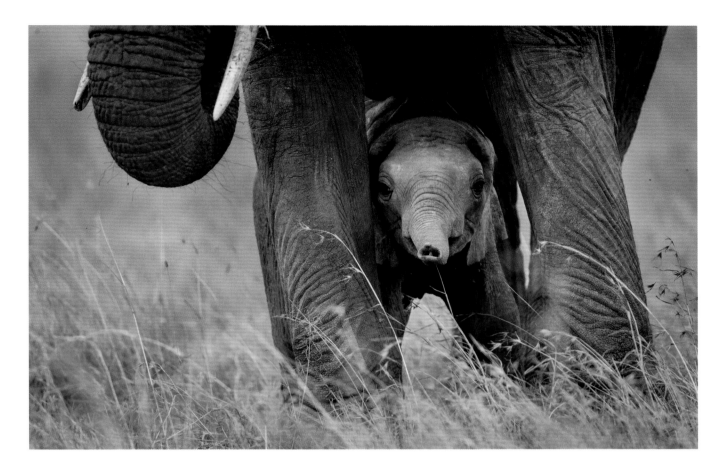

Above: This calf is very young, less than six months old, and still 'fits' within the frame of its mother's body as a safe shelter. The mother just carries on eating, but the calf is aware of me, and somehow manages to simultaneously convey both curiosity and caution in its body language.

Mara North Conservancy, Greater Masai Mara, Kenya
Nikon D5 + 180-400mm f4 lens + 1.4x extender at 560mm;
1/1250 sec at f5.6

Left: Calves move their young bodies as if they're still testing out new equipment — a sudden prance or run but still wobbly on their legs. After the mad puppy dash, this calf stumbled and fell — fortunately into the safe bulk of its mother, who was always close by.

Kitirua Conservancy, Amboseli, Kenya
Nikon D5 + 180-400mm f4 lens + 1.4x extender at 490mm;
1/2000 sec at f5.6; ISO 1250

Photographic tip
Framing the calf

Elephant calves are very endearing, and they present really nice opportunities for photography. The calf often stays close to its mother, either to one side or under its mother's legs. One technique that can work well is to use these legs to frame the calf, both emphasising the bond between mother and calf, and vividly showing how tiny the calf is compared to its mother.

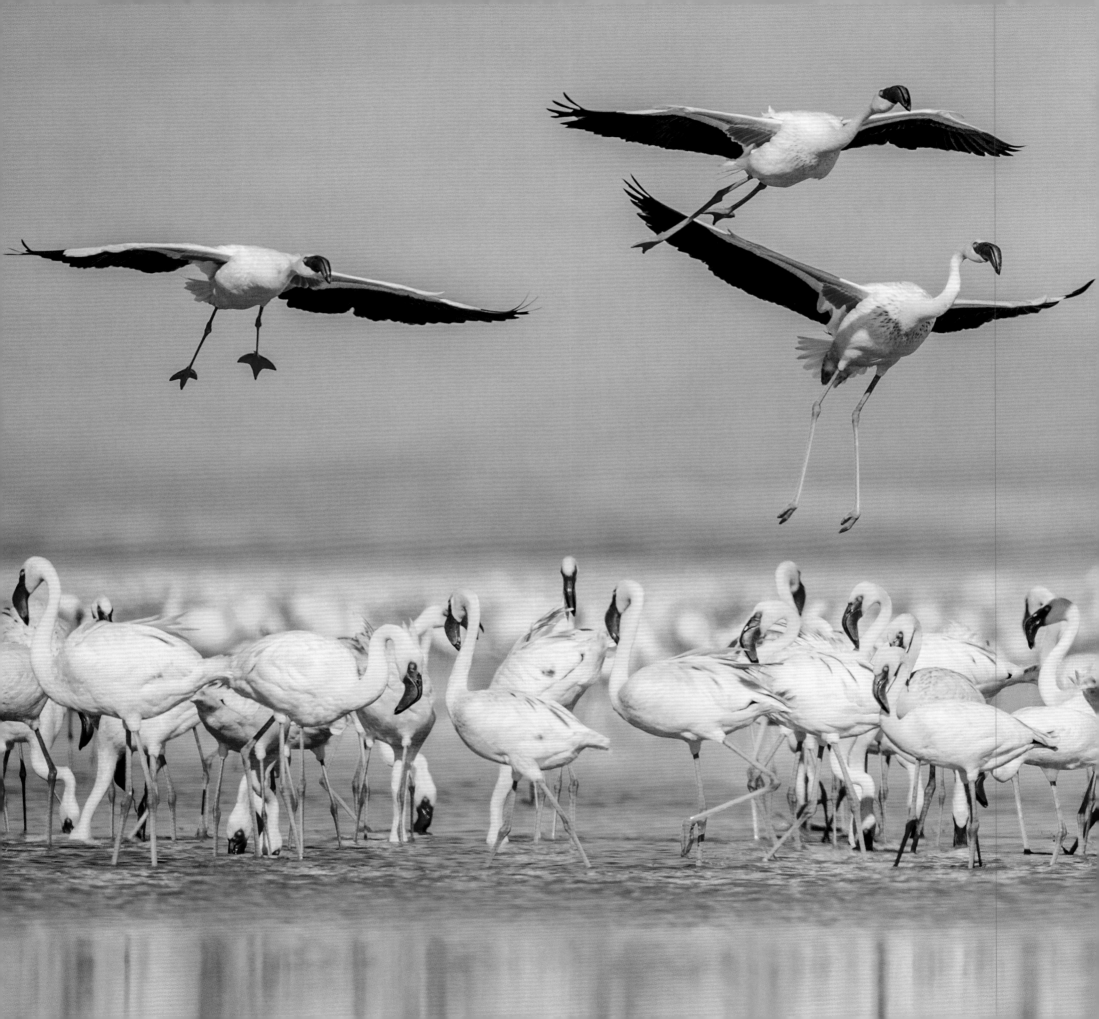

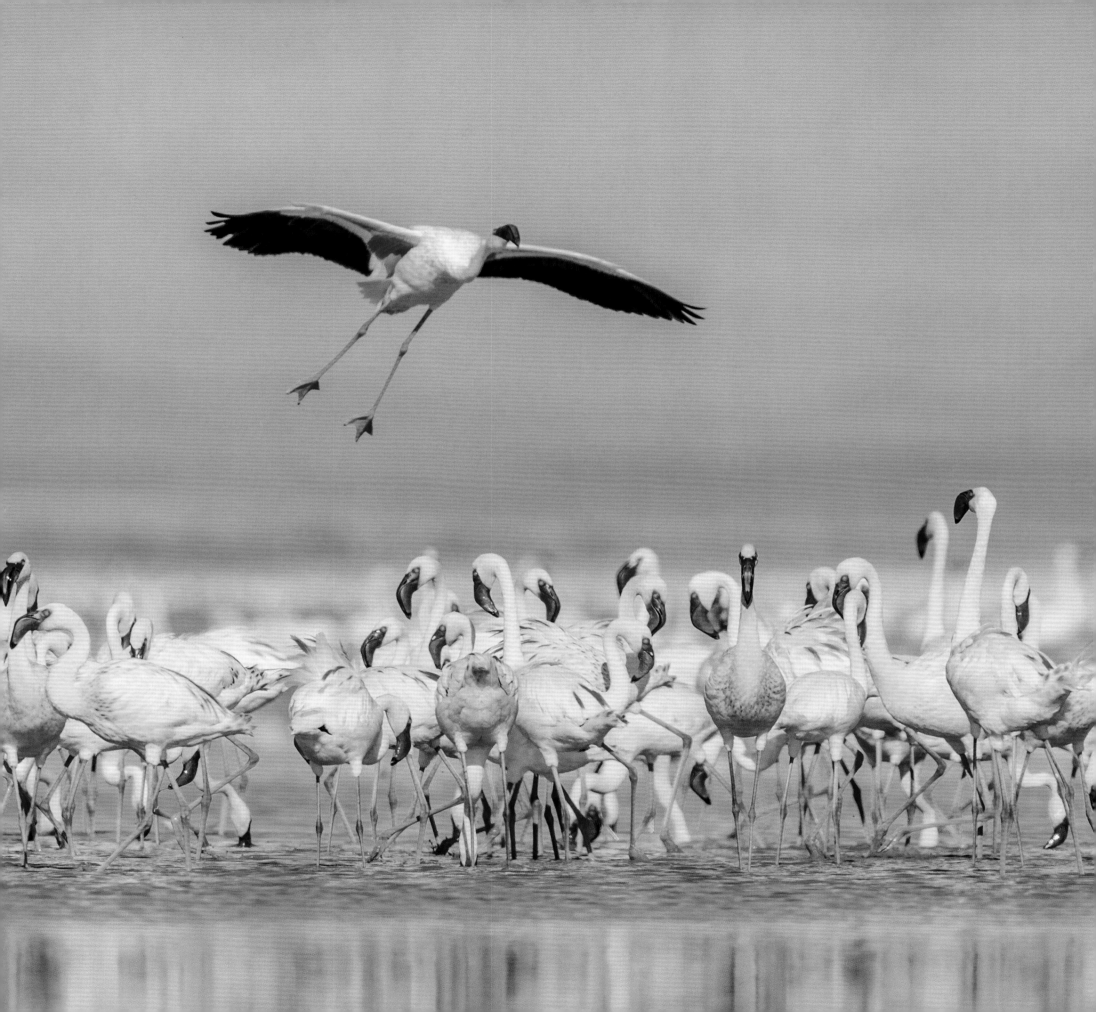

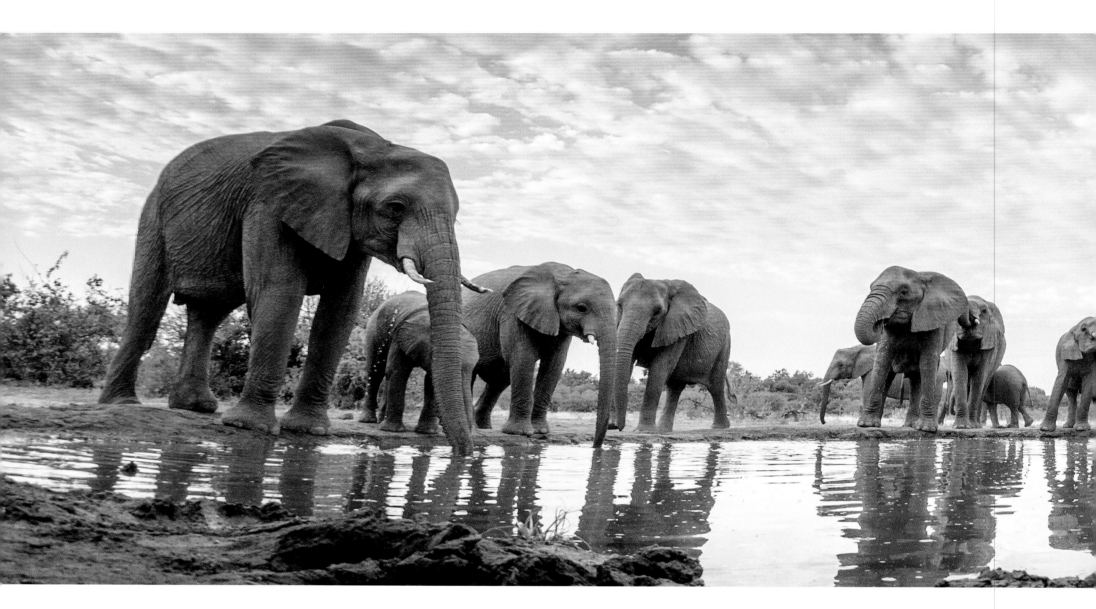

Above: A sunken hide at this watering hole offered a fantastic perspective from which to photograph elephants. I watched as this large herd gathered to drink, and took this image from the hide with a fish-eye lens. I wanted to capture the size of the herd as each elephant took its place around the water.

Mashatu, Northern Tuli Game Reserve, Botswana
Nikon D5 + 15mm f2.8 fish-eye lens;
1/400 sec at f5.6; ISO 200

Previous spread: In some years, flamingos flock to this lake in Amboseli National Park. I've seen so many photographs of these large gatherings of flamingos and their reflections in the water, so again I was looking for something different. I decided to focus on the contrast with those that were 'landing' — their feet outstretched and the black and red underside of their wings revealed.

Kitirua Conservancy, Amboseli, Kenya
Nikon D5 + 180-400mm f4 lens at 400mm;
1/2500 sec at f4; ISO 250

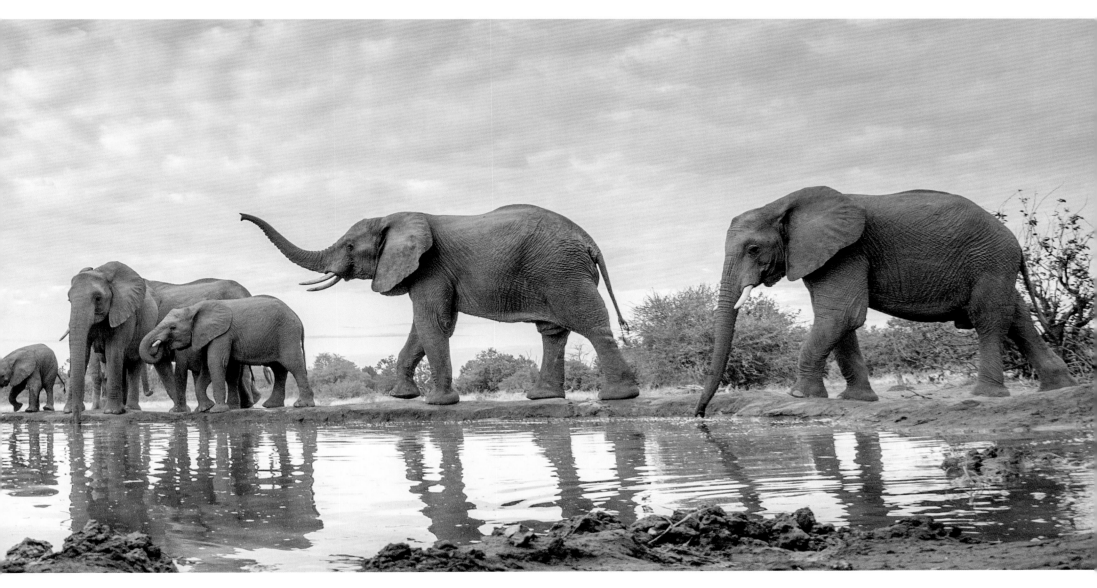

Photographic tip
Get Low
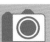

It might seem counter-intuitive, but even with a huge animal such as an elephant, a photo is usually better taken from a low position. In particular, it helps to emphasise the size of the animal. Options for getting low are often quite limited when in a safari vehicle, although the seats nearer the front tend to be lower, in particular the front passenger seat. Careful positioning of the vehicle can help a lot. The very best places are where you are allowed to photograph from out of the vehicle, so you can sit or lie on the ground close to it. Some reserves have purpose-built sunken hides, usually at waterholes, and these can be superb for photography.

Above: Trunks up! These elephants are very close, just about 10 metres (33 feet) away across the water from the dramatic location of the submerged hide. This camera angle gives a sense of the height of the elephants and the way they lift their heads as if synchronised as they drink.

Mashatu, Northern Tuli Game Reserve, Botswana
Nikon D500 + 16-80mm f2.8-4 lens at 16mm;
1/640 sec at f11; ISO 900

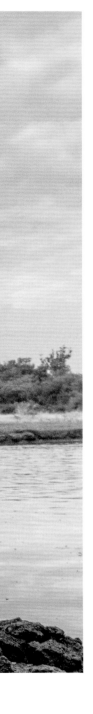

Right: Close focus reveals the incredible range of textures and colours of the elephants' skin: the folds and wrinkles, the encrusted mud, the fuzz of black fur over the baby. It was an irresistible photo opportunity to see this calf framed by its parent's legs: the juxtaposition of small trunk and huge toenails!

Mashatu, Northern Tuli Game Reserve, Botswana
Nikon D4S + 600mm f4 lens;
1/640 sec at f7.1; ISO 2000

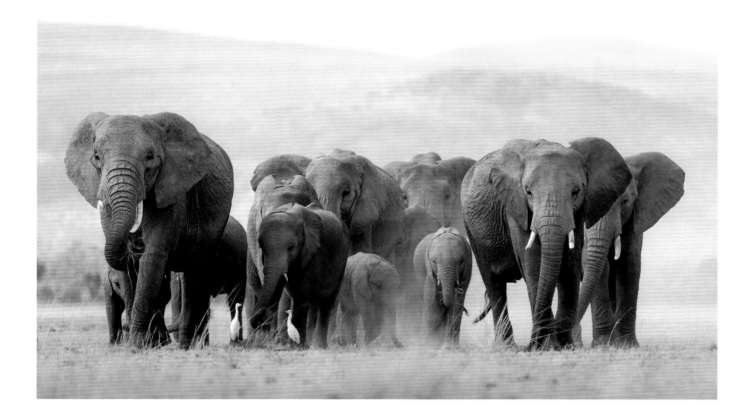

Matriarch

The elephants usually spend each night in the forest, and at dawn they head out, making their way across the grasslands, feeding as they go. They are led by the matriarch, whose intention is to get them to the swamp by late morning, where they continue to feed in the cooling waters during the heat of the day.

We have just found one such herd crossing the grasslands, clearly on a mission, marching along as a coherent group. I can see why they are referred to as a parade of elephants. We position the vehicle ahead and just to the side of the line they are following, and I jump out to photograph them as they walk towards us.

They make an impressive spectacle: up to a dozen elephants bearing down on us. They come in all sizes; from small calves, through numerous youngsters and adolescents, up to some huge adults. When they get close, I jump back into the vehicle, we drive off and around in a loop and position ourselves ahead of them again and repeat the exercise.

We do this again, and again, and again. They just keep marching across the plains. Each time it is slightly different. Sometimes they march past farther away, other times very close. This time as they approach us, they bunch up a little, with some of the other elephants flanking the matriarch on both sides. I am low down in the grass looking up at them. It is a tremendous sight. ●

Above: Kitirua Conservancy, Amboseli, Kenya
Nikon D5 + 180-400mm f4 lens + 1.4x
extender at 450mm; 1/1250 sec at f5.6;
ISO 360

Right: Kitirua Conservancy, Amboseli, Kenya
Nikon D5 + 180-400mm f4 lens at 400mm;
1/2000 sec at f5.6; ISO 640

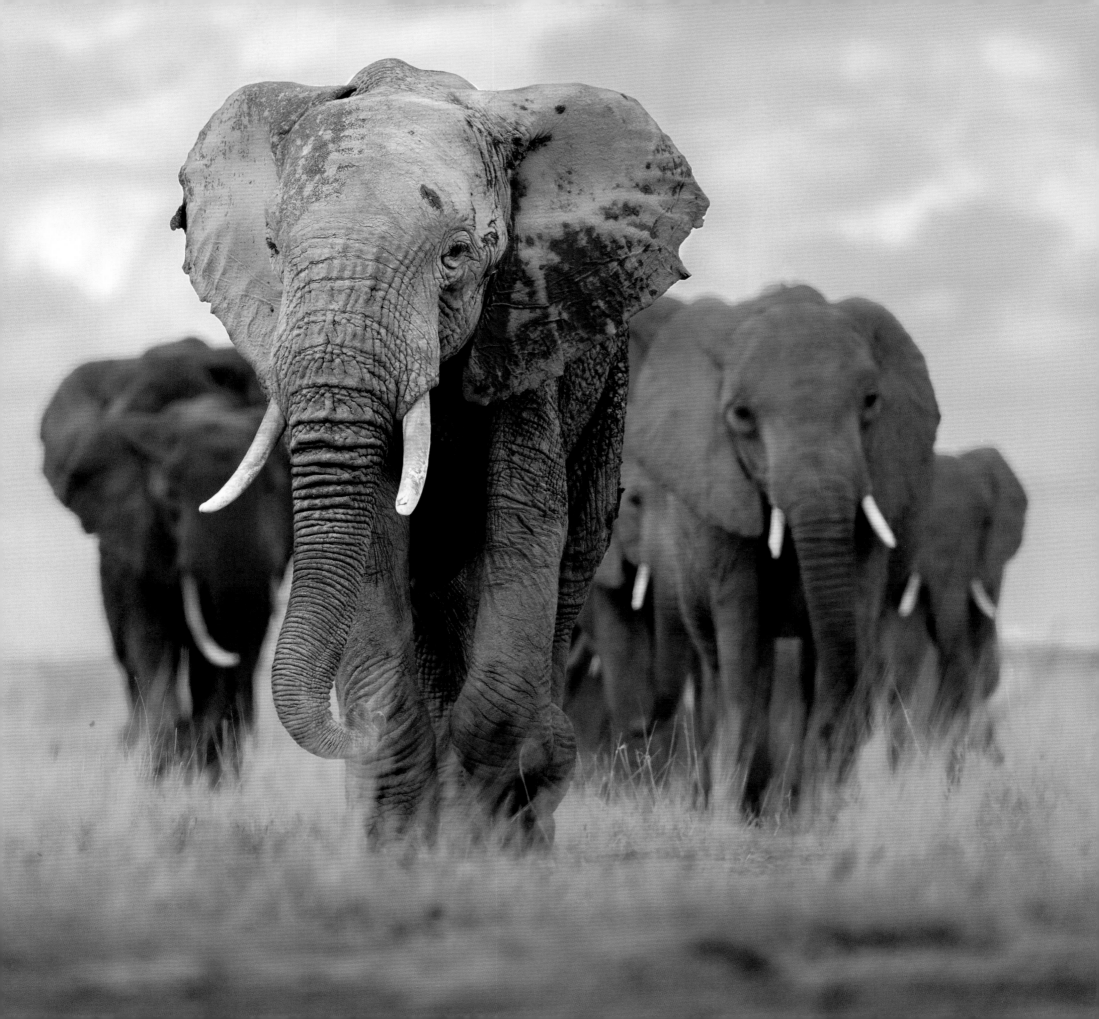

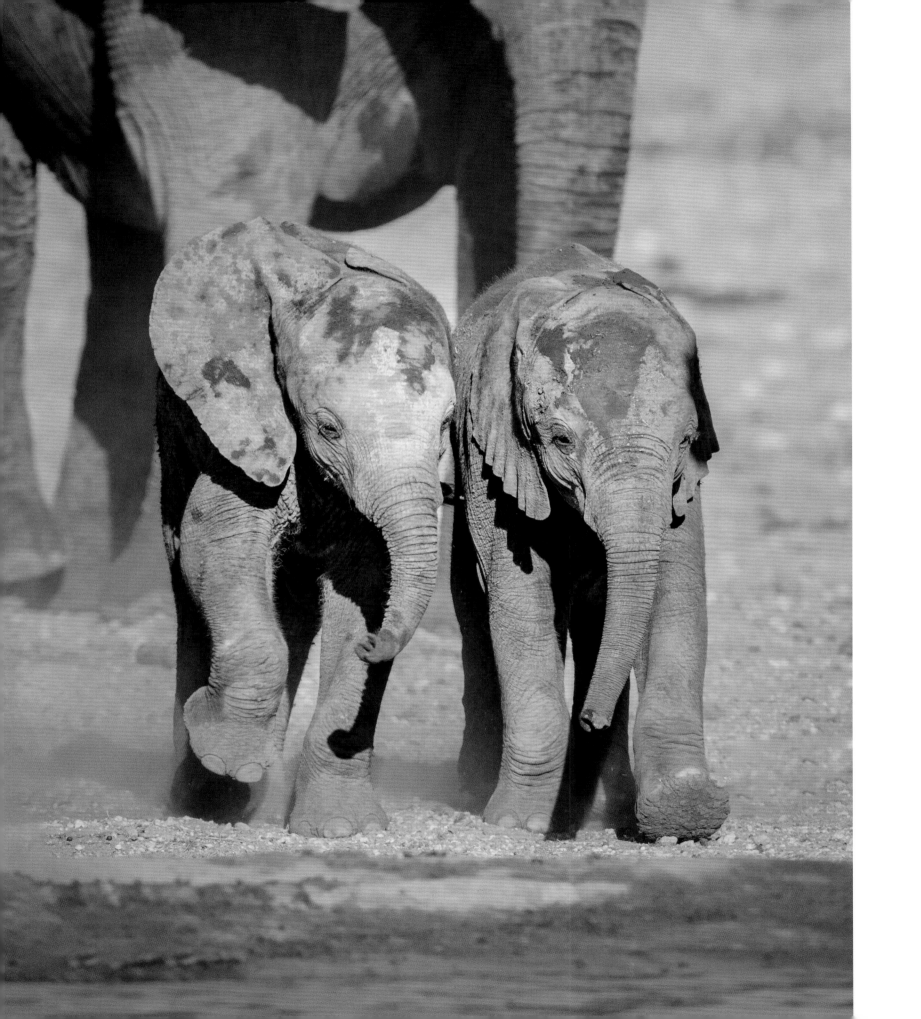

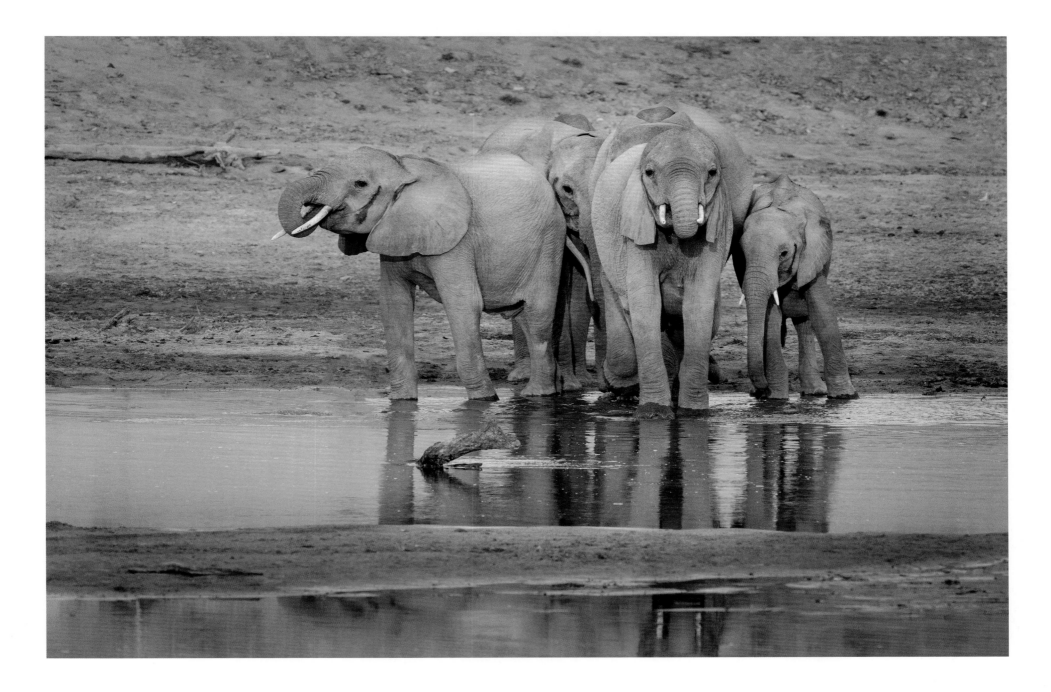

Left: I loved the sense of muddy kids at play — these two look like they're best pals getting up to mischief! There's a feeling of forward momentum in their raised feet, and a backstory told in the different colours of mud: they have both been rolling around in it, but one in white chalky clay and the other in terracotta.

Etosha National Park, Namibia
Nikon D800 + 600mm f4 lens;
1/500 sec at f7.1; ISO 200

Above: Again it's the golden hour, the magic time between 6 and 7am. I'd spotted these elephants having a morning drink at one of the tributaries of the Zambezi. In some ways this breaks a rule of photography: having the subject stand out against the background. But for me it's the uniformity of colour that makes this image: land, water and elephants all bathed in this beautiful pink morning light.

South Luangwa National Park, Zambia
Nikon D810 + 600mm f4 lens;
1/800 sec at f6.3; ISO 720

'None of the bushes is walking'

Our guide Anthony emerges from the gloom holding his binoculars. 'I've scanned from horizon to horizon, and none of the bushes is walking!' he explains somewhat cryptically. We are on top of a small hill, which is normally an excellent vantage point overlooking Amboseli's Kitirua Conservancy. We are shivering in the cold. It is 5:30am and still pitch black. The only way to differentiate an elephant from a bush when it is so dark is to wait and see if it walks off. At the moment, none of the bushes is walking, at least as far as Anthony can tell in this dim light.

Yesterday we arrived at the same lookout just before 6:00am, just ten minutes before sunrise, and the light was coming up really quickly. Although we spotted elephants pretty much straightaway, it was a mad scramble to get to them in the first light. We are trying to photograph them silhouetted against the amazing orange, blue and purple colours of the dawn sky. The trick is to find some elephants with a clear eastern horizon behind them, and then drive to them before the dawn moment passes. It was all too rushed yesterday, and so determined to do it better today, we got up at an unholy hour, and have now arrived a little too early.

Ten minutes later Anthony spots a couple of 'walking bushes' through the brightening twilight — elephants in good open ground, and although they are some distance away, he estimates that we should be able to reach them in time. We head off to intercept them. We are in business!

It's been a fifteen-minute bouncy, bumpy, dusty drive, along dirt tracks and across plain grasslands. In the National Park you have to stick to the roads, but the beauty of being in this Conservancy is that we can leave the road and position the vehicle in the best spot to photograph. That's critical for this sort of shot. When we arrive, we pause for a brief moment to assess where to put the vehicle. We need a clear view, and an open horizon, with no bushes or trees behind the elephants. We settle on a spot and I jump out of the vehicle, back to my now customary spot underneath the spare tyre.

It's now a patience game. I'm hoping an elephant will present a nice silhouette before we lose this fantastic multi-coloured sky. But it's not working, the elephants have moved off to the left. I scramble back into the vehicle and we reposition, and I jump out again. Time is passing, will this work? Again, we reposition, and this time it does come together — a big bull elephant with a stunning orange sky behind him.

And it's not over yet, the sun will come over the horizon in moments. Let's try to get a sunrise shot. Again, we reposition the vehicle, I jump out and wait on the ground for an elephant and the sunrise to come together. Well worth the early morning start. ●

Right: Kitirua Conservancy, Amboseli, Kenya
Nikon D5 + 70-200mm f2.8 lens at 160mm;
1/1000 sec at f4.5; ISO 160

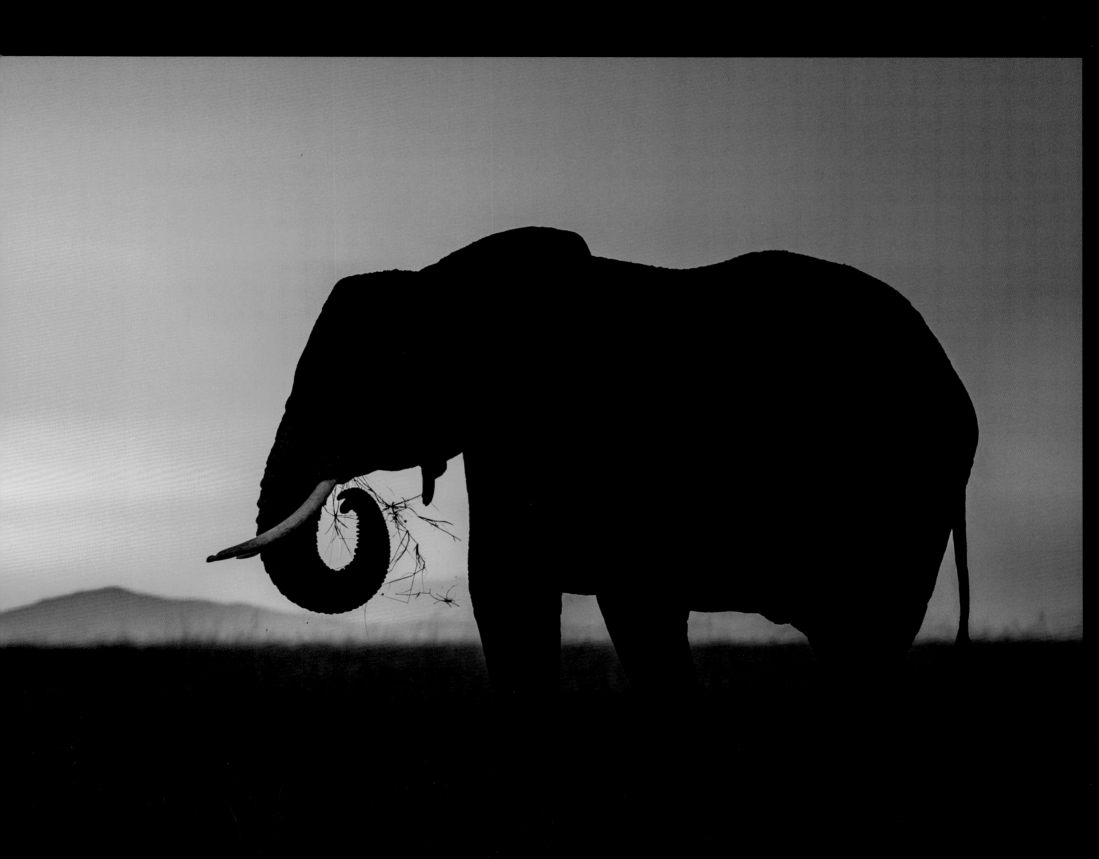

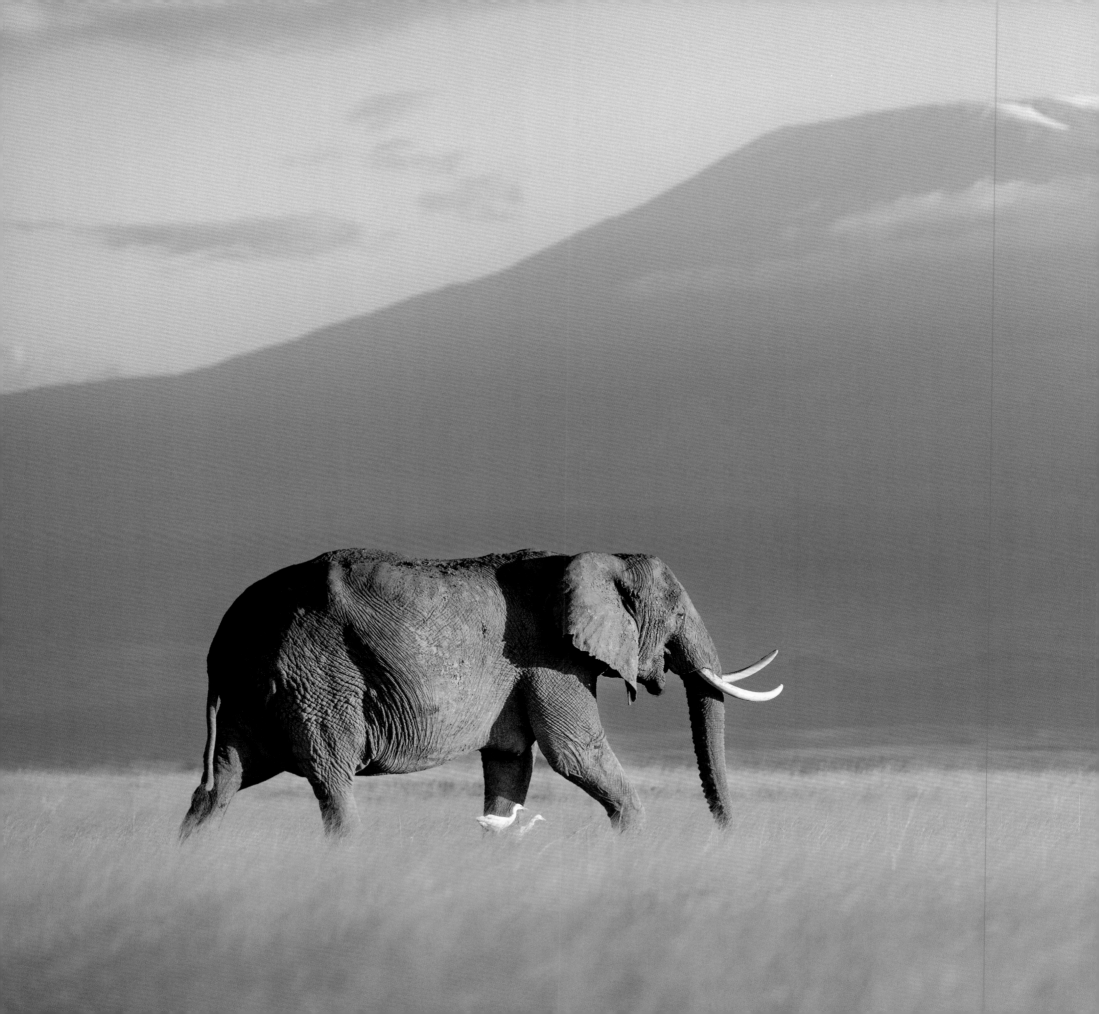

Photographic tip
Support matters

Method		
	●	Recommended
	○	Possible use
	●	Not recommended
Handheld	●	There is usually good light, allowing for fast shutter speeds. With good technique, this is a very practical option. If photographing from the vehicle a beanbag is preferable (see below)
Beanbag	●	When photographing from the vehicle, this is usually the best option. Place the beanbag on the side of the vehicle, and when taking a shot gently press the camera lens down onto it. Also useful in hides that have a suitable shelf.
Monopod	○	Not really necessary, as the beanbag works so well. In some vehicles the sides are too low to easily use a beanbag, and here a monopod is an option. Additionally, consider clamping a monopod to the vehicle. This provides excellent support, but with somewhat restricted viewing
Tripod	○	Not practical in a vehicle. A tripod works well in some hides. Some hides have a shelf to which you can attach a tripod head.

Left: A large male strolling near the foothills of Mount Kilimanjaro, a sense of grandeur in the bulk of the sunlit animal and the sweep of the mountain behind. The white birds at its feet are cattle egrets, which are commonly seen in association with elephants. I've seen them on the backs of elephants, and sometimes they spoil the photographs! But here I like the contrasting scale as they walk alongside — catching the light, as do the elephant's impressive tusks.

Kitirua Conservancy, Amboseli, Kenya
Nikon D5 + 70-200mm f2.8 lens at 165mm;
1/4000 sec at f3.5; ISO 360

**Organisational tip
Dedicated vehicle**

The needs of photographers will often be
totally different to those of many safari
guests. Whilst others are trying to see all the
animals within limited time, photographers
will want to stay and 'work' a special
situation, potentially for hours on end!
It is essential to have a dedicated vehicle
for photography. This can be expensive, so a
good alternative is to travel with a group of
like-minded photographers so that any extra
costs can be shared or hopefully eliminated
altogether.

Right: We were just to the side of the track when
this herd came walking towards us. They stopped,
then came forward and passed us in precise
formation, like a multi-legged creature with many
layers of ears. The raised feet capture the rhythm of
walking in step, just like I've seen in comics or in the
Jungle Book, but this was for real!

South Luangwa National Park, Zambia
Nikon D4S + 80-400mm f4.5-5.6 lens at 400mm;
1/1000 sec at f9; ISO 400

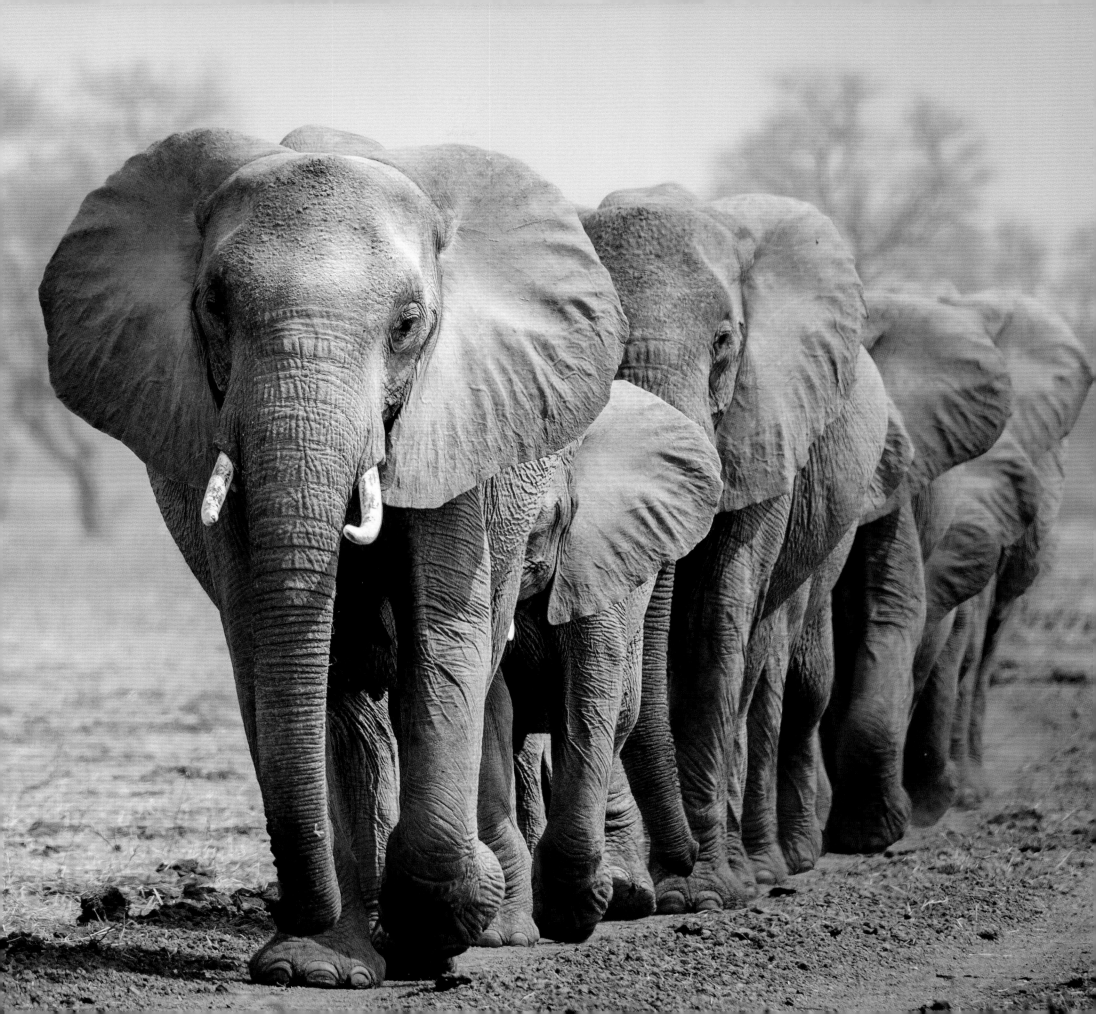

Planning your ultimate elephant safari

Where to go?

There are a number of national parks and game reserves in Africa with healthy elephant populations, so you are likely to see African elephants on a regular safari to one of the major parks or reserves.

For an interesting photograph though, we can narrow down the selection by considering some of the key ingredients:

- Herds — good numbers of elephants to generate lots of opportunities, for example breeding herds with calves, big males etc.
- Terrain — variety such as interesting backgrounds, open flat terrain, lakes, river banks, salt pans, clouds of dust: these are all things that may elevate the photo from the ordinary.
- Skies — dawn and sunset colours; cloudy skies are better than slabs of blue
- Viewpoint — a low camera angle will normally improve the image — such as a shot taken from the ground outside the safari vehicle, or a purpose-built sunken hide at a waterhole

The photographs in this chapter are taken in various parks and reserves from Kenya, Zambia, Namibia and Botswana — all great places to go for elephant photography.

But one of these stands out as my favourite location — Kitirua Conservancy, which is adjacent to Amboseli National Park in Kenya.

Amboseli is famous for its large herds of elephants, with more than 1,000 individuals living within the Park's eco-system. In the background, towering above the Park, are the majestic snow-clad peaks of Mount Kilimanjaro, Africa's highest mountain. The land here is extremely flat, so the elephants are crossing great open plains, with big skies and Kilimanjaro behind them. Amboseli National Park is excellent, but Kitirua Conservancy has some extras to offer. Here safari vehicles are permitted to go off-road, giving much more flexibility in positioning; and with appropriate care, you are allowed to get out of the vehicle and lie on the ground besides it, to get special low camera angles. Once you have done this a few times, you will always be spoilt compared to when photographing from the back of a safari vehicle! Access to Kitirua Conservancy is exclusive to Tortilis Camp — a superb tented site set within the National Park, and just a few kilometres from the Conservancy.

When to visit?

There is a lot of flexibility in when to visit. If you want elephants with open, relatively grass-free plains, kicking up clouds of dust, then the dry seasons are best (August-October, February-March). If you want moody, cloudy skies, then the short rainy period would be better (November). However, at this time you do run the risk of losing some game drives due to heavy rain or impassable roads.

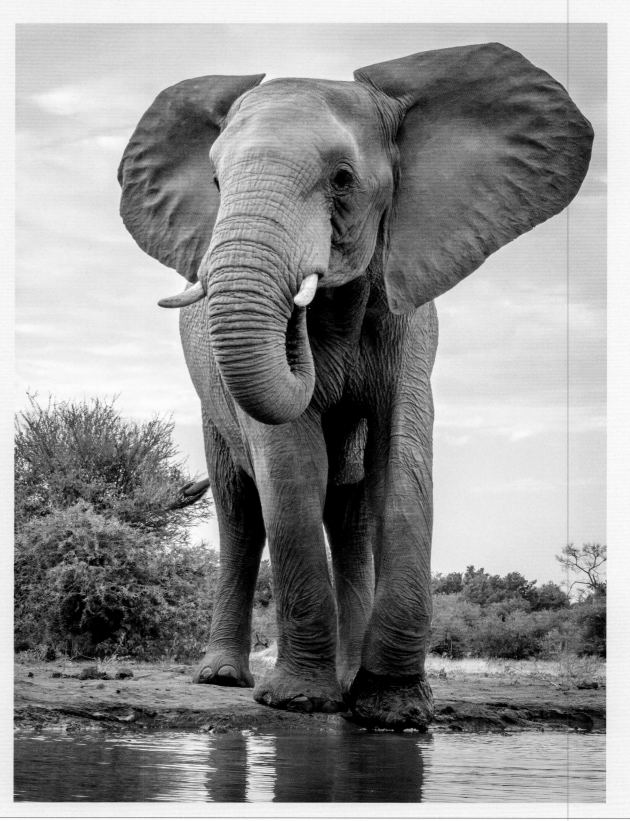

For my 'Ultimate Elephant Safari' I flew from Nairobi by light aircraft to Elewana Tortilis Camp in Amboseli, Kenya and stayed for six nights in November on a private trip booked through Safari Consultants, a UK-based travel agency specialising in African safaris.

Recommendation summary

Location: Elewana Tortilis Camp Amboseli, Kenya.

Best time to visit: February to March or August to October for dusty shots, and November for interesting cloudy skies.

Getting there: Fly to Nairobi and then by light aircraft to Amboseli airstrip.

Access: Kitirua Conservancy for low camera angle shots of herds of elephants.

Duration: 5-7 days

How to book: Through a specialist wildlife travel agency:

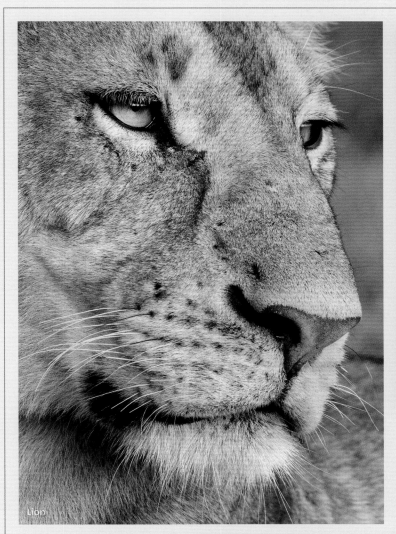

Lion

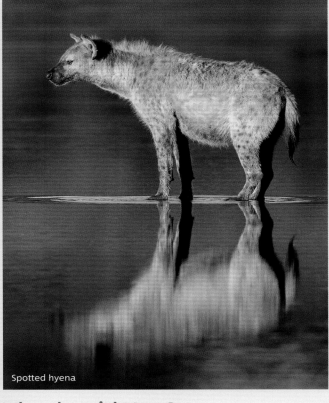

Spotted hyena

What else might I see?

Elephants certainly dominate the park and surroundings, and you won't see here the full variety of African wildlife that you might in the Masai Mara or Serengeti. However, there are plenty of other mammals and birds around — small numbers of lion, large herds of wildebeest and zebra, spotted hyenas, and some years there are huge flocks of flamingos.

Wildebeest

Grizzlies

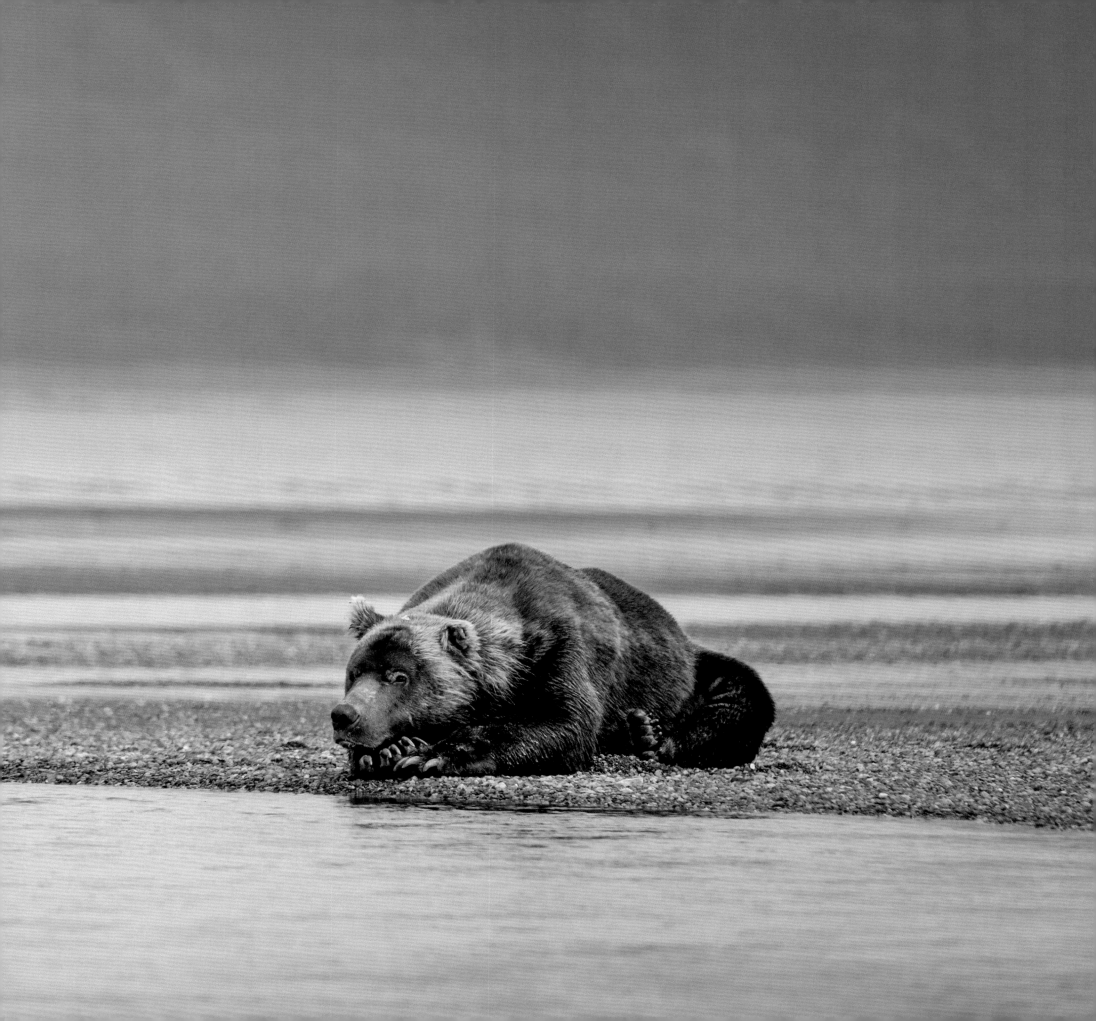

A critical conversation took place during my very early days of wildlife photography, when I was on my first trip to Tanzania. A couple on the same safari had recently been to Alaska to photograph grizzly bears fishing for salmon. They described to me how they went onshore from a small boat and wandered around on a beach with grizzly bears. I was astounded: how could this be possible with such dangerous animals? Surely, I asked, you must have been in some sort of protective cage or the guides must have carried rifles? But no, I was told these sorts of measures were not necessary, as long as you behaved around the bears in a sensible and predictable way.

Intrigued, I researched the subject further once I got home. The grizzly bear is also known as the North American brown bear. Typically, males can weigh up to 360 kg (800 lb), whilst females are smaller, coming in at up to 180 kg (400 lb). In coastal areas, with a rich diet of salmon, bears are significantly larger, with some males up to 550 kg (1,200 lb) in weight. They range widely through Alaska, much

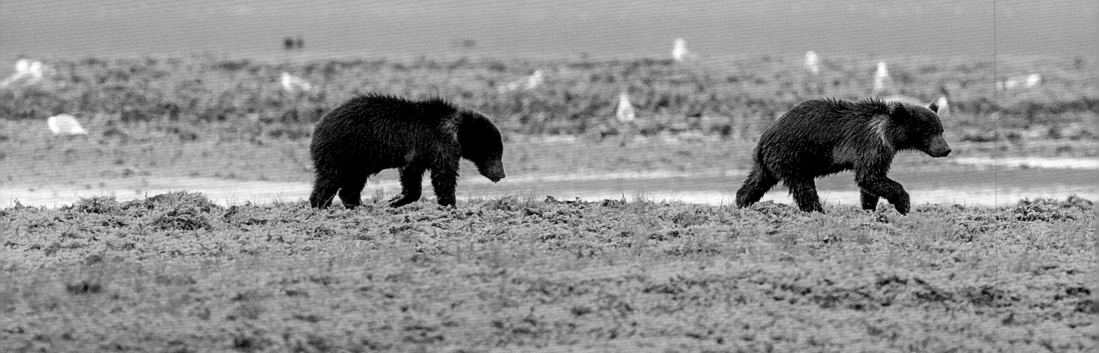

of western Canada, and portions of the north-western United States. The Pacific northwest coast has the highest numbers — around 15,000 in Canada's British Columbia, and 30,000 in Alaska. Grizzlies are omnivorous, eating both plants and animals: sedges, berries, salmon and larger prey, such as elk and moose, all feature in their diet.

The word 'grizzly' could have two different origins – either 'grizzled' as in the golden and grey tips of their hair, or 'grisly' as in gruesome. The word's spelling suggests the former, but the scientific classification *Ursus arctos horribilis* implies the latter. However, thankfully my research confirmed it was possible to visit and walk safely amongst grizzly bears. I was convinced and set about finding such a trip. I have now been fortunate enough to photograph grizzly bears in this way on numerous occasions, particularly in British Columbia and Alaska. I can't recommend it highly enough — a trip like this is without doubt one of the most thrilling and inspiring wildlife opportunities you could ever wish for.

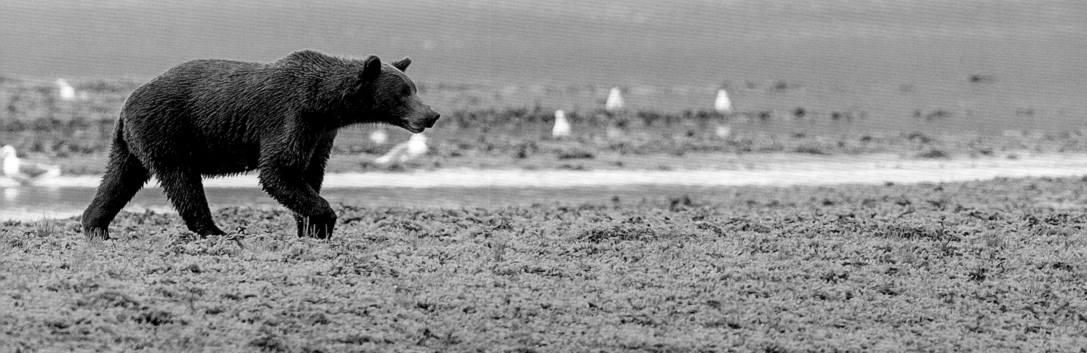

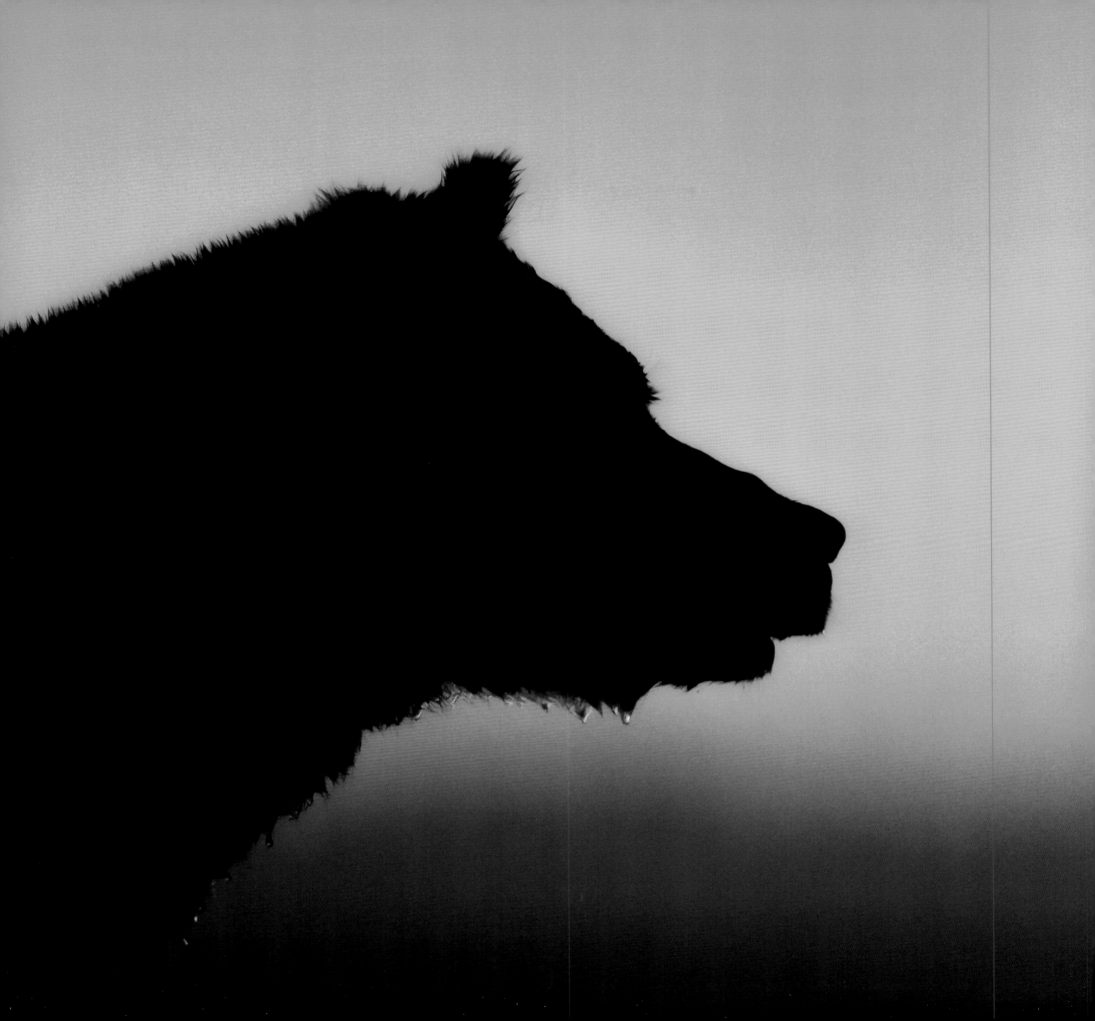

'Your job is not to touch any of the controls'

What to take? What to leave here at the hotel? Our luggage allowance is just 23 Kg (50 lb) in total. The camera gear weighs about 17 Kg (37 lb), that leaves me with a very paltry allowance for everything else, my clothes etc, for the next eight days. In this situation, I don't want to spoil the trip by not taking the lenses, tripod and camera bodies that I feel I need, so the gear generally takes precedence, but this is a tough one! I cut down and cut down, and eventually get to a reasonable combination of gear and luggage, ready for our flight in the morning.

Our flight to Katmai leaves from the Kodiak floatplane dock. When we arrive, the passengers are divided into two groups of four. They weigh the four of us together with our bags on a big weighing platform. And it's all fine — phew! As we drink a coffee in the small lounge, we watch as the bags are loaded onto two small orange planes bobbing around in the water.

Down on the dock we are greeted by the pilot and he directs us to board the plane — three passengers are placed in the back and the pilot selects me to go upfront next to him. Once all seated, we are asked to don the headphones and test they are working, so that we can hear and talk with the pilot. He tells us that the flight will last just over an hour, and we will fly at 3,048 m (10,000 ft). He turns to me, looks me in the eye, and says: 'Your job is not to touch any of these controls.' I shuffle nervously in my seat, trying to keep my knee well away from that important-looking lever just to my left.

Taking off in a floatplane is different to a conventional take-off and certainly much more fun. We quietly taxi along the smooth water to the end of the little bay, the plane turns and with a mighty roar of the engine, we lumber along gaining speed. It seems to take ages to get to the necessary velocity, but eventually we glide nicely off the water and into the air.

We are on our way. ●

Left: Lake Clark National Park, Alaska, USA
Nikon D5 + 180-400mm f4 lens at 400mm;
1/320 sec at f4; ISO 25600

Title pages:
Katmai National Park, Alaska, USA
Nikon D5 + 80-400mm f4.5-5.6 lens at 400mm;
1/1250 sec at f7.1; ISO 500

Introduction pages:
Katmai National Park, Alaska, USA
Nikon D5 + 500mm f4 lens;
1/1250 sec at f6.3; ISO 1250

D-Day style landing craft

We are about to arrive. I remove my life jacket and grab my waterproof backpack, which is stashed with all my precious gear. The front door of our D-Day-style landing craft drops down, and waves start to lap into the bottom of the boat. I can see the beach about 100 metres (110 yards) ahead of me, there are bears in the distance, but nothing close; this shouldn't be too difficult. Walking carefully down the ramp, I gingerly test the depth of the water, it's nearly a metre (3 feet) deep. I step off the metal ramp onto the soft sand beneath my waders. Got to be careful now, there are slippery rocks as well. One cautious step at a time, I wade towards the sandy shore.

But as we walk towards the beach, the view has changed. A large grizzly bear is coming along the shoreline, and we seem to be on a collision course. The guide gets us to all bunch up together, and we stand quietly in the lapping waves as we wait for the bear. I am wearing chest waders and walking boots. They are cumbersome at first and take some getting used to, but they are very effective in this sort of situation. The water is cold, but I am dry and warm.

We're in Geographic Harbor, in Alaska's Katmai National Park. It is a beautiful mountain-bound bay, with braided streams running down a large beach. At first sight, the tops of the surrounding peaks appear to be covered with snow. However, it is not snow, but a pale cream-coloured ash, which has been here for over a hundred years. It was in 1912 that Novarupta, Katmai's huge volcano erupted, expelling thirty times the magma volume of the famous 1980 Mount St. Helens eruption. In 1916, the National Geographic Society dispatched an expedition to study the effects of this massive event, and this bay was used as a landing site, hence its name. It is a very sheltered bay, a natural harbour, making a perfect anchorage. I can see our small ship across the other side, about a kilometre (half a mile) away.

The streams here are full of salmon, heading upstream to spawn. The bears are here for the salmon — and we are here for the bears.

Eventually the bear that has been blocking our route moves on, and we resume our cautious trudge through the water, soon reaching the firmer footing of the beach. There are four bears in the bay at the moment, scattered around the various streams. Our guide surveys the scene and selects a suitable spot for bear viewing. It is 400 metres (440 yards) away, and as a group we follow him, picking our way along the beach, across a number of fast-flowing streams to arrive at a small sandbank between two of the streams. We position ourselves in a line, all eight guests are offered canvas stools to sit on, and we settle down to watch the action. This works well: by forming a nice straight line along the stream bank, we don't block each other's view.

After a while a bear approaches our stream. It sits down opposite us, about 10 metres (33 feet) away on the far bank, watching and listening. When a salmon makes a run up the shallow streams, you sometimes hear it before you see it: a tell-tale sound as it splashes over the gravel.

These bears are incredibly patient; they can sit for hours watching, listening, waiting. We have to be patient as well, but always ready with cameras poised, ready for action. I leave the relative comfort of my stool, and position myself lying on the beach, wanting the best camera angle. Suddenly our bear jumps up and runs full speed through the stream, huge splashes everywhere. It is an incredible sight, an enormous brown bear chasing after a salmon — from this low angle, it looks in the camera viewfinder as if the bear is running straight at me. And pounce! Paws splayed, head straight down into the water. Up it comes with a salmon in its mouth. With its prize, the bear heads back to the far bank, and sits down to eat a well-earned meal. ●

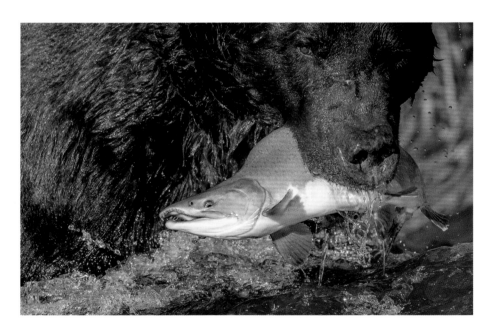

Above: Katmai National Park, Alaska, USA
Nikon D5 + 180-400mm f4 lens at 400mm;
1/3200 sec at f4; ISO 560

Opposite: Katmai National Park, Alaska, USA
Nikon D5 + 180-400mm f4 lens + 1.4x extender at 400mm;
1/3200 sec at f5.6; ISO 800

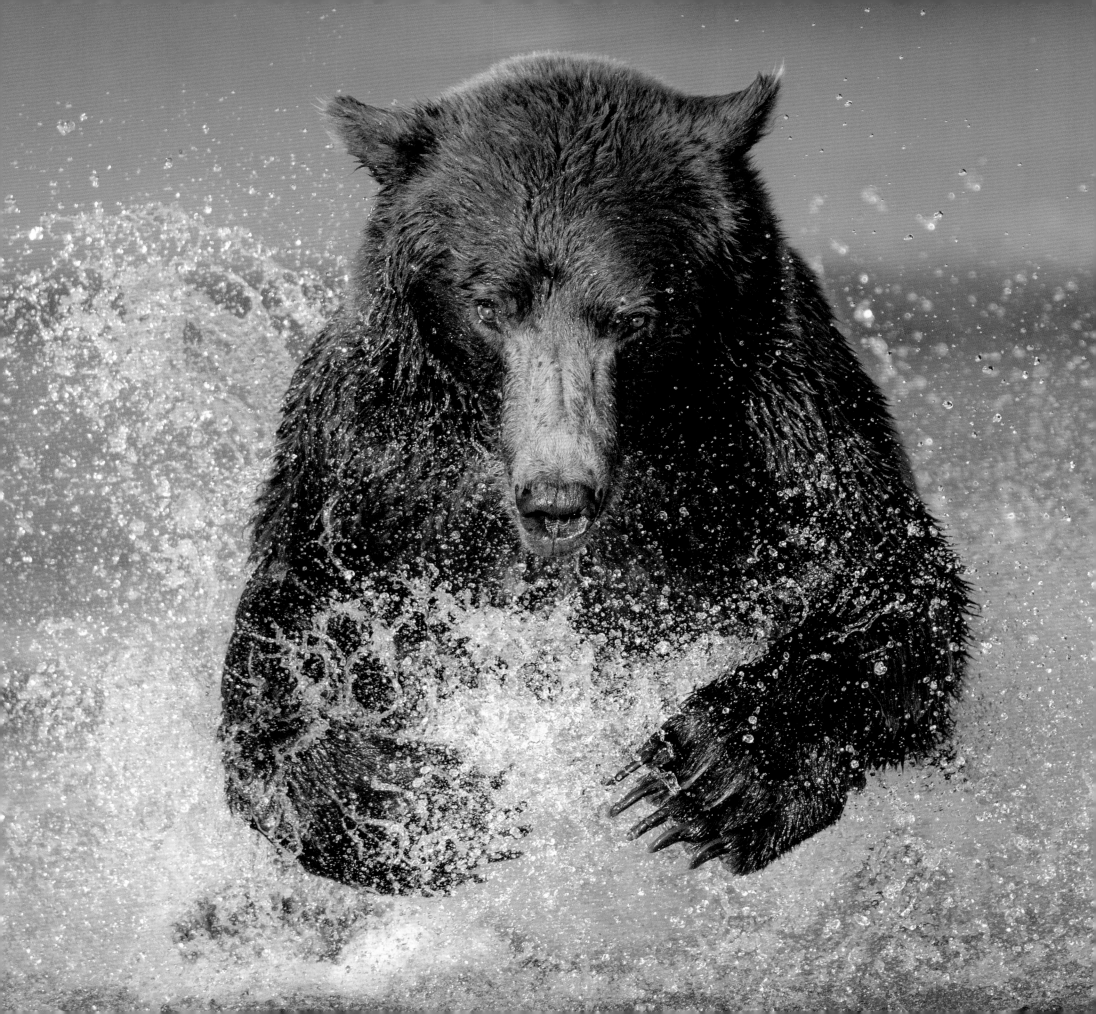

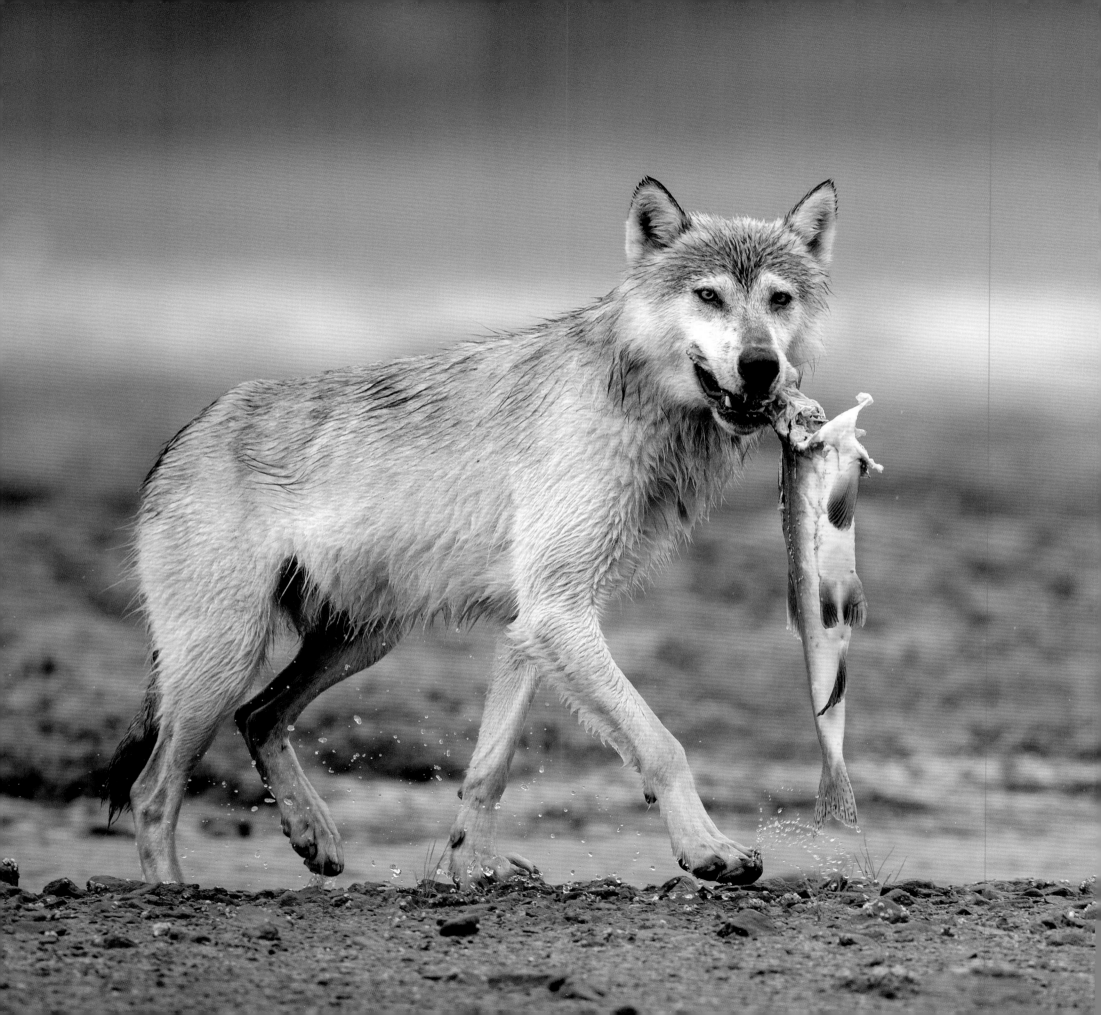

**Photographic tip
Get low**

This tip keeps coming up! What might seem to be a small change in height will make a massive difference to your image. For example, the difference between using the camera when sitting on a small stool, compared to lying on the beach holding it just above the sand. Yes, it's uncomfortable lying down holding the camera, ready for action for long periods of time, but absolutely worth it.

Left: I was sitting at the coastline waiting for bears, when in the far distance I spotted a wolf walking in front of the cliffs. It then continued along the base of the cliffs and came within 5 to 10 metres (16 to 33 feet) and walked right passed me! About ten minutes later it appeared again, this time strolling by me with a fish in its mouth: one of my most memorable wildlife sightings.

Katmai National Park, Alaska, USA
Nikon D5 + 500mm f4 lens; 1/800 sec at f5; ISO 1250

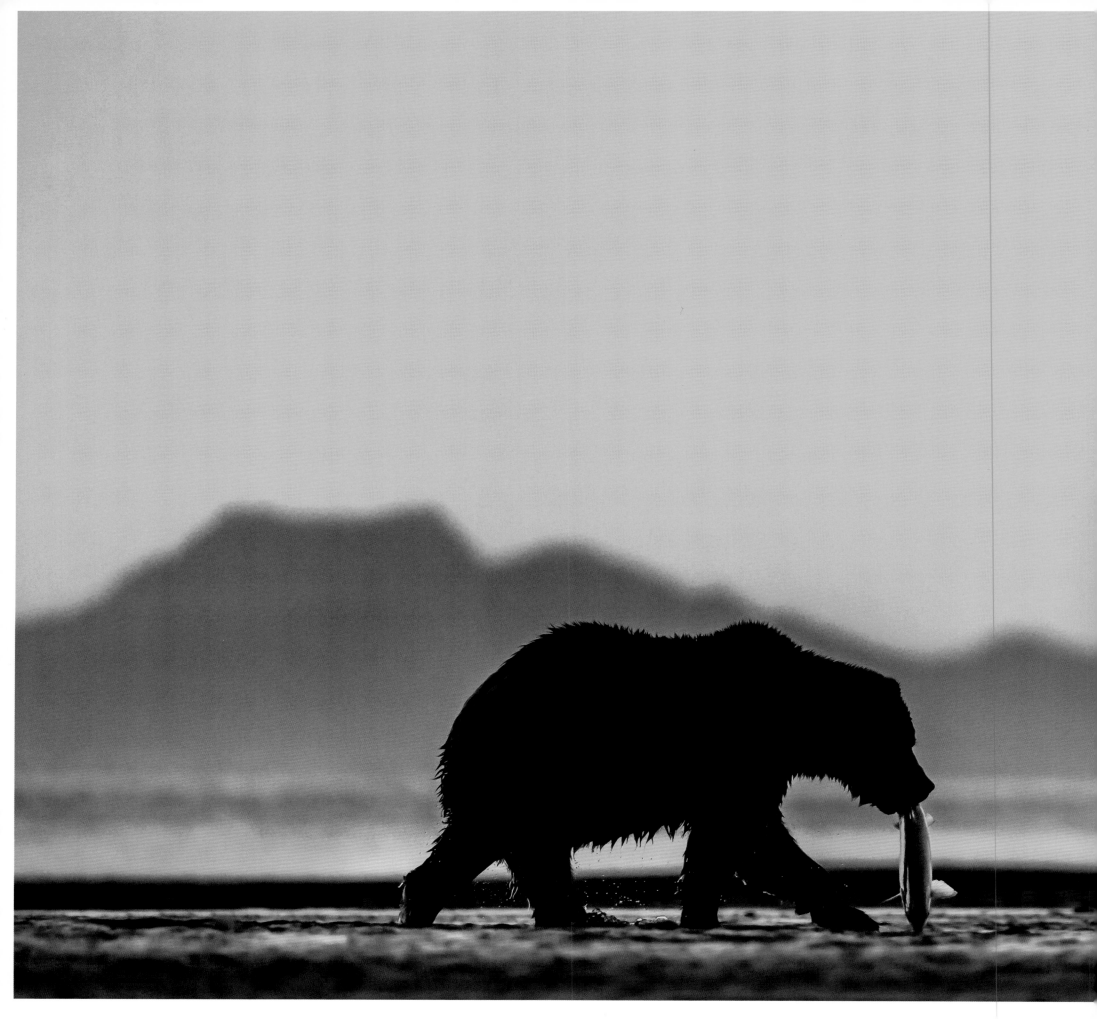

Orange dawn

It's still dark as we clamber into the trailers on the back of the ATVs. Every morning we leave the lodge at 6:15am to head towards the beach. Here at Silver Salmon Creek, the beach faces east, offering the potential to photograph bears silhouetted against the dawn sky.

We drive off, puttering along the dirt track. We now know the route well. Without having to be told, as we approach the deep stream, we lift our backpacks off the floor. Down into the channel we go, water floods into the trailer, and then as we go up the other side, the water pours out again. As in Katmai, we are wearing chest waders, so we stay dry. After passing through a thicket of bushes we arrive at the open beach.

Time to stop and scan. Our guide is searching the distant tideline with his binoculars, trying to find a bear in the right situation. Time is of the essence, the sky is beginning to brighten, and it is going to be a beautiful orange dawn. Target chosen, we head off towards a bear in the far distance and drive about five minutes before we stop. We will have to walk from here, as we don't want to disturb the bear with the noisy engines, and in any case the sand here is too wet for the ATVs to go much further.

The bear is still far away. As we walk out towards it, we can see it is pacing up and down looking for salmon in the shallow water of one of the streams crossing the beach. This could work well. We get to within about 10 metres (33 feet) and settle down with cameras either on low tripods or resting on the beach itself. It is still extremely dark. It's going to be difficult to get a good clean shot.

I decide that the best way to handle the situation is to take multiple shots with varying combinations of settings, hoping that if the bear doesn't move too much, one of the settings will work. In an effort to keep the camera and lens dry and free of sand, I place a plastic sheet on the beach before putting the camera down.

Soon the light is perfect, the bear is in the right position. Over the next five minutes of so, I take hundreds of photos, and hope that at least one of the settings will work. ●

Left: Lake Clark National Park, Alaska, USA
Nikon D5 + 180-400mm f4 lens + 1.4x extender at 560mm;
1/1600 sec at f5.6; ISO 2500

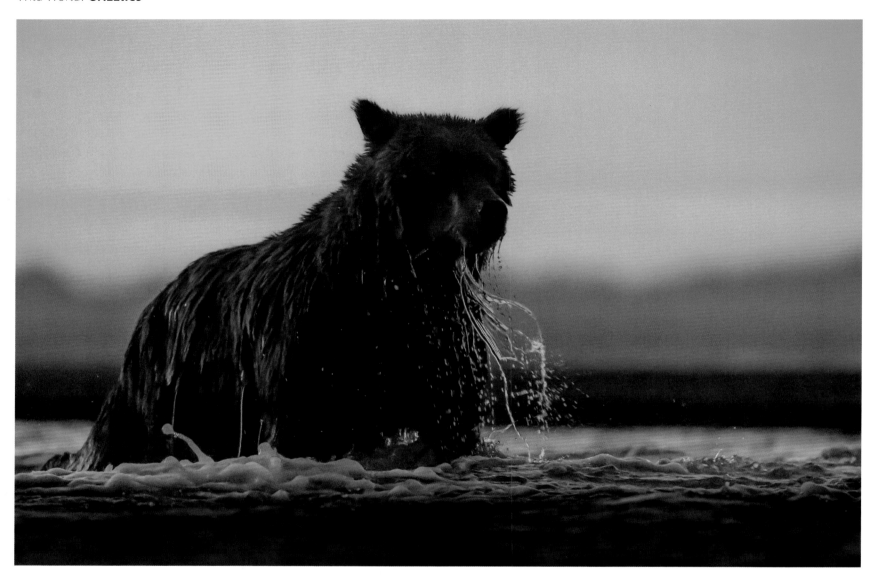

In very low light such as the dawn twilight, it can be difficult to get a clean sharp shot. Firstly, the lens needs to be set to its widest aperture, to let in the maximum amount of light. Then ideally you would like to set a fast enough shutter speed to freeze the movement of the bear and avoid camera shake, and also to set an ISO setting that doesn't produce too much noise. However, if the light is very low, you will have to compromise on both these numbers. I ended up with 1/320 sec and ISO 25,600. This is the highest ISO that I dare use with the Nikon D5. To ensure at least some shots were sharp, I took multiple images with the motor drive, hoping that in some, the bear wouldn't be moving too much. With such high ISOs, the images needed a careful noise reduction in post-processing.

Above: This bear was looking for salmon before dawn at Cook Inlet. This is a wide, east-facing inlet, which offers a backdrop of mountains on the far side, as well as that bright orange sky. I wanted to capture the way the water pouring off the bear's chin picked up the flaming light of pre-dawn.

Lake Clark National Park, Alaska, USA
Nikon D5 + 180-400mm f4 lens at 400mm;
1/320 sec at f4; ISO 25600

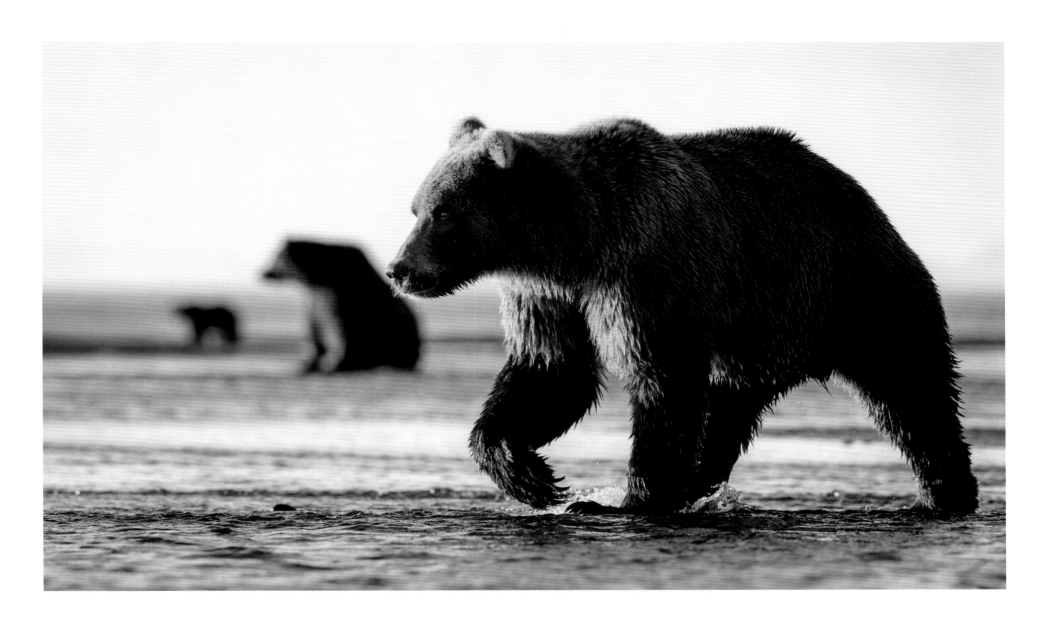

Above: Three bears line up at the side of the stream, poised and waiting for the arrival of salmon. I call this image 'trio' and it looks like a team effort, but it's all for themselves: they are spaced out like this to claim their own space — and their own salmon.

Lake Clark National Park, Alaska, USA
Nikon D5 + 180-400mm f4 lens at 340mm;
1/1600 sec at f6.3; ISO 1400

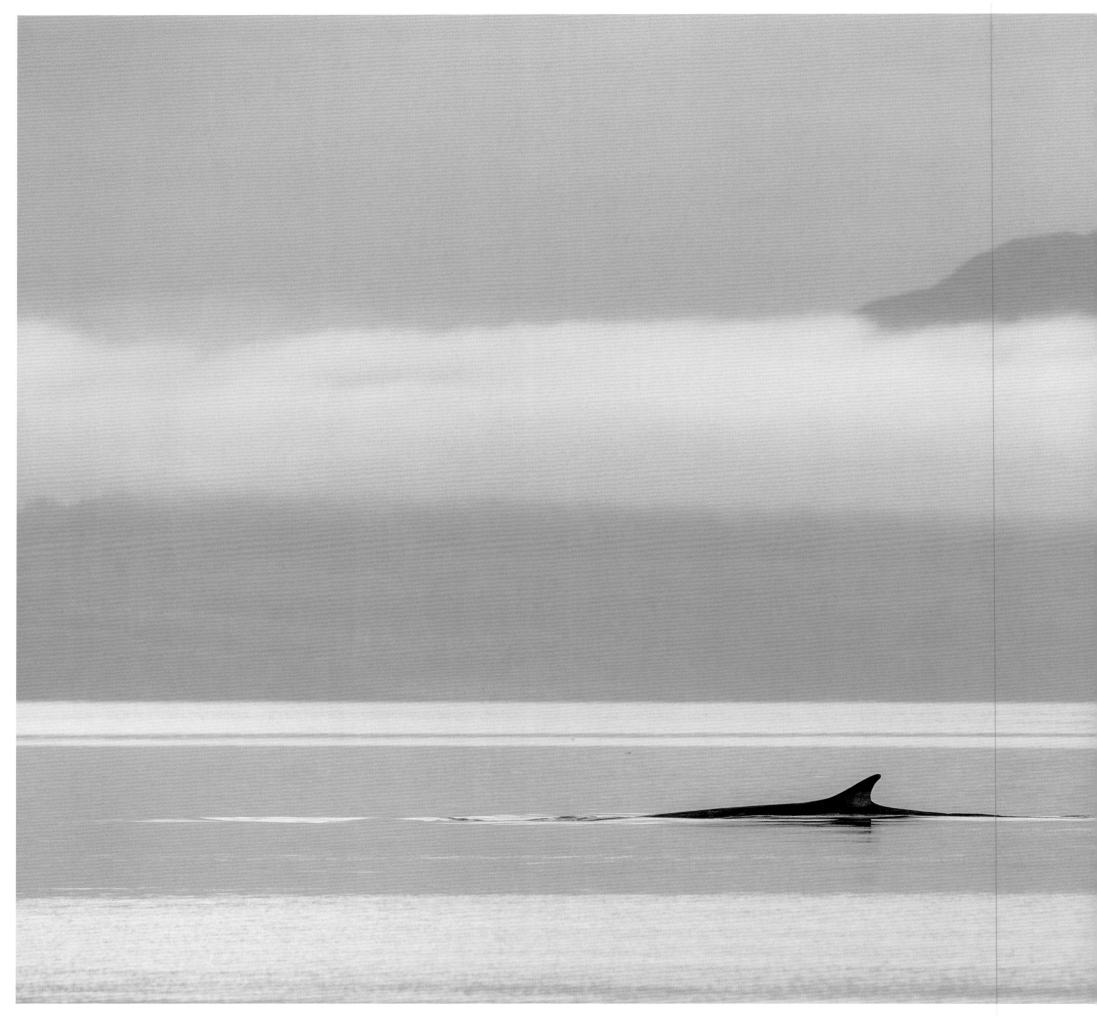

Left: I went to Alaska in search of bears, but was always aware of the rich diversity of other wildlife all around. Taking a trip out in a small boat, I was lucky enough to see the second largest of all whales: a fin whale. I wanted to capture the stillness of the water and the whale just cruising by, the streaks of cloud on the mountainous coastline echoing the blues and greys of the light on the water.

Off Kodiak Island, Alaska, USA
Nikon D4 + 80-400mm f4.5-5.6 lens at 400mm;
1/2000 sec at f5.6; ISO 800


Right: I couldn't resist a backlit bear! I shot deliberately into the sun in the last half hour of daylight, to capture this tubby youngster surrounded by a golden glow of late afternoon sun. I liked the way the wash of low light also picked up the golden colours in the grasses behind.

Lake Clark National Park, Alaska, USA
Nikon D5 + 180-400mm f4 lens + 1.4x extender at 560mm;
1/2000 sec at f8; ISO 2000

Photographic tip
Support matters

Method	
	● Recommended
	○ Possible use
	● Not recommended
Handheld	● There is usually good light, allowing for fast shutter speeds. With good technique, this is a very practical option.
Beanbag	● Not suitable
Monopod	○ Could be an option, but in all cases a tripod would be better
Tripod	● Good for long lenses particularly when waiting for long periods. It needs to be a type that can open right up to support the camera really close to the ground. Also useful for a longer exposure, such as the waterfall described in the narrative.

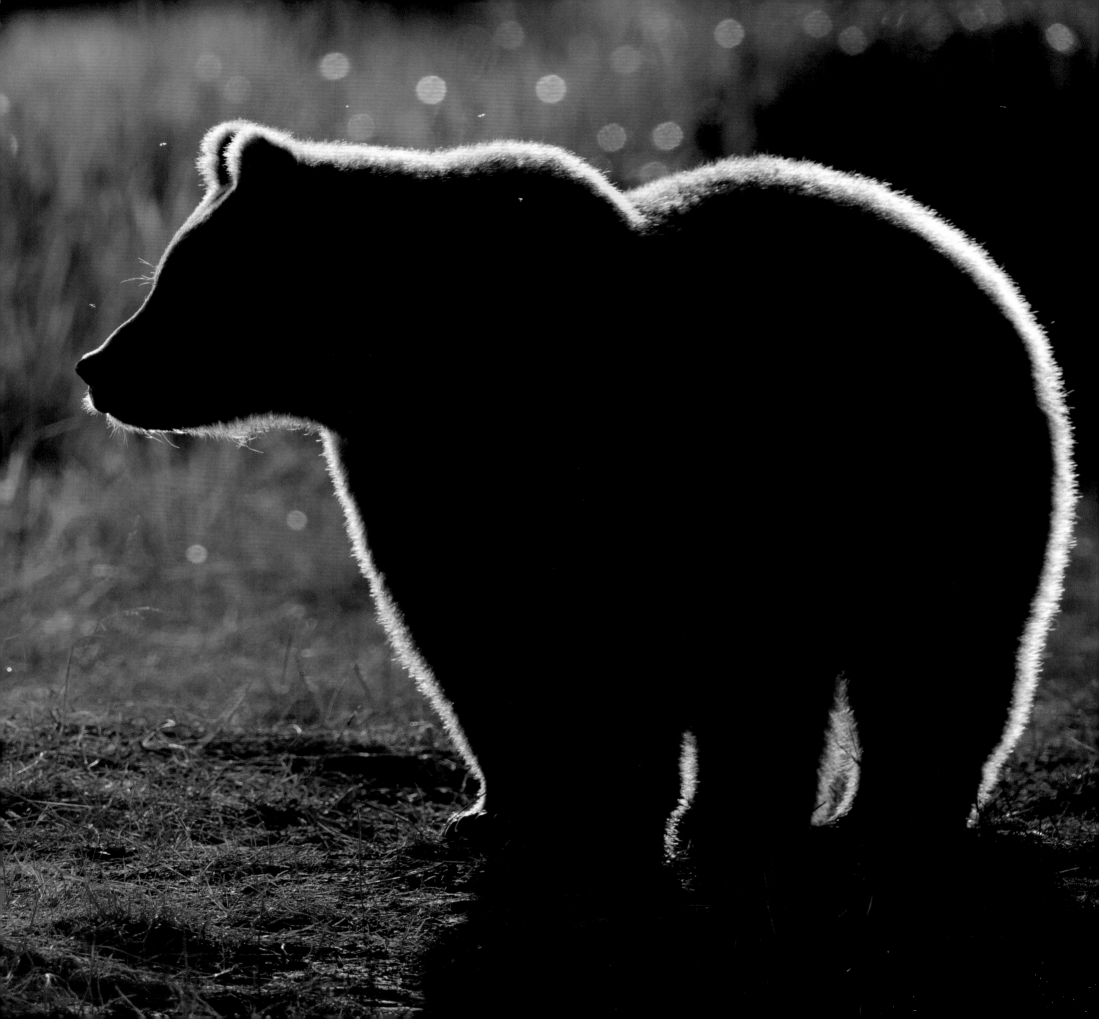

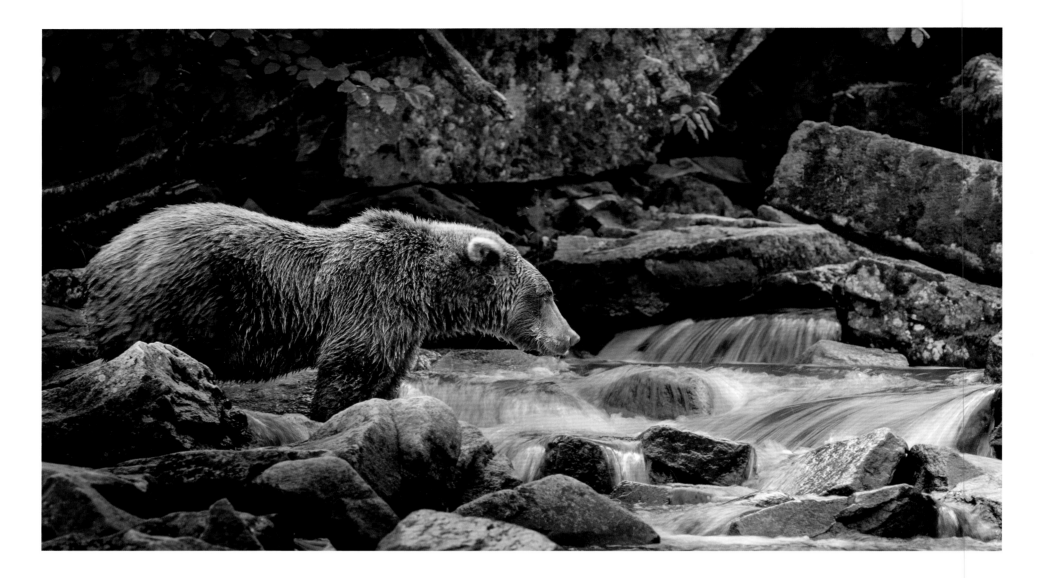

Photographic tip
Shooting waterfalls

One technique when photographing waterfalls is to use a slow shutter speed to give the water a feeling of movement with a nice smooth silky look. The actual shutter setting that is required will depend on the speed that the water is flowing — you have to experiment with some test shots to find what looks best. To achieve such low shutter speeds, the ISO should be set close to the base ISO of the camera, and depending on the light level, you will probably need to stop down the aperture as well. The camera will need to be firmly mounted on a tripod.

This is all well and good, but the bear keeps moving! To get a sharp shot, whenever the bear is standing reasonably still, take multiple images using the motor drive. Hopefully in at least one image the bear has been stock still.

Above: For me, this image was about patience: the way a bear just stands waiting and waiting and waiting for salmon. The challenge was to simultaneously capture the stillness of the bear, and the movement of the water rushing over the rocks.

Katmai National Park, Alaska, USA
Nikon D5 + 180-400mm f4 lens + 1.4x extender at 490mm;
1/13 sec at f13; ISO 110

Right: Poised for action. This photograph is all about the enormity of the paw, and the claws on the paw. The sheer size of both emphasises the power and strength of the bear.

Katmai National Park, Alaska, USA
Nikon D5 + 180-400mm f4 lens at 400mm;
1/2000 sec at f7.1; ISO 2200

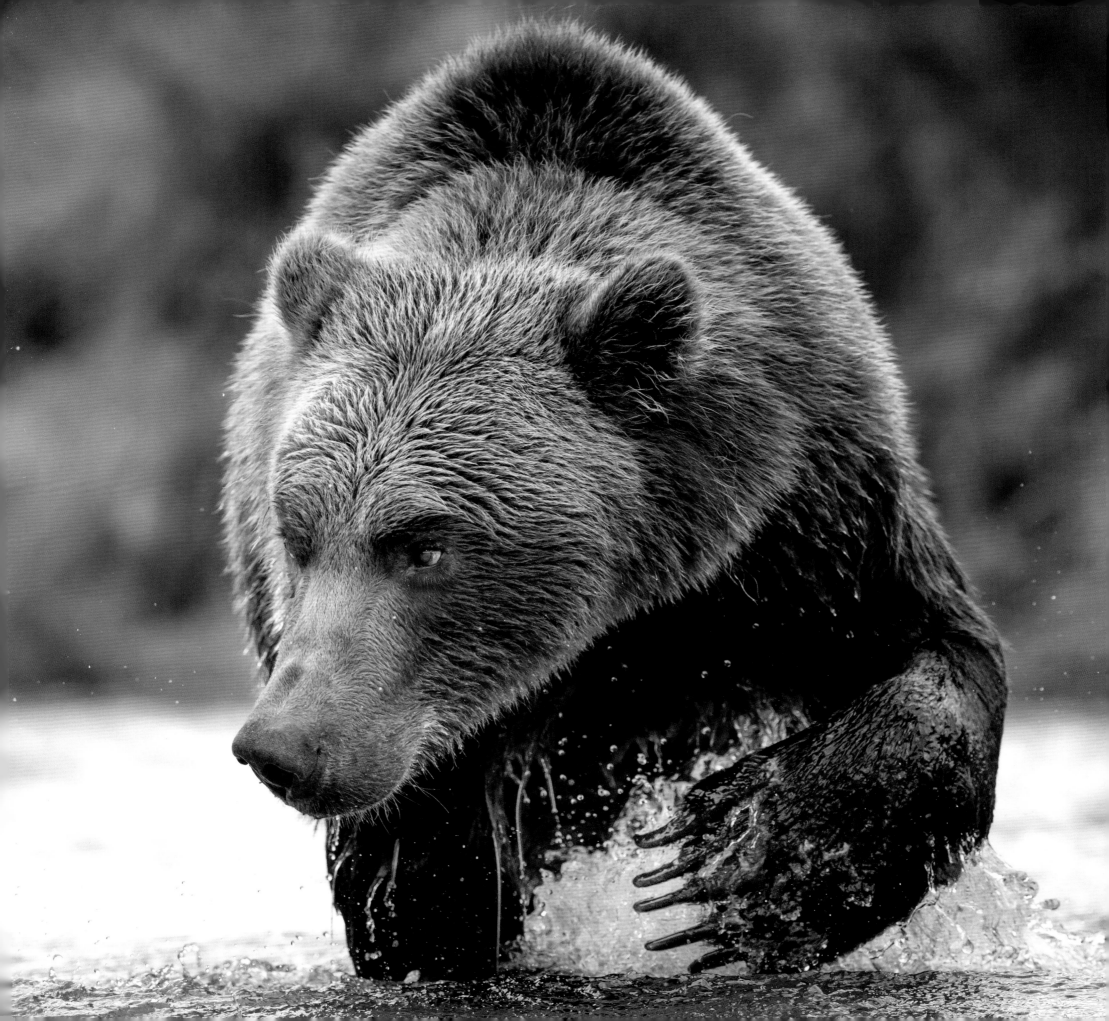

Flight delayed — bear on runway

t is sweltering in here. Another cloudless sky. It's been the same all week, and the sun is beating down. There is virtually no ventilation until the engine starts, and I wonder why it is taking so long. We're told it's not normally like this: overcast rainy days are the norm in mid-September.

We are on the beach in a sixty-year-old Beaver plane. It looks as though it has seen a lot of service, resembling something out of an Indiana Jones movie. This plane has wheels because here the beach *is* the runway. The pilot points down at a bear that is snuffling around. 'We will have to wait for that bear to move off the beach!' he tells us. Flight delayed — bear on runway. This has never happened to me before, but at Silver Salmon Creek, in Alaska's Lake Clark National Park, this is a frequent occurrence.

After a few more hot, sticky minutes waiting, it seems the bear has decided that there are better pickings elsewhere, and moves off towards the sea, away from our improvised runway. But still we are stationary. 'There's a wolf emerging from the bushes, we better wait,' the pilot remarks. Sure enough, some distance away we can see a wolf trotting towards us, along the line of bushes parallel to the back of the beach. It seems quite cautious, before venturing out into the open, sniffing the ground and foraging as it moves out towards the sea.

'No, I think it will run when I rev the engines, we will go...', and with that the pilot pulls back on the throttle. The engine roars. The pilot was right, as we hurtle down the beach, the wolf is off back into the bushes at lightning speed. ●

Right: Katmai National Park, Alaska, USA
Nikon D5 + 180-400mm f4 lens at 320mm;
1/1000 sec at f4; ISO 3200

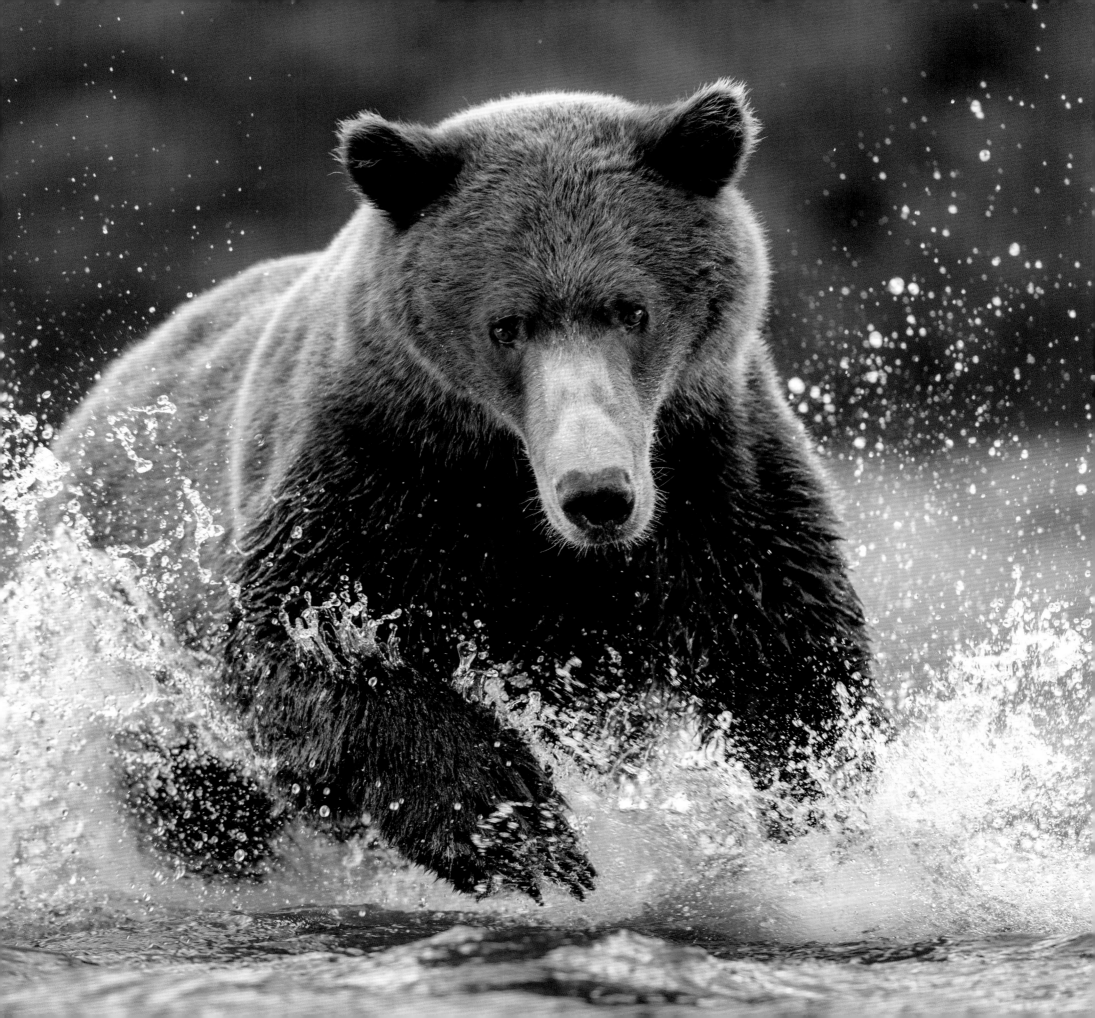

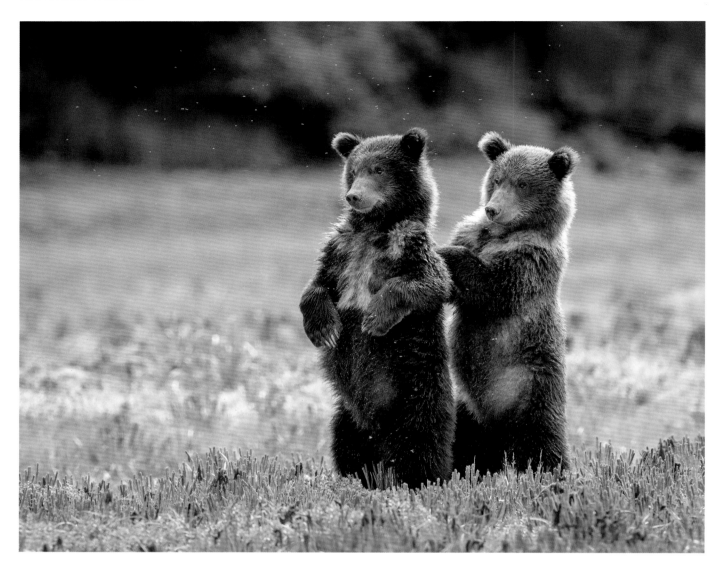

Above: These cubs were watching their mother
fishing. As she dipped down into the stream below,
the cubs would stand up — one propping the other
up — so that they could keep an eye on mum.
A cloud of bugs surrounded them like light rain.

Katmai National Park, Alaska, USA
Nikon D5 + 500mm f4 lens; 1/1000 sec at f6.3; ISO 400

Right: It was almost dark when this bear ventured
out for a drink in one of the freshwater streams that
feed into the estuary. The evening light rendered
the vegetation in the background like a soft pastel
painting, and emphasised the ripples that circled
out from the bear.

Khutzeymateen Grizzly Sanctuary, British Columbia, Canada
Nikon D4S + 80-400mm f4.5-5.6 lens at 400mm;
1/400 sec at f5.6; ISO 2800

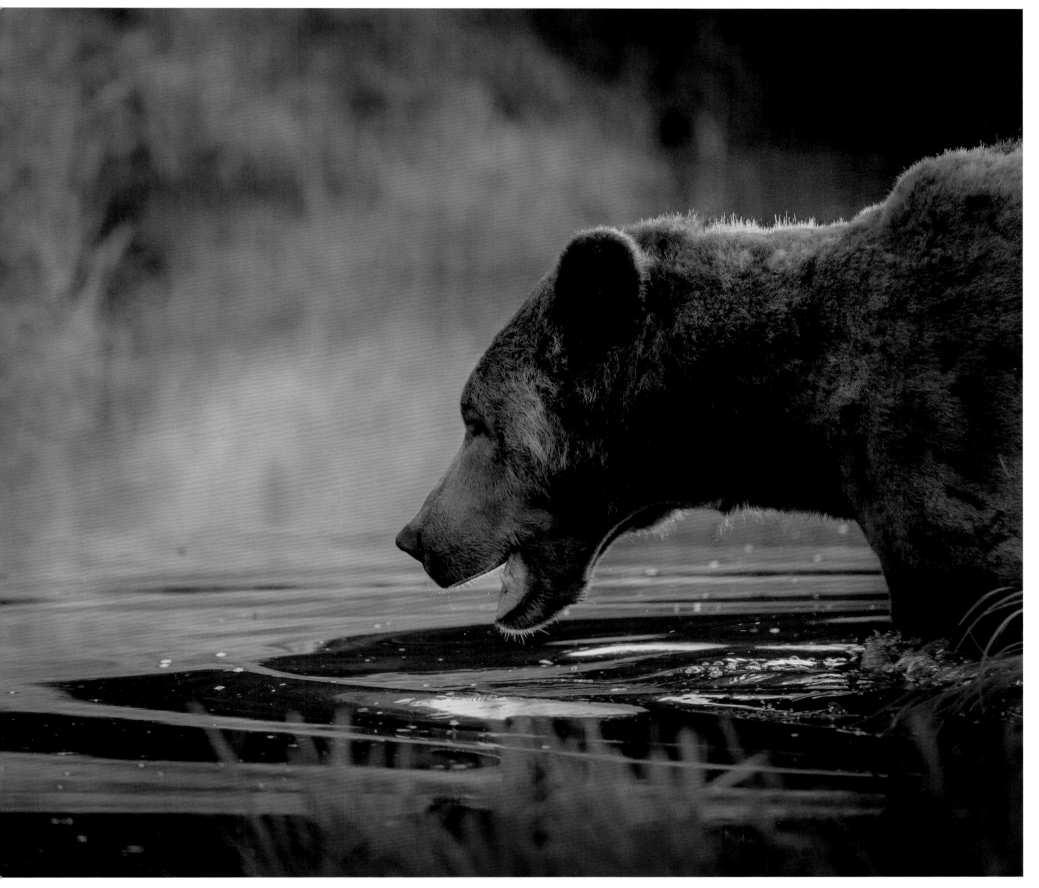

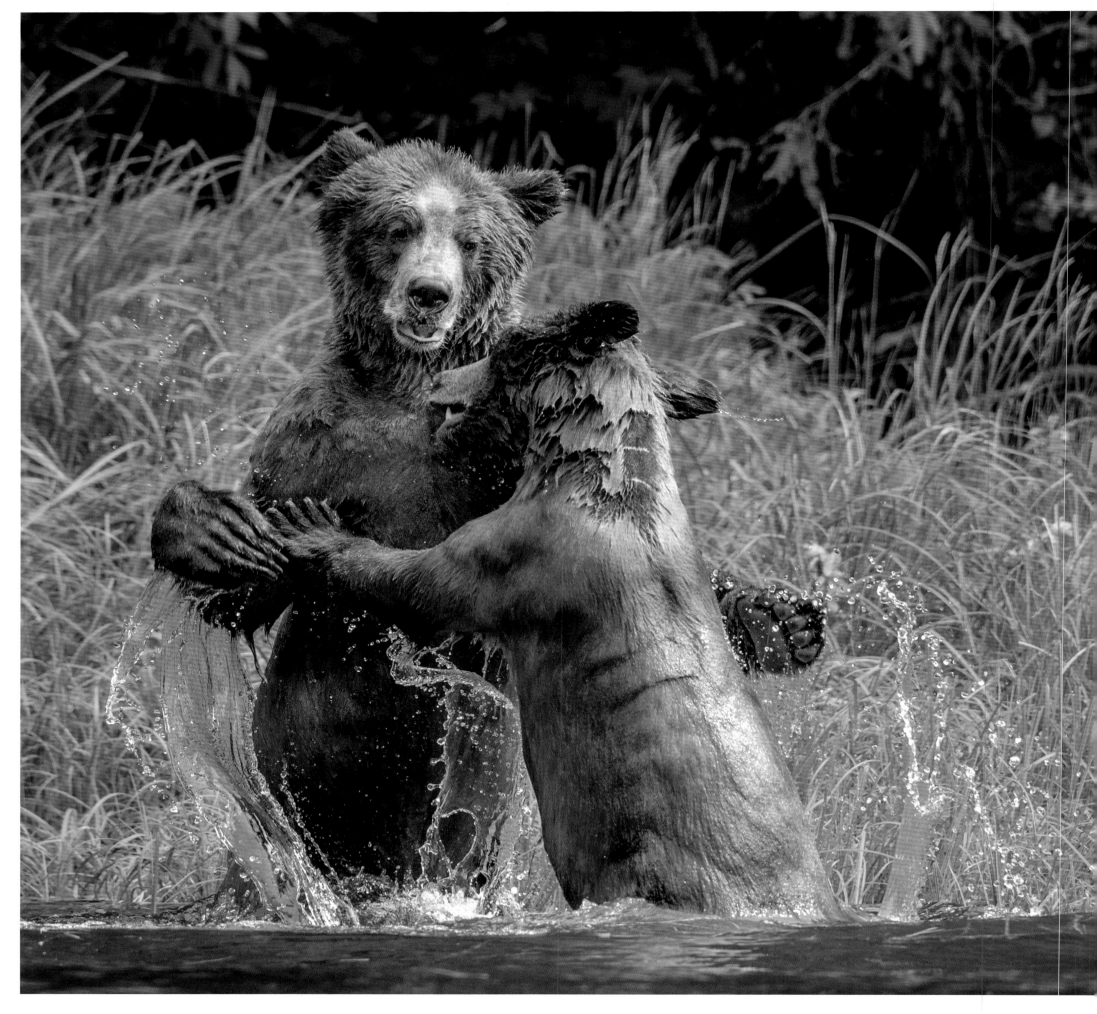

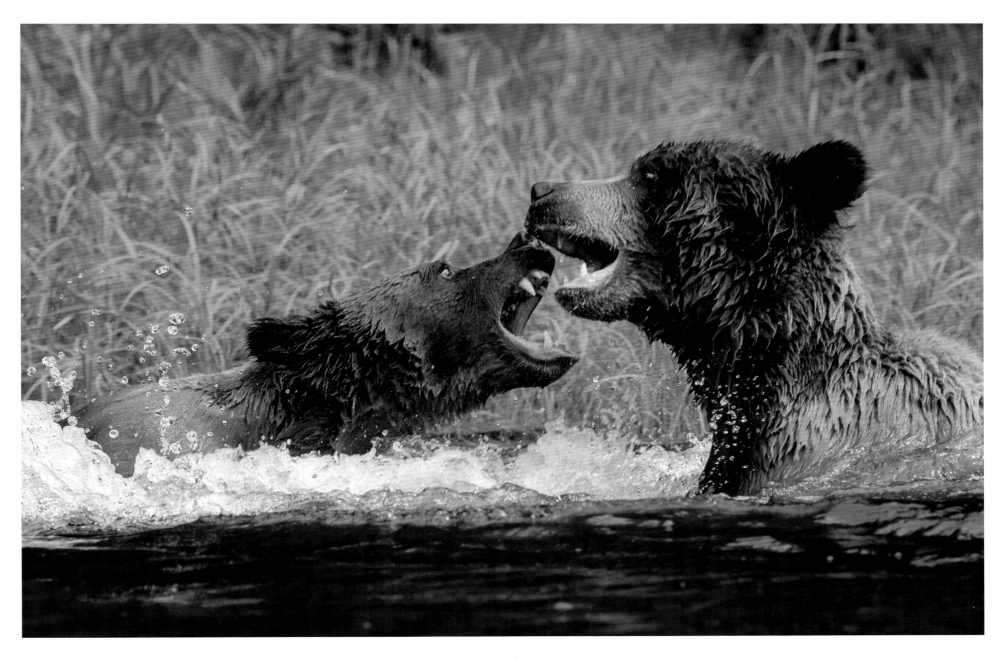

Left: Shall we dance? These young siblings — a male and female about five years old — are well known by, and habituated to, the tour operators in the area. Apparently this was a daily routine of the female wanting to play-fight and the male pushing her away.

Khutzeymateen Grizzly Sanctuary, British Columbia, Canada
Nikon D4S + 80-400mm f4.5-5.6 lens at 400mm;
1/1000 sec at f9; ISO 1400

Above: As the siblings continued their scrap, I leant over the side of the boat, holding the camera as close as I could get to the water's surface. This gives an intimacy — as if looking up at the bears from the water — that I wouldn't have achieved with a higher angle.

Khutzeymateen Grizzly Sanctuary, British Columbia, Canada
Nikon D4S + 80-400mm f4.5-5.6 lens at 230mm;
1/1000 sec at f9; ISO 800

Above: These bears are opportunistic omnivores, taking advantage of a wide range of food according to the season, such as salmon, sedges, grasses and berries. When berries are available and plentiful, the grizzly bears here feast on them in great quantities — heading up into the wooded hills and continuously eating. Often bear scat is full of berries. I don't know if this bear took any of the berries, but I felt that this moment told a story with the angle of the bear's head pointing at the berries, illustrating the importance of this food source in their diet.

Katmai National Park, Alaska, USA
Nikon D4 + 80-400mm f4.5-5.6 lens at 260mm;
1/640 sec at f7.1; ISO 2000

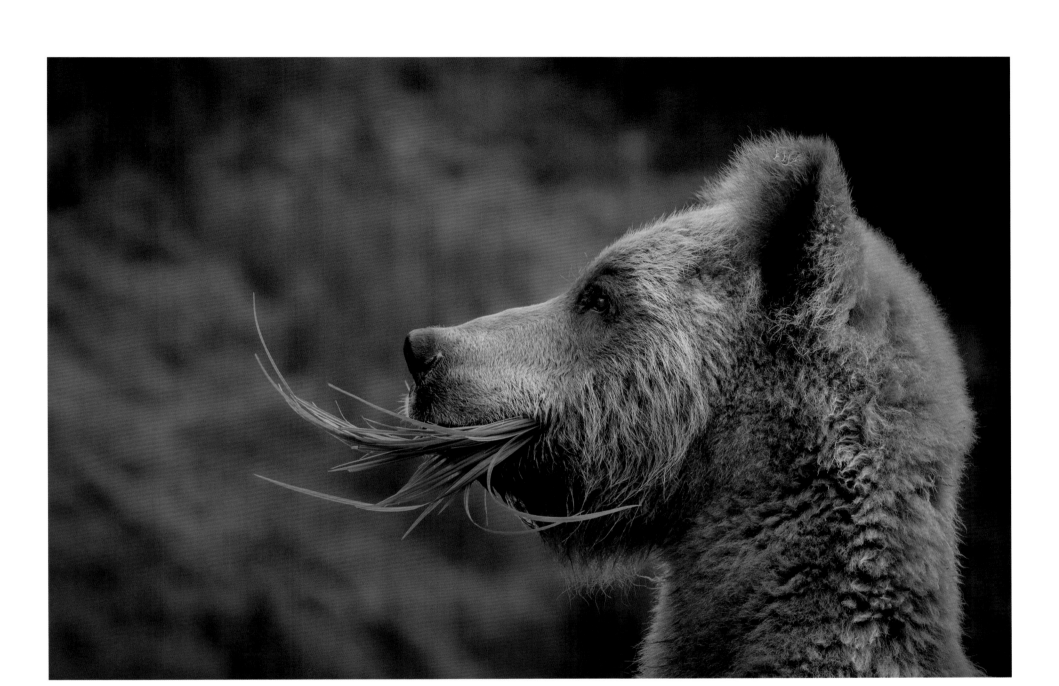

Above: You don't think of bears eating grass, perhaps because they look like such powerful predators — but plants such as grass and sedges are valuable food and a source of protein. The timing of protein-rich salmon depends on the rivers, with some rivers in the area having two runs for different species of salmon. But before the salmon arrive, the bears must feed on whatever is available. We watched from the Zodiac as bears fed on sedges near the shoreline. This bear spotted another in the distance and stood up to investigate, still chewing, and I noticed the green stains on the fur around its mouth.

Khutzeymateen Grizzly Sanctuary, British Columbia, Canada
Nikon D4S + 80-400mm f4.5-5.6 lens at 260mm; 1/1000 sec at f13; ISO 2200

Planning your ultimate grizzly safari

Where to go and when to visit?

British Columbia in Canada and Alaska in the United States are the two main hotspots for Grizzly Bear photography. There are three locations that are particular favourites of mine, all of which I can recommend.

Katmai National Park, Alaska, USA

There are numerous bays and inlets along the coast with small salmon streams. The best approach is to book a tour that uses a small live-aboard boat as a base, from which excursions are made in a skiff to shore. The boat will work the coastline going to the best locations at the time, depending on where the bears are, which will generally be to the streams where the salmon are running. Tours run from mid-June to mid-September. In the early season through to the end of July, bears are foraging the shoreline for clams and feeding in the sedge meadows. July is the peak of the mating season. August onwards is all about salmon, when the bears are intent on feeding as much as possible to gain the maximum amount of weight before their winter hibernation. There are dozens of bears along the Katmai coast, and with the added flexibility of being on a boat, all tours get to see bears. There are good chances of seeing coastal wolves in some of the bays.

● For my 'Ultimate Katmai Grizzly Bear Safari', in the third week of August I flew by floatplane from Homer to spend eight nights on board *Natural Habitat Ursus* chartered by Natural Habitat, a specialist wildlife tour company, booked through UK wildlife specialists Wildlife Worldwide.

Recommendation summary

Location: The coast of Katmai National Park, Alaska, USA
Best time to visit: mid-August to mid-September
Getting there: Depending on the tour, there are two main departure points, Kodiak and Homer. Then by float plane to and from the boat
Access: Live-aboard boat with skiff for shore excursions
Duration: 4-8 days on the boat
How to book: Through a specialised tour company running these boat trips, or through a wildlife tour operator who have chartered a trip.

Silver Salmon Creek, Lake Clark National Park, Alaska, USA

This location has a much smaller habitat than Katmai, consisting of one river with a handful of bears, most of which you will see each day. Mothers with cubs and juvenile bears are most commonly seen, with the occasional big male. It is a more economical option than the live-aboard Katmai trip. Photographically, it has a lot to offer. In particular the east-facing coastline at Silver Salmon Creek offers great potential at dawn. Activity revolves around tide times, as access to the beach is not possible at and around high tide, but you can still see bears further up the creek and in the meadows. It's a lodge-based location, with guides who escort you around the area on ATVs with trailers, so access is easy. The seasons are mid-June to mid-September, as in Katmai (left) and bear activity during each month is similar.

● For my 'Ultimate Silver Salmon Creek Grizzly Bear Safari', in the first week of September I flew from Anchorage on a light aircraft to spend seven nights at Silver Salmon Creek Lodge on a specialist wildlife photography tour run by UK-based Natures Images.

Recommendation summary

Location: Silver Salmon Creek Lodge, Lake Clark National Park, Alaska, USA
Best time to visit: mid-August to early-September
Getting there: By light aircraft from Anchorage
Access: Lodge based with guided excursions on ATVs and then on foot
Duration: 4-7 days
How to book: Either directly with the lodge or with a small group photographic tour run by a specialist company.

Khutzeymateen Grizzly Sanctuary, British Columbia, Canada

Canada's only grizzly bear sanctuary is located at the tip of a remote inlet in the northernmost reaches of British Columbia's coast, immediately south of Alaska. Home to about fifty resident grizzlies, with many others passing through, it is closed to the public and access is only permitted for very small groups led by just two licensed guides. A remote, verdant piece of pristine wilderness and a completely intact temperate rainforest, Khutzeymateen is very special indeed. The word itself is a native word meaning 'a confined space of salmon and bears'. You live aboard a small sail boat anchored in the inlet, and access the bears using a Zodiac (a type of inflatable boat). Although you may go on land occasionally to have a short walk, almost all photography is from the Zodiac. The season is from early May to mid-June, which is the time of year shortly after bears have emerged from their hibernation dens. The salmon have not started to run, so the bears are mainly feeding on the bright green sedge meadows along the shore of the inlet. This is an interesting alternative to bears fishing salmon.

● For my 'Ultimate Khuzeymateen Grizzly Bear Safari', at the end of May I flew by float plane from Prince Rupert to spend five nights on board *Oceanlight II* on a specialist wildlife photography tour run by Natural Art Images, a Canadian specialist wildlife photography company.

Recommendation summary

Location: Khutzeymateen Grizzly Sanctuary, British Columbia, Canada
Best time to visit: mid-May to mid-June
Getting there: Fly from Vancouver to Prince Rupert and then by floatplane from Prince Rupert
Access: Live-aboard anchored sail boat, with excursions to photograph the bears from a Zodiac
Duration: 5 days
How to book: Book a photo tour through Natural Art images, or for a general wildlife tour book directly with the boat owners Ocean Light II Adventures.

Bald eagle

Horned puffin

Sea otter

What else might I see?

The scenery is very special throughout these areas, so there are lots of opportunities for landscape photos. Other wildlife includes wolf, moose, various deer species, sea otters, sea birds and bald eagles.

Cheetah

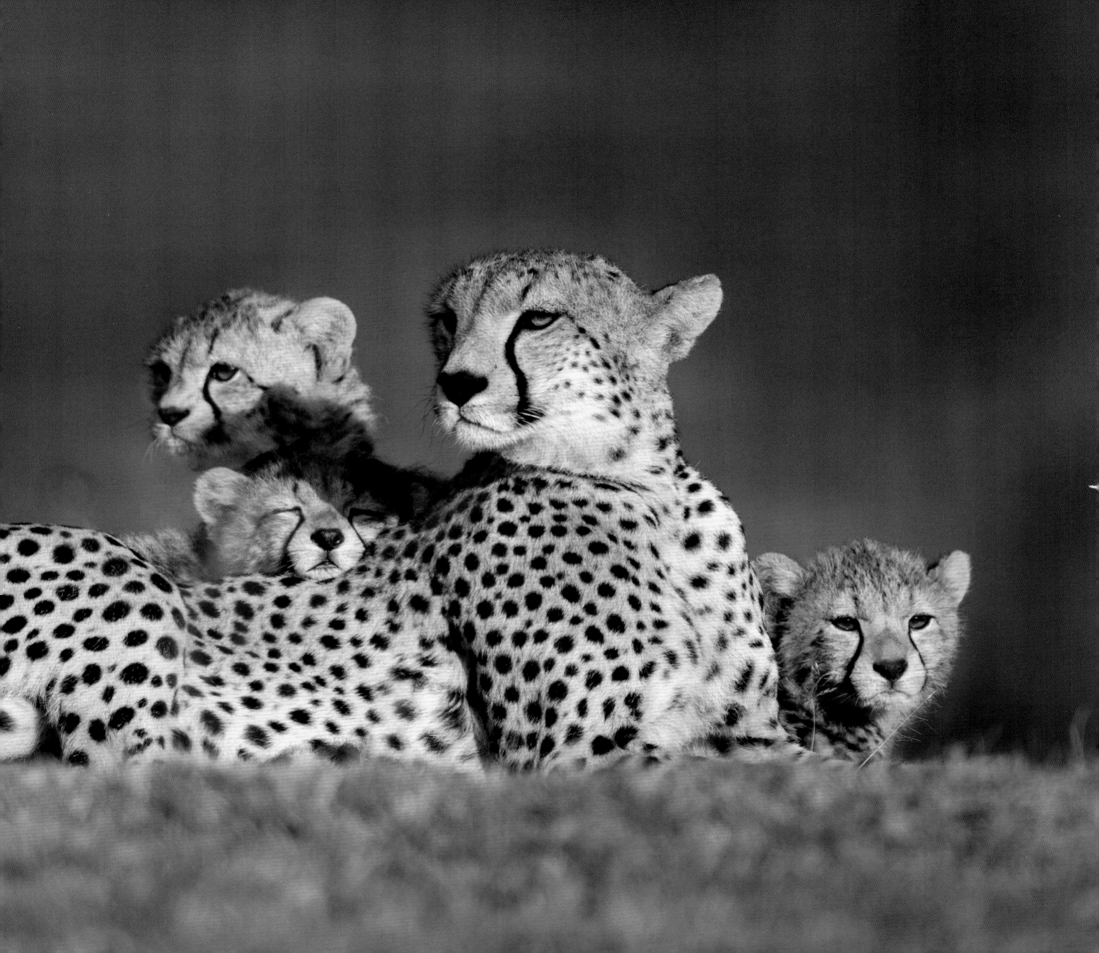

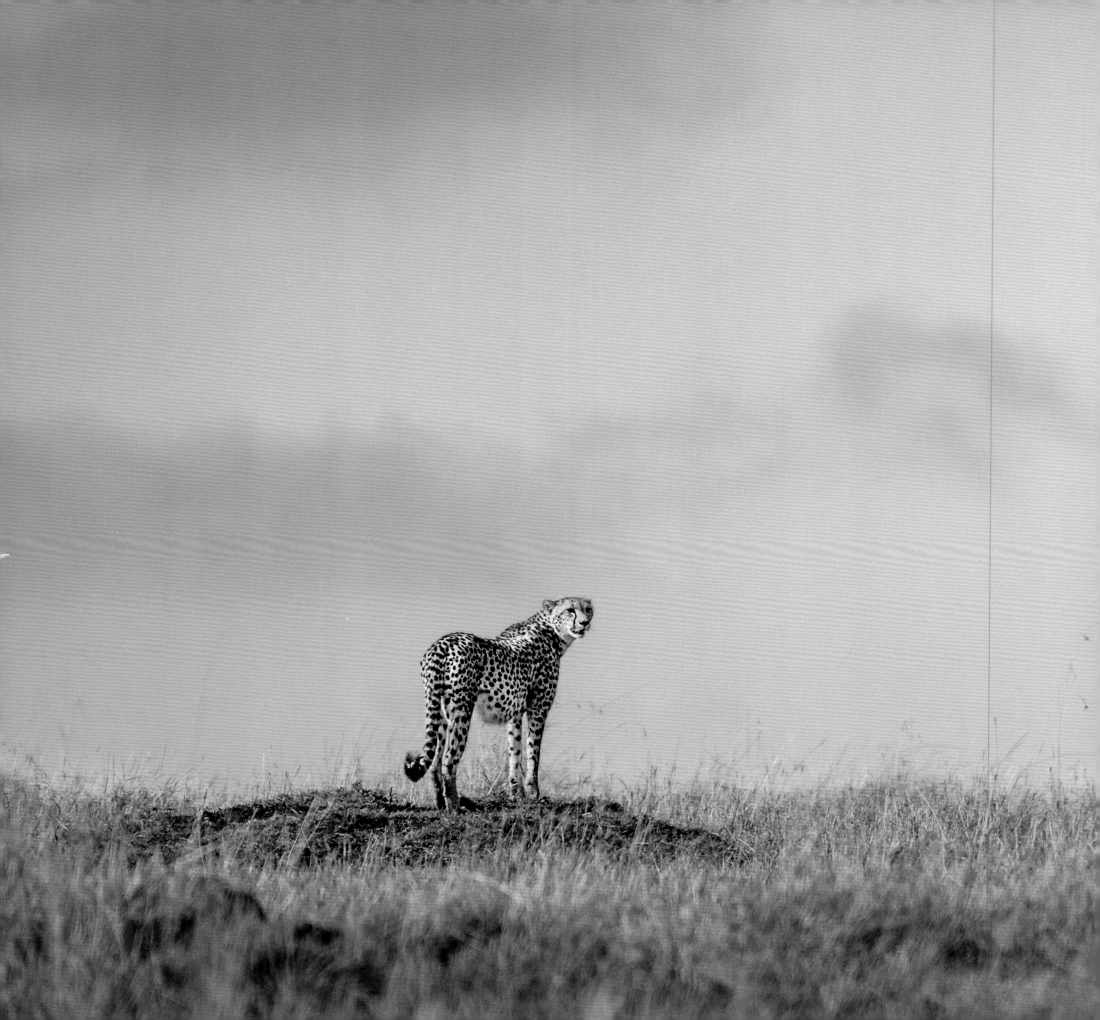

With long legs and a lithe frame, the cheetah is built for speed. The fastest terrestrial mammal, it is the only cat adapted for a sustained high-speed chase of its prey. With a slender build, unlike that of any other cat, it can reach speeds of over 100 kph (62 mph) and sustain a chase for up to 600 metres (650 yards). This slim, elegant profile and the dark 'tear' streaks on its face make it unmistakable. The cheetah is the sole species in its genus; it diverged from the puma lineage around seven million years ago. Its closest living relatives are the puma and the jaguarundi — a small, wild cat native to Central and South America.

The cheetah is listed as vulnerable, having lost 80 per cent of its historic range in Africa, and its entire Asiatic range with the exception of a tiny number left in central Iran. Its remaining strongholds are East Africa and Southern Africa, with a current estimated population of 7,000 to 9,000 adults.

For the wildlife photographer, the cheetah is an exceptional cat. It hunts in the daytime, and so unlike the other big cats in Africa, it probably offers the best prospect of seeing a cat successfully hunting its prey — while setting a demanding high-speed challenge for a photographer! Its elegant form lends itself to exquisite portraiture, and then there are the large litters of playful cubs. There are so many photographic opportunities, I highly recommend arranging a trip to Africa to see and photograph this beautiful cat.

Animals can come and go

It's pitch-black outside. I unzip the side of my tent and peer out into the gloom. I am wanting to go to the main tent for dinner, but first I must get a Maasai guard (known locally as an 'askari') to escort me safely across the few hundred metres of open ground. I am staying in an unfenced tented camp in the Olare Motorogi Conservancy in Kenya. Animals can come and go as they please — we've just seen some giraffes strolling by against the setting sun — so I have to be careful and stick to the camp's rules.

I flash my torch a couple of times, and soon hear the sound of pounding footsteps as the askari rushes towards my tent. Carrying a wooden stick for protection, he's sweeping his powerful torch across the surrounding area. As we head off towards the campfire he enquires if I had enjoyed my shower. 'Yes,' I respond, 'it was great.' Washing off all the grime from the day's hot and dusty game drive is always great.

'Any animals around tonight?' It's a question I ask every night. No, it's all quiet, he tells me. I have absolute confidence in these askari. They are completely at home in this environment, having grown up with wild animals around them. In the event of a potentially dangerous encounter, they don't need to rely on weapons; they use their bushcraft skills to avoid or, if necessary, drive away any threatening wildlife. We arrive safely at the fire, and I settle down for a pre-dinner drink with other guests.

After dinner it's time for a 'taxi' home. I flash my torch again, and soon an askari arrives. 'Tembo tent, please,' I request, and off we head into the darkness. Before I have a chance to ask my question, he volunteers that two male buffaloes came through the campsite during dinner. He thinks they have moved on, but we proceed cautiously, as buffaloes are particularly dangerous. But soon I am at the entrance to my tent, and then securely inside. These tents are a delight, more like 'glamping' than an ordinary tent. You can stand up full height, there is a comfortable bed, an armchair, and off to the side a bathroom and wardrobe area. But the real advantage of a tented camp is the sense of total immersion in wild Africa. Tucked up in bed, I listen to the sounds of the African bush — some zebras are whinnying nearby, an elephant trumpets down by the river, and in the far distance a lion is roaring. Not a bad way to fall asleep! ●

Right: Olare Motorogi Conservancy, Greater Masai Mara, Kenya
Nikon D810 + 70-200mm f2.8 lens at 200mm; 1/1000 sec at f5.0; ISO 1000

Title pages:
Ndutu, Ngorongoro Conservation Area, Tanzania
Nikon D5 + 800mm f5.6 lens; 1/1250 sec at f5.6; ISO 400

Introduction pages:
Mara North Conservancy, Greater Masai Mara, Kenya
Nikon D5 + 200-500mm f5.6 lens at 500mm; 1/1600 sec at f5.6; ISO 250

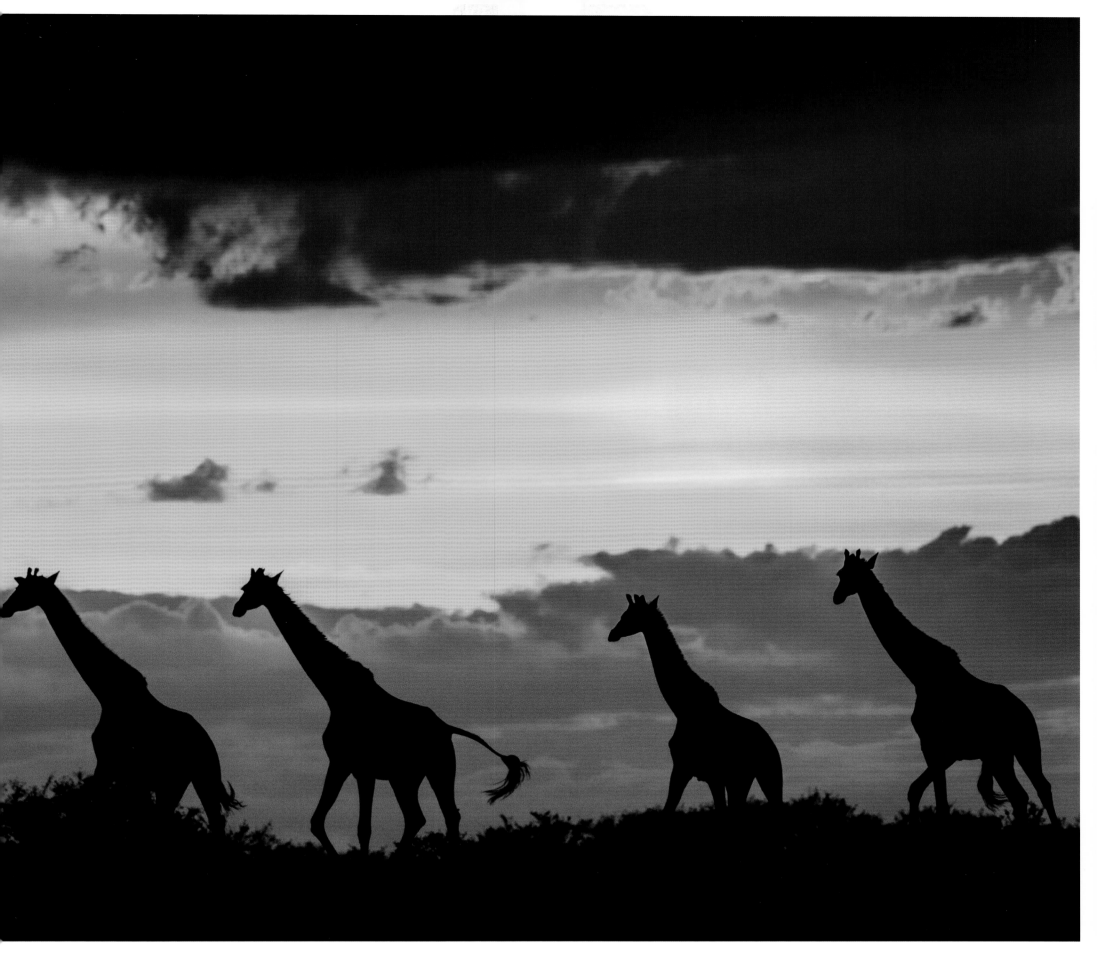

Organisational tip
Camera gear on light aircraft

Many African safaris involve a light aircraft to fly you
to the lodge or camp. They often have very strict luggage
weight limits, which could result in you not being able
to take all the camera gear you would like. I recommend
booking an extra 'freight seat' (sometimes also called
a 'child seat'), which effectively gives you a bigger
weight allowance, and can be shared out between
those travelling.

Right: Male cheetahs form bands of
brothers known as coalitions which
operate as a team, living and hunting
together. Working in this way makes their
hunting more effective and they can take
on bigger prey. These three came striding
down the hill towards us. I liked the sense
of confidence and purpose, and the
pronounced swagger in their step.

Olare Motorogi Conservancy,
Greater Masai Mara, Kenya
Nikon D4 + 200-400mm f4 lens at 270mm;
1/320 sec at f7.1; ISO 3200

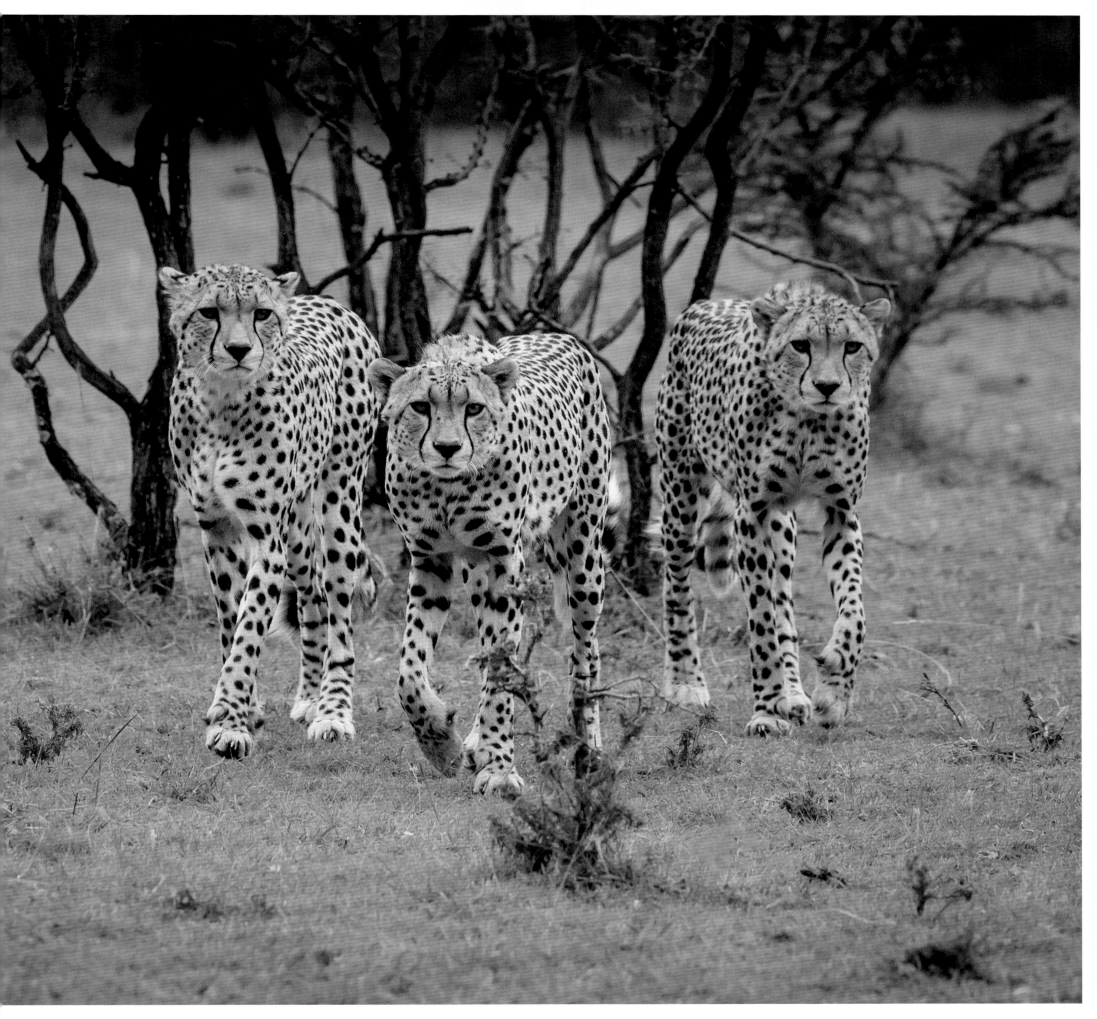

She explodes up from the ground

Sitting in our safari vehicle in the middle of open savannah, we are patiently waiting. We're watching a cheetah with two cubs. Cheetahs need to hunt regularly, particularly a mother like this with two fast-growing cubs, and we're hoping to see and to photograph her hunting. We are in the Mara North Conservancy, one of a number of private conservancies adjacent to the Kenya's Masai Mara National Reserve. The people in the area are the Maasai, but when the word is used for the location, it is spelled Masai.

We first found her four days ago, and ever since we have been waiting for the action. Each day we have managed to re-find her and then watched and waited. We don't think we have missed anything, as cheetahs almost always hunt in the daytime, and they still look pretty hungry. In fact, those cubs look very hungry. We know it must happen eventually, for it is now becoming an urgent necessity. But we thought that yesterday. She seemed to be in an absolutely perfect location, completely hidden within some bushes, when a couple of gazelles started wandering towards her. Gazelles are perfect prey for cheetahs. Our cameras were poised — this is it! Minutes passed, the gazelles got closer and closer. Only 10 metres (33 feet) away. Any moment now! But no, the gazelles walked on, right past her, never suspecting a thing. Why didn't she go for them? Why waste that opportunity? To us it looked perfect, but to her, well, she's the expert, and clearly something wasn't quite right.

Today we are doing it all over again. Right now, with their mother watching on, the two cubs are playing, chasing each other around. Great fun for them and for us. But suddenly they go quiet and sit down in the long grass. An opportunity has arisen — two male Thompson's gazelles are wandering towards the adult cheetah. Unfortunately, her cover is nowhere near as good as yesterday. It doesn't look too promising, and probably won't happen. But just in case, our cameras are poised.

She explodes up from the ground and sprints towards one of the gazelles. The two cubs are also in hot pursuit, but they are nowhere near as quick as their mother and her prey. The gazelle is running directly towards us. The cheetah is closing the gap, but now the gazelle swerves sharply off to its right, a jinking movement that momentarily gains a little ground. But not for long, and the big cat is once again closing him down. Her front left paw trips the gazelle. He's down! Within a fraction of a second the cheetah has a throat-hold on the unfortunate gazelle, just as her two cubs catch up with the action. It's all over, ten seconds from beginning to end. ●

Right: Mara North Conservancy, Greater Masai Mara, Kenya
Nikon D5 + 200-500mm f5.6 lens at 420mm;
1/1600 sec at f7.1; ISO 1800

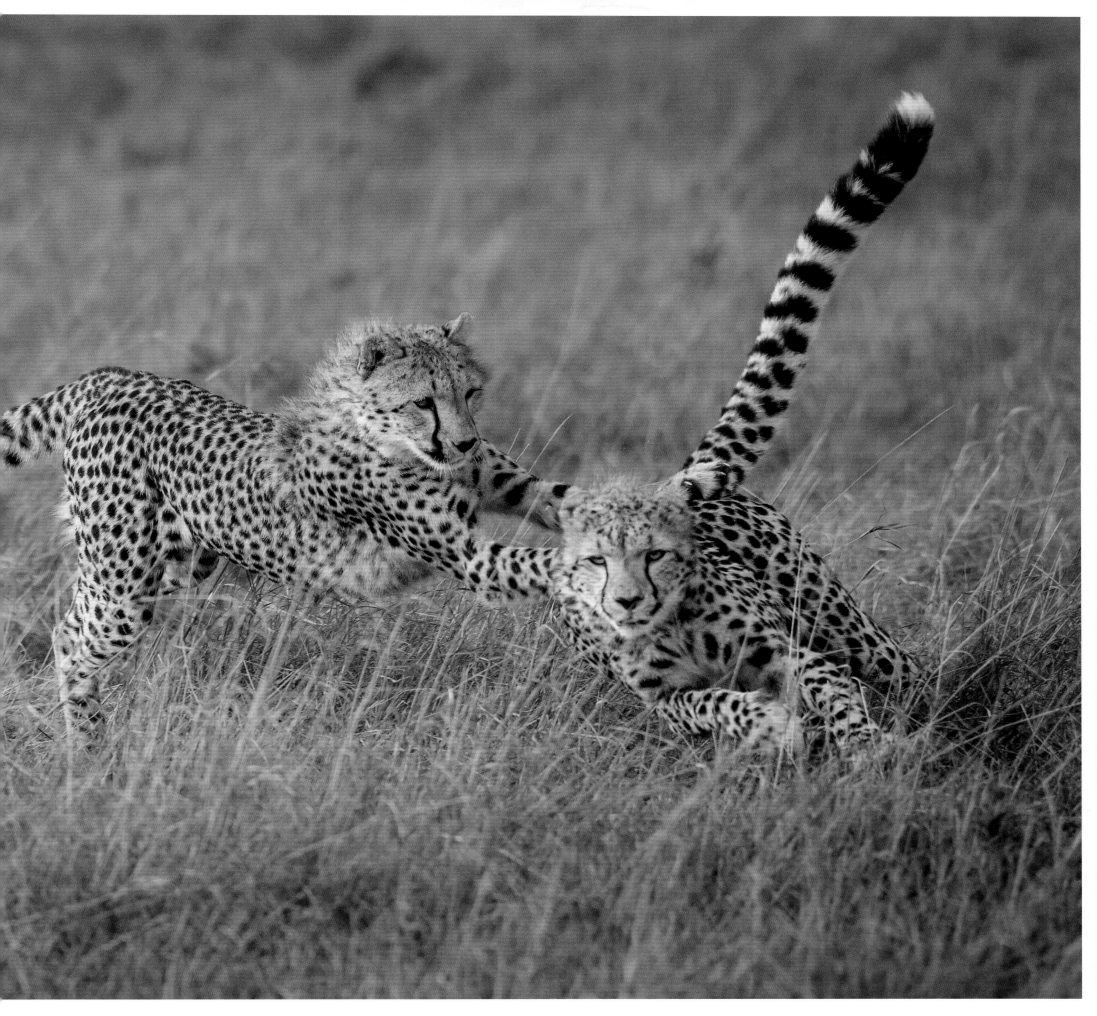

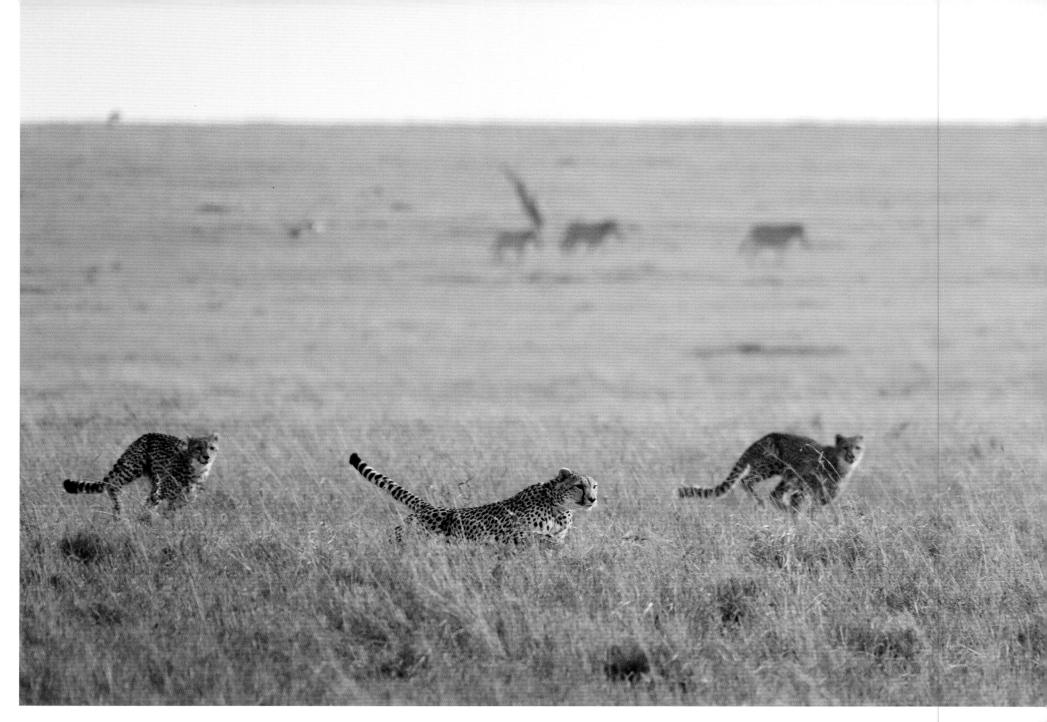

Photographic tip
High-speed hunts

When photographing any animal hunting, lens selection is crucial. You need to use a lens that you are comfortable hand holding, one that you can swing smoothly to follow the action. Be careful not to use too long a lens, as this will make tracking the encounter very difficult. Position the vehicle to try and get the clearest unobstructed view of the area. I find it best to put the main focus point right in the centre, and to enable tracking on the focus points adjacent to it.

All above and right: Mara North Conservancy, Greater Masai Mara, Kenya
Nikon D5 + 200-500mm f5.6 lens at 500mm; 1/2500 sec at f7.1; ISO 1250

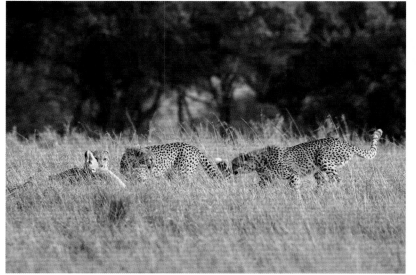

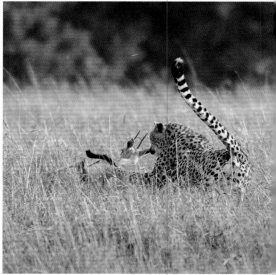

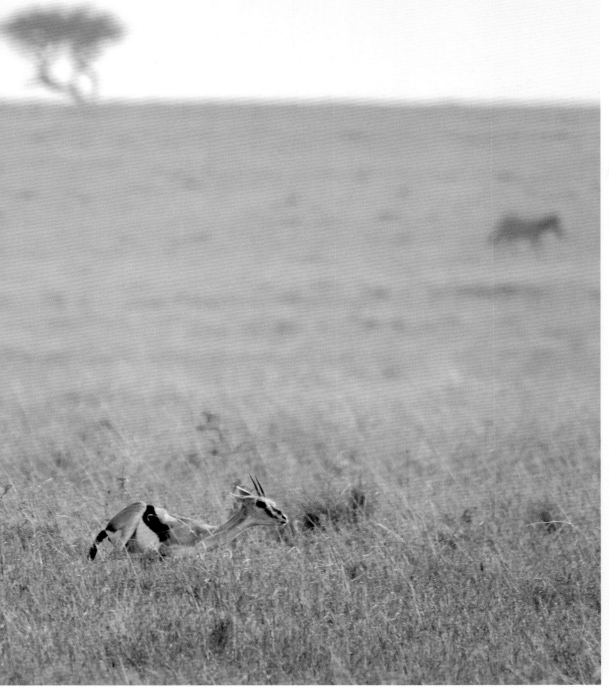

Clockwise from left: The mother (in the middle) sets off after a gazelle. The cubs can't keep up so the mother springs ahead, her huge tail acting like a rudder for balance as she twists and jinks, keeping pace with the fleeing gazelle. When she brings down her prey, the cubs catch up with her and they all feed together.

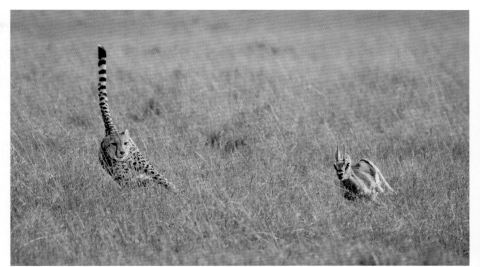

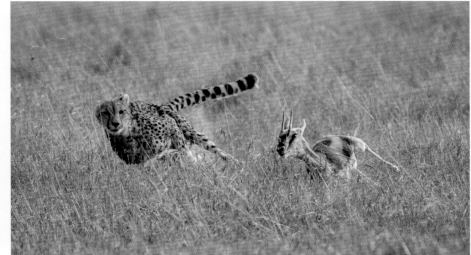

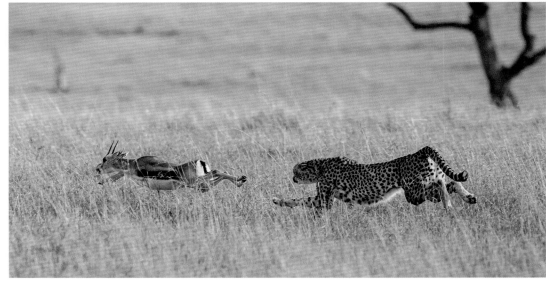

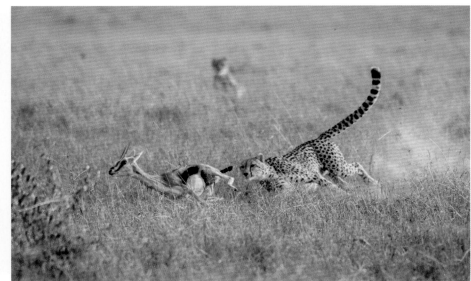

Organisational tip
Bush breakfast

It never ceases to amaze me that many guests on safari stay in the lodge or camp to have breakfast and consequently miss the best part of the day. First thing in the morning it is nice and cool, many animals are more active, and the light is at its best. Always head out before sunrise and take a packed breakfast — you can eat it later, once the action has died down and the light has become harsh. Breakfast out in the bush is a wonderful experience!

Left: First thing in the morning, we were up and out to take advantage of the soft, golden light. You never know what you'll see until you drive around the next corner. We were lucky to spot this female cheetah alone and just waking up. As with many wild cats, yawning is a sign of imminent activity. I managed to get down at eye level to capture the peaceful moment in the morning light.

Masai Mara National Reserve, Kenya
Nikon D5 + 600mm f4 lens;
1/800 sec at f4; ISO 1250

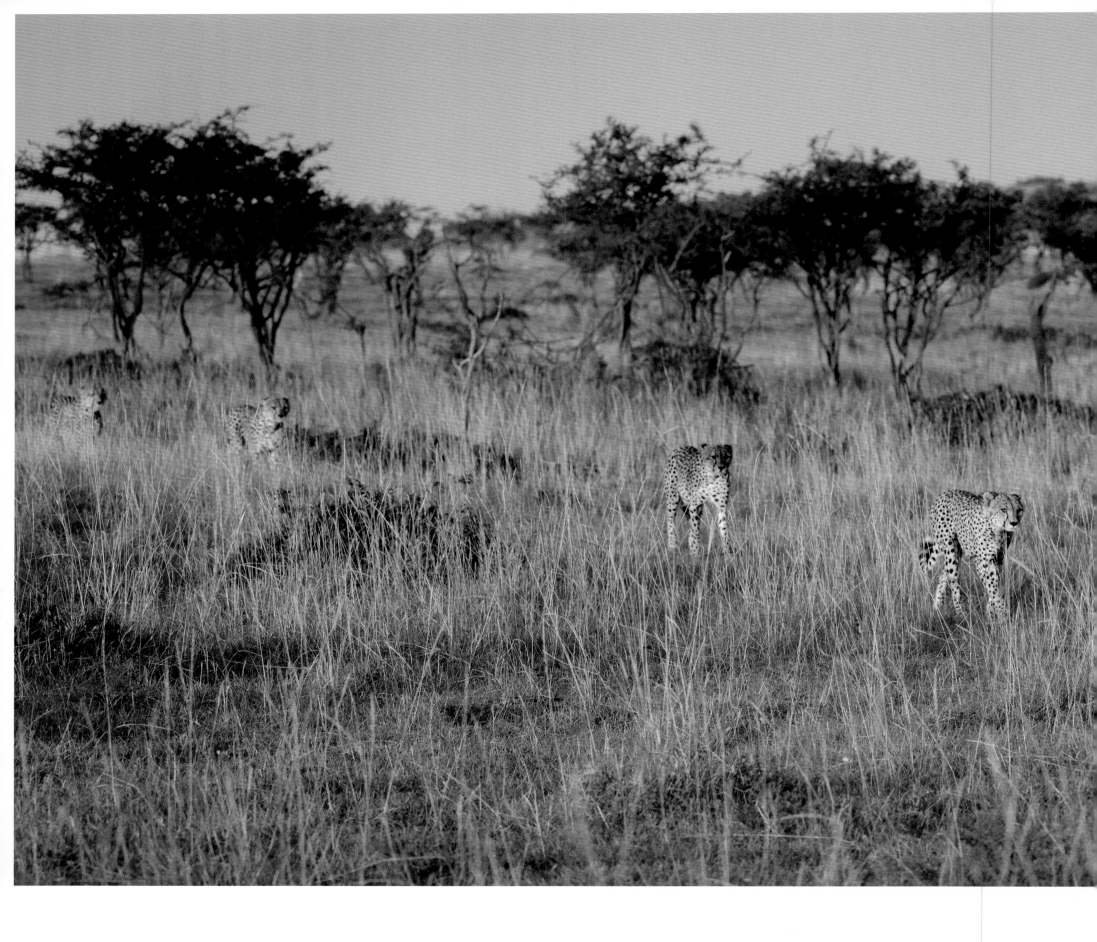

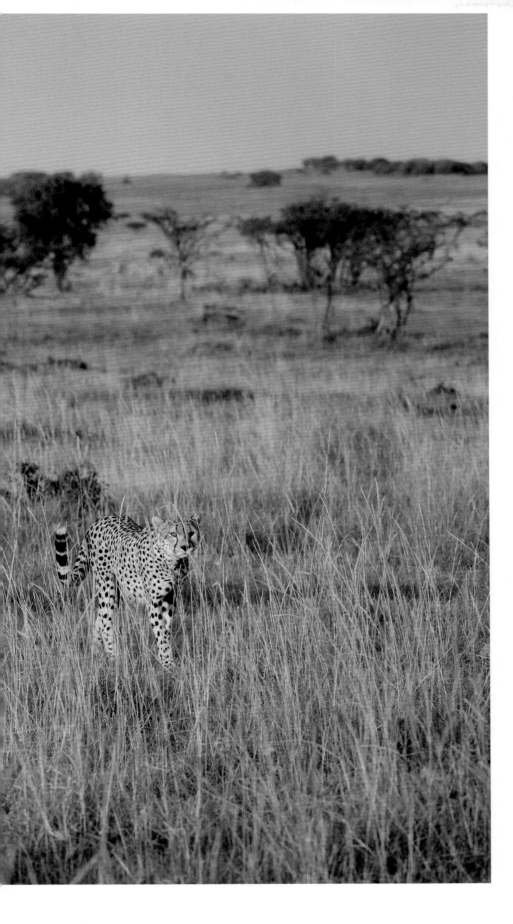

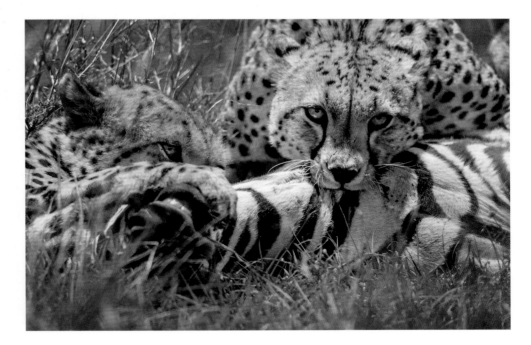

Left and above: This particular gang of five is the biggest coalition of cheetahs ever known in the Masai Mara. It is thought that these five males could be two sets of brothers, or two pairs of brothers and one other male, that have teamed up and have stuck together for years. They came strolling along early in the morning. A large herd of zebra was grazing close by and it seemed we were poised for a hunt, but nothing happened. So we scooted off to have breakfast nearby, and had just laid out a 'buffet on the bonnet' when we got a call from another vehicle saying the cheetahs were about to hunt. We packed up the uneaten breakfast at top speed and got back to the scene as the hunt began. I've never seen anything like it, the cheetahs just walked into the herd of zebras, which scattered in all directions. Then they honed in on a large foal, surrounded it and brought it down.

Above: Olare Motorogi Conservancy,
Greater Masai Mara, Kenya
Nikon D5 + 800mm f5.6 lens;
1/2000 sec at f5.6; ISO 360

Left: Olare Motorogi Conservancy,
Greater Masai Mara, Kenya
Nikon D5 + 180-400mm f4 lens at 180mm;
1/1600 sec at f8; ISO 2000

Golden hour with golden cats

Tanzania's Ngorongoro Conservation Area, which lies just outside the Serengeti National Park, is one of the world's hotspots for cheetahs, particularly mothers with cubs. Yesterday we enjoyed watching a young family at play. As their mother looked on, her three cubs were an absolute delight, chasing each other around, biting, playing, and generally having fun.

Now we are driving out from the lodge, the sun is just coming up, and we're heading back to Ndutu's big marsh where we were yesterday to see if we can find them again.

In no time at all we spot them close to where we left them yesterday. This morning they are sitting together on a small raised bank. We carefully position the safari vehicle on slightly lower ground, with the rising sun behind us, taking care that our shadow won't fall onto the cheetahs.

This looks perfect — gorgeous early morning light, a beautiful cheetah with three cubs, and great separation between the cats and the background. The family seems to be enjoying each other's company, sitting close together, almost on top of each other. As they pose one way and another, we take hundreds of photographs — a golden hour with golden cats!

Their mother locks onto something. It's a small herd of gazelles walking across the marsh, a long way behind us, way too far away to hunt. But cheetahs can't resist the urge. They appear to be looking straight at us as they all watch the distant herd wandering past. And now, with this distraction gone, it's playtime again — the cubs are up and running — magic! ●

Right: Ndutu, Ngorongoro Conservation Area, Tanzania
Nikon D5 + 800mm f5.6 lens; 1/1250 sec at f10; ISO 1400

Photographic tip
Going off road

Many of Africa's national parks and reserves forbid off-road driving. This is completely understandable given the number of vehicles, but it does make photography much more difficult — the animals may be too far away, or the light angle may be all wrong. For photographic safaris it is usually best to go to areas where off-road driving is permitted, such as the conservancies in Kenya, conservation areas in Tanzania or the private reserves in southern Africa.

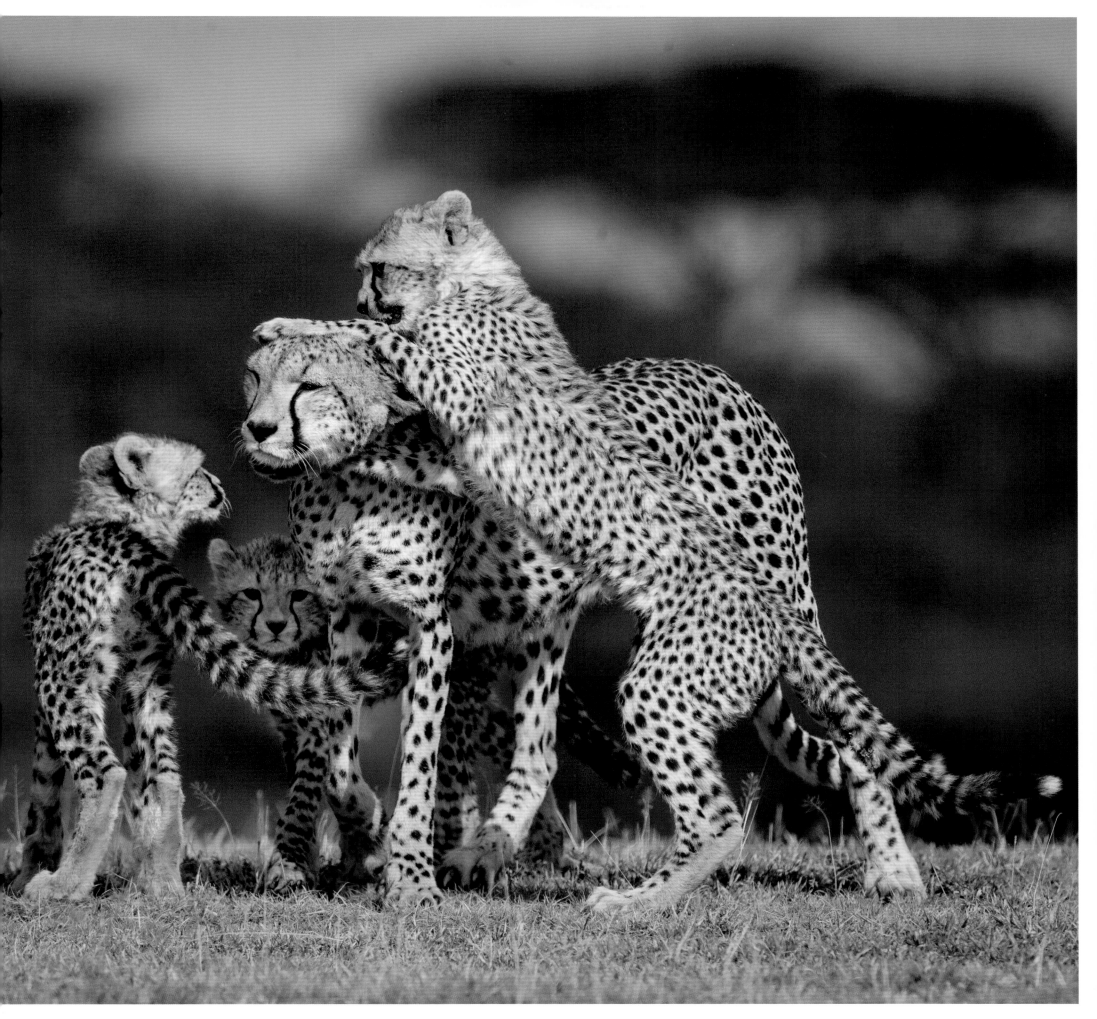

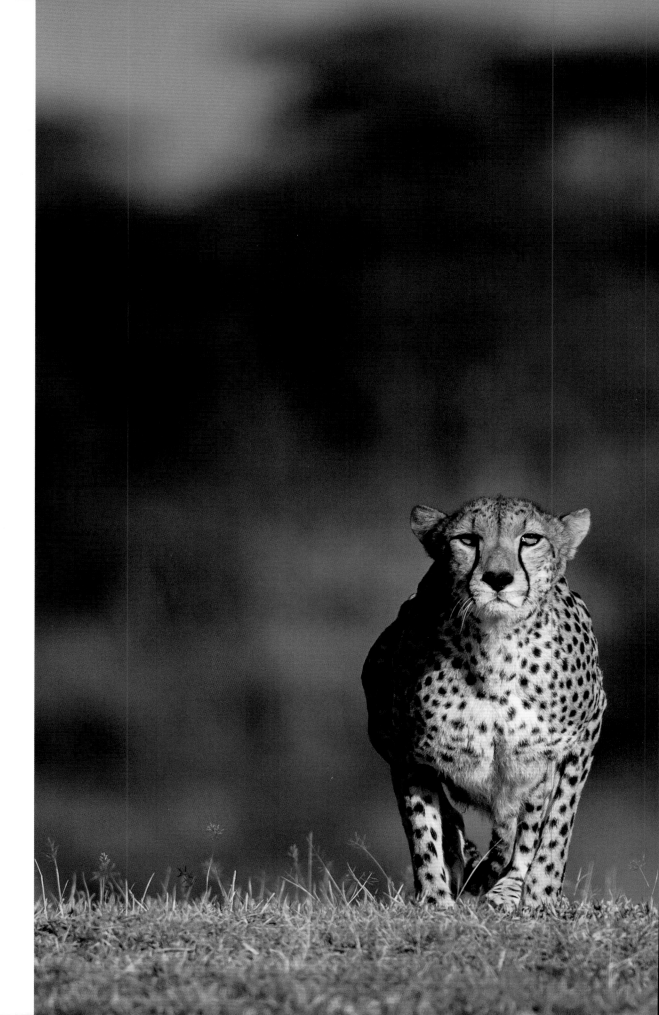

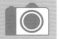

Photographic tip
Shadows at sunrise/sunset

Getting a great encounter at sunrise or sunset is every wildlife photographer's dream. But take care when positioning the vehicle. For conventionally-lit shots, that is, with the sun behind you, you need to be as close as possible to a direct line with the sun, whilst ensuring that your shadow doesn't fall on the subject. If you are off at a wider angle, you will tend to get ugly black shadows. Alternatively, you can position yourself looking towards the sun, for backlit shots — these can work really well, particularly with furry creatures!

Right: Ndutu, Ngorongoro Conservation Area, Tanzania
Nikon D5 + 180-400mm f4 lens with 1.4x converter
at 560mm; 1/2500 sec at f5.6; ISO 1000

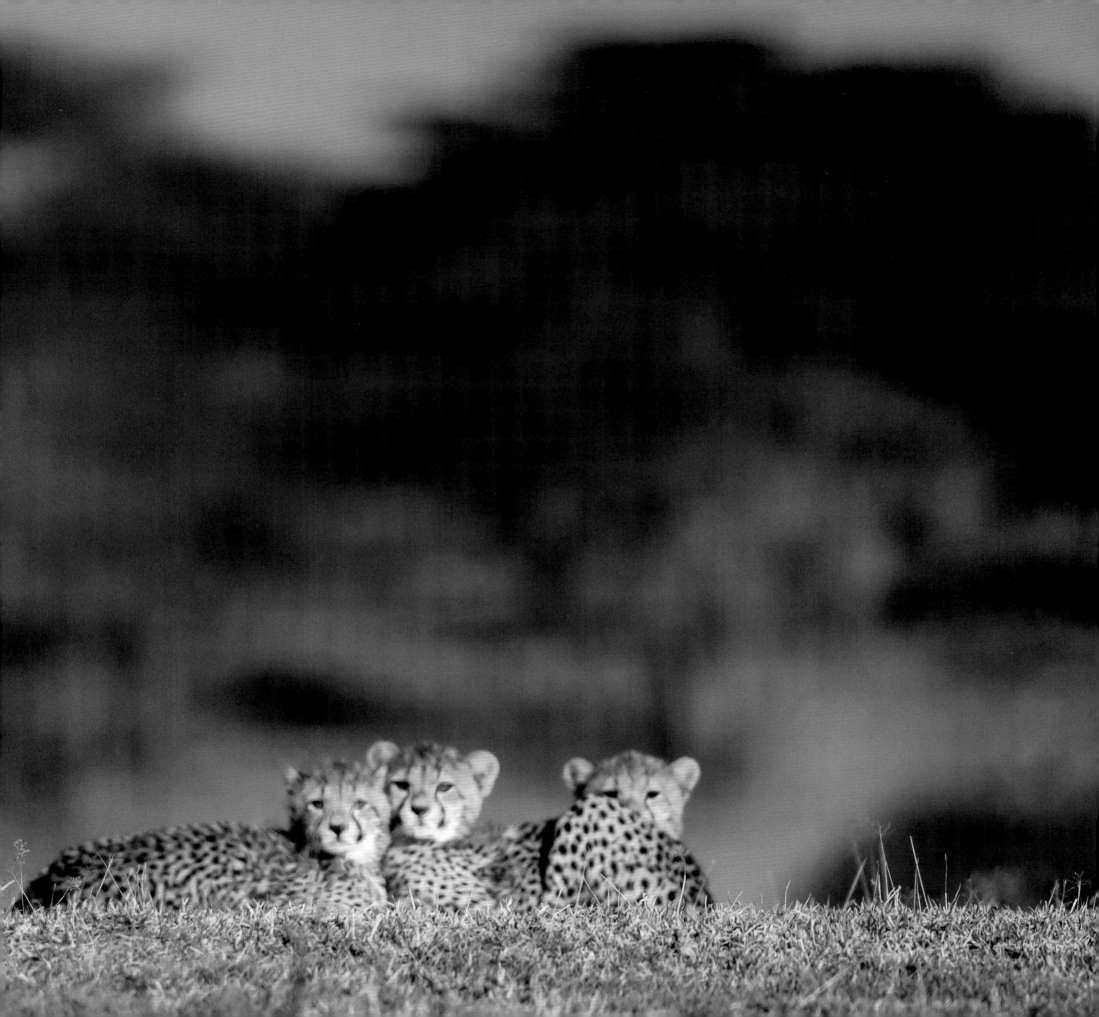

Photographic tip
Support matters

Method		
	●	**Recommended**
	○	**Possible use**
	●	**Not recommended**
Handheld	○	Generally light levels are quite high, allowing for fast shutter speeds. With good technique, this is a practical option, although a beanbag is better.
Beanbag	●	Usually the best solution in a safari vehicle. Place the beanbag on the windowsill and rest the camera lens on it. Take care to ensure your lens is nicely nestled into the beanbag, to stop it wobbling around.
Monopod	○	If you sit on the floor of the vehicle a monopod can work quite well.
Tripod	●	Not suitable in a safari vehicle. May be useful around the grounds of the lodge for photographing birds during the midday break.

Right: Cheetahs are out and about hunting and nursing in the daytime. It's safer and they're less likely to have their kill stolen when other predators are sleeping, but difficult for photography with the harsh light of African sun. I knew the light wasn't great, but I couldn't resist the opportunity to photograph a nursing mother with five cubs. They were very young, about 8 weeks old, and walking together across the plains. She reached an area of elevated ground and they sat down beside her before suckling.

Ndutu, Ngorongoro Conservation Area, Tanzania
Nikon D3S + 200-400mm f4 lens at 200mm;
1/400 sec at f11; ISO 2000

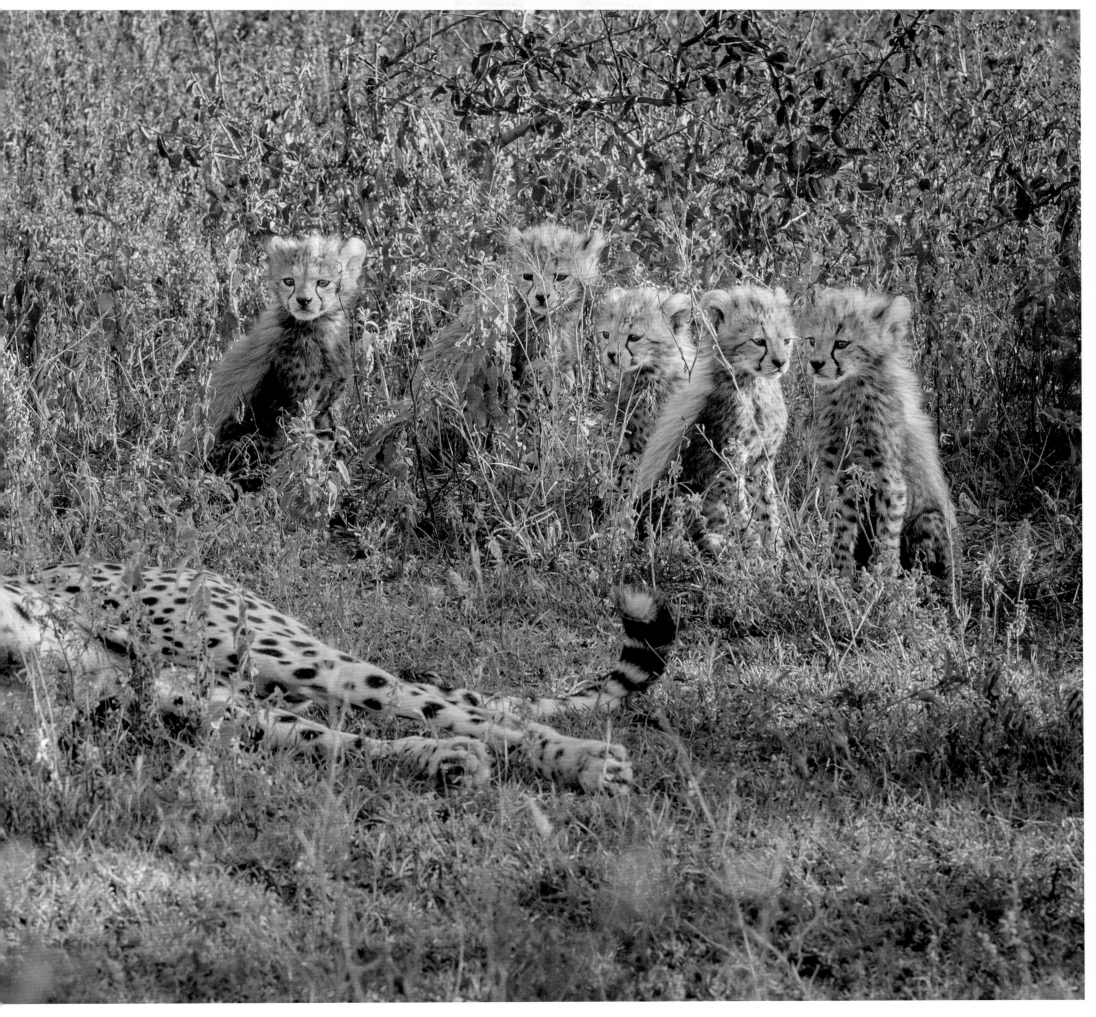

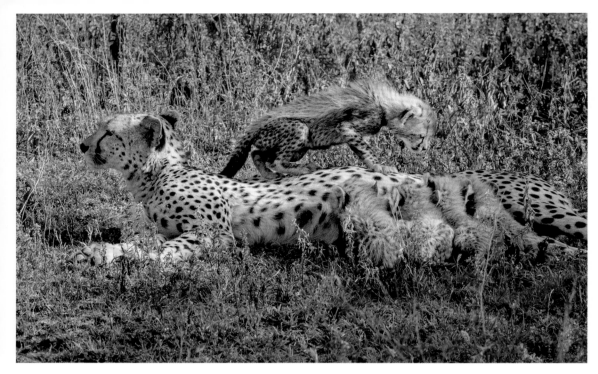

Above and right: The young cubs clamber over their mother, and settle down to suckle. The one on top of her (above) couldn't get in to feed, but its position shows off the mane-like fur known as a mantle that gives the cubs extra camouflage. It's highly unlikely that these five will all make it to adulthood. There are many hazards and cub mortality is high. A cheetah mother raises her cubs alone and so she has to leave them hidden while she's hunting and that's when they are vulnerable to other predators, especially lions and hyenas. And of course, her hunts need to be successful for the growing cubs to feed and thrive.

Above: Ndutu, Ngorongoro Conservation Area, Tanzania
Nikon D3S + 200-400mm f4 lens at 220mm;
1/640 sec at f11; ISO 2000

Right: Ndutu, Ngorongoro Conservation Area, Tanzania
Nikon D3S + 200-400mm f4 lens at 400mm;
1/400 sec at f11; ISO 2000

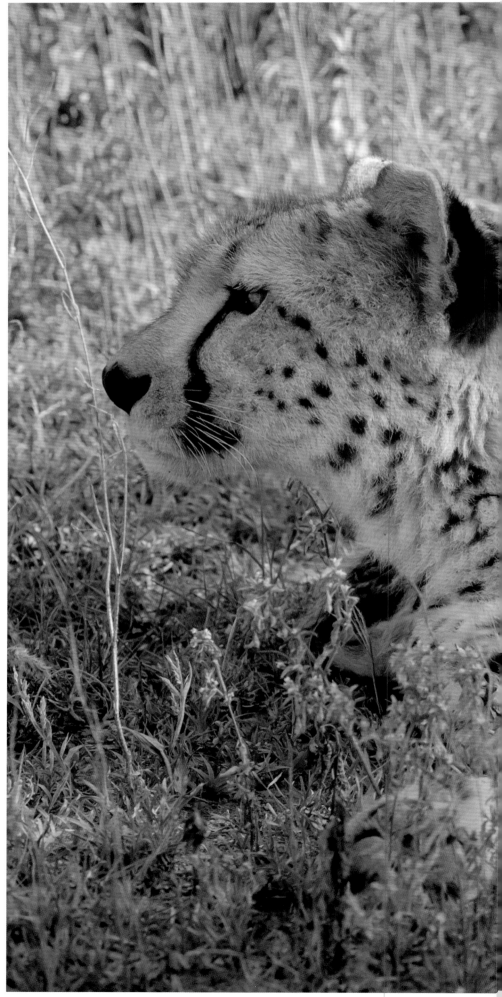

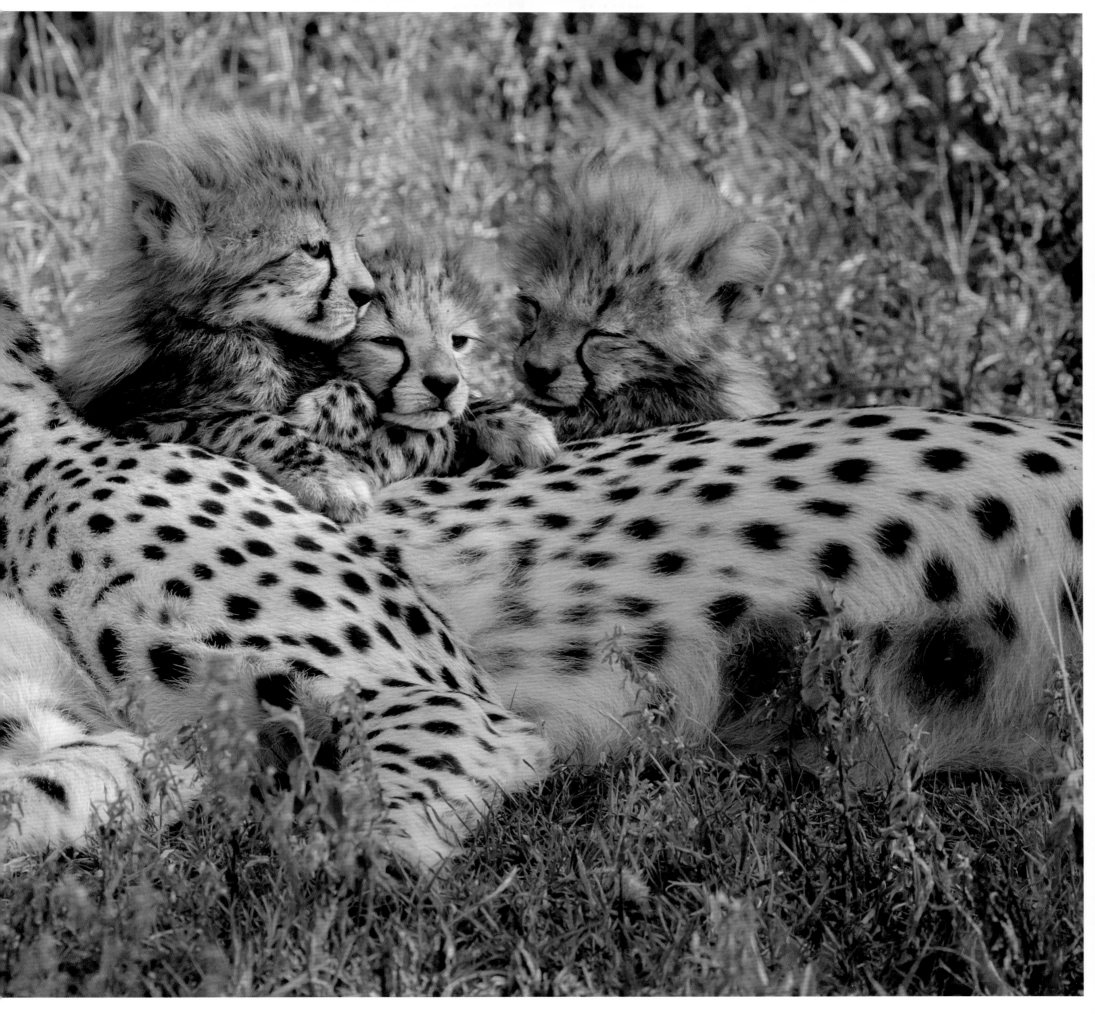

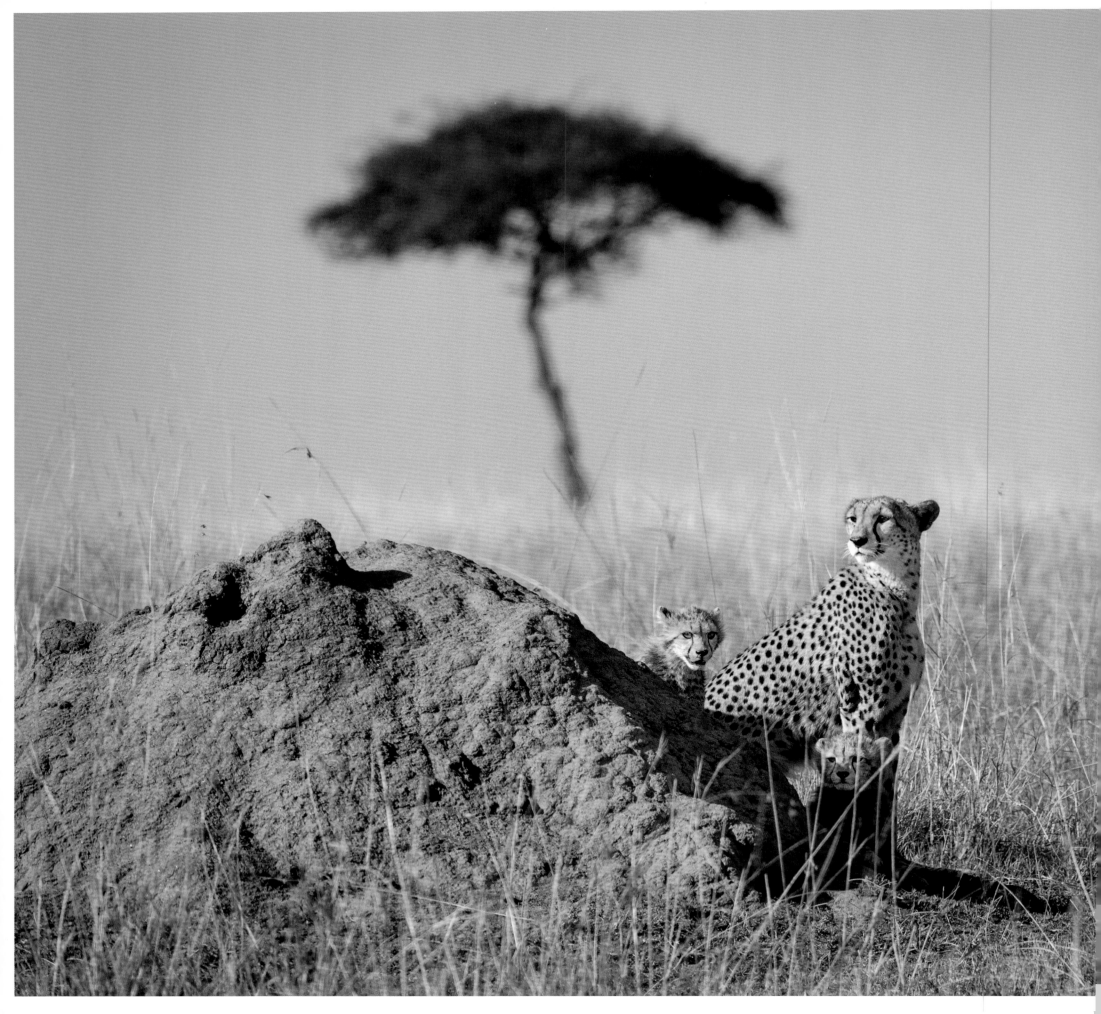

Left: A mother shields her two young cubs behind a termite mound. I liked the juxtaposition of her upright stance and the quintessential African backdrop of the acacia tree, and so we positioned our vehicle to get the tree in the right alignment. I've often seen cheetahs standing on top of termite mounds, using the extra elevation to see further over the long grass of the plains.

Olare Motorogi Conservancy,
Greater Masai Mara, Kenya
Nikon D4 + 200-400mm f4 lens at 380mm;
1/1000 sec at f8; ISO 500

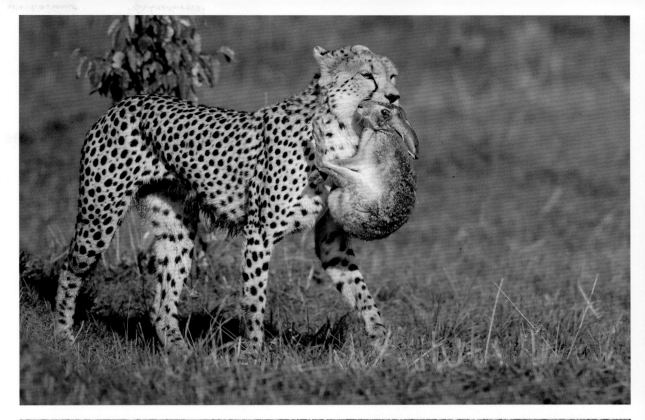

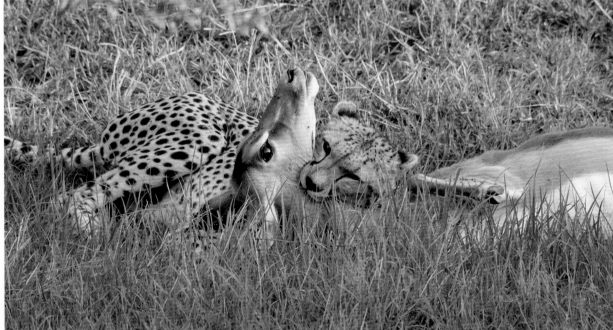

Above: This cheetah was very well known in the area. Named Malaika, she was a superb hunter who had successfully raised a lot of cubs. We watched her hunting an impala, it's still alive in this photograph and she's holding on — cheetahs kill by suffocation with a sustained bite to the throat.

Masai Mara National Reserve, Kenya
Nikon D5 + 200-500mm f5.6 lens at 400mm;
1/2000 sec at f10; ISO 5600

Above top: We watched this cheetah snuffling around in the long grass, and then suddenly a hare bolted away. She streaked after it and we could hear its high-pitched squeals — it was still alive as she carried it away.

Masai Mara National Reserve, Kenya
Nikon D5 + 200-500mm f5.6 lens at 410mm;
1/500 sec at f5.6; ISO 140

127

Right: We had seen three male cheetahs the previous evening and so went out looking for them before sunrise the next morning. We drove to the top of a hill to get a vantage point and our guide scanned the area and spotted them. We went down quickly to them just as the sun was coming up. I managed to get just below this cheetah to frame it silhouetted and stretching on the gentle slope, edged with gold by the backlighting of the rising sun.

Mashatu, Northern Tuli Game Reserve, Botswana
Nikon D5 + 200-500mm f5.6 lens at 400mm; 1/1600 sec at f10; ISO 450

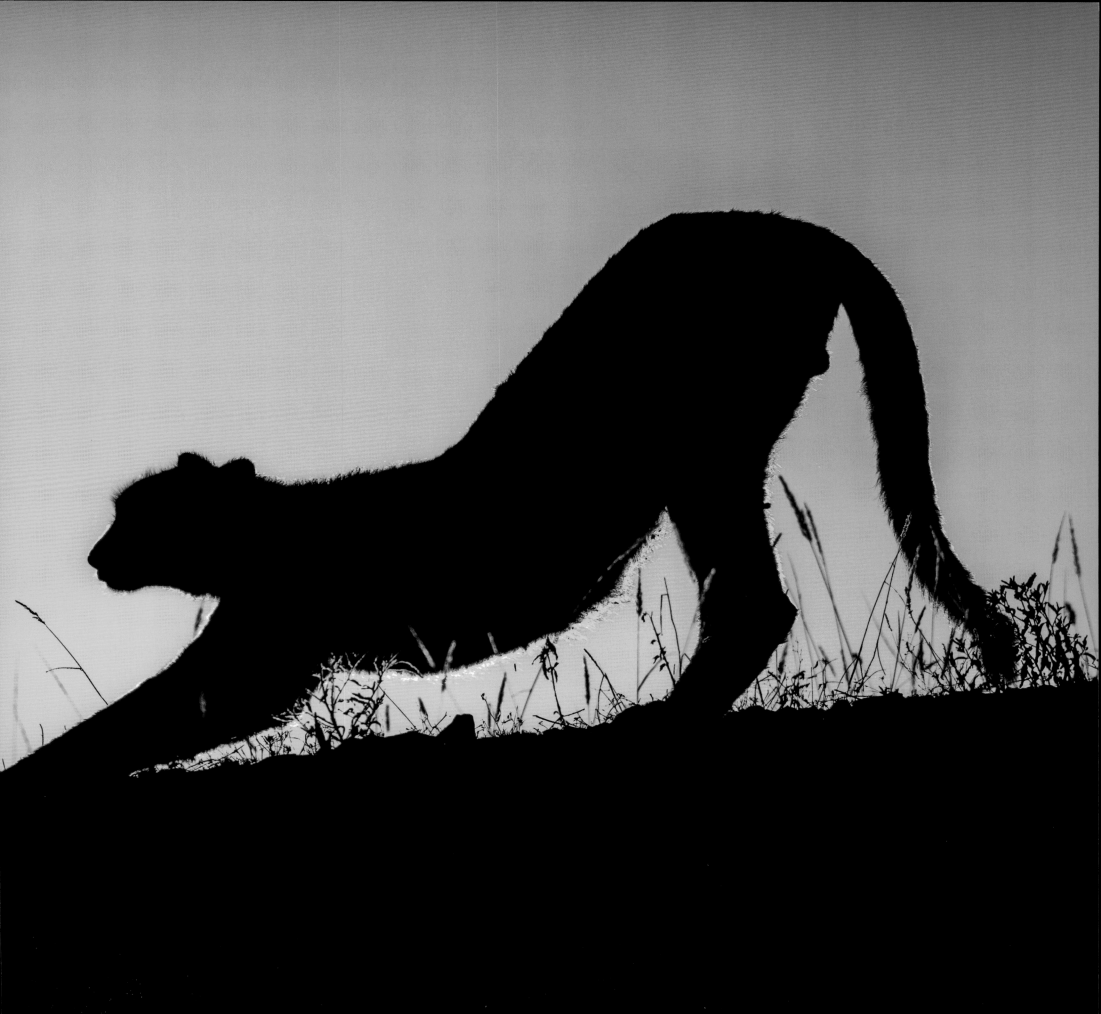

Planning your ultimate cheetah safari

Where to go and when to visit?

My two recommended locations for cheetah safaris are both within the Serengeti-Masai Mara Ecosystem. This is a vast area straddling the border between Kenya and Tanzania, famous for the annual wildebeest migration, it also one of the best places in Africa to see the continent's big cats.

Olare Motorogi Conservancy or Mara North Conservancy, Greater Masai Mara, Kenya

The conservancies are in lands adjacent to the Masai Mara National Reserve, which were known in the past as Group Ranches. Communally owned by hundreds of local Maasai herdsmen, they were run as cattle ranches. In recent years a new arrangement has been established, whereby in exchange for a guaranteed monthly income the Maasai have agreed to the area being managed for wildlife and tourism. The effect has been amazing. Known as 'conservancies', these areas not only give the Maasai people a guaranteed income, but the wildlife habitat has improved so much that the best animal encounters are often in the conservancies. And, unlike in the National Reserve, tourist numbers are strictly limited, making the whole experience much more enjoyable. With off-road driving also officially permitted, these wildlife-rich conservancies have become a magnet for serious wildlife photographers.

My two favourite conservancies are Olare Motorogi and Mara North, both buzz with wildlife and are excellent for a comprehensive African safari, and particularly for the big cats. Whilst nothing is guaranteed with wildlife, there is a high chance that you will see cheetahs on a safari there.

As to when to visit, there are two factors to consider — peak visitor times and seasonal rains. Whilst visitor numbers are tightly controlled in the conservancies, with vehicles at a sighting typically restricted to no more than five, I still prefer to go during quieter times, avoiding busy periods such the school holidays, Christmas/New Year and the peak of the wildebeest migration. The best times are mid-January to mid-March, or mid-September to mid-December. It's probably a good idea to avoid the long rains in April and May when many roads can be flooded, and most camps are closed. The short rains in November can be viewed in two ways — an inconvenience or an opportunity. Whilst the inconvenience is obvious, the rainy season may

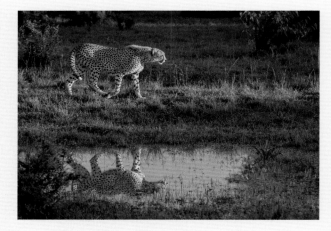

bring less harsh light and much more interesting cloudy skies as a backdrop for your photographs.

For my 'Ultimate Masai Mara Cheetah Safari', in February I spent six nights at Kicheche Bush Camp in Olare Motorogi Conservancy, booked through Safari Consultants, a UK-based specialised travel agent

Recommendation summary:

Location: Olare Motorogi or Mara North Conservancies, Greater Masai Mara, Kenya
Best time to visit: Either mid-January to mid-March or mid-September to mid-December
Getting there: Fly to Nairobi (Jomo Kenyatta International Airport) and then transfer to Wilson Airport for a scheduled light aircraft flight to the Masai Mara.
Access: By safari vehicle
Duration: Five to seven days
How to book: Through a specialised wildlife travel agency or join a small group photographic tour run by a specialist company.

Ndutu, Ngorongoro Conservation Area, Tanzania

The Ngorongoro Conservation Area is a huge tract of land adjacent to the world-famous Serengeti National Park, and Ndutu itself is right on the border with the Park. Huge wildebeest herds come here to give birth each year, arriving on their annual migration in December, and leaving around April. During this period they are resident in the area (not crossing rivers, that's further north later in the year), so it is a time of plenty for predators. However, contrary to popular belief, big cats are territorial and do not follow the migration. So once the herds have left, prey is much tougher to find for leopards and lions. However, for cheetahs, which generally choose smaller prey such as impala and gazelles, that is not so much of a problem — these antelope don't migrate and are there year-round. The Ndutu area is superb for cheetah encounters and is particularly renowned for seeing cheetah mothers with cubs.

Whereas off-road driving is strictly prohibited in the National Park, in Ndutu it is allowed, making it the ideal location for a photographic safari.

If you want to see the mega-migration herds, then the best time to visit is January though to March. However, this is peak season, and there will be large numbers of tourists in the area. At these times it is not unusual to have twenty or thirty vehicles at a cheetah sighting. I prefer to visit in the off-peak times, such as September to November — then you will still get superb wildlife sightings, including of cheetahs, but often have them all to yourself! It is also cheaper.

For my 'Ultimate Ndutu Cheetah Safari', in September I spent five nights at Ndutu Safari Lodge on a photo tour run by Nick Garbutt booked through UK-based Wildlife Worldwide.

Recommendation summary:

Location: Ndutu, Ngorongoro Conservation Area, Tanzania
Best time to visit: September to November
Getting there: Fly to Kilmanjaro International Airport. Then either fly by light aircraft from nearby Arusha Airport to Ndutu Airstrip or take a road transfer (about seven hours)
Access: By safari vehicle
Duration: Five to seven days
How to book: Through a specialised wildlife travel agency

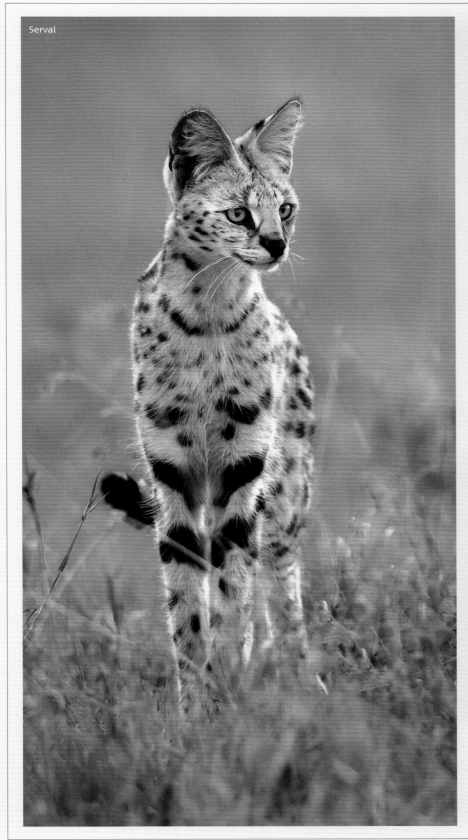
Serval

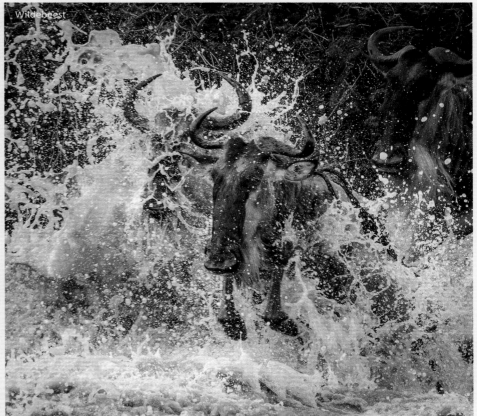
Wildebeest

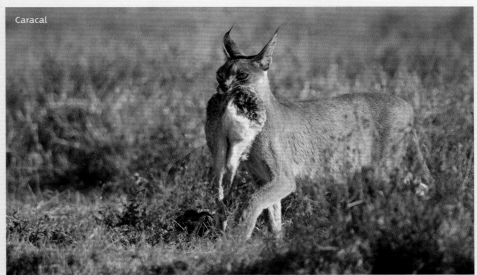
Caracal

What else might I see?

These two locations offer a superb selection of African wildlife, including some of the smaller cats such as caracal and serval. If you visited during the period when the wildebeest herds are crossing the Mara River (normally July to October), you could have a two-part safari combining cheetahs in Ndutu with a migration trip further north by the Mara river.

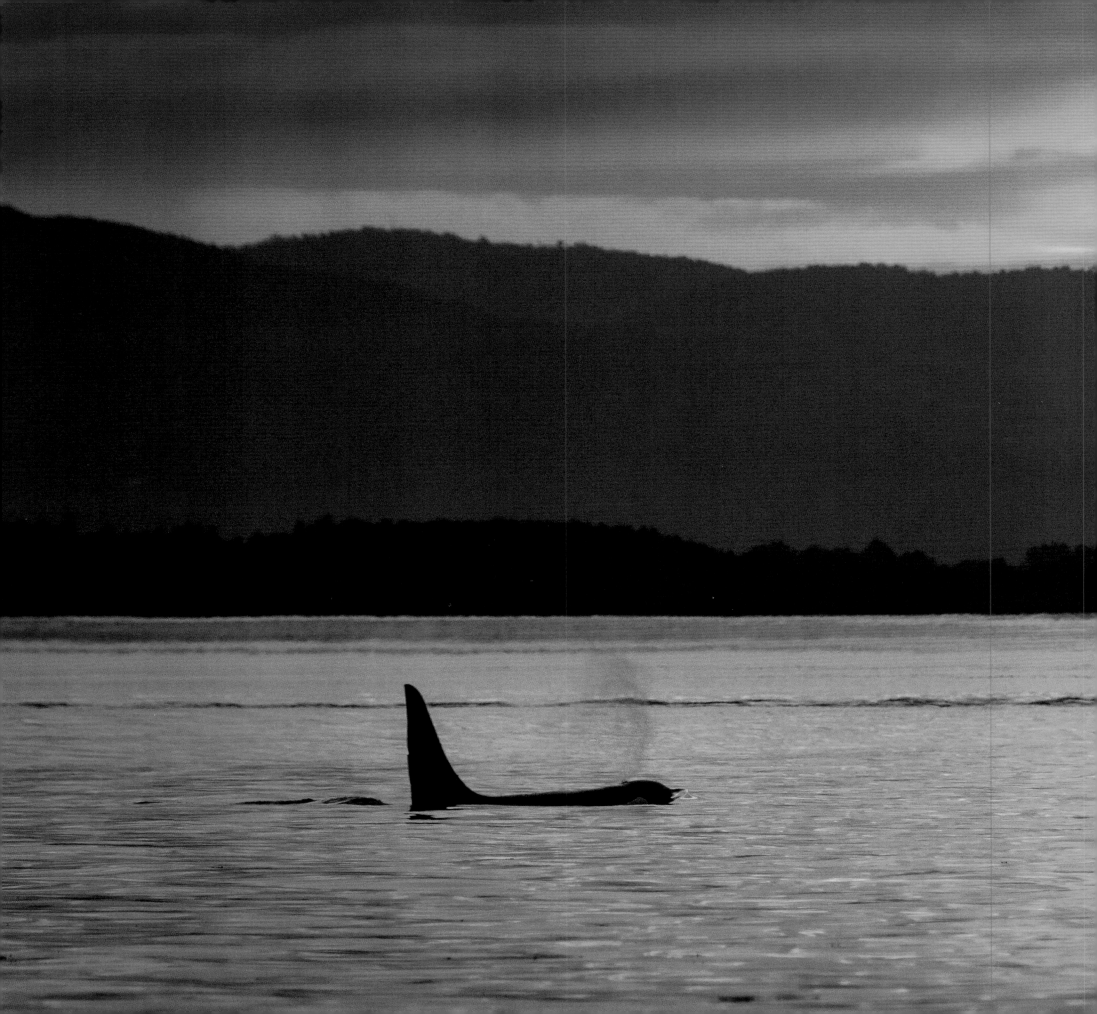

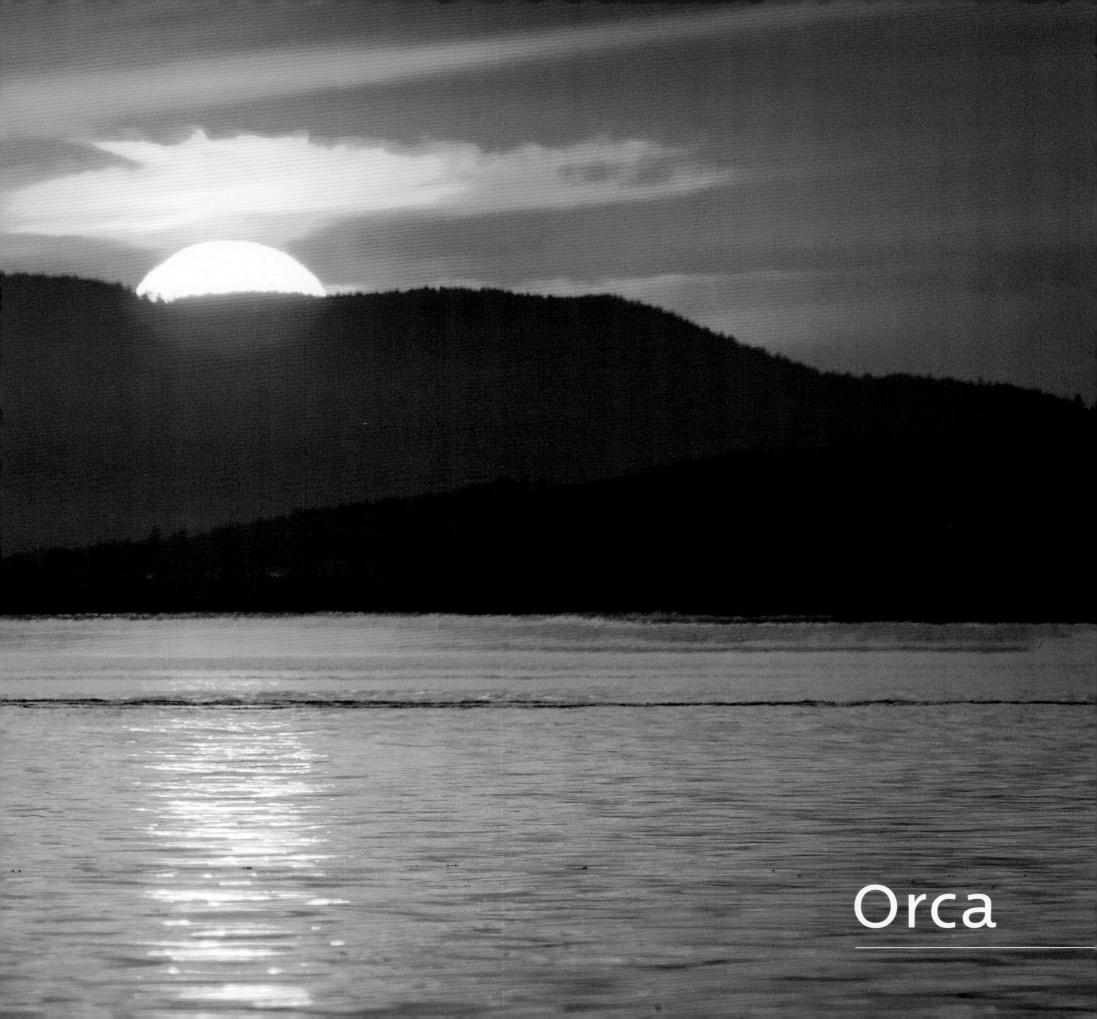

Orca

Predators, for me, are among the most compelling animals to photograph. As one of the ocean's supreme apex predators, orcas are high on my list of target subjects — even though being ocean-based makes photography more difficult. Orcas are also known as 'killer whales' and referred to as the 'wolves of the sea' due to their tendency to hunt as a pack. Some eat exclusively fish, others hunt marine mammals such as seals, other dolphin and whale species.

Adult orcas range from 5 to 8 metres (16 to 26 feet) in length and can weigh up to 6 tonnes (6 tons). The males, which are much bigger than the females, can easily be distinguished by their huge sail-like dorsal fin, up to 1.8 metres (6 feet) in height.

Orcas are very social animals, living all their lives in tight-knit family groups, so that you rarely see them on their own. They exhibit a huge range of behaviours, including socialising in pods, spy-hopping, tail-lobbing, strand-hunting and breaching. All this, together with their distinctive colouration and markings, makes them highly photogenic creatures. And with the right sea and light conditions, orca-watching should result in plentiful opportunities for photographs of the animals in the context of their beautiful environment.

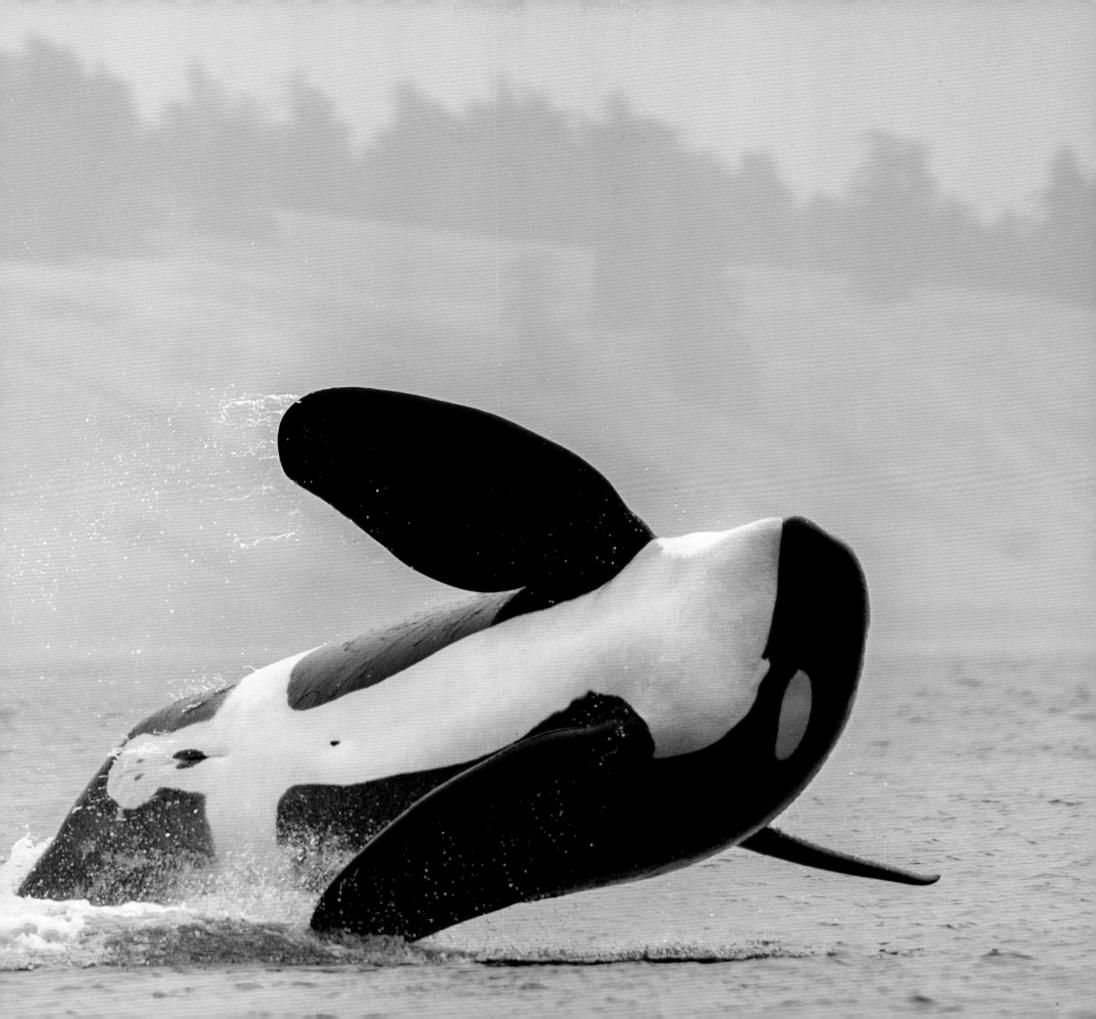

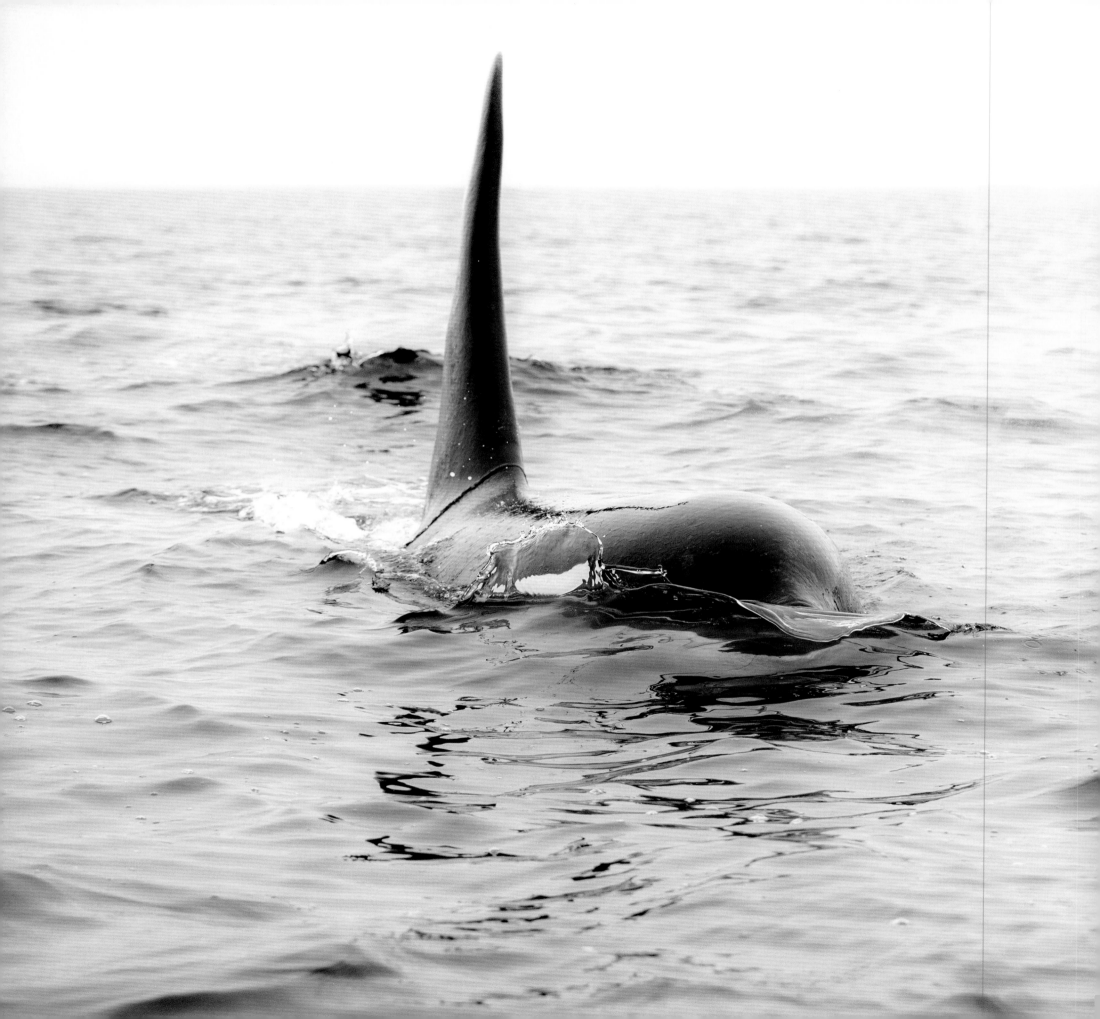

Getting in gear

It's a beautiful day here at Sidney-by-the-Sea on British Columbia's Vancouver Island. Tourists are wandering back and forth along the seafront promenade wearing T-shirts and shorts, enjoying the late summer sunshine. Motor boats are whizzing along the shoreline. The cafes are buzzing, their customers sitting under shady umbrellas sipping cold drinks and latte coffees. We are in a slightly stuffy shopping arcade, trying on clothes.

Today is the first day of our six-day visit to see orcas. The Salish Sea — the waters between Canada's Vancouver Island and Washington State, USA — is famous for its orca populations. There are different and separate types of orca society: 'residents', as the name suggests, stay in one area and feed on fish, while 'transients' range wider, hunting marine mammals. Here there are three large pods of 'resident' orcas, numbering nearly eighty individuals in total, and numerous much smaller pods of 'transient' orcas, feeding on prey such as harbour seals and dolphins.

We plan to spend up to ten hours each day out on the water looking for photographic opportunities with these orcas. But firstly, we need to get ready. The regulations stipulate that everyone on the boat must wear a total immersion suit, so I am now struggling to put on this rather cumbersome bright red article of clothing. The temperature today is forecast to peak at 28°C (82°F), and it feels warmer than that already in the arcade. Eventually, I am fully into the suit, getting hotter and hotter. Once everyone is similarly attired, we head out into the sunshine, and down towards the boat dock. Tourists stop to gape — on one of the hottest days of the year, we are certainly looking very silly!

Just over an hour after setting off, we've forgotten all about our sartorial struggles: a small pod of orca has been sighted by the skipper! My camera has been stashed on the deck in a safe spot under the seat in front of me, so I grab it and prepare for the first encounter of the trip.

Scanning the sea, I see a blow and then an orca surfaces just in front of us. Its dorsal fin is massive — a large male orca — the size of this apex predator is absolutely stunning! I move carefully to the side of the boat, steady myself against the rail, and take my first shot. ●

Left: Salish Sea, British Columbia, Canada
Nikon D5 + 80-400mm f4.5-5.6 lens at 90mm;
1/1600 sec at f6.3; ISO 2500

Title pages:
Salish Sea, British Columbia, Canada
Nikon D5 + 80-400mm f4.5-5.6 lens at 290mm;
1/1600 sec at f5.6; ISO 1250

Introduction Pages:
Salish Sea, British Columbia, Canada
Nikon D5 + 80-400mm f4.5-5.6 lens at 400mm;
1/2000 sec at f6.3; ISO 800

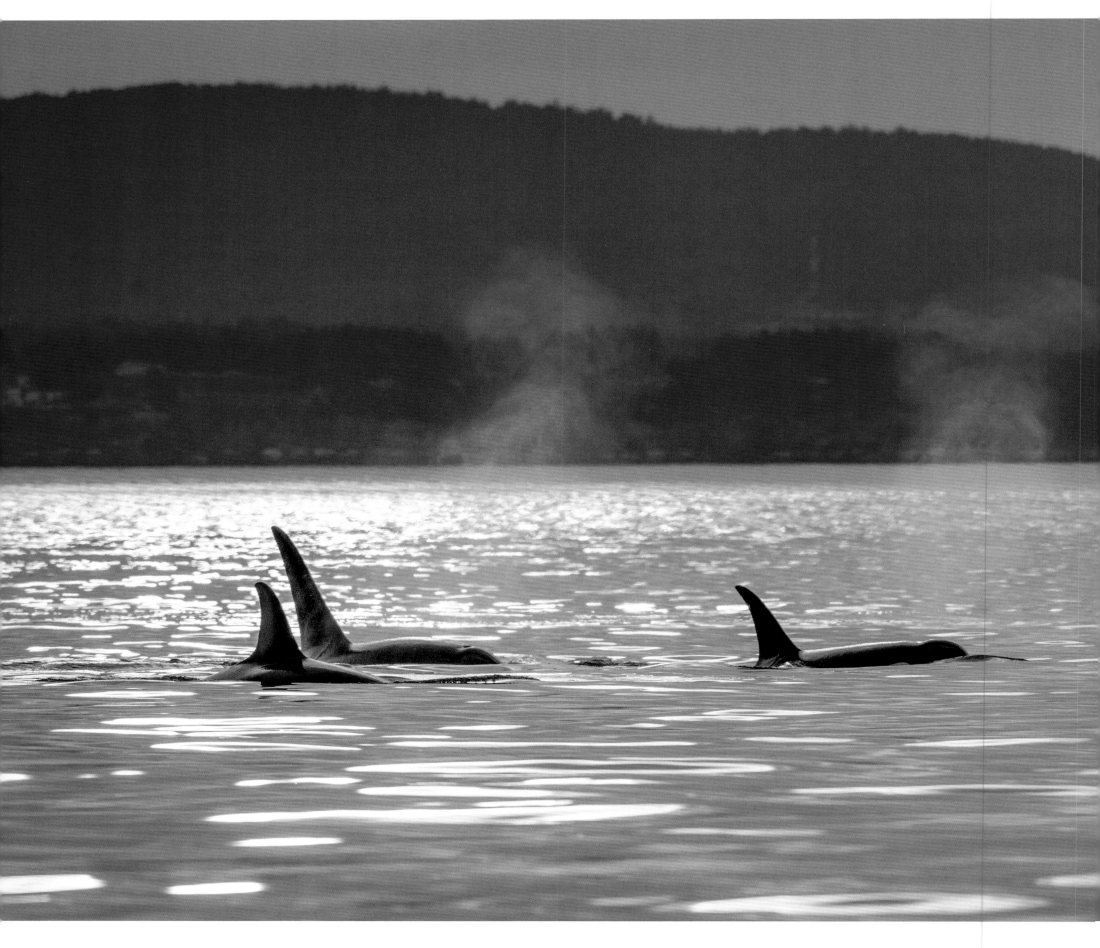

Meeting the residents

We have been out for a couple of hours, it's our second day, and things are a little slow. The boat captain is checking out all the regular spots, places where yesterday we had found a number of pods of transient orcas, but today it seems there's nothing. Buzzing around in this small open aluminium skiff, I'm actually glad we had to wear these immersion suits; whilst wearing them felt way too warm on land, here on the water travelling at speed, it is surprisingly cold.

The radio crackles to life. I can't tell what's said over the noise of the boat's engines, but it is clearly of interest, for the captain stops the boat to talk to us. Apparently, a megapod of orcas, 78 in total, has been seen travelling towards the area from the Pacific side of Vancouver Island. This megapod is comprised of all three pods of resident orcas together, coming in towards the Salish Sea, on one of their occasional forays looking for salmon in the river mouths. We are lucky as they haven't been seen here for over a month. It will take us about two hours to get to where they are, and the water in the open ocean will be quite choppy. Do we want to go? Well, yes, of course!

Crashing through the waves is pretty uncomfortable. First the boat pitches upwards, then smacks down into the next trough. On and on it goes. I am holding onto my seat, trying to stay in one place. Earlier, I had placed my camera on the floor so that it is firmly wedged between the side of the boat and my right foot, but now the crashing motion is so great I begin to worry about it getting damaged. So I pick it up, and now I am holding onto both camera and seat as best as I can, just waiting for us to arrive. Hoping it won't take much longer.

Eventually, in the distance we begin to see a number of boats, all in a line, coming towards us. We have found them! These are whale-watching boats, staying to the side of this massive group of orcas. The orcas are spread out over a huge area, probably two or three kilometres (one or two miles) in length and half a kilometre (quarter of a mile) wide. We travel with a number of sub-groups as they work their way into the Salish Sea. Once we leave the open ocean, the water is a lot calmer, making it much easier to take photos. The opportunities keep coming: orcas splashing, tail-lobbing, spy-hopping, all in nice groups together; there's an exuberant atmosphere, the orcas really seem to be enjoying themselves.

It's now been five hours since we caught up with the megapod, and they are reaching the channels between all the little islands. The sun is beginning to set, the sky is a beautiful orange, and the light is superb. We keep re-positioning the boat to get different angles, sometime with the light on the orcas, at others the sunset behind them. Altogether an amazing encounter, in superb conditions. ●

Left: Salish Sea, British Columbia, Canada
Nikon D5 + 200-500mm f5.6 lens at 390mm;
1/1600sec at f7.1; ISO 500

Right: A small group of transient orcas were passing by the headland and one stopped to 'spy hop'. We were in a boat about 100 metres (330 feet) away so it was probably having a look at us: a whale watching people whale watching! For me this photograph is all about the line of the wooded headland coming down and continuing in the sleek curve of the orca's back. You can't plan that, can't manoeuvre the boat to the right angle or anticipate where the whale will appear, but I'm always looking for opportunities and seized the moment. That alignment of orca and headland makes it for me.

Salish Sea, British Columbia, Canada
Nikon D5 + 80-400mm f4.5-5.6 lens at 400mm;
1/1600 sec at f6.3; ISO 2000

**Photographic tip
Keep flexible**

A zoom lens is the best way to operate on a small boat. Because the action can often be quite quick, a zoom gives you flexibility to quickly frame the shot, alter the composition, go in tight or zoom out to capture the animal in its environment. You could use two cameras with different lenses, but I find that switching cameras quickly on a small boat doesn't really work. You need a safe place to stash the spare camera, where it won't slip loose with the boat's movement, and where it won't be trodden on or knocked by other passengers. It will often take a while to work your way across to this spot, grab the spare camera and safely stash the other, by which time the action is all over!

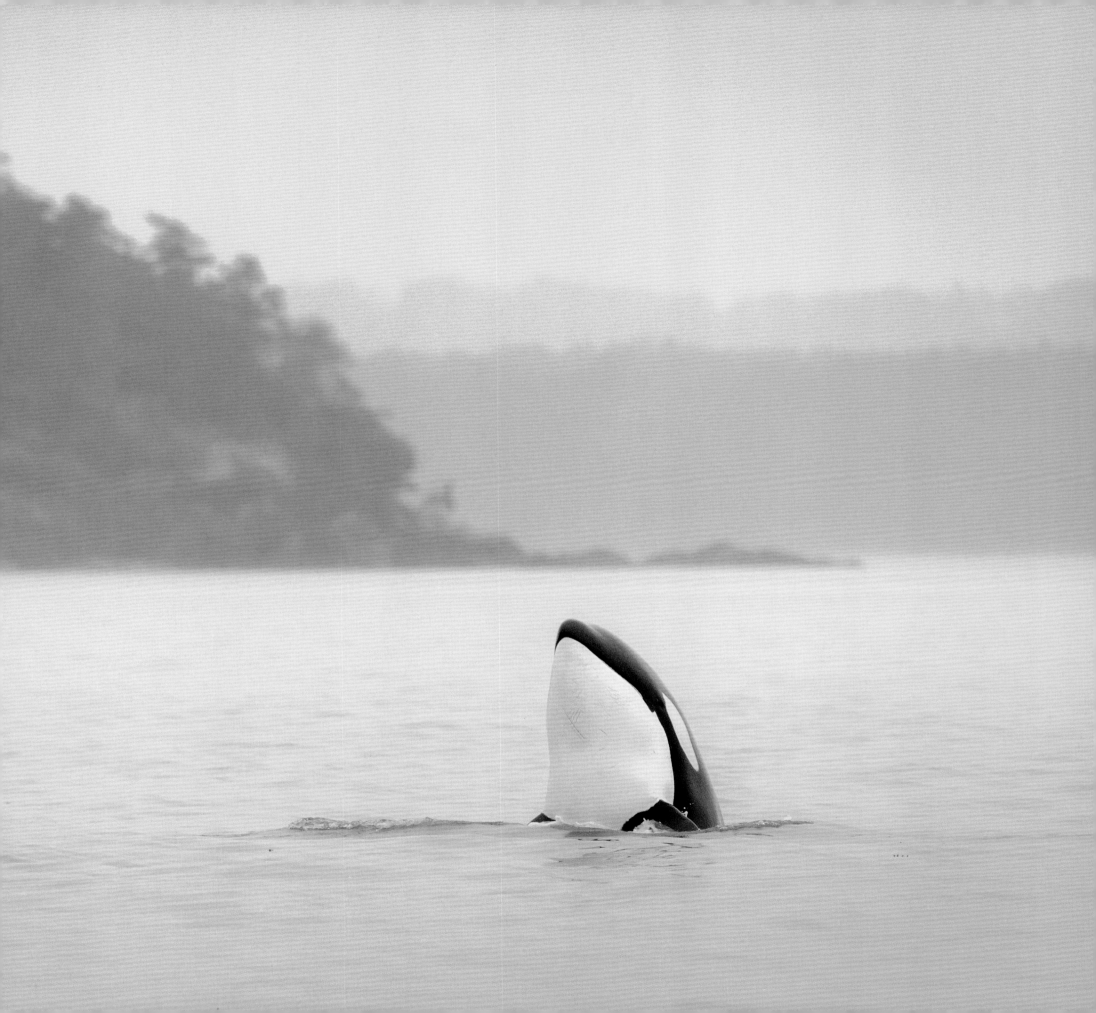

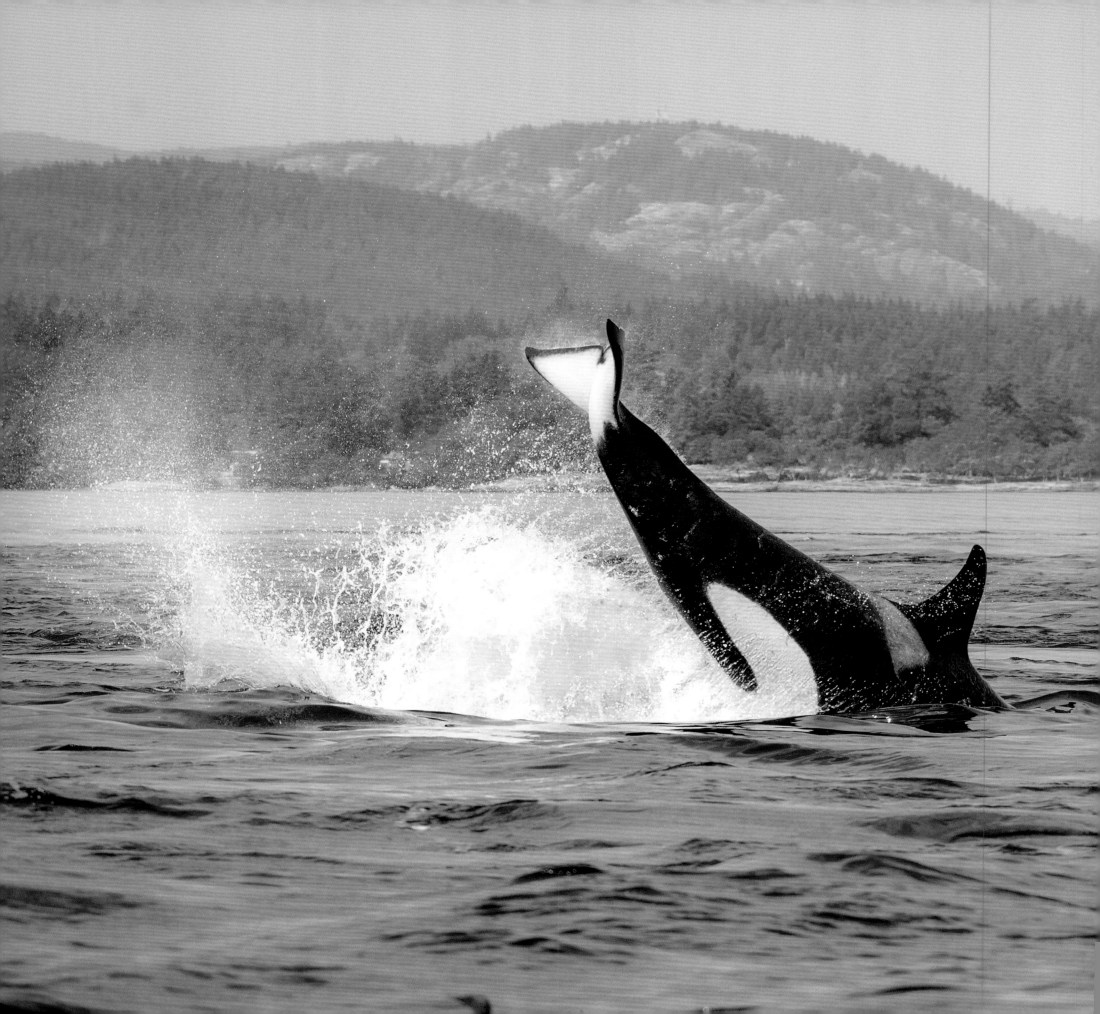

Left: 'Lob-tailing', also known as tail slapping, involves lifting tail flukes out of the water and bringing them down hard on the water's surface, making a loud slap! It sounds pretty loud even from the boat, and carries far underwater. There were 78 resident orcas coming in, dotted around in separate groups, but there was a great sense of communication going on, with acrobatic movements and frequent tail slaps. Sometimes they would repeat this behaviour 10 or 15 times, so we could reposition the boat to get the best angle to capture it: much easier to photograph than a sudden, single breach!

Salish Sea, British Columbia, Canada
Nikon D5 + 200-500mm f5.6 lens at 220mm;
1/2500 sec at f7.1; ISO 450

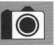

Photographic tip
Don't be greedy

I find it is very easy to be 'over-lensed' when working from a small boat. A big zoom such as Nikon's 200-500mm may seem like an ideal choice, so that you can get tight in on more distant subjects. But just imagine, when hand-holding a long lens on a small boat bobbing around in the sea, trying to place the focus point with precision on a distant fast-moving orca that is disappearing in and out of the waves and swell! Not easy. Not only will you miss the focus on many occasions, but there is also motion blur to grapple with, sometimes in poor light conditions, when you can't push the shutter speed to fast enough levels. If you take too long a lens, there is a danger that when you get back on shore and start to look at what you hope will be prize-winning photos, many will be disappointing. The best choice is not to get too greedy but settle for a mid-range telephoto zoom lens such as an 80-400mm or a 100-400mm.

Previous spread: On the coast of British Columbia, a transient orca cruises along the shoreline, on a recce for future hunting. We chugged along behind, following its course, going in and out of rocky inlets. These harbour seals are safe on the rocks, but followed the movement of the orca with wary eyes. I liked the textures of rock, water, seal pelt and sleek dorsal fin — and the pervasive sense of menace. Every seal is watching that whale!

Salish Sea, British Columbia, Canada
Nikon D5 + 80-400mm f4.5-5.6 lens at 400mm;
1/1600 sec at f7.1; ISO 3600

Right: An adult South American sea lion just splashing about in the shallow water, as huge breakers rolled in. Every time a wave came, the sea lion would turn towards it, and then twist away at the very last moment before the wave broke. I was sitting on the beach close to the water line, and loved the sense of power and energy in the oncoming wave, with small stones thrown up into the air amidst the surging water.

Punte Norte, Peninsula Valdes, Argentina
Nikon D5 + 500mm f4 lens;
1/4000 sec at f5.6; ISO 160

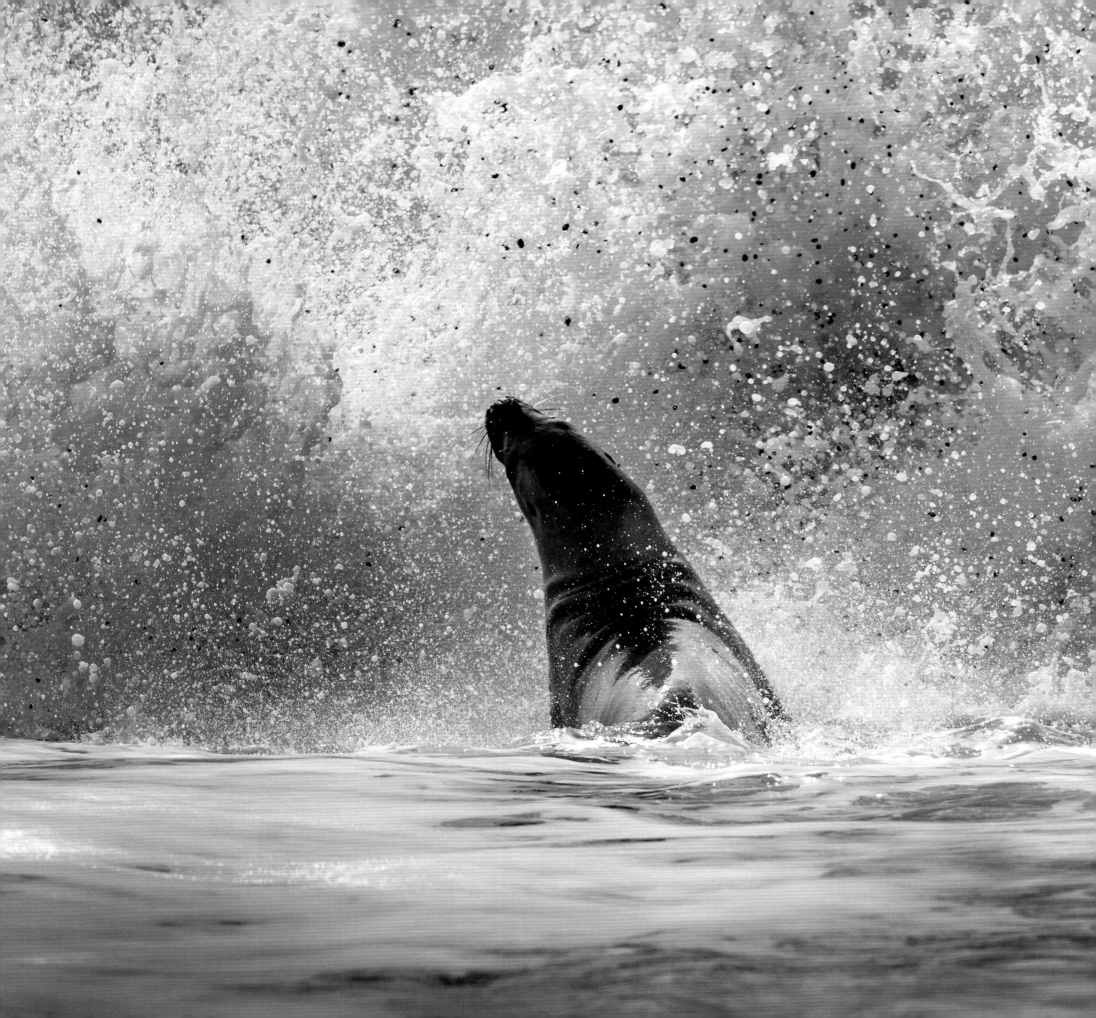

Above: Punte Norte, Peninsula Valdes, Argentina
Nikon D5 + 80-400mm f4.5-5.6 lens at 135mm;
1/800 sec at f6.3; ISO 5000

Beach holiday

It's 7:45am and I am sitting on the beach gazing out to sea. This is my third day sitting on the beach here. These are uncomfortable beaches, as they slope quite steeply and comprise lots of small round slippery pebbles. And as it is early in the day and late into the autumn, it's a very cold beach, so I'm wearing an insulated jacket and insulated trousers. I'm not here to sunbathe!

At breakfast today Juan, the guide, had said that because the wind had changed direction overnight, we needed to go to a different beach. We are staying in the lodge at Estancia la Ernestina, a huge sheep ranch owned by Juan and his family, at Punte Norte on the Peninsula Valdes in Argentine Patagonia. Sitting on the beach the previous two days, all day, we had seen loads of sea lions and some distant orca, but we had not been fortunate enough to see what we had come all this way to see.

After driving a short distance from the ranch, we had parked the Land Rovers up on the dirt track and then trekked for twenty minutes to this beach. When we arrived, Juan had surveyed the long beach, looked at the sea and wind conditions and after due consideration had chosen this spot as the best place. He positioned our group of eleven wildlife photographers in a line, up the slope. I'm nearest to the ocean, which is about 10 metres (33 feet) away. As the tide comes in, we will progressively need to move back, so when I move I will go all the way to the back of the line. But right now, I'm feeling lucky to be at the front, right beside the sea.

There is a colony of South American sea lions a bit further along the shore, lounging well up on the beach, safely back from the water. I have only just set up my tripod and camera, when I notice a couple of young pups waddling down towards the surf. They stop on the shoreline just in front of where I am sitting. Now they are playing in the water, a foolish thing to do, but they are too young to know.

It's a long way off, but we all can clearly see a sail-like fin approaching. When it comes closer to shore, even the pups can see it, but they take no notice. The water is such fun! This big male orca is gradually coming in towards the shore. He's clearly an expert, judging the very best moment, watching and sensing the waves and the pups, taking his time. The pups are swimming in the shallows. A few minutes pass. Suddenly, with the full thrust of his tail fluke, this massive predator comes hurtling in and up onto the beach. He grabs one of the pups. The pup gasps as the orca's teeth make contact, it flails upwards, and within a fraction of a second, it is fully grasped by the jaws. As the huge orca wriggles on the pebbles, trying to leave the beach, the other pup watches as if bemused, without any apparent fear or understanding. Now both orca and pup have gone. The attack has taken just thirty seconds.

It was all so close, I had to quickly zoom right out to capture everything. And all so quick — minutes after we'd arrived at the beach. Did I get it? Feverishly, I check through my images. Yes! ●

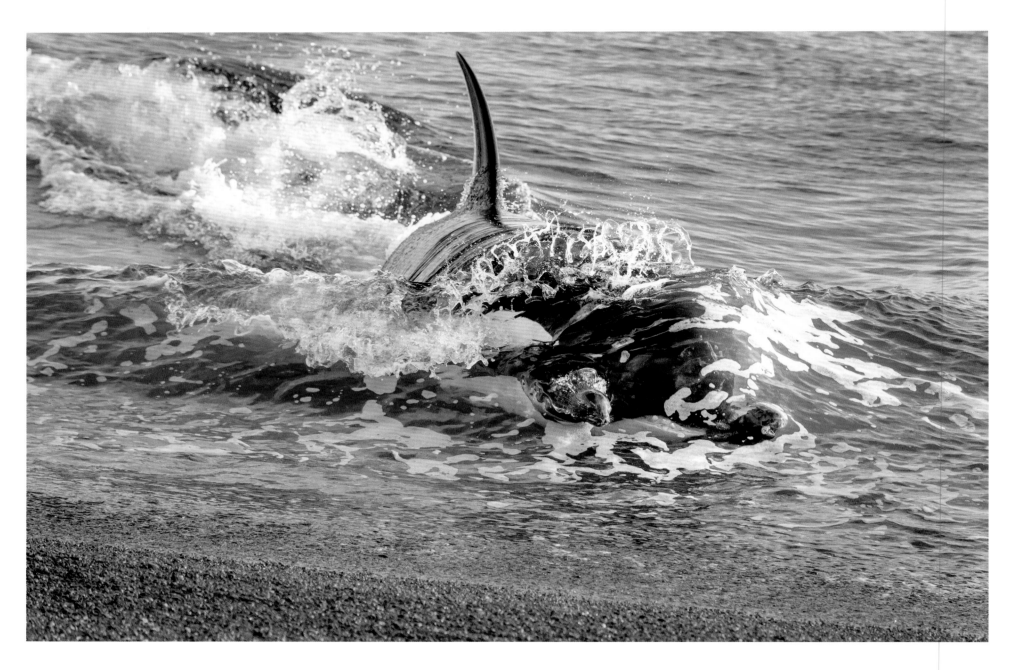

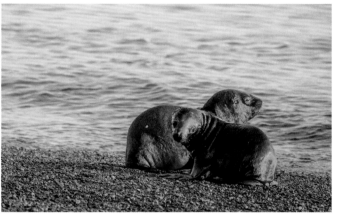

Above: The moment of capture: a surge and sense of power as the orca reaches the beach. It's not swimming here, but pushing itself forward with a powerful thrust.

Punte Norte, Peninsula Valdes, Argentina
Nikon D5 + 80-400mm f4.5-5.6 lens at 210mm;
1/1000 sec at f8; ISO 5600

Left: Golden light from the rising sun hit these young sea lion pups on the beach, just moments before the orca launched itself into the shallows and snatched one.

Punte Norte, Peninsula Valdes, Argentina
Nikon D5 + 80-400mm f4.5-5.6 lens at 370mm;
1/800 sec at f5.6; ISO 2800

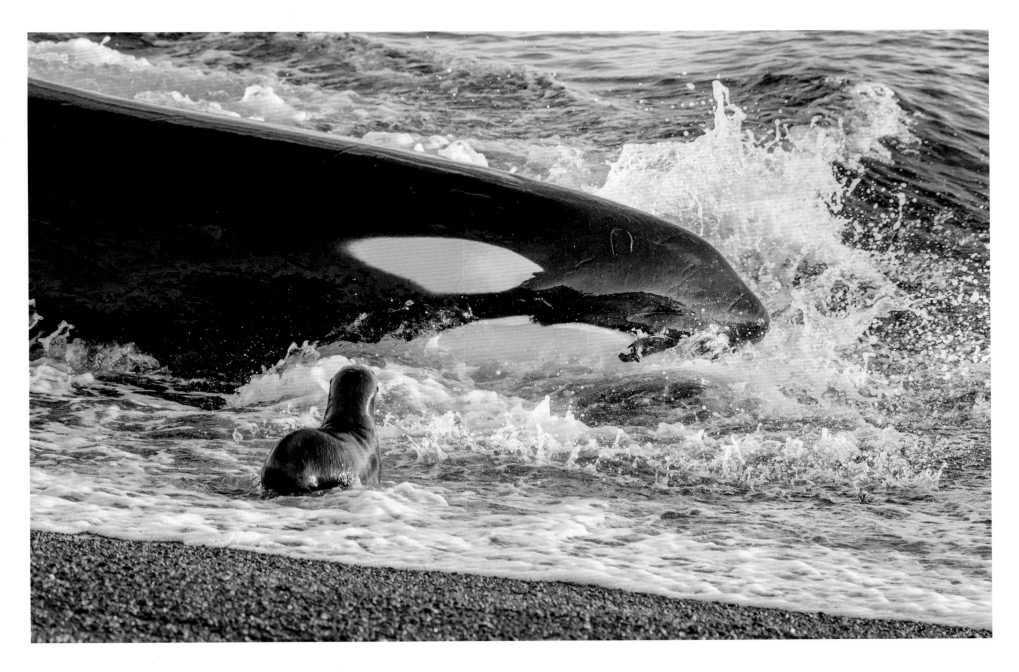

Above: As the orca manoeuvres itself back into the water, I could see the flipper of the sea lion pup in its mouth. Its little friend looked on and still seemed oblivious of the danger. The whole event happened so fast, and so close, I was struggling to fit all the action into the frame!

Punte Norte, Peninsula Valdes, Argentina
Nikon D5 + 80-400mm f4.5-5.6 lens at 210mm;
1/1000 sec at f8; ISO 3600

Planning your ultimate orca safari

Where to go and when to visit?

Orcas are widely distributed throughout the world's oceans, so the issue of where to go and photograph them is really more about accessibility.

Firstly, for general orca photography, most of the photographs in this chapter were taken in the Salish Sea, in Canadian British Columbia. Two types of orca are regularly seen here — 'residents', which feed on fish, mainly salmon, and 'transients', which feed on marine mammals such as harbour seals. Whilst the transients are currently doing relatively well, there are serious concerns for the resident orca, whose numbers are dropping year by year. There are many possible causes, including shortage of salmon (from overfishing) and disturbance from shipping. To try to improve the situation, strict new regulations were introduced in May 2019, specifying a minimum distance of 400 metres (440 yards) from orca for all ships, although whale-watching operators have a dispensation and are allowed within 200 metres (220 yards) of 'transient' orca. The aim of these regulations is laudable, and hopefully general whale-watching visitors will still have the thrill and enjoyment of seeing these magnificent animals. However, for photography, this distance is a real challenge, and therefore it may be worthwhile looking at other locations. This is an example of how circumstances can change at any time, making it important to check all information is current when planning a trip.

Fortunately, there are many relatively accessible locations around the world for orca photography. In Europe these include Iceland (Grundarfjordur - January to March), Norway (Vesteralen and Troms November to February), and the UK's Shetland Islands (all year round, but best in June and July). In North America, in addition to the Salish Sea and adjacent areas such as the San Juan Islands and Johnstone Strait, orcas are regularly seen on whale watching trips in south-east Alaska and off the Californian coast.

A word of caution: orca follow their prey species, and with some prey such as herring, the location of their annual migration changes over time. So before booking a trip it is particularly important to check that the location you are considering is still an orca hotspot.

Then we have the sensational intentional stranding behaviour, which is only seen in a very limited number of places in the whole world. This is where the orca emerges almost totally out of the sea to grab a young sea lion pup from shallow water. It is a learned behaviour passed down from generation to generation. Punta Norte on Argentina's Peninsula Valdes is the only relatively accessible location with regular sightings of this amazing phenomenon. Here the steeply sloping

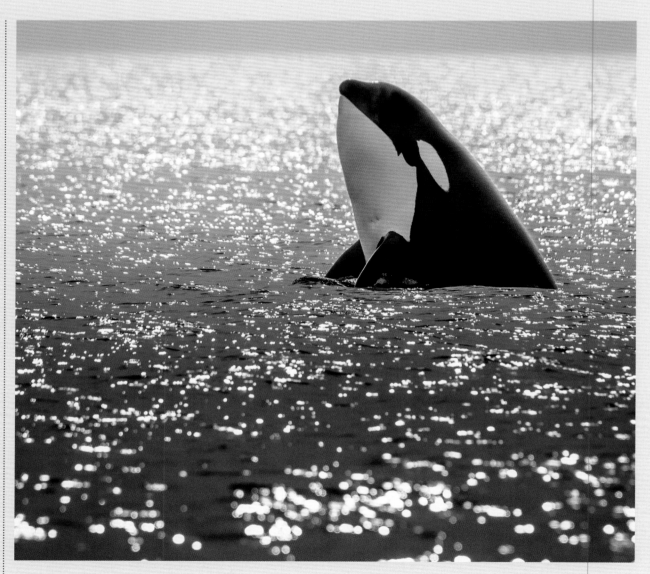

beaches comprising small round pebbles help the orca to wriggle its way back into the ocean without getting completely stranded.

There is a public viewing area at Punta Norte, which overlooks one of the main areas where orcas are regularly seen. Whilst it is possible to see and photograph orcas hunting from this location, in my opinion a much better option is to stay on Estancia la Ernestina, the ranch that owns the surrounding beaches. The best locations on any given day are determined by tides and wind direction, and because this ranch has about ten miles of beaches to select from, this flexibility increases your chances of observing this rare behaviour.

The season is quite short, determined largely by the breeding cycle of the sea lions, and lasts from late February to late April, with the peak period being mid-March to early April.

Ultimate Orca Safari

For my general 'Ultimate Orca Safari', I was based in Sidney-by-the-Sea. In September we spent six full days travelling out on a small aluminium skiff on a small group holiday run by Mark Carwardine Adventures.

For the specialised safari, I travelled on a group tour in the second week of April operated by the UK-based photo tour operators Natures Images. We stayed for seven nights at Estancia la Ernestina, visiting the beaches of Punta Norte every day, guided by the owner and cetacean expert Juan Copello.

Recommendation summary

General Orca photography

Location: In Europe, Norway or Iceland; in North America, Alaska or California.

Duration: 3-4 days

How to book: The best way is to find a specialist photographic tour operator offering a dedicated orca trip. Regrettably these are quite rare, so it is worth notifying key operators of your interest. Alternatively, talk to a specialist wildlife travel agency, explaining exactly what you are wanting to achieve. In the absence of a specialised orca trip, in South East Alaska and Canada's Inside Passage, a live-aboard small boat would work well for a more general wildlife trip, combining orca with other animals such as humpback whales and bears.

Orcas hunting sea lions

Location: Estancia la Ernestina, Punte Norte, Peninsula Valdes, Argentina

Best time to visit: mid-March to early April

Getting there: Fly via Buenos Aires to either Puerto Madryn or Trelew. Then transfer by road to the ranch (4-6 hours)

Access: Daily visits to the beaches

Duration: 7 days

How to book: There are three options; book directly with the Estancia through their website, book through a specialist wildlife travel agent, or join a small group photographic tour.

Elephant seal pup

Southern rockhopper penguin

What else might I see?

Alongside the sea lions on the beaches of Peninsula Valdes there are groups of southern elephant seals with young pups. Magellanic penguins have large nesting sites behind the beach and if you are lucky, you may see the occasional southern rockhopper penguin.

Chimpanzee

Primates are interesting but demanding subjects to photograph. You generally have to work quite hard compositionally to engage the viewer. But unlike most genres of wildlife photography, with primates there are similarities to portrait photography of humans. Particularly with the great apes (gorillas, bonobos, orangutans and chimpanzees), these similarities come to the fore. Studying these animals close up reveals so many parallels with ourselves — facial expressions, hand movements, social interactions and more.

Chimpanzees are one of the most charismatic primates. They are native to the forests and grasslands of tropical Africa, and can be found in 21 countries, most of which are in central Africa. There are thought to have been about a million chimpanzees in the early 1900s, but today's population is estimated at 170,000 to 300,000 and they are listed as 'Endangered' on the IUCN Red List of Threatened Species. Although legally protected in most of their current range, chimpanzees are still a common target for poachers as bushmeat, with infants sold to the local pet trade and the international wildlife trade.

Chimps have coarse black hair, but it is their bare faces, fingers, palms, toes and soles of feet that make them so photogenic for portrait-type shots. It is not surprising that they have so many human-like features and characteristics, as humans and chimps share 98 per cent of the same DNA. They live in groups of between 15 and 150 individuals. Their society is a male-dominated strict hierarchy, with plenty of social interactions and demonstrative behaviours that offer stunning raw material for photography.

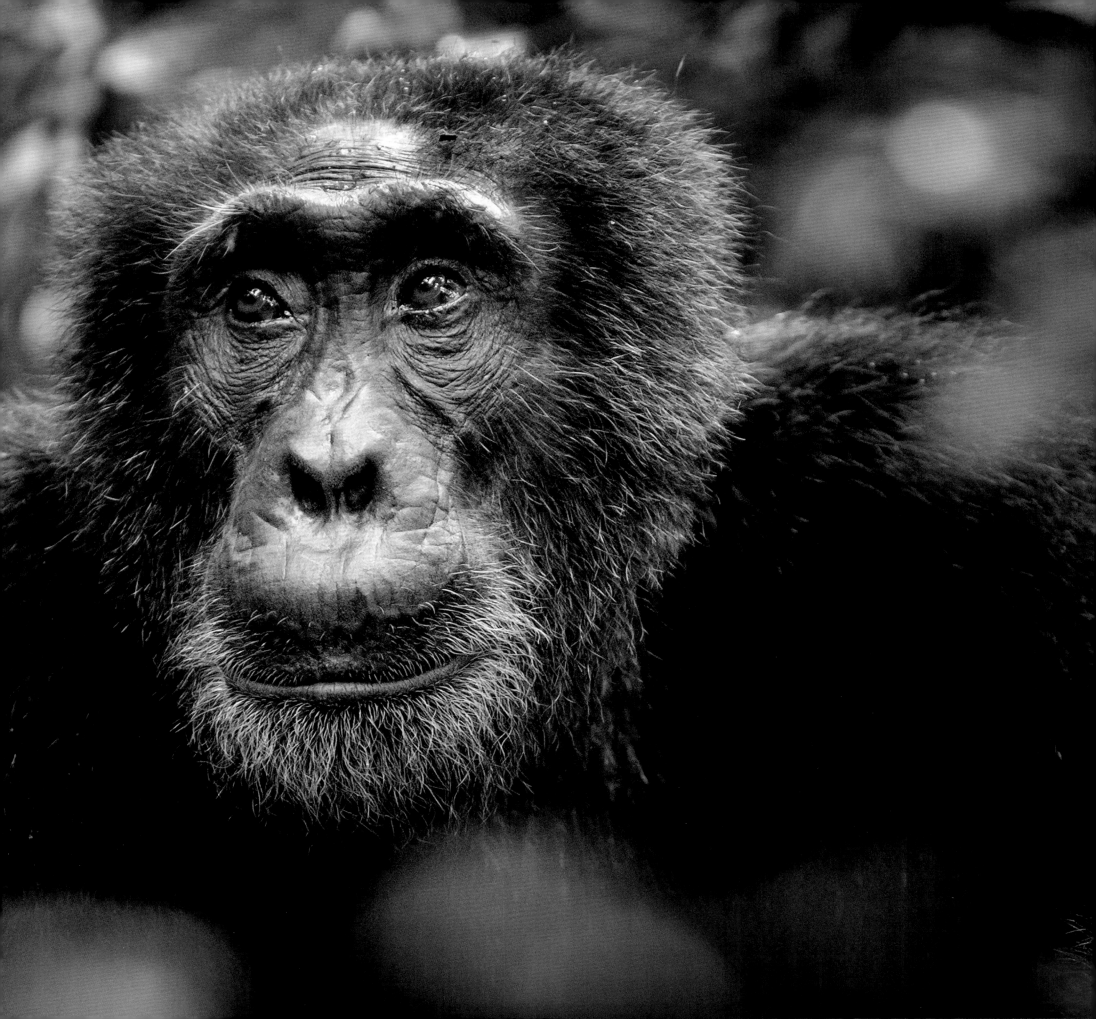

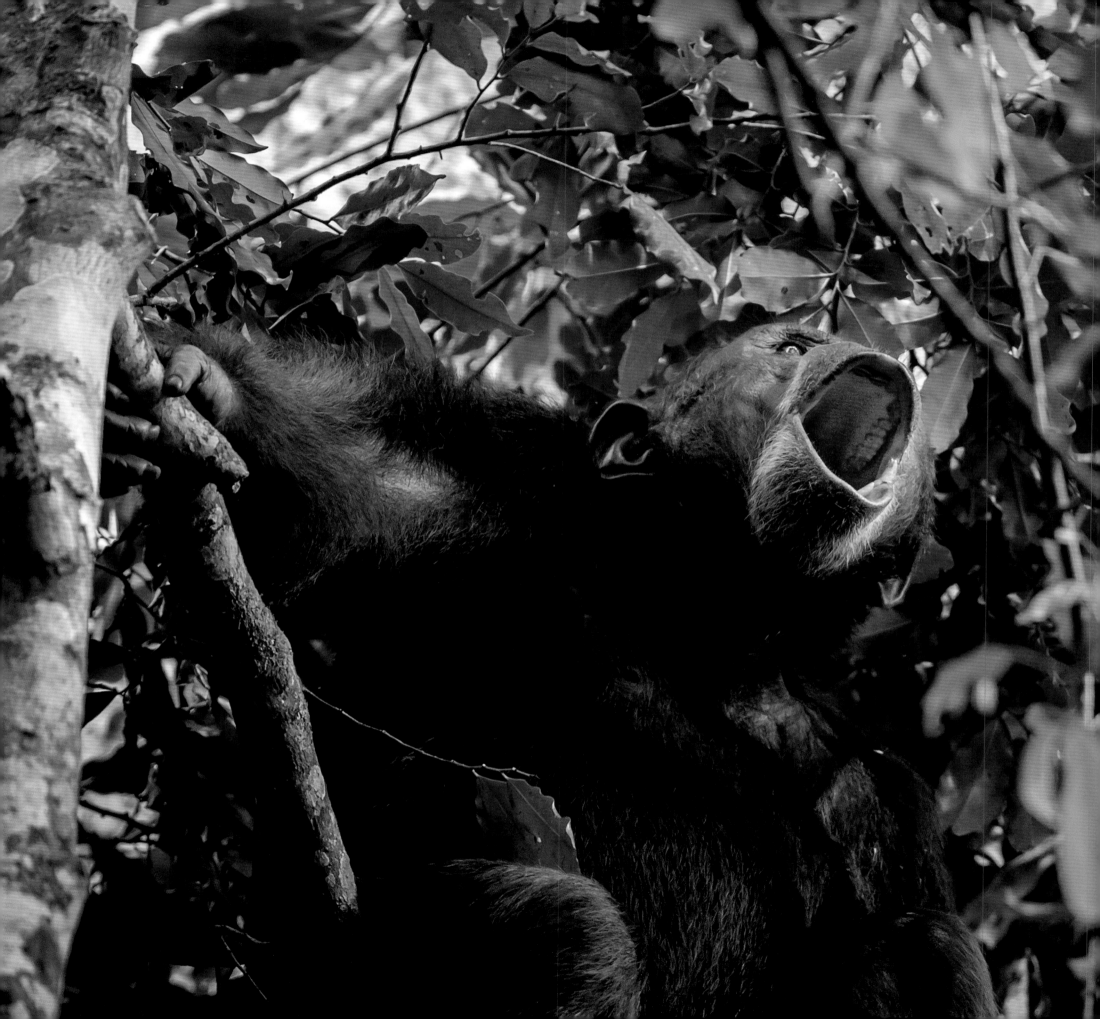

A deafening cacophony of screeches and whoops

Above the dense trees of the tropical rainforest, pale dawn light is just beginning to show in the sky. I am very excited — today I hope to see my first wild chimpanzees. I have just arrived at the ranger station, which is located next to one of the gates to Kibale National Park. I sign the register — writing in the column headed 'Activity' the abbreviation CHEX: 'Chimpanzee Habituation Experience'. There are five guests on today's CHEX expedition, together with a park ranger. I request a porter to carry my heavy camera backpack. It will be a long and arduous day, and I want to take all the gear I might need but carrying it as I scramble around trying to photograph will be a struggle. I also think it important to provide work for the local porters. There are a number of them here, waiting and hoping to be hired and earn a day's pay — this is ecotourism at the grass roots.

In the briefing room the guide explains how the day's activities will work. She says that we will walk directly from here into the jungle, and it will be very wet, muddy and slippery. Take care! The community of chimpanzees we hope to find are 'semi-habituated'. This means that they are in the process of slowly becoming used to humans on the forest floor, but they may at times be a little skittish. CHEX is a first step in gaining the trust of a chimpanzee community. The plan is that once they are fully habituated, it will be possible for regular tourists to visit them, as happens with some chimp communities in other parts of the Park. She also gives a word of caution. The chimpanzees will occasionally be very vocal, but we should under no circumstances attempt to mimic them. As we don't know what they are saying, repeating it back to them would be foolish, potentially even dangerous.

With the briefing over, we head off down a dirt track, across the main road, and into the forest. Our ranger guide is carrying an old rifle, just in case. There are buffaloes and elephants in the Park, and although we are unlikely to see them, the rangers always carry a rifle when escorting visitors. I hope it won't be needed, and I am sure it would be only used as a last resort in an encounter that had gone badly wrong.　　▶

Left: Kibale National Park, Uganda
Nikon D5 + 180-400mm f4 lens at 330mm; 1/400 sec at f4; ISO 2500

Title pages:
Kibale National Park, Uganda
Nikon D5 + 70-200mm f2.8 lens at 160mm; 1/500 sec at f4; ISO 5600

Introduction pages:
Kibale National Park, Uganda
Nikon D5 + 70-200mm f2.8 lens at 200mm; 1/320 sec at f2.8; ISO 3600

▶ We are crossing a swamp on a narrow boardwalk, which although quite slippery, is surprisingly easy going. My surprise at finding that there is a boardwalk in the jungle is short-lived, as it only lasts for about 100 metres (330 feet). Then we dive into the forest proper, clambering over fallen trees, ducking under low branches and snaking through the dense undergrowth. This is what I'd expected! The ranger is frequently stopping, listening for sounds of the chimpanzees, but to no avail. We walk on and on.

It's three hours into our muddy hike, nearly 10am, when we spot our first chimpanzees. High up in the canopy we can just make out a mother with a youngster, but they take fright at the sight of us and scramble away through the high branches and out of sight. No time to take a photo — this is going to be difficult. Our ranger explains that as these two were detached from the main group, they would have probably felt uneasy with us down below.

We carry on for a while, hearing sounds of chimpanzees but not able to see them. Suddenly there is a deafening cacophony of screeches and whoops, echoing through the jungle. It is the amazing, awe-inspiring sound of wild chimpanzees communicating with each other across the tree tops. It rolls through the forest like a wave. We have found the main group!

They seem a little wary of us, but not overly so. They are mostly high up in the canopy, and with all the leaves and branches, and then the bright sky behind, photographing them is next to impossible. But here's one down at a lower level. I clamber through the undergrowth, manoeuvring to get a relatively clear shot. I need to get a sightline through the branches, but from a side angle, not directly below. Frustrating in a way, as to get a decent camera angle, I need to move further away. Eventually one position works: just as the chimps start another round of whooping, I get my first useful shot. ●

Organisation tip
Visit in the rainy season

It might seem a strange recommendation, but the best time to visit is in the rainy season. Overcast skies are much better for photography of black furry animals than bright sunshine. There are two further benefits of visiting in the rainy season: tourist numbers are much lower, and so are permit and accommodation prices!

Right: Kibale National Park, Uganda
Nikon D5 + 70-200mm f2.8 lens at 200mm;
1/500 sec at f4; ISO 7200

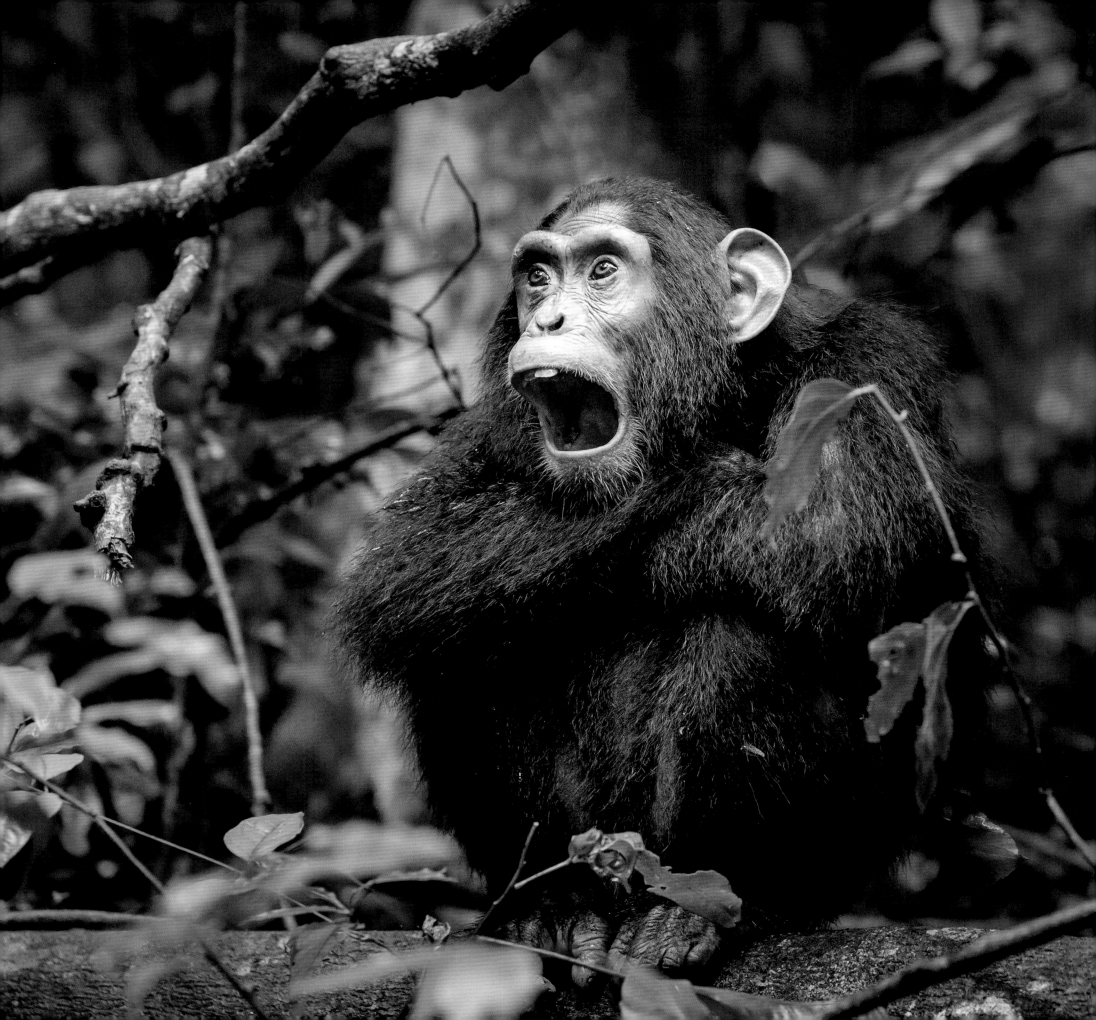

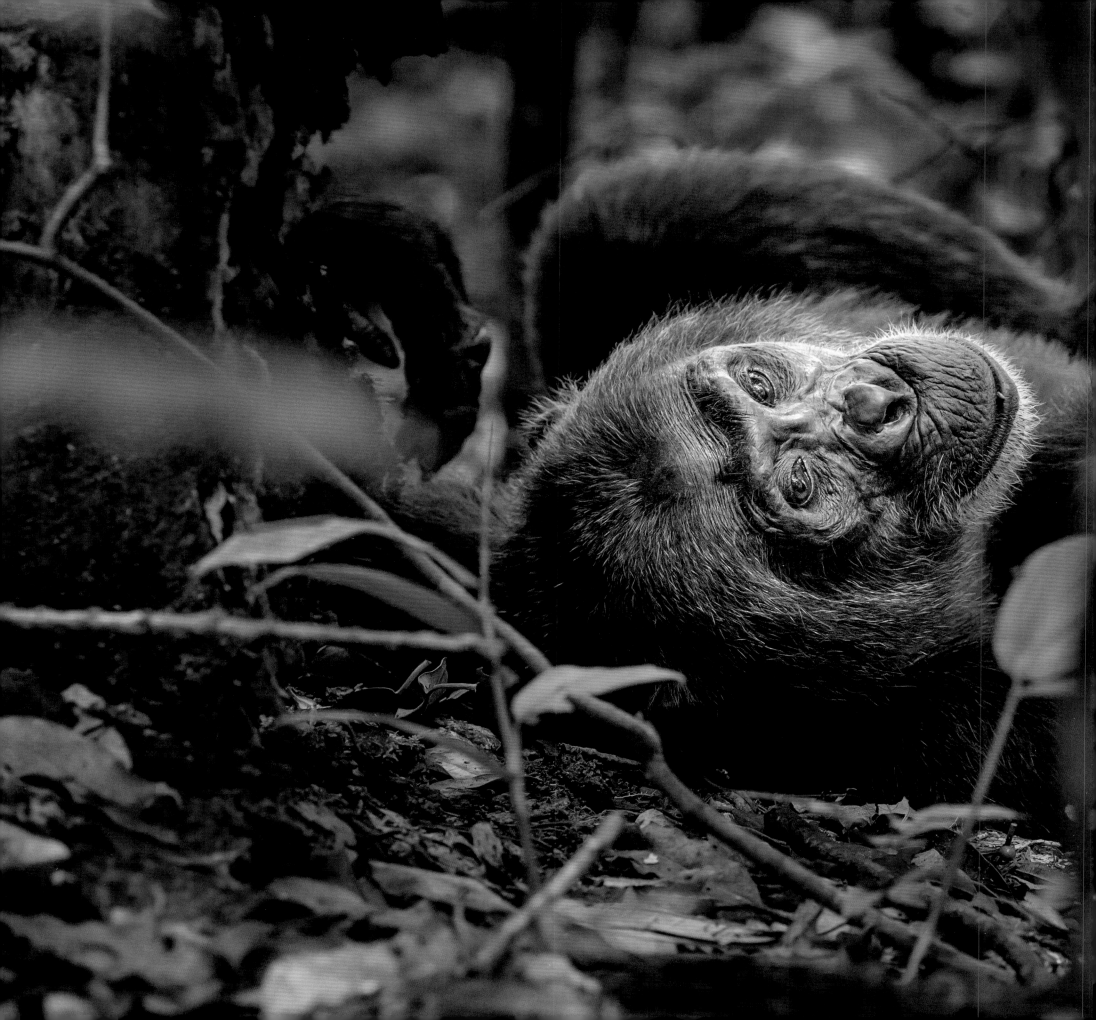

The sky is slate grey, almost black

Rain is pouring down the back of my neck. I shuffle tighter into our huddled group to try to get some shelter. The sky is slate grey, almost black, the forest is dark and feels closed in around us. Flashes of lightning. Thunder crashing overhead. Our ranger has strung a flimsy plastic sheet between two trees, and our little group is sheltering underneath it. Rain keeps building up its sagging folds, before pouring off in random directions. We are trying, but failing, to keep dry. This is a dramatic ending to our day — a thunderstorm in a tropical rainforest!

As I wait for the downpour to end, I muse to myself over the decision to come here in November. It was a conscious choice to visit at this time of year, during Uganda's short rainy season. Photographing furry black animals in bright sunshine was never going to give good results. Even down on the forest floor, shafts of harsh light get through, and backgrounds are full of distracting highlights. Although it's possible to try and work around this situation to some extent, generally those sorts of light conditions won't be good for chimpanzee photography. Much better and more consistent results come from the soft light of overcast skies. The aim is for nicely-lit black fur, with no distracting bright spots in the background, and the wet, green foliage of the jungle showing in beautifully saturated colours.

I had come prepared for lots of rain in this hot and humid jungle, a lightweight waterproof coat, waterproof over-trousers and rubber boots being essential. A waterproof camera bag or suitable rain cover for the bag, and a cover for the camera as well. After a bright and sunny start, the storm has brought my first day to a sudden and premature end. But it has been quite a day. My first wild chimpanzees, and a huge troop. A total of three exhausting hours following this very mobile group as best we could. The sights and sounds of those chimps will stay with me forever.

I got some nice shots along the way, but also a realisation that this is going to be a challenging animal to photograph: chimps are always moving and mostly very high up in the dense canopy. Tomorrow I will try the alternative option — called by the Park 'Chimpanzee Trekking' — this will be a visit to one of the habituated communities of chimps. Viewing time though is much shorter, generally restricted to one hour. When I have seen how this alternative works out photographically, I'll then have to make a big decision as to how best to approach the challenge on my remaining three days. ●

Left: Kibale National Park, Uganda
Nikon D5 + 70-200mm f2.8 lens at 170mm;
1/250 sec at f4; ISO 7200

'The president is being groomed'

In front of me, just a few metres (yards) away, two chimps are grooming each other. I circle around them to find the best angle. With the black fur of both animals, and their limbs intertwined, it's not easy to portray in an image what is going on. Eventually I settle on a spot and start to watch and photograph. The ranger says, 'The president is being groomed.' She explains that this is the alpha male of the chimp community being groomed by, and in turn grooming, another senior male.

The light today is by far the best we have had. The fourth day out of five in the jungle, and finally we have perfect conditions. Overcast skies, no rain, and just enough light to work with. This is what coming here in the rainy season is all about. And we have relaxed chimpanzees out of the high canopy, down on the forest floor. An habituated community that is completely ignoring us and getting on with their chimp business.

It's very easy to get stuck in one place. It's enthralling watching these two chimps grooming, all the time trying to photograph them with the best combination of hand and head positions. But I must remember to look around and see if anything else is going on. And thank goodness I do. Here on a nearby branch, only a couple of metres (6 feet) above the ground is a young chimp relaxing, and it is a beautiful sight. Again, I am moving around, trying to get a good line through the dense trees. Where is best to stand? Just in time I select a spot. He stretches out and yawns — nice! (See page 154).

Suddenly there are sounds and movements around me. The chimps are moving on. Rustling leaves in the undergrowth alert me just in time. I turn around as the alpha male on all fours walks straight towards me on the forest floor. He almost brushes me as he strolls past. A thrilling encounter. I'm so aware of how big and powerful they are when up close. These habituated chimps make for superb photography. With all the chimp action, and today's overcast skies and soft light, this is the best day yet. ●

Photographic tip
Don't keep chopping and changing lenses

Although I had a selection of lenses available in my backpack, I generally found it is better to stick to one lens for some time rather than constantly chopping and changing. For example, I used the long 500mm lens for quite some time and concentrated my efforts on tight portraits. Mostly I used the 70-200mm f/2.8: that's the perfect lens for this location. It's a fast lens for the low light conditions of the dense forest but gives a wider perspective than the 500mm, with the flexibility to zoom. For habituated groups of chimps, the range of 70-200mm is perfect for most situations. Additionally, every time you change a lens in the damp and humid rainforest, you run a risk of rain water or condensation damaging your gear.

Right: Kibale National Park, Uganda
Nikon D5 + 70-200mm f2.8 lens at 80mm;
1/250 sec at f4; ISO 5600

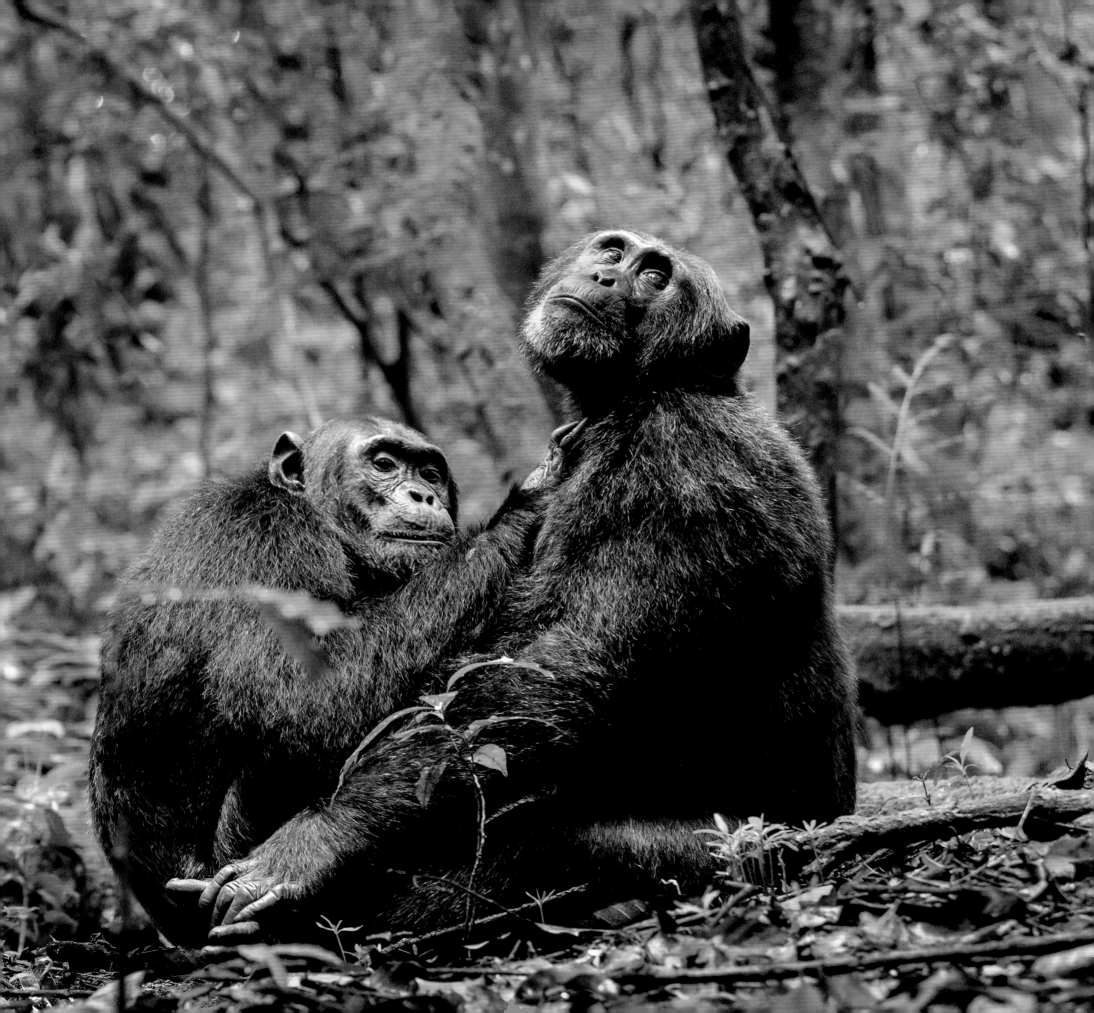

Photographic tip
Take a camera with a high ISO performance

There's no easy way around this one. The light levels in the forest are generally quite poor, and with the chimps almost always moving, you need to keep your shutter speed up, to freeze their movement. Even with a fast lens (say, f2.8), this may well result in uncomfortably high ISO settings. Ideally, you need a camera with excellent low noise at high ISOs, otherwise it's a struggle to get clean sharp photos.

Right: While I was watching the president being groomed, an elderly chimp was sitting a little further away, just watching the world go by. I noticed his white whiskers and intensely calm face — it's hard not to read human thoughts into it and think of him as wise. I got down low to be slightly below him. He was watching me but seemed totally unconcerned.

Kibale National Park, Uganda
Nikon D5 + 70-200mm f2.8 lens at 75mm;
1/320 sec at f3.2; ISO 3600

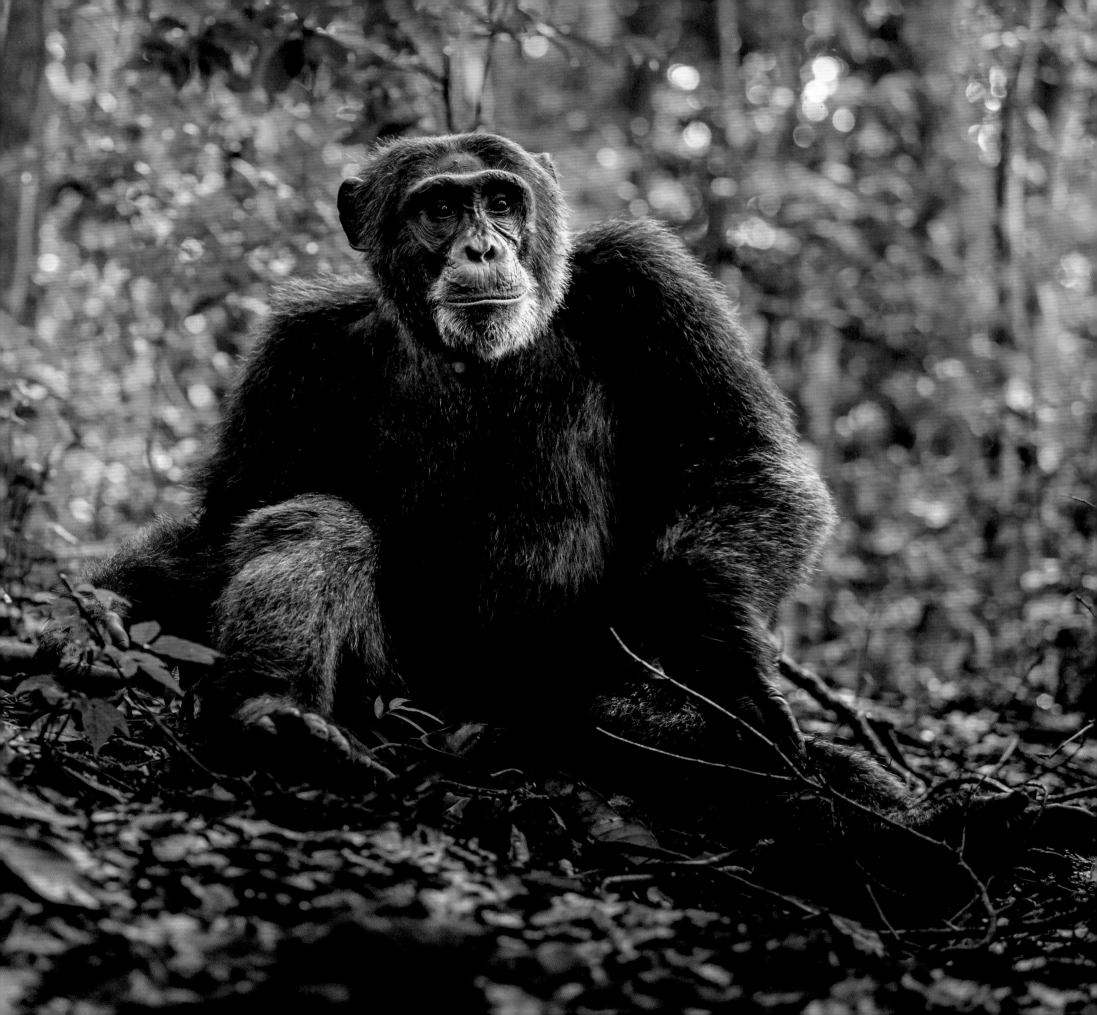

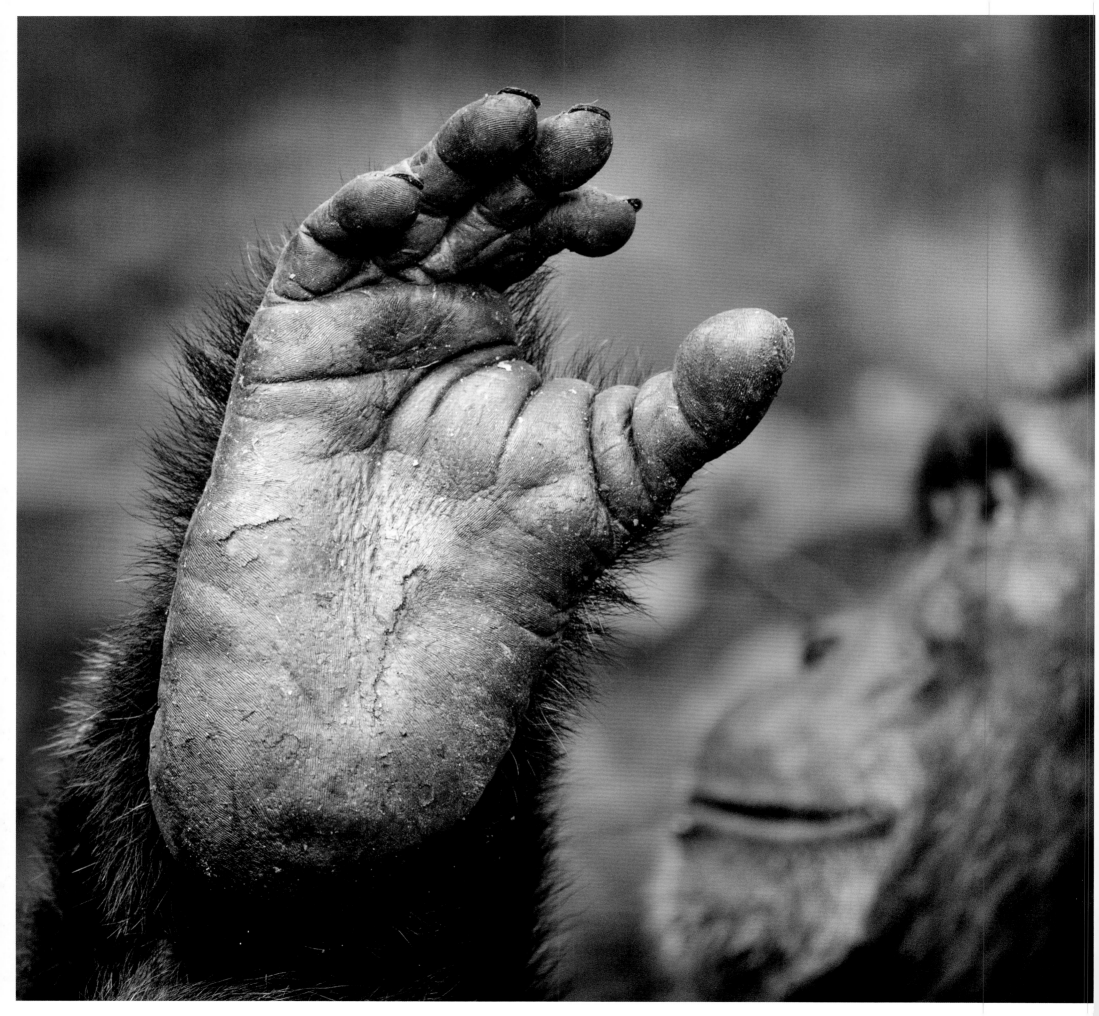

Left: This chimp was sitting on the ground having a stretch, revealing the details of its foot: the scars and scuffs on the sole and the thumb-like toe that equips it so well for its forest life.

Kibale National Park, Uganda
Nikon D5 + 500mm f5.6 lens; 1/100 sec at f5.6; ISO 4500

Right: I find the hands of chimps particularly special. They are so human-like, you can see immediately that they are such close relatives of ours. I wanted to emphasise this by isolating the hand from everything else.

Kibale National Park, Uganda
Nikon D5 + 70-200mm f2.8 lens at 200mm;
1/200 sec at f2.8; ISO 3200

**Photographic tip
Carry rain covers for
your gear**

It will almost certainly rain during your chimp safari, and it's likely the vegetation you are clambering through will be wet. Take a suitable rain cover for your camera and lens — one that's effective at keeping the whole combination dry, without impeding your operation of the camera.

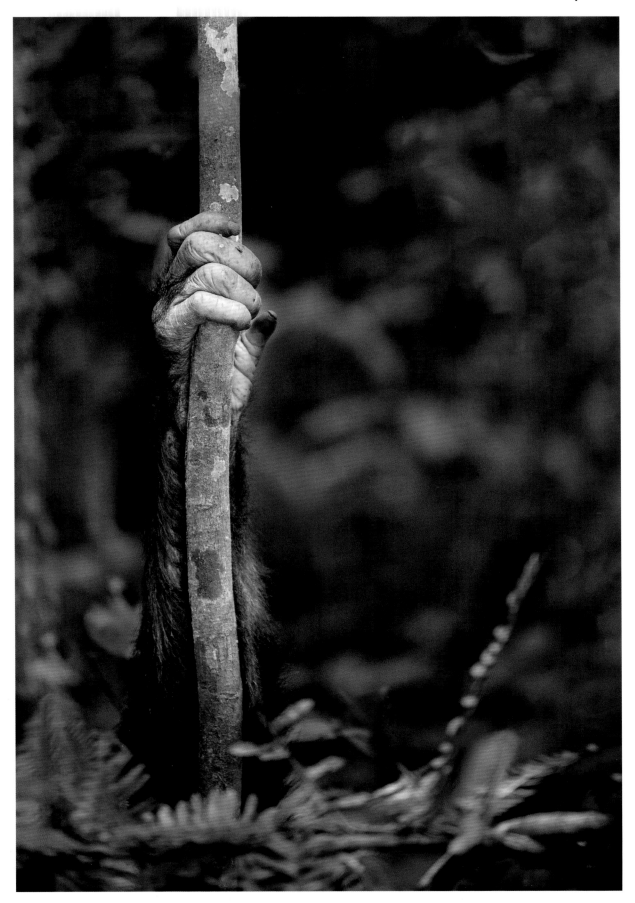

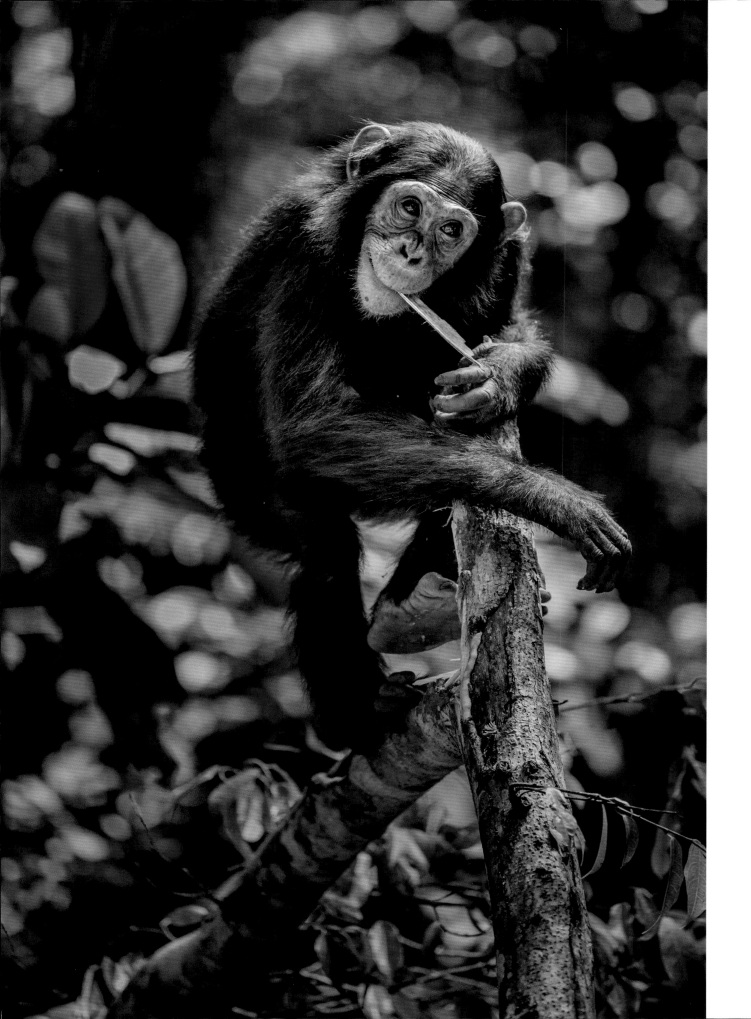

Left: These habituated chimps don't mind getting close. This youngster (the young chimps have pale faces) was playing with bark, only 5 metres (16 feet) away.

Kibale National Park, Uganda
Nikon D5 + 70-200mm f2.8 lens at 200mm;
1/1000 sec at f2.8; ISO 900

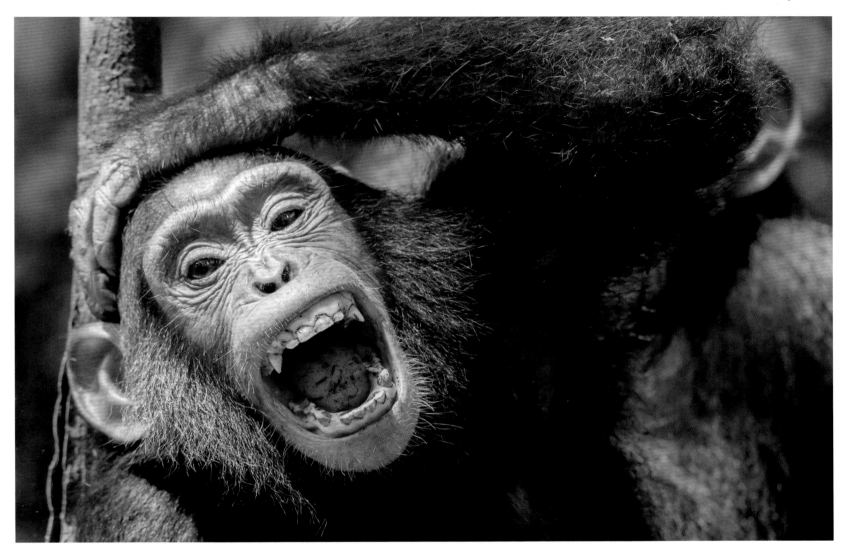

Above: It's both fun and a challenge to photograph young chimps at play. They're noisy and boisterous, often moving fast and you have to grab what you can when they pause — like this one, mid-scream (above), note the ear of its playmate behind!

Kibale National Park, Uganda
Nikon D5 + 500mm f5.6 lens;
1/500 sec at f5.6; ISO 14400

Photographic tip
Support matters

Method		
	●	Recommended
	○	Possible use
	●	Not recommended
Handheld	●	This is the main option. Good technique is required as light levels are low
Beanbag	●	Not suitable
Monopod	○	Can be an option, particularly if using a big telephoto lens, but it will to some extent restrict your ability to move quickly
Tripod	●	Not practical in the uneven terrain and with the fast-moving action

Planning your ultimate chimpanzee safari

Where to go?
Many chimpanzee communities are wary or even scared of humans, and so for a photographic safari it is essential to visit an habituated group, or at least one that is a semi-habituated, such as those in Tanzania and Uganda. I recommend Kibale National Park in southwestern Uganda. There are two different ways to see chimps in Kibale — 'Chimpanzee Habituation' (also referred to as CHEX)', and 'Chimpanzee Trekking'.

Kibale Chimpanzee Habituation Safari
Habituation is the process of getting the chimps used to having people around them, and to be comfortable when being tracked by visitors. The process takes a long time; it's about three years before an habituation group is ready for regular visits by groups of tourists. During habituation safaris, visitors are given much longer to spend with the chimps, typically about six hours, occasionally the whole day.

As described, these semi-habituated group are amazing to see, but very challenging to photograph. They spend most of the time high up in the tree canopy, often moving through it quickly. It is really difficult to get a clear view to take good shots as the animals are usually at substantial distances, silhouetted against the bright sky.

Kibale Chimpanzee Trekking Safari
On 'trekking safaris' you will go to see a group of chimps, who will be fully accustomed to human visitors. There are normally two trekking visits each day: morning and afternoon. The visit starts with a safety briefing by a park ranger, who explains how to behave in the Park. For safety reasons, children are not allowed. Six people, accompanied by two rangers, then head out into the Park. It generally takes about three hours in total, with one hour with the chimps. Photography is generally much easier, the chimps spending much of their time on or near the ground, and you are allowed to approach up to within 10 metres (33 feet). Often, they will choose to come much closer, clearly having not read the regulations!

When to visit?
Uganda lies on the equator, so the temperature doesn't change much all year round. The rainy seasons are April to May and October to November, with the rest of the year mostly dry. Overcast skies are best for photography of chimpanzees, so I recommend going in one of the rainy months. As a cautionary note, even in the rainy months it won't be overcast all the time. Sometimes it will still be bright and sunny.

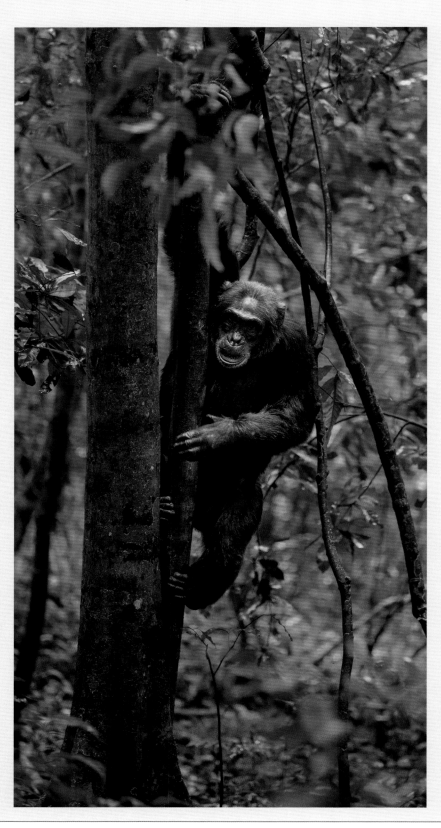

For my 'Ultimate Chimpanzee Safari' in early November I flew to Entebbe and transferred by car to Kibale National Park and stayed for seven nights at Primate Lodge on a private trip booked through Safari Consultants, a UK-based travel agency specialising in African safaris.

Recommendation summary
Location: Kibale National Park, Uganda.
Best time to visit: April, May, October or November.
Getting there: Fly to Entebbe and then transfer by safari vehicle, total journey time about 5 hours.
Access: Chimp Trekking for best photo opportunities. Chimp Habituation Experience for an exciting day with wild chimpanzees.
Duration: Four to five days.

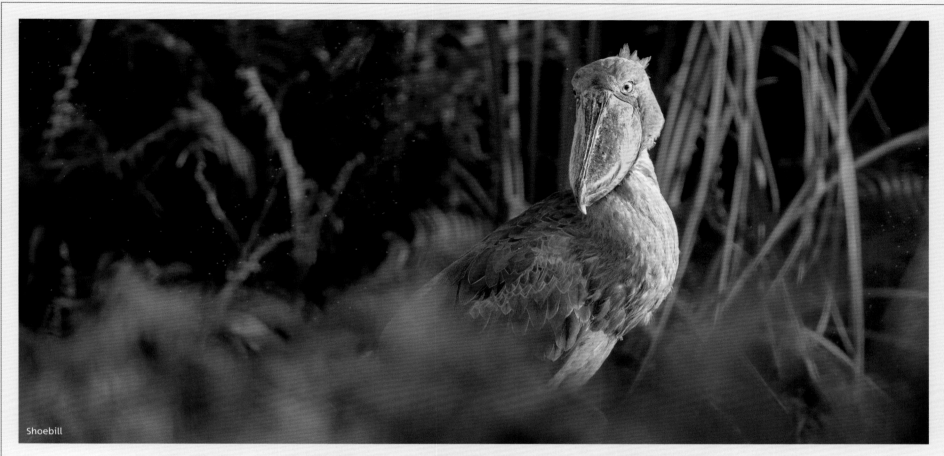
Shoebill

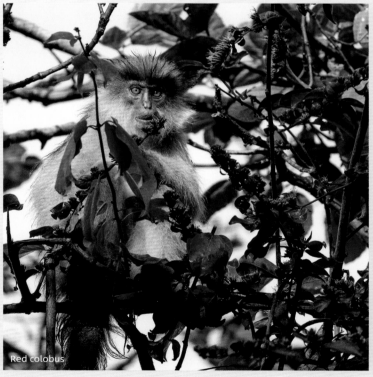
Red colobus

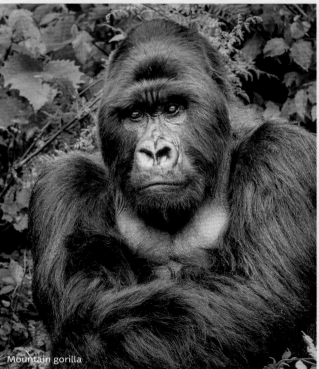
Mountain gorilla

What else might I see?

A good option on arrival day into Entebbe is to visit nearby Mabamba Swamp in Lake Victoria, and see the amazing shoebill. Chimp trekking is tiring, and so if you are staying at Kibale for a few days, take a break one day and visit Bigodi Wetlands. Here there are lots of other primates, such as the red colobus, and numerous water birds. There is also an excellent location to see Uganda's mountain gorillas in Bwindi Impenetrable National Park, about seven hours drive from Kibale.

Jaguar

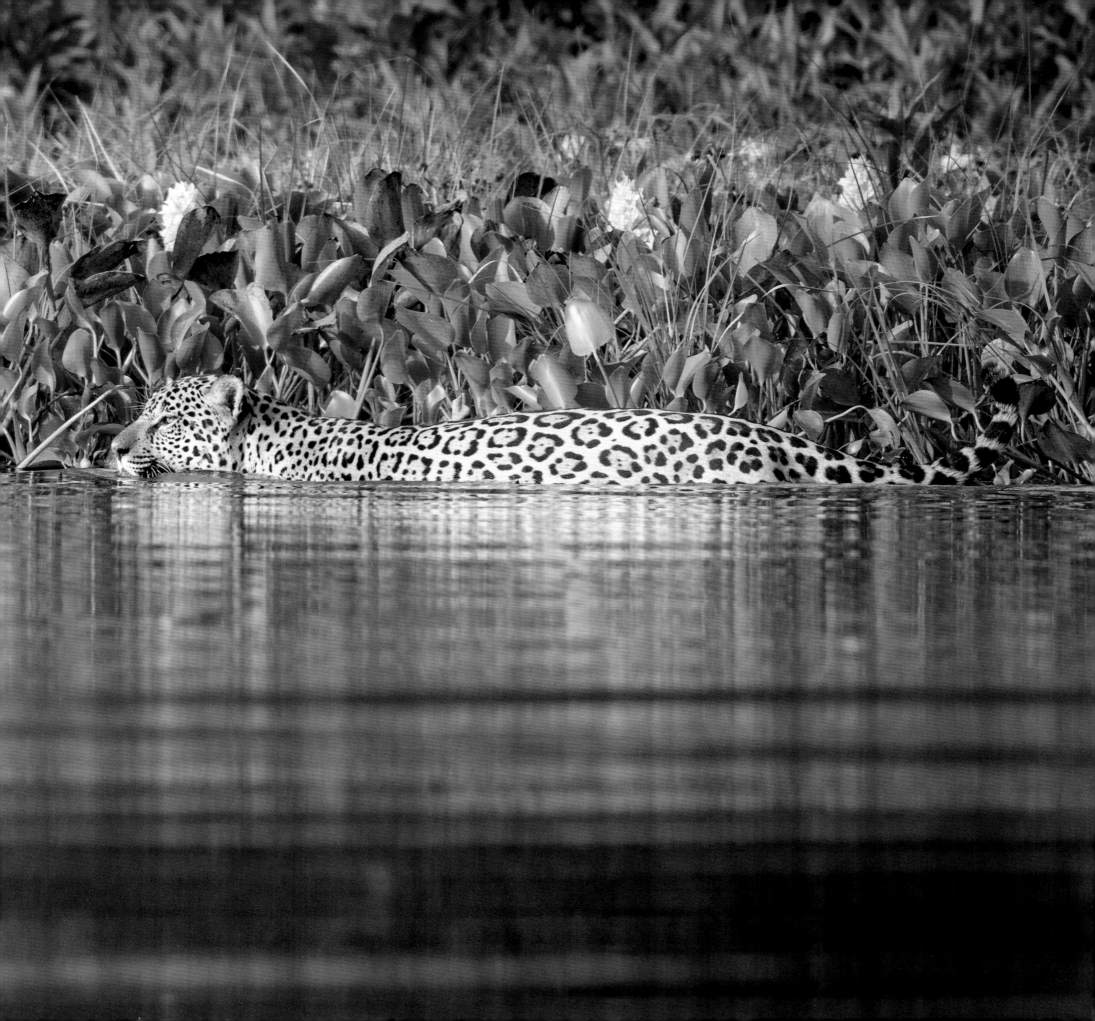

Although centuries of persecution have reduced their numbers considerably, jaguars are still found over a huge geographic range, spanning across the Americas from northern Mexico, through Central America to south eastern Brazil and northern Argentina. Their size varies according to their geographical distribution: the smallest are in the northern part of their range, and the largest in the south; in Brazil's Pantanal males can weigh up to 150kg (330lbs) — about the same as a lioness. Jaguars are the third largest of all the big cats, after tigers and lions, and the most robustly built, with the males having a particularly thickset body, deep chest and short waist.

Jaguars' wide geographic range belies the difficulty in finding them. In most places they are almost impossible to see without the aid of specialist equipment such as camera traps. This very challenge has helped them become one of the most sought-after big cats for keen wildlife photographers. They also offer superb photographic opportunities as they exhibit many different behaviours — climbing trees, hunting along riverbanks, swimming across rivers — in varied and often beautiful surroundings.

In recent years a nascent jaguar-tourism industry has sprung up in the world's largest tropical wetland — Brazil's Pantanal. Here a virtuous circle of eco-tourism has become established — the jaguars have become habituated to visitors, making sightings more reliable. As tourist numbers increase, local people have benefited from the revenue they bring, and no longer consider jaguars a liability but an asset that's worth protecting.

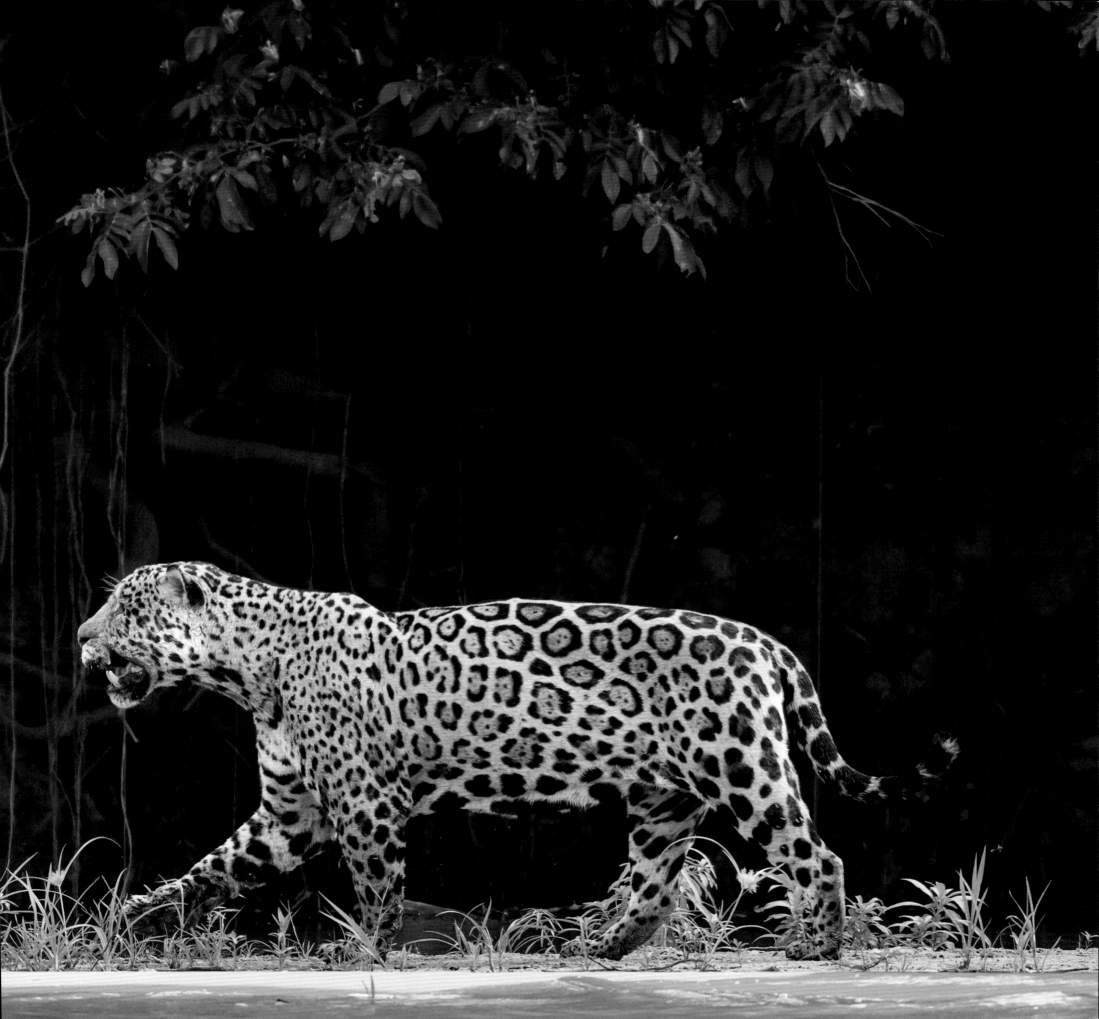

Hold on to your hats

It's now mid-morning and the sun is beating down from directly overhead. Coming from a northerly latitude, it always amazes me just how quickly the sun rises here in the tropics, it goes straight up vertically from the horizon in double quick time. The 'golden hour' of sunrise here is compressed into a 'golden half hour'. And then the sun seems to slow right down and be overhead for hour after sweltering hour. At 6:30 am, when we set off from the boat dock at Porto Jofre, it was beautifully cool. The sun was just rising, and we were all keen to start another day searching for jaguars on the massive Cuiaba River here in Brazil's Pantanal.

But now we are very hot and getting just a little desperate for a sighting. As the temperature soars, our energy levels slump. We've now been out in the boat for over four hours, we are wilting in the heat, and we have yet to see a jaguar. Fred, our guide, tells us that the temperature in the sun is over 50°C (122°F) . 'What's the temperature is in the shade?' I ask, thinking that is a more normal way to measure the temperature. Fred retorts: 'It's 42°C (108°F) in the shade, but I gave you the temperature in the sun, because we are in the sun!' He's right. We are in the full blast of the tropical sun, in an open boat, cruising slowly along this airless river.

Our boat driver is on the radio, speaking in Portuguese. I can't understand a word, but the urgency in his voice sounds promising. 'Hold on to your hats,' Fred shouts. We have become accustomed to this message over the last few days. We hold on to everything as the driver guns the engine and our powerboat accelerates away. With its huge 200bhp engine pushing us through the water, the speed builds and builds. We now know the 'hold onto your hats' drill: it means another boat has radioed in a jaguar sighting, and we are on our way. Our driver is a true expert, weaving his way along the twisting curves of the river at top speeds of more than 65kph (40mph). On the water it seems alarmingly fast. The boat tilts as we swoop around the river's tighter bends, and then we accelerate again on to the straighter sections. This is a real-life roller coaster! Great fun, and with the rushing air bringing welcome respite from the heat, we enjoy a few minutes of exhilaration and wonderful coolness. ▶

Right: Cuiaba River and tributaries, Pantanal, Brazil
Nikon D5 + 180-400mm f4 lens at 210mm; 1/2000 sec at f4; ISO 320

Title pages:
Paraguay River and tributaries, Pantanal, Brazil
Nikon D5 + 180-400mm f4 lens + 1.4x extender at 560mm; 1/1000 sec at f5.6; ISO 1000

Introduction pages:
Cuiaba River and tributaries, Pantanal, Brazil
Nikon D5 + 200-500mm f5.6 lens at 370mm; 1/4000 sec at f5.6; ISO 2200

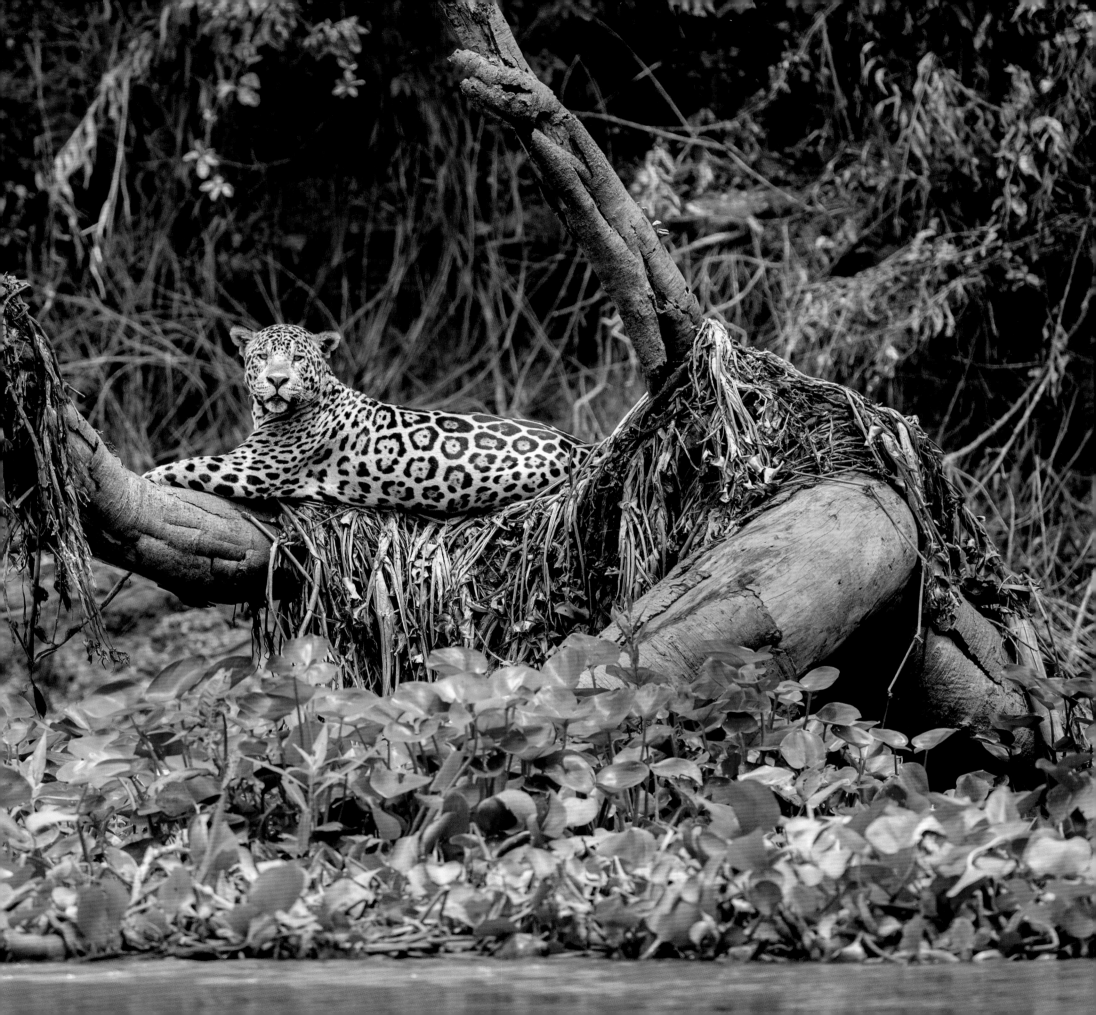

▶ We know we have arrived when we see a small armada of boats ahead of us, milling around close to the riverbank. Slowing right down, we approach quietly. There is a fallen tree leaning out over the river, with a beautiful jaguar stretched out on it, resting calmly. As he looks down at our group of little boats, all jostling for the best viewing position, he seems completely at ease. He has limited interest in us, as he doesn't see the boats as a threat or a food source — fortunately! He has seen it all before. We are certainly not his centre of attention, but he is absolutely our centre of attention. He is what we have come all this way to see and photograph.

Given where he is sitting, there are really only two possible angles from which to take a good photo. From the first, where we are now, the jaguar is looking towards us, but there is a rather messy tangle of branches and vegetation in the background. From the other side it looks as though we should get a much cleaner background, well separated from the jaguar, but he is currently looking the wrong way for that shot. We've already taken some photos here, and after a short discussion, we decided to take the gamble and reposition our boat to the other side.

Slowly we sail around, weaving our way between the other boats, and now we are in position for our imagined shot. After a few minutes we get lucky. He turns towards us, and now we are in business. He gives us plenty of time to take photographs, but then after a few yawns, he stands up and walks along the fallen tree back towards the riverbank. What is he going to do next? ▶

Right: Cuiaba River and tributaries, Pantanal, Brazil
Nikon D5 + 180-400mm f4 lens at 400mm;
1/400 sec at f4; ISO 2200

Photographic tip
Anticipate, and keep ahead

A relatively frequent sighting is one where the jaguar is stalking along the riverbank, necessitating constant repositioning of the boat. As discussed for other animals in this book, our needs as photographers often differ from those of regular tourists. Most boats will cruise along steadily just behind the jaguar. Besides being rather uncomfortable for the jaguar (having a boat just out of sight over its shoulder), this doesn't work well for photography. Try to anticipate the jaguar's next move, and then ask the driver to place the boat well ahead, in a stable position. This way you can get multiple shots as it walks towards you.

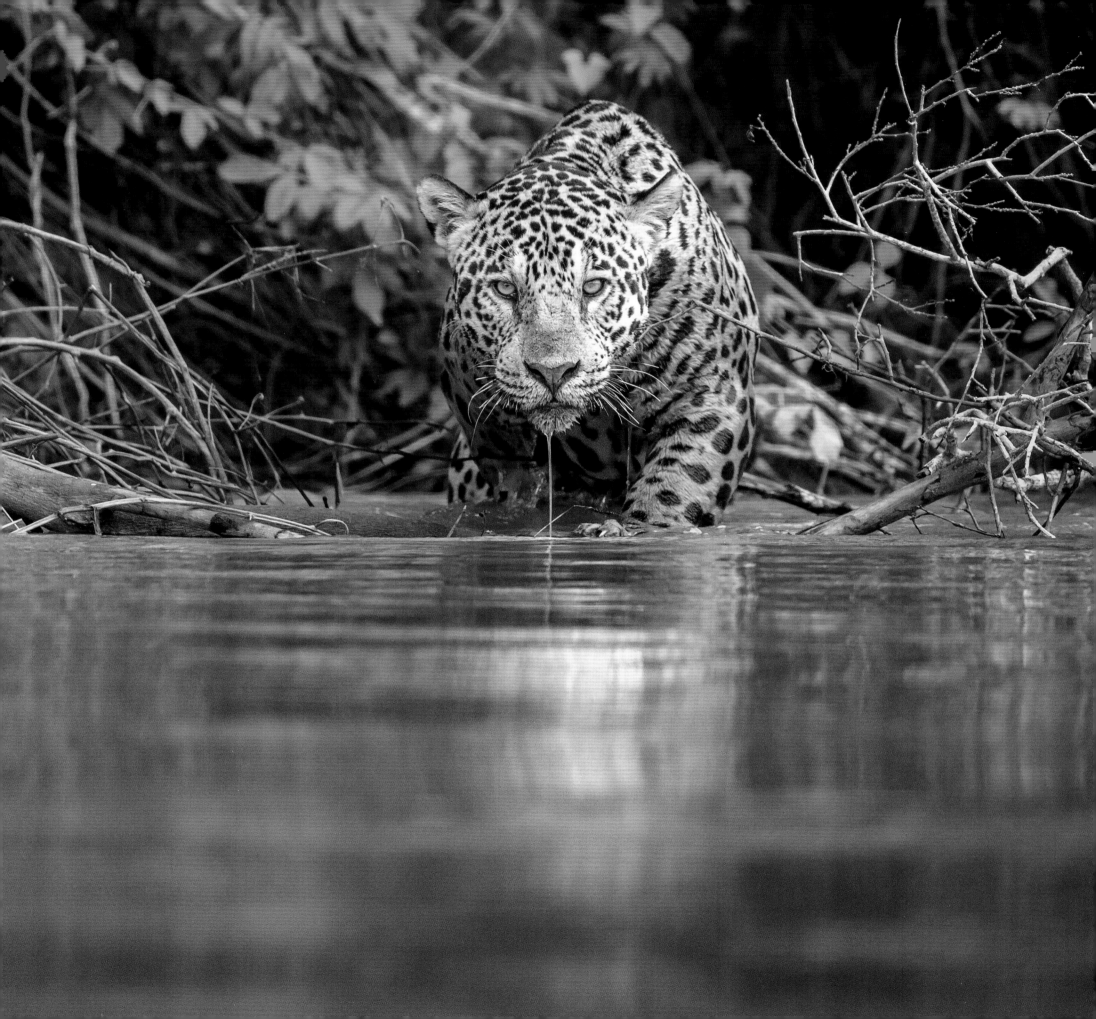

▶ He is walking along the steep slope of the riverbank, sometimes right on the top, other times down at the bottom wading through the water, working steadily along. He's hunting: opportunistically scanning for whatever he may come across — possibly a yacare caiman, or maybe a capybara.

Jaguars in the Pantanal operate differently from most other cats. Many cats avoid water; here the jaguars love it. Most cats rest up during the heat of the day, but down in the cooling water of the river, these jaguars very often hunt in the full glare of the midday sun. Over the next two hours the jaguar walks and walks, and we shoot and shoot, taking hundreds of photographs from every possible angle of this huge cat going about his daily life.

The following day we find him again, in the cool and soft light of early morning. He's still hunting, and we enjoy another three hours with this magnificent creature. ●

Above: Cuiaba River and tributaries, Pantanal, Brazil
Nikon D5 + 180-400mm f4 lens + 1.4x extender at
560mm; 1/640 sec at f5.6; ISO 2000

Right: Cuiaba River and tributaries, Pantanal, Brazil
Nikon D5 + 180-400mm f4 lens + 1.4x extender at
560mm; 1/1600 sec at f5.6; ISO 640

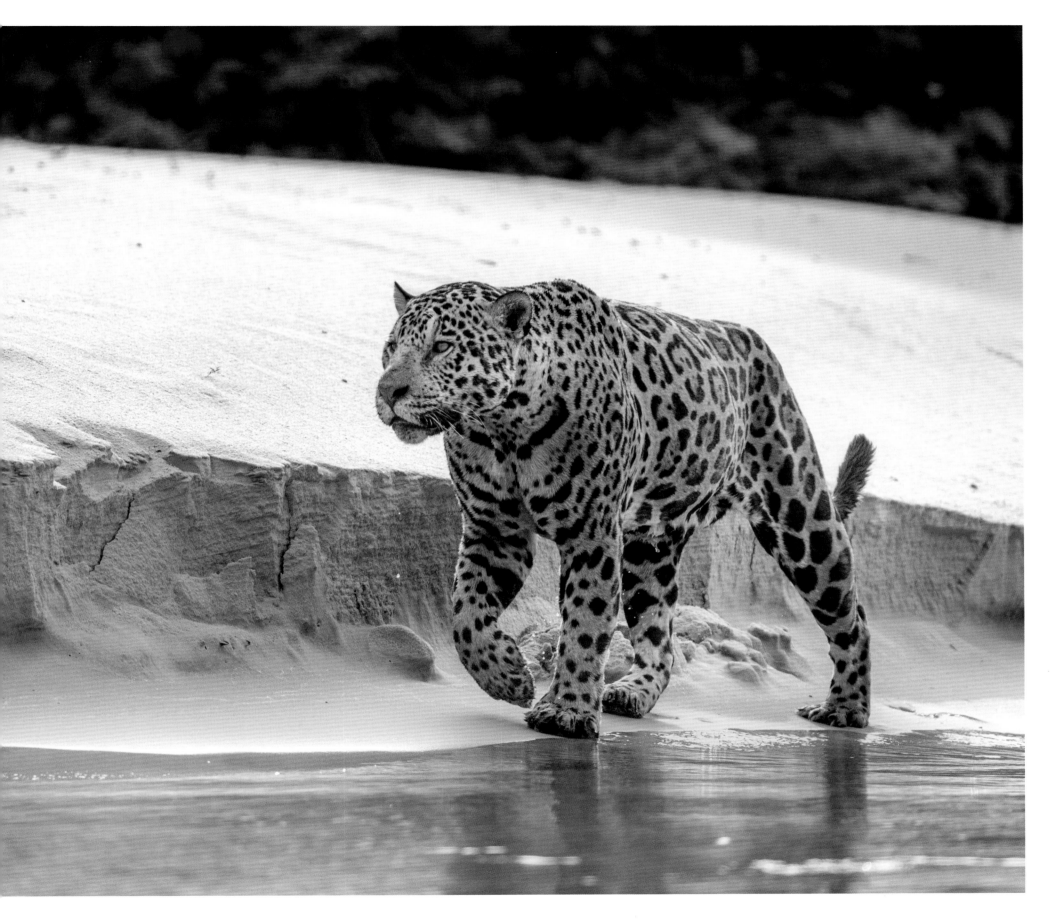

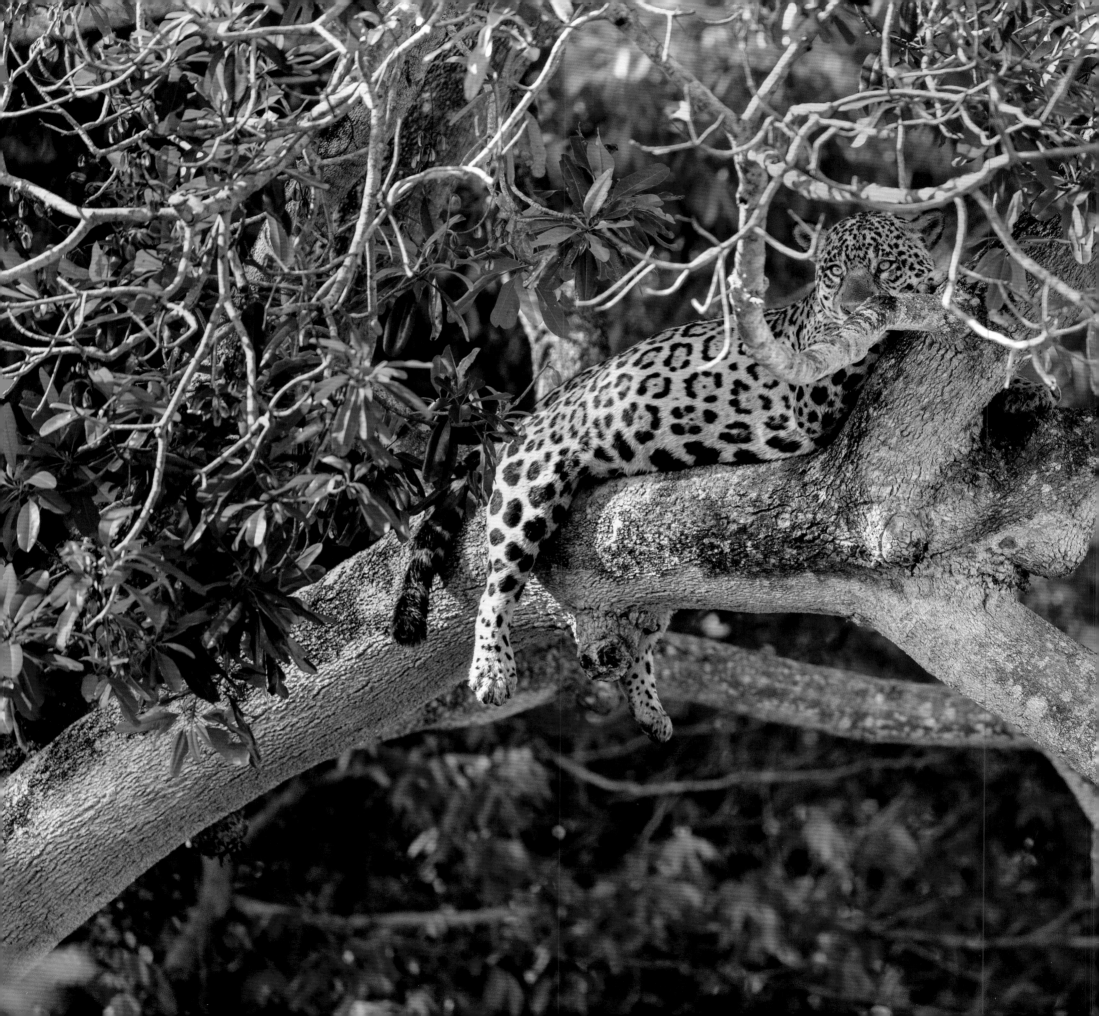

Photographic tip
ISO insurance

For such a bright and sunny place, the Pantanal often presents serious challenges with light levels. This is because much jaguar activity happens in the deep shade of the riverbank, and you are normally photographing from the relative instability of a speedboat. Selecting a high enough shutter speed to freeze any movement of the animal or camera often results in an uncomfortably high ISO setting, resulting in noisy images, particularly if you need to recover shadow detail when processing. To try and avoid this, after taking the first batch of shots at the higher ISO level, I then progressively move to slower and slower shutter speeds (and hence also lower ISOs). At each step, I take a series of short bursts. Whilst not all the shots will be sharp, you only need one!

Left: A jaguar is a big cat to be up a tree — it can't scale a vertical trunk the way a lithe leopard can, but a sloping trunk offers an inviting route to a comfortable, shady place to rest. I've quite often seen jaguars in trees in the heat of the day, taking advantage of the shade and relatively bug-free environment.

Cuiaba River and tributaries, Pantanal, Brazil
Nikon D5 + 180-400mm f4 lens at 330mm;
1/1250 sec at f4; ISO 640

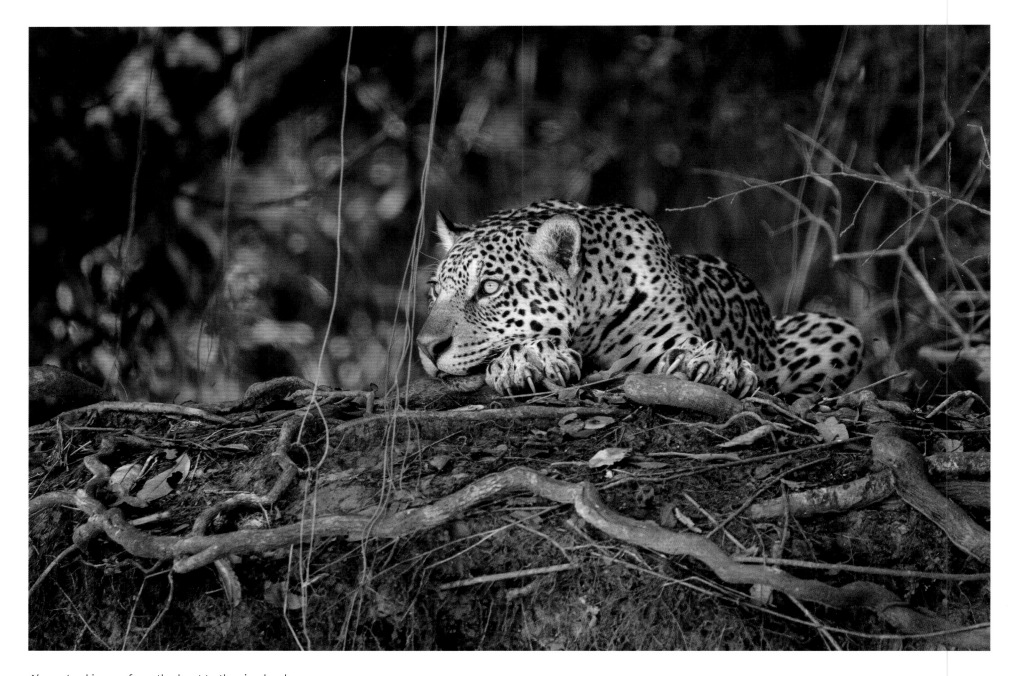

Above: Looking up from the boat to the riverbank, I honed in on this cat because of the massive claws on display. The size and prominence of the claws — and paws — gives a vivid sense of the power and strength of this predator.

Cuiaba River and tributaries, Pantanal, Brazil
Nikon D5 + 180-400mm f4 lens + 1.4x extender at 550mm; 1/320 sec at f5.6; ISO 1600

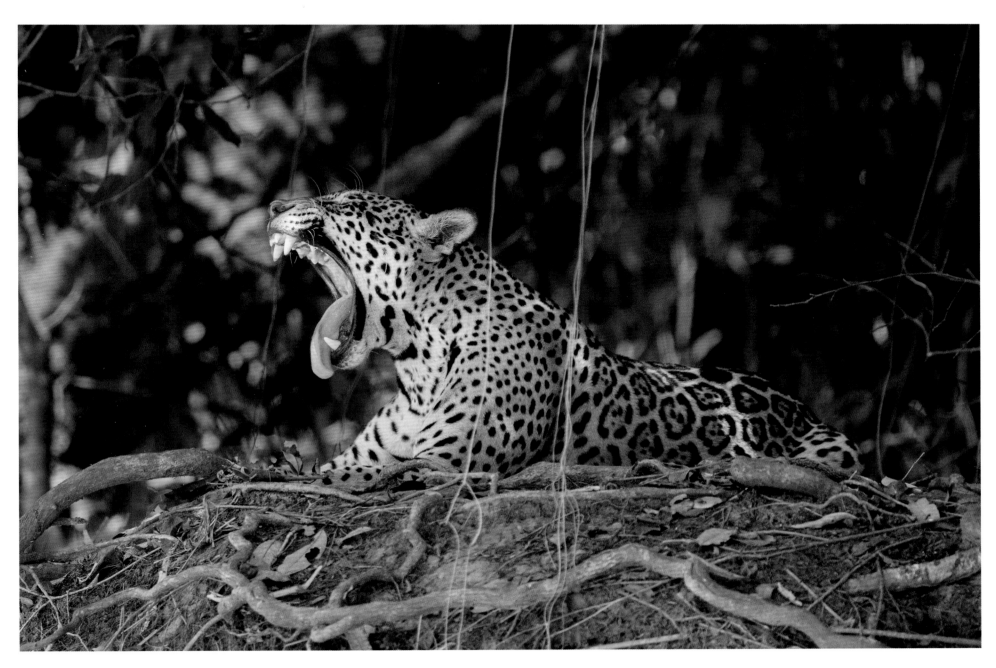

Above: When a jaguar yawns you hear cameras clicking around you — just as the mouth is shutting from a yawn, the face resembles a fierce snarl, an image that many visitors want to capture. Yawning doesn't normally mean tiredness, but that the jaguar is rousing itself. They start to yawn after resting, and after two or three yawns it's time to get up and go, so it's a helpful cue to anticipate a change of behaviour.

Cuiaba River and tributaries, Pantanal, Brazil
Nikon D5 + 180-400mm f4 lens + 1.4x extender
at 560mm; 1/320 sec at f5.6; ISO 1600

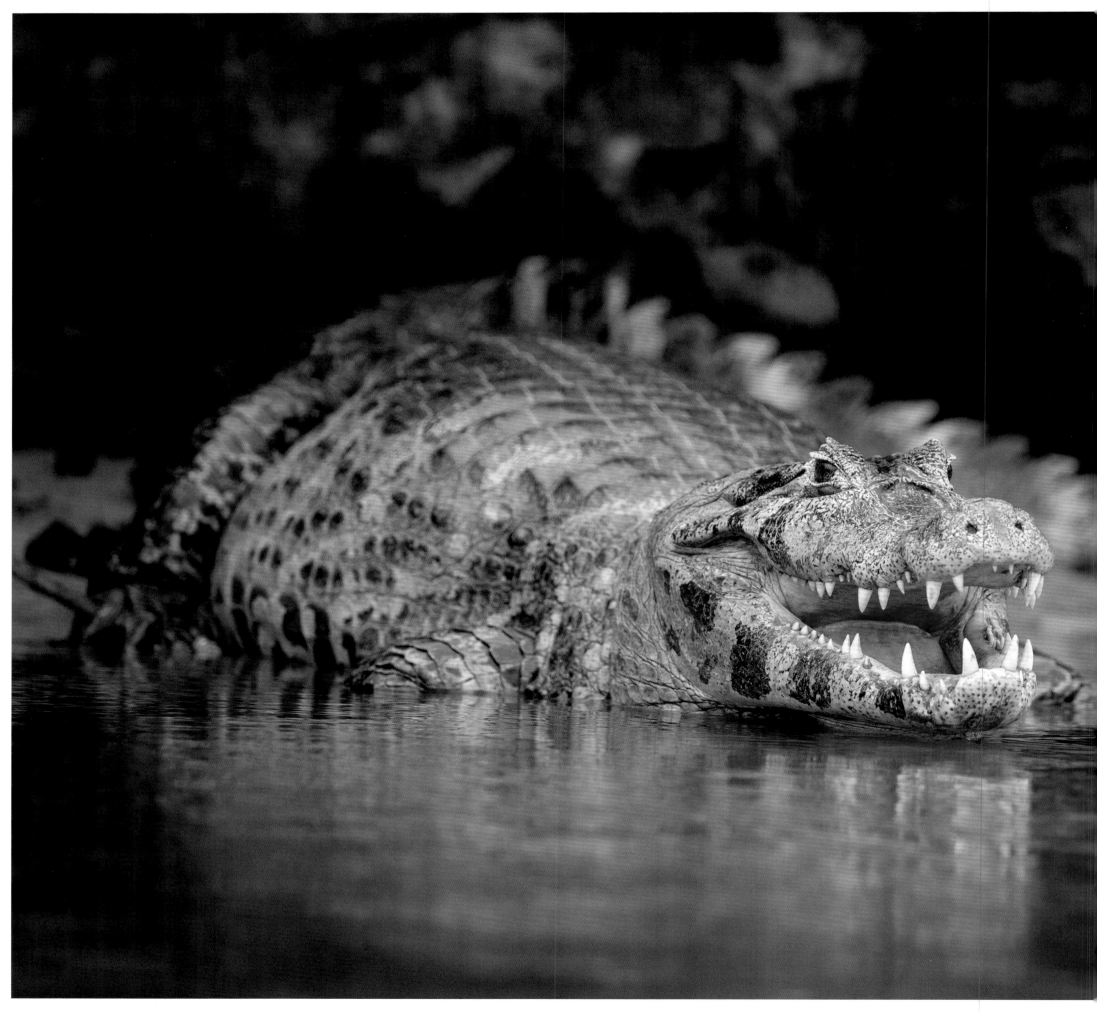

Photographic tip
Support matters

Method		
	●	Recommended
	○	Possible use
	●	Not recommended
Handheld	●	There is usually good light, allowing for fast shutter speeds. With good technique, this is a very practical option.
Beanbag	●	A good option for the vehicle-based jaguar viewing at Caiman Ecological Refuge.
Monopod	●	When operating from a speedboat, this is my preferred option. A monopod makes it easier to hold the camera in position for long periods when waiting for action during an encounter, and can allow slower shutter speeds when the light is challenging, such as the deep shade of the riverbank.
Tripod	○	Not suitable for boats or safari vehicles, but can be useful in the grounds around the hotel/lodge.

Left: There are estimated to be 5 million yacare caiman in Brazil's Pantanal. Though the caiman is an enormous predator itself, reaching 5 metres (16 feet) in length, it's one of the main prey species of the jaguar. Jaguars hunt them by pouncing, then use their powerful bite to pierce the back of the neck or skull, killing the caiman instantly.

Cuiaba River and tributaries, Pantanal, Brazil
Nikon D5 + 180-400mm f4 lens at 400mm;
1/1600 sec at f5; ISO 640

A tough choice

I never thought I would be this close to a Jaguar! We are only a few metres (yards) away. He is sitting on top of the riverbank, and we are just below, looking up at him. He is a large cub, almost fully grown, but still with the curiosity of a youngster. His mother is away to one side, hardly visible as she sleeps in the dense vegetation, for she has no interest in us. But the cub is out in the open so he can get a good view of our boat, just below him. Occasionally he dozes, but then he looks up to inspect us, before dozing again. It is nice to be able to take our time and frame some portraits of this beautiful cat posing in front of us. But now the light is failing as the sun has set, and so we leave these two jaguars and return to our lodge for the night.

The following morning it's almost midday when we arrive in the same area. We find the same young male, on his own this time, on the opposite side of this small tributary of the Paraguay River. He is out hunting, walking along the riverbank looking for prey. Once again, the temperature is back up towards 40°C (104°F), and on this occasion the jaguar does appear to want to rest up. He has just walked into the very tall grass up on the riverbank and disappeared from view. We think he may be sitting down in the shade, but we are not really sure.

We tie up the boat on the opposite side under a shady tree and wait. Time passes, nothing is happening and eventually we discuss our options — we can either sit it out through the heat of the day, and wait here to see what happens. Alternatively, we can go back to the lodge, eat and relax a bit, and then come back and see if he reappears once the temperature dies down and the light quality improves. In the end, we opt to go back to the lodge. We know this could go wrong and we may miss the jaguar, but we need a break from this heat.

This temperature can be debilitating, but it's worth it. It was a conscious choice to come here at the hottest time of the year, when there is less water and so the wildlife concentrates around what is left, maximising our chances of finding jaguars. ▶

Right: Paraguay River and tributaries, Pantanal, Brazil
Nikon D5 + 180-400mm f4 lens + 1.4x extender at
550mm; 1/400 sec at f5.6; ISO 5000

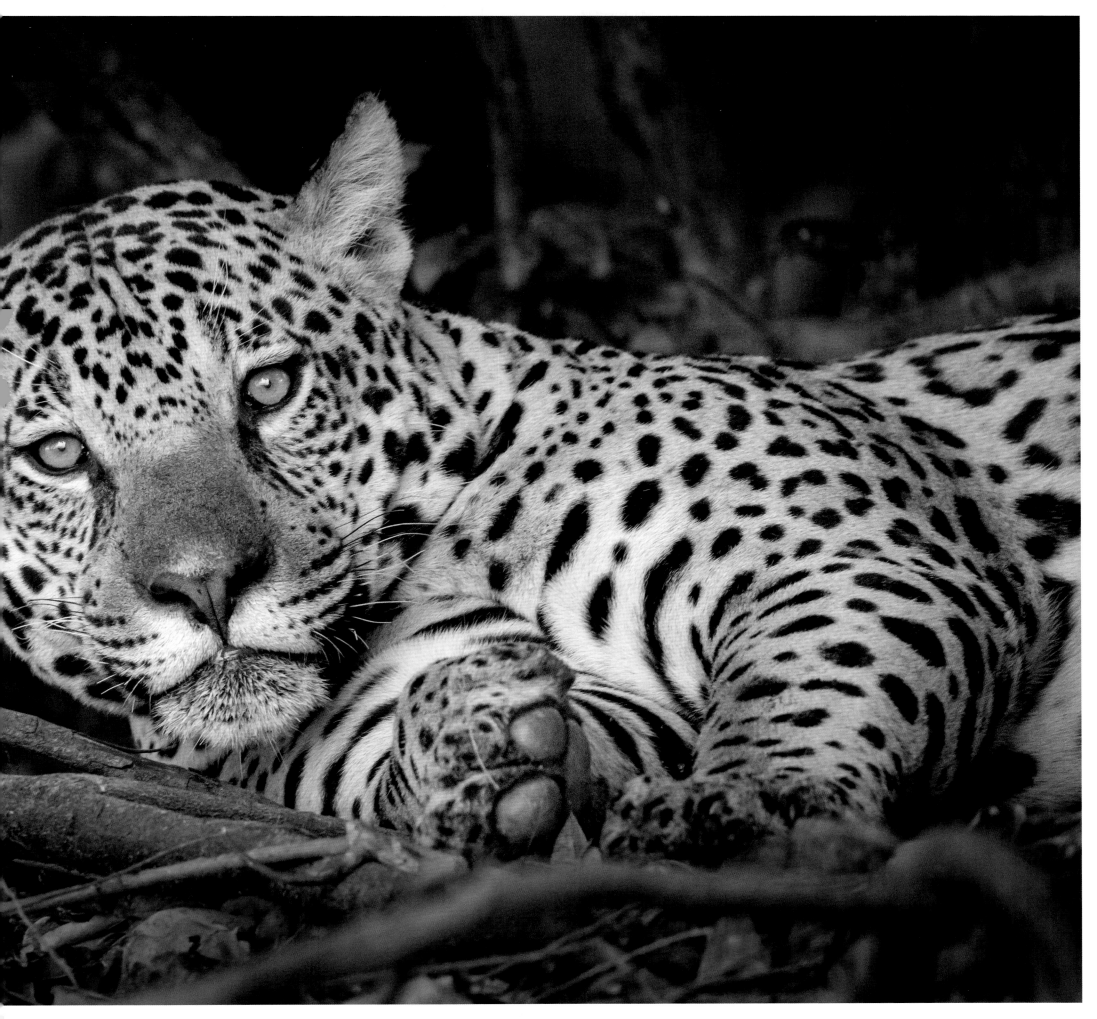

▶ In the early afternoon we head back out hoping to find our young jaguar. When we arrive, we scan along the river in the area where he was last seen. But it is to no avail, so we return to our same shady tree and park up the boat. We will wait for the rest of the afternoon to see if he reappears. A couple of hours pass, and we are beginning to wonder if this was such a good plan. Maybe he moved on when we were away, and we have missed him? But then we spot the jaguar walking through the long grass, just across the river from our tree. A little way along the riverbank he finds a sandy beach and sits down again. It is late afternoon and the light is improving all the time.

The Paraguay River is a stunning area, the wide, winding river and its backwaters are surrounded by beautiful hills, forested areas, rocky granite escarpments, luscious vegetation and wildflowers. And, we are on our own. Unlike the busier spots around the Cuiaba River, here there are only three or four boats in the whole area. We had hoped that coming here would allow us to photograph jaguars in beautiful surroundings, without the crowds of boats seen in other places, and that's just how it's working out.

Now our young jaguar is on the move, walking across the shoreline and into the water. Wading through the river surrounded by flowering water hyacinths, giving us a great photo opportunity. We hear a jaguar calling from the opposite side of the river — it's his mother! He responds immediately. Wading deeper into the water, he starts swimming across the river right in front of us, returning to the opposite bank in answer to his mother's call. ●

Right: Paraguay River and tributaries, Pantanal, Brazil
Nikon D5 + 180-400mm f4 lens at 400mm;
1/1600 sec at f5.6; ISO 1800

Organisational tip
Downpours

Occasionally, even though it is the dry season, you will get a thundery downpour. In an open boat it can be a real challenge keeping your gear dry. I carry a large heavy-duty bin liner, so I can quickly sleeve the whole camera bag (with camera and lenses inside) into this waterproof bag.

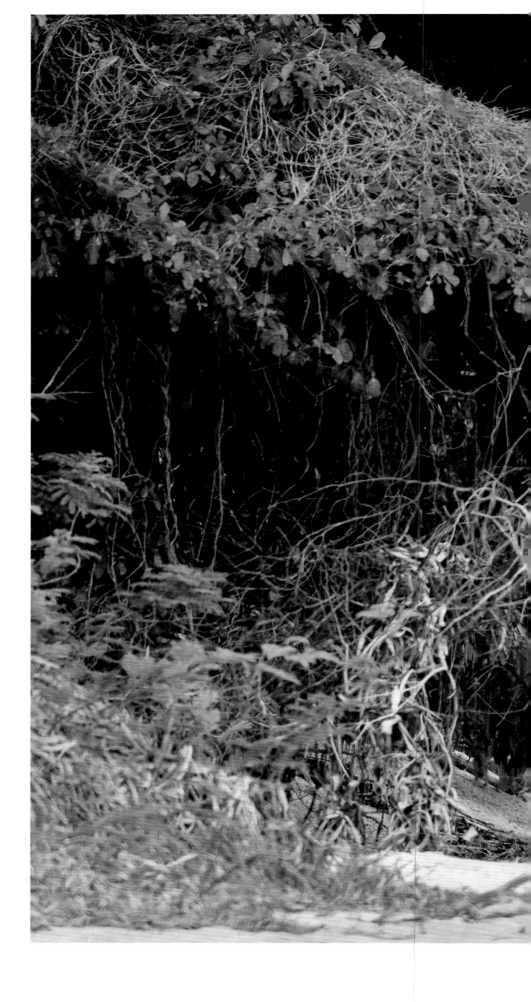

Organisational tip
Shade or shots

Most of the speedboats in the Pantanal have a retractable sunshade. There are struts and ropes to support it, which can be restrictive when photographing, particularly if the action is quick and intense — if you quickly pan round, the last thing you need is an aluminium strut blocking the front of your camera! Take a sun umbrella instead and ask the boat driver to remove the shade.

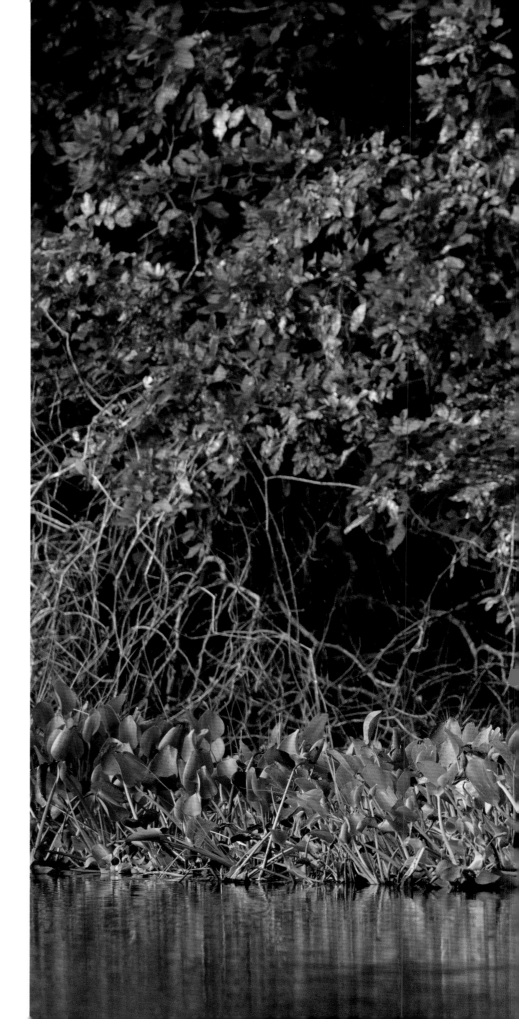

Right: Paraguay River and tributaries, Pantanal, Brazil
Nikon D5 + 180-400mm f4 lens at 400mm;
1/1600 sec at f5.6; ISO 2200

Following pages:
Paraguay River and tributaries, Pantanal, Brazil
Nikon D5 + 180-400mm f4 lens + 1.4x extender
at 560mm; 1/1600 sec at f5.6; ISO 2500

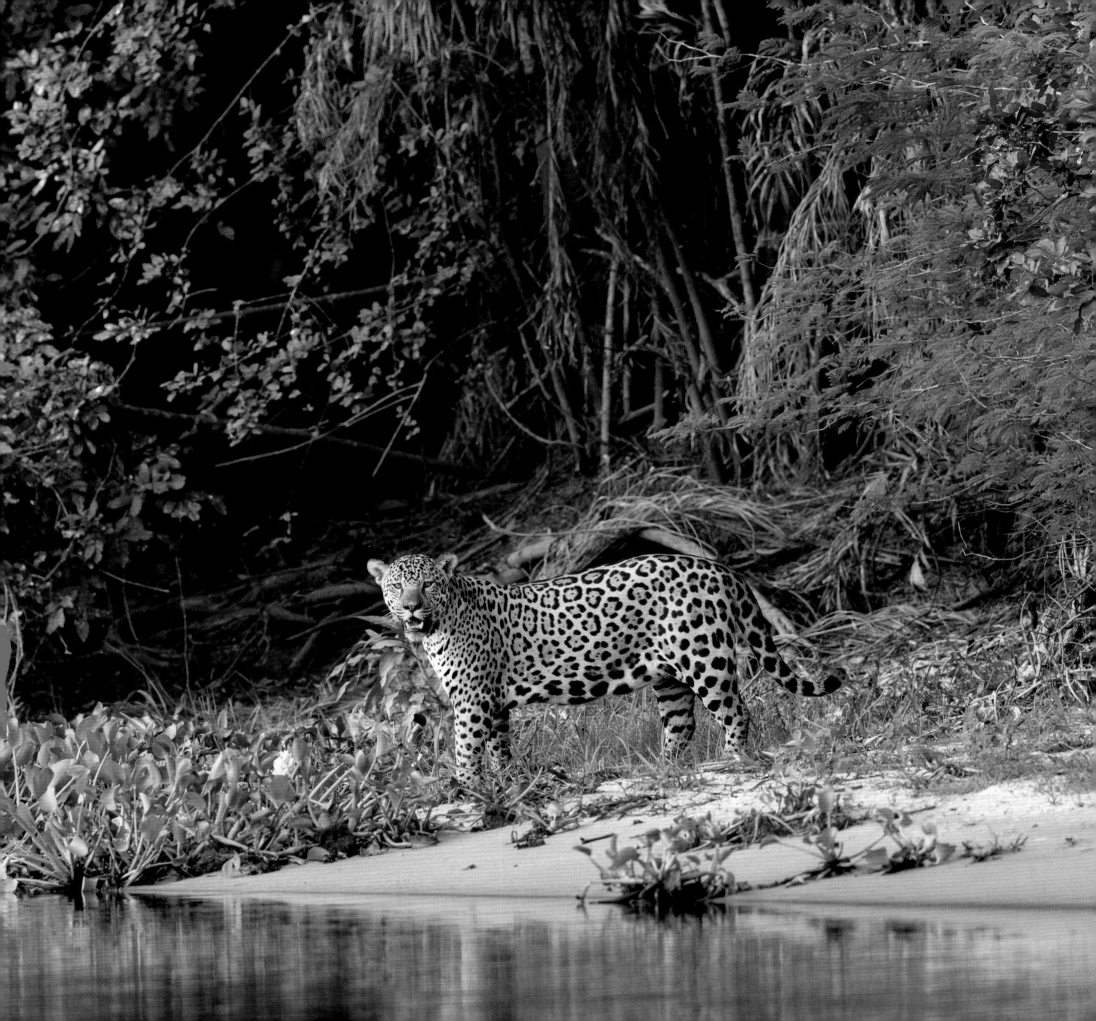

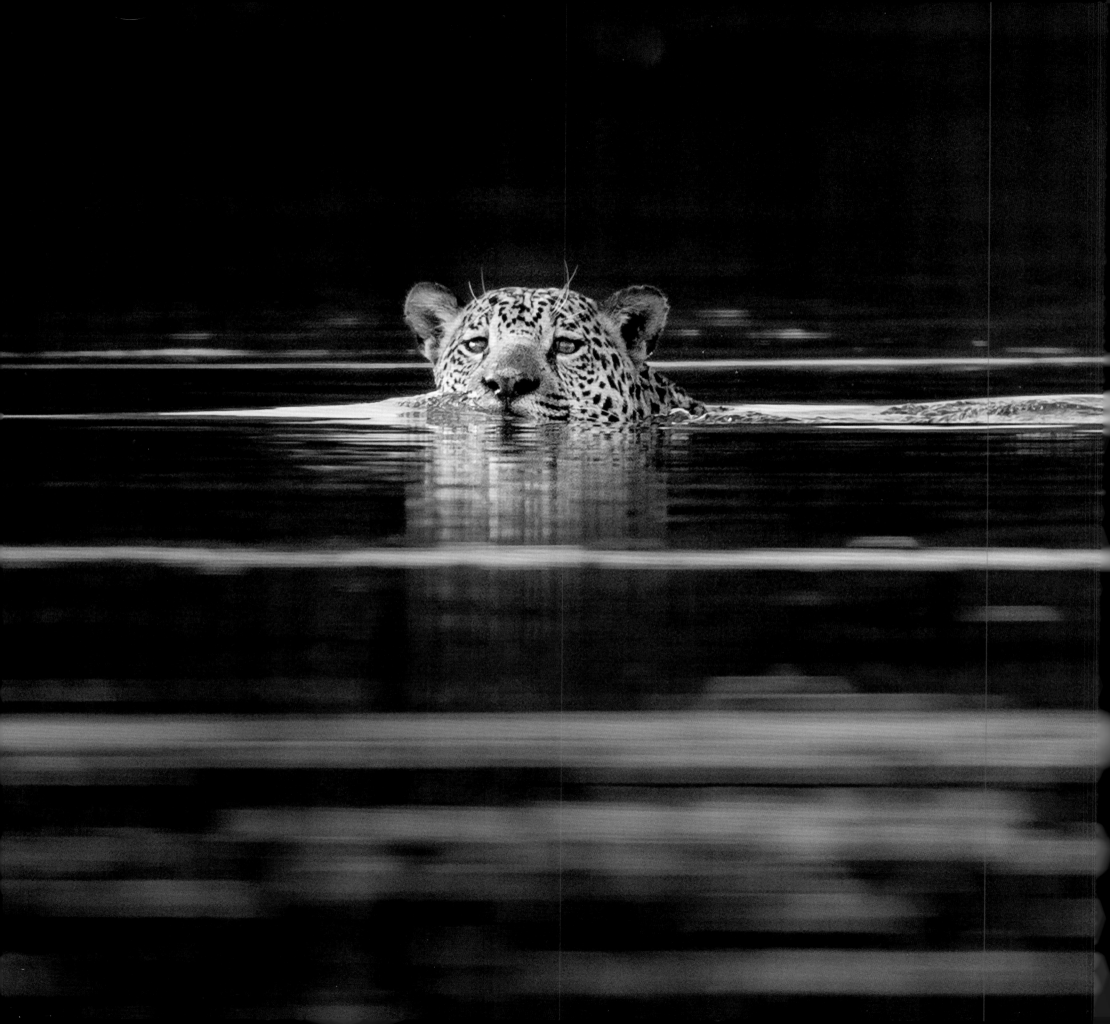

Organisational tip
Photographic gear in
air-conditioned rooms

Most accommodation in the Pantanal is air-conditioned, which is a necessity given the very high temperatures. However, taking a chilled camera straight outside from your room will result in instant and terrible condensation problems, potentially even permanently damaging the equipment. One option when heading out is to leave your camera gear in the camera bag or a waterproof sealed bag and allow it to warm up slowly over half an hour or so. A better alternative, if available, is to store your gear out of the air-conditioned part of the room. Most bathrooms are not cooled, and they stay close to ambient temperature, making them an ideal place to stash your gear — just make sure it's in a safe dry corner!

Left: This was almost a head-on collision — I was lurking around on the ground hoping the giant anteater would come running towards me, and suddenly it did! At up to 2.2 metres (7 feet) long, the name 'giant anteater' is not an exaggeration, and these 50kg (110lbs) creatures hoover up about 35,000 ants and termites each day, or rather each night. Giant anteaters are mostly nocturnal, but you can occasionally catch them still foraging at twilight or dawn. We would spend a few hours early each morning looking for these incredible characters.

Pousada Aguape, Pantanal, Brazil
Nikon D5 + 180-400mm f4 lens + 1.4x extender
at 560mm; 1/1600 sec at f5.6; ISO 640

We are habituating a jaguar!

We are at 2,400 metres (8,000 feet) in a light aircraft, surrounded almost entirely by a sea of green. We took off just over an hour ago from the Porto Jofre airstrip in the northern Pantanal, and we are heading to a rather unusual wildlife refuge in the southern Pantanal. Immediately after take-off we crossed the huge, winding Cuiaba River, and then flew over miles and miles of forested land, interspersed by the odd lake or small watercourse.

Slowly I noticed the landscape changing as it became much 'swampier' over the central part of the Pantanal. Even at the end of the dry season, this area was still flooded. This is a great way to understand the geography of the Pantanal, and vividly see how the two Brazilian states that encompass this area are well named — in the north it is Mato Grosso or 'great swamp', and in the south Mato Grosso do Sol — 'great swamp of the south'.

Now, just over an hour into our journey, we are over ranch land. Rearing livestock has been the way of life in the Pantanal for over 250 years, and it is estimated that there are more than four million cattle. The land is 95 percent privately-owned agricultural land, but unlike arable farming, cattle rearing is surprisingly compatible with the natural landscape and the wildlife in this area. It is estimated that 80 percent of the vegetation is preserved, making it Brazil's most intact biome. However, there is potential for ongoing conflict between the ranchers and jaguars, which have long been persecuted for taking cattle.

It's not all green below. Since leaving Porto Jofre, I have seen over a dozen giant plumes of smoke rising up from the grasslands and forests — wildfires. It's a natural hazard at this time of year, with afternoon thunderstorms happening every few weeks. But the frequency of fires has increased as they are also started by local people — most unintentionally, but sometimes deliberately, such as land clearance for agriculture. Although vegetation has evolved to cope well with the occasional wildfire, I wonder how well the vegetation and all its dependent wildlife will fare if this increased frequency continues year after year? ▶

Right: Forest fires are quite frequent in this area, and though jaguars are quite capable of escaping the flames, they opportunistically prowl the burnt-out landscape afterwards in search of animals that weren't so lucky — a lightly toasted reptile, perhaps.

Cuiaba River and tributaries, Pantanal, Brazil
Nikon D5 + 200-500mm f5.6 lens at 460mm;
1/320 sec at f5.6; ISO 6400

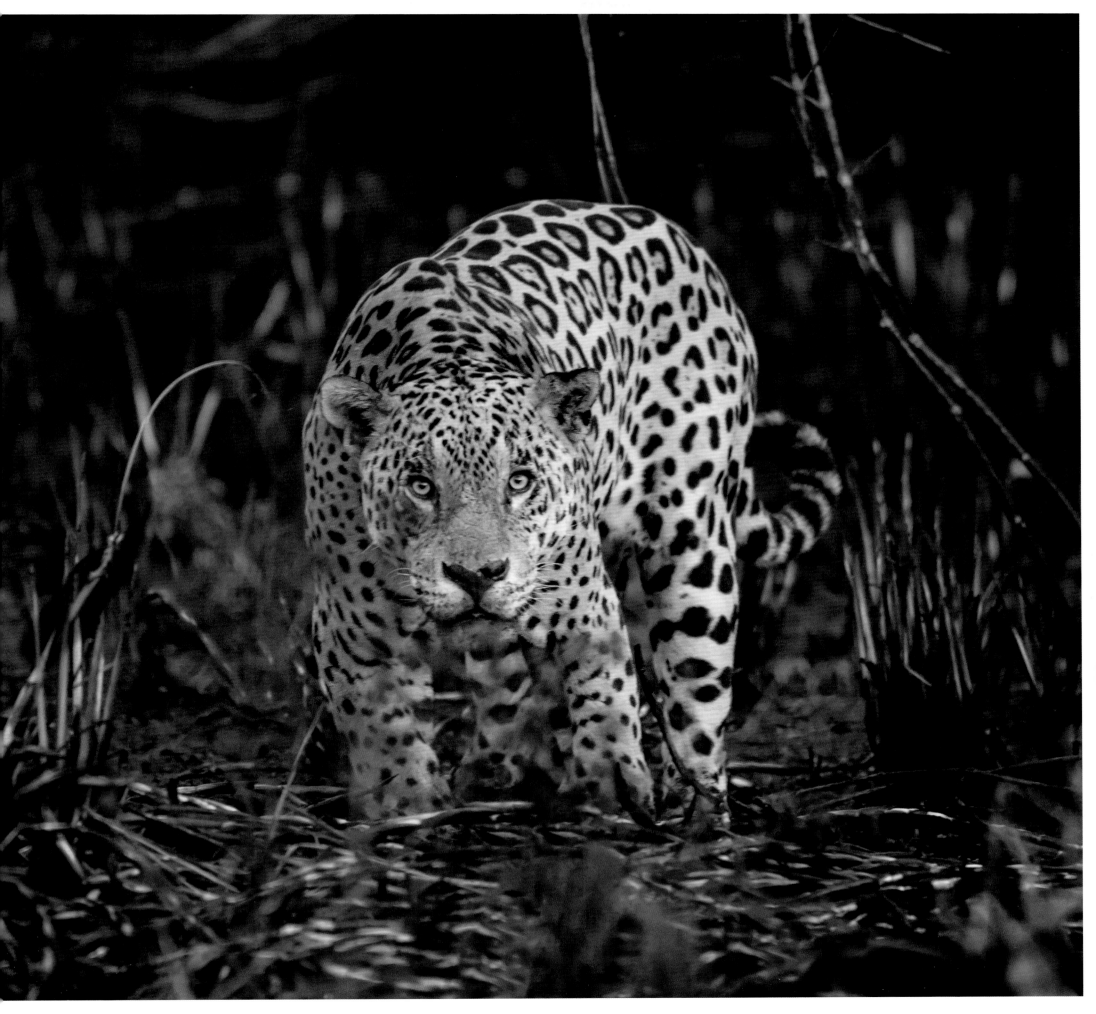

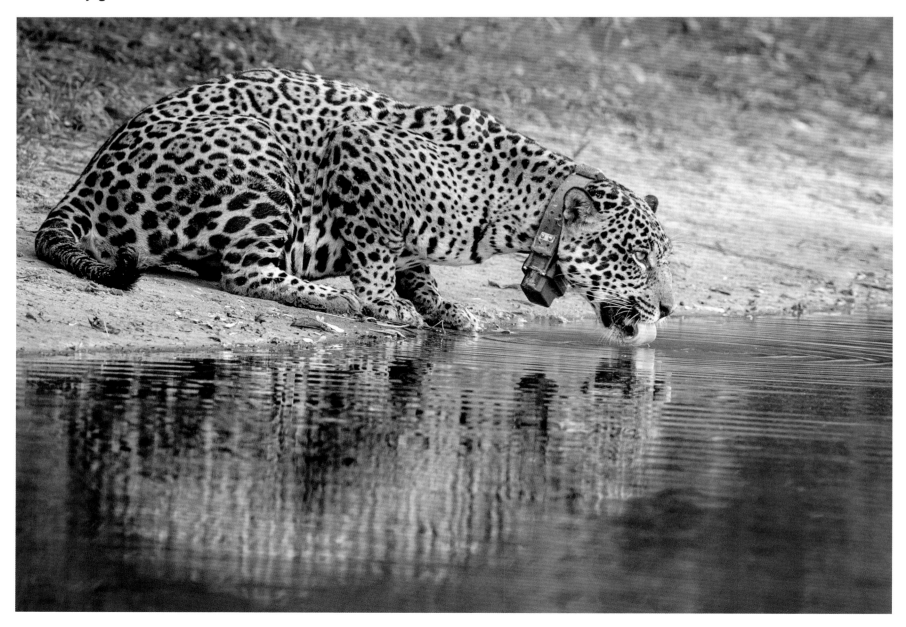

Above and right: I'm sometimes disappointed — grumpy even! — when I see collared animals. I understand that these collars are very important for research and conservation, but the images don't work for me. However, with patience it is possible to get useful shots, in which the collar is hardly visible (right), and probably wouldn't be noticed if you weren't looking for it. We found this collared female jaguar by a waterhole and watched carefully, trying to anticipate her moves and taking a number of shots on each good opportunity.

Above: Caiman Ecological Refuge, Pantanal, Brazil
Nikon D5 + 180-400mm f4 lens at 400mm;
1/500 sec at f5.6; ISO 3200

Above right: Caiman Ecological Refuge, Pantanal, Brazil
Nikon D5 + 180-400mm f4 lens at 400mm;
1/500 sec at f5.6; ISO 3600

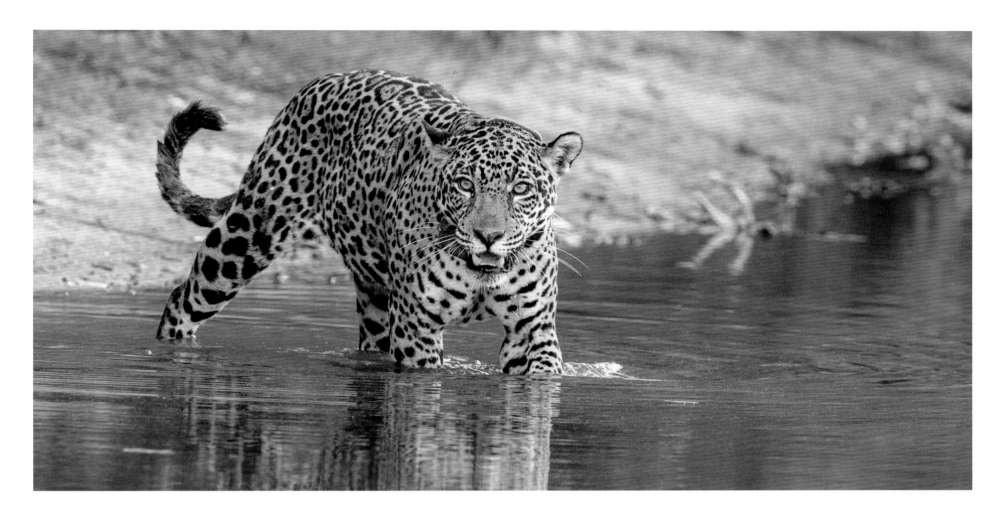

▶ We are on our way to Caiman Ecological Refuge, a huge cattle ranch with a difference. The enlightened owners of this vast 53,000 hectare (130,000 acre) property have turned it into a wildlife refuge, actively encouraging wildlife to live alongside their cattle. It is an excellent example of how traditional agriculture and wildlife tourism can not only live side by side but thrive together.

As we begin our descent towards the airstrip, I'm aware of how different this jaguar-watching experience could be compared with looking for them from boats on the river. I can see huge grassy fields, lots of forested and thicketed areas, and the occasional waterhole. This is going to be very interesting. Once on the ground, we are collected by a safari vehicle and driven the short distance to the lodge.

'Please quickly drop your bags in your room, grab your cameras, and straight back to the vehicle,' Fred asks us. Then as we set off, he tells us: 'Hold onto your hats!' After a twenty minute bumpy, dusty ride speeding along the dirt roads, we pull off the track, and approach a small waterhole. There is a striped yellow vehicle here — this must be the Onçafari research team.

Project Onçafari is the name of a unique jaguar project based here in the Refuge. A non-profit conservation initiative, its aim is to conserve the region's apex predator, the jaguar, using eco-tourism. Learning from the success of habituating leopards to tourist vehicles in South Africa, they have adopted similar methods with jaguars. This is not about taming an animal but gaining acceptance that tourist vehicles are neither a threat nor an opportunity, so that the jaguar's behaviour is not altered by our presence. A small number of jaguars are collared as part of the research project, making it much easier to find them. The collars automatically release themselves from the animal after about a year.

There is a brief discussion on the radio between our driver and the research vehicle, and then we drive around the waterhole to a small stand of trees. Peering out at us from behind some bushes is a jaguar cub! We can only glimpse it every now and then; it seems both curious and wary of us at the same time: curious to see what we are, but wary of our large, rather noisy, safari truck. We are habituating a jaguar! After a short while it disappears into the bushes. We continue driving along the edge of the waterhole, and spot another jaguar up in a tree, stretched out on a thick branch, fast asleep. It's his mother — not bothered at all about us, sleeping on undisturbed. This 'land' jaguar is acting more like the big cats in Africa — sleeping in the heat, as opposed to its cousins further north, who regularly hunt on the big rivers in the middle of the day.

It's now noon, the sun is overhead, and the light is awful for photography. ▶

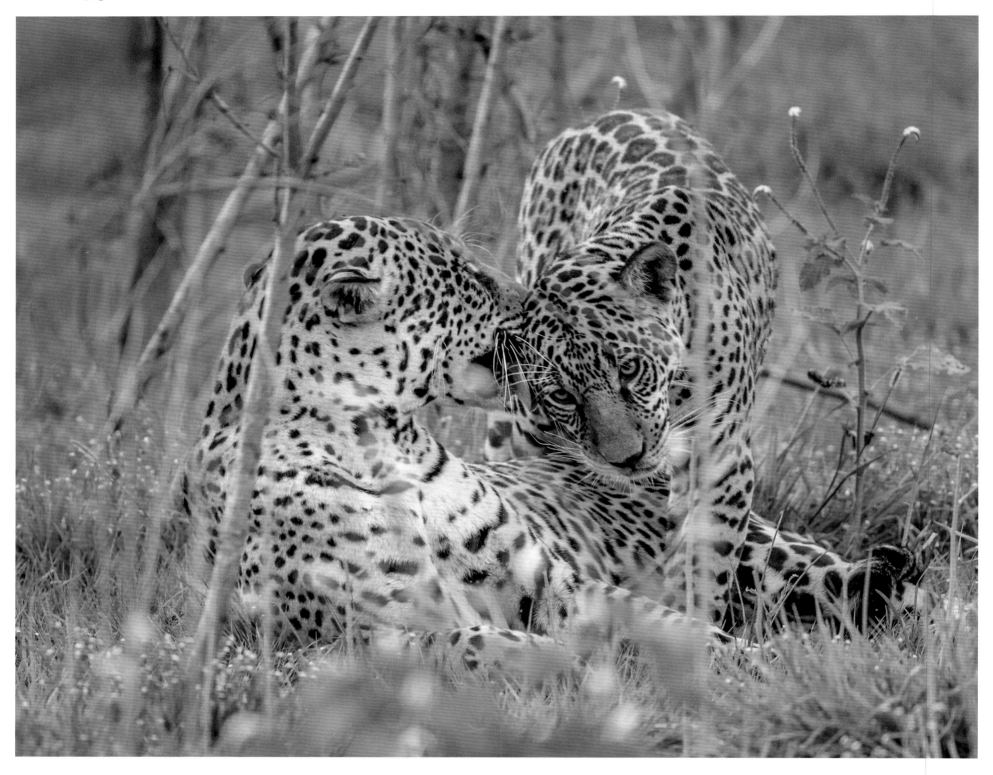

Above: Caiman Ecological Refuge, Pantanal, Brazil
Nikon D5 + 180-400mm f4 lens at 380mm;
1/320 sec at f4; ISO 2500

Above right: Caiman Ecological Refuge, Pantanal, Brazil
Nikon D5 + 180-400mm f4 lens at 370mm;
a 1/500 sec at f4; ISO 5000

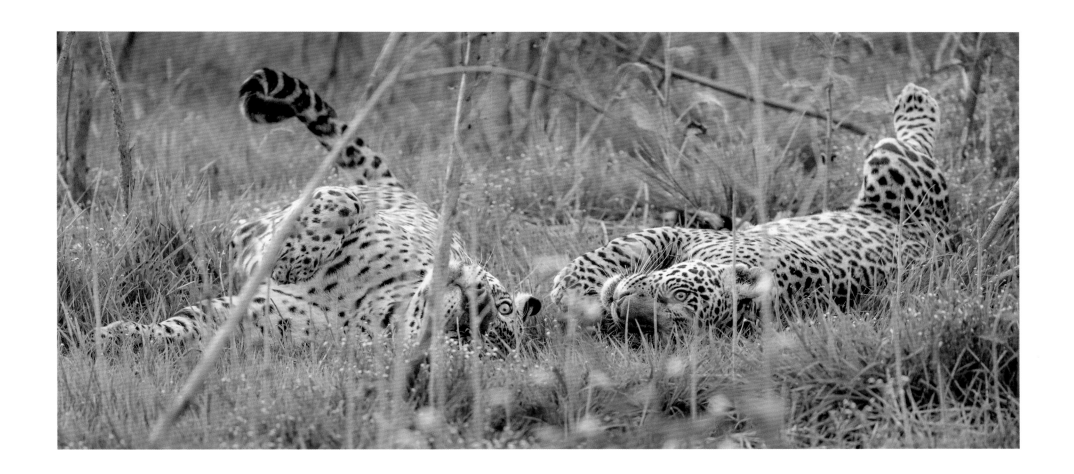

▶ Exhilarated at what we have just seen, we decide it's best to return to the lodge for the time being.

At 3:30pm we are back in the vehicle, this time making a more sedate pace, heading back to the waterhole. Will our quarry still be there? As we approach, we can see that the research vehicle is still there. And as we round the bend, so is the mother, now sitting on the ground near water. We pause and take some photos from a distance, for we don't know how the jaguar will react if we go closer. She seems relaxed enough, and after a while we ask the researchers if we can move closer. They radio back to confirm it's OK, and we move to within about 10 metres (33 feet). She is still relaxed and just sitting and looking around.

After about an hour she gets up and walks off behind the same stand of trees where we saw the cub this morning. Now, this is when we get the advantage from being in a vehicle rather than a boat. In a boat, the encounter would now have been over. But here we simply drive around, park near the jaguar and continue the encounter. This feels like being on an African safari, except of course, the cat is rather different!

And then we hit the jackpot! The cub wanders up and starts to play with its mother. It is now late afternoon, the light is already fading, and the vegetation is rather dense. Does it matter? No, this is the sort of jaguar encounter you would struggle to get anywhere else. ●

Right: These two male cubs are pretty much fully grown. They have already left their mother — or she has left them — but are sticking around as brothers and hunting successfully together. Eventually they will split off and go their separate ways - probably when they find themselves fighting over a female!

Cuiaba River and tributaries, Pantanal, Brazil
Nikon D5 + 180-400mm f4 lens + 1.4x extender at 490mm;
1/1600 sec at f5.6; ISO 800

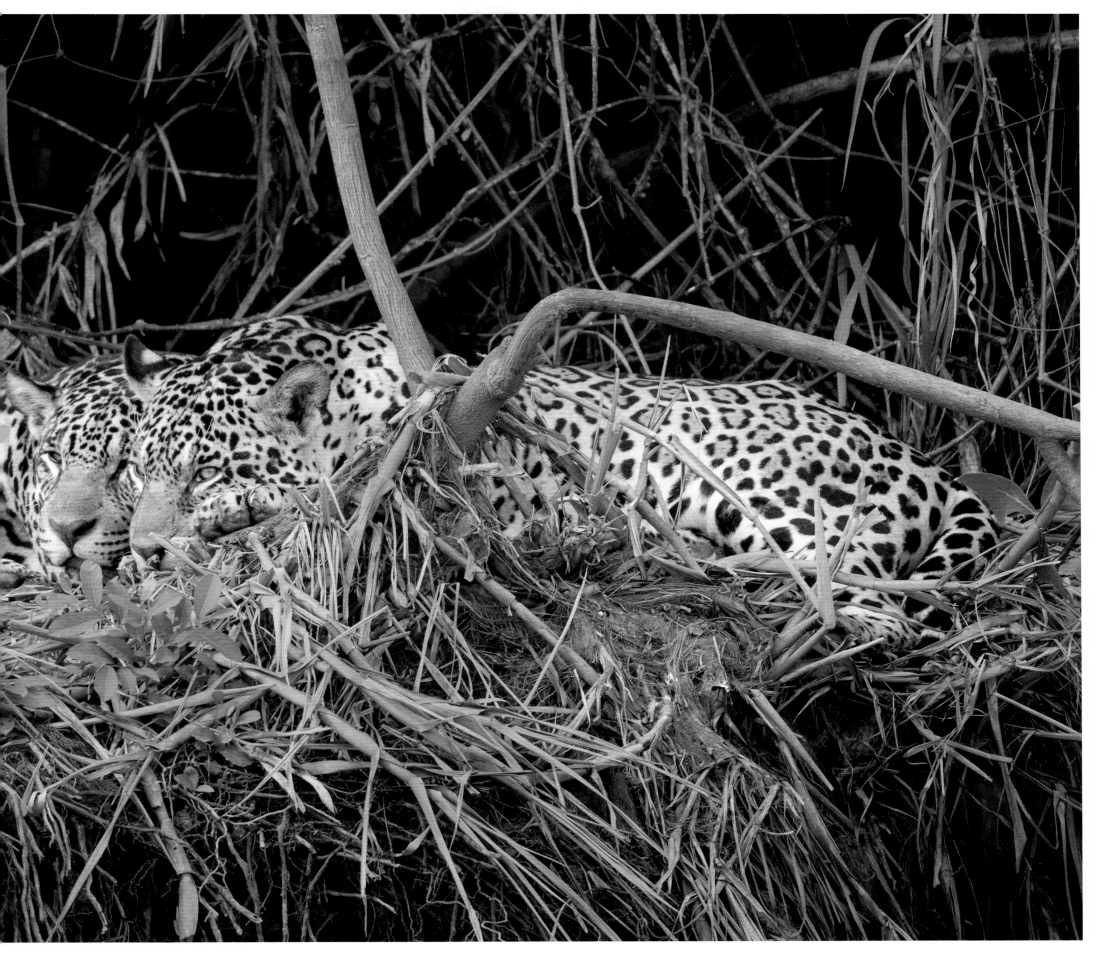

Planning your ultimate jaguar safari

The Pantanal in Brazil is the world's largest tropical wetland, approximately seven times larger than Florida's Everglades. There are a number of locations within this vast area where jaguars are habituated to tourists, giving visitors a good chance of seeing one of the largest apex predators in the Americas.

When to visit?

Choosing the best month to visit is a compromise between comfort levels, sighting frequency and tourist numbers. When the rainy season ends around April/May each year, the area is almost completely flooded. The jaguar's main prey species such as capybara and caiman generally stay close to water, so at that time of the year they are spread out over a huge area. As the dry season progresses and the water dries up, these animals become more and more concentrated at the remaining water, basically the main rivers and their tributaries. The jaguars will be close to their potential prey, which is the reason that most jaguar-watching in the northern Pantanal is from boats on these rivers. To have a good chance of finding jaguars, you have to come in the dry season, so most wildlife enthusiasts visit here between late June through to early November. Each year water levels vary, but as the dry season progresses and the water recedes more and more, the chances of sightings increase. Consequently, September and October are the peak tourist months, but visitors need to put up with the very high temperatures. By November and December, although there is normally little rain in this area, the rainy season will already have started in the hills and mountains upstream. Once again water will start flooding into the area, bringing the 'jaguar-watching season' to an end.

Where to go?

I have three favourite locations, all of which I can recommend.

Hotel Pantanal Norte, Porto Jofre, northern Pantanal

Located at the southern end of the famous Transpantaneira Highway, this hotel sits right beside the Cuiaba River. Jaguar-viewing in this area is from speedboats. The boat dock is a few metres (yards) from the rooms, making it the ideal location to access this most visited section of the Pantanal. Of the three locations, the Cuiaba River probably offers the best chances of seeing jaguars, but it will usually be busy with lots of other boats around. There are also alternative lodges near Porto Jofre and a number of 'flotels' (floating hotels) just a short distance upstream. Whilst the flotels tend to be a little nearer the main jaguar viewing area, lodges offer the added benefit of seeing and photographing other wildlife, particularly birds, in their grounds.

For my 'Ultimate Cuiaba River Jaguar Safari', in the second half of October, I stayed at Hotel Pantanal Norte for six nights, booked through and guided by Brasil Aventuras, a Brazilian wildlife tour company.

Recommendation summary
Location: Porto Jofre, Cuiaba River, northern Pantanal, Brazil
Best time to visit: October
Getting there: Fly to Cuiaba from Sao Paulo, then by road transfer down the Transpantaneira Highway (5-6 hours). Alternatively, fly by light aircraft to the on-site airstrip
Access: Twice daily speedboat excursions
Duration: 6 days
Accommodation: Hotel Pantanal Norte
How to book: Through a specialised tour company

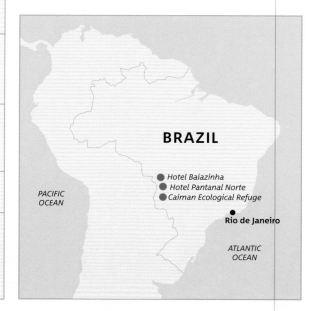

When to visit?			
	Mid-June/Mid-August	**Mid-August/September**	**October/early November**
Climate/ temperature	The dry season is getting underway, but temperatures are still relatively comfortable. The occasional cold front comes through, when it can be very cold for 2-3 days, with few sightings. However, immediately afterwards there can be lots of good animal activity	Temperatures are becoming much higher, particularly from mid-morning onwards	Peak of the dry season, with daily highs often in the range of 38-45°C (100-113°F)
Water level	It will vary year to year, but is relatively high, meaning wildlife may be spread out and more difficult to find	Water levels are at their lowest, concentrating wildlife near to large rivers and their major tributaries	Water levels remain low, but may begin to rise a little from early rains upstream
Jaguar-spotting active,	Generally good, but more challenging in years with high water levels or during a weather cold front	Very good. Jaguars remain active hunting along rivers even during the heat of the day	Very good. Jaguars remain hunting along rivers even during the heat of the day
Comfort	High. Comfortable temperatures	Moderate. High temperatures in the middle of the day	Uncomfortably high temperatures
Tourist numbers	Moderate, can be busy at some jaguar sightings	Very high — peak season. Lots of boats at most jaguar sightings	Moderate to low. More enjoyable sightings as there are fewer boats, particularly towards the end of October and in early November

Hotel Baiazinha, Paraguay River, Northern Pantanal

The Paraguay River is the main river of the Pantanal system, and this hotel is located on the riverbank. Jaguar viewing is from speedboats. Whilst there may be fewer jaguar sightings in this area in comparison to the Cuiaba River near Porto Jofre, the beautiful unspoilt scenery of rivers, lakes and granite hills offers stunning photographic potential. There are very few boats operating here, so the jaguar encounters are with only a couple of other boats, or you may have them all to yourself!

For my 'Ultimate Paraguay River Jaguar Safari', in the second half of October, I stayed at Hotel Baiazinha for four nights, booked through and guided by Brasil Aventuras, a Brazilian wildlife tour company.

Recommendation summary
Location: Paraguay River near Cáceres, northern Pantanal, Brazil
Best time to visit: September and October
Getting there: Fly to Cuiaba from Sao Paulo, then by road transfer (4 hours)
Access: Twice daily speedboat excursions
Duration: 6 days
Accommodation: Hotel Baiazinha
How to book: Through a specialised tour company

Caiman Ecological Refuge, southern Pantanal

This ecolodge lies in a huge 53,000 hectare (130,000 acre) cattle ranch, which operates as a spectacular private nature reserve. The centre conducts ground-breaking research, conservation and ecotourism, and offers the best wildlife viewing in the southern Pantanal. Wildlife viewing is all by safari vehicle, offering very different photographic potential to boat-based tours. Project Onçafari is a jaguar research and ecotourism initiative based in the reserve. For research purposes a small number of jaguars have radio collars, which makes finding these particular animals relatively easy.

For my 'Ultimate Caiman Ecological Refuge Jaguar Safari', in October, I stayed at Caiman Ecological Refuge for six nights, booked through and guided by Brasil Aventuras, a Brazilian wildlife tour company.

Recommendation summary
Location: Caiman Ecological Refuge, southern Pantanal, Brazil
Best time to visit: August-October
Getting there: Fly to Campo Grande from Sao Paulo, then by road transfer (4 hours). Alternatively, fly by light aircraft to the on-site airstrip
Access: Safari vehicle
Duration: 6 days
Accommodation: There is a choice between a small number of similar lodges spread around in the central section of the reserve
How to book: Through a specialised tour company

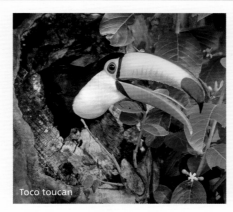
Toco toucan

What else might I see?

The Pantanal teems with wildlife. There are the main prey species of the jaguar, such as the capybara and yacare caiman. Another apex predator, the giant river otter, is frequently seen travelling along the rivers in family groups hunting for fish and eels. There are huge numbers of spectacular birds: around the lodge you may see the hyacinth macaw and toco toucan, and out on the river, birds such as the cocoi heron and roseate spoonbill.

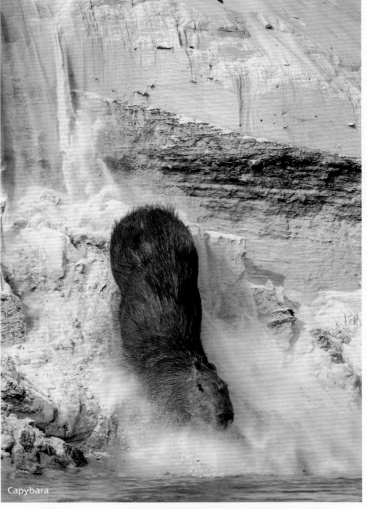
Capybara

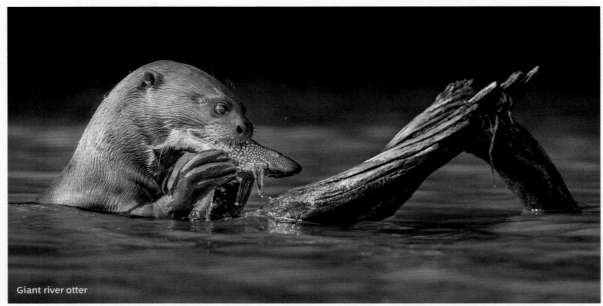
Giant river otter

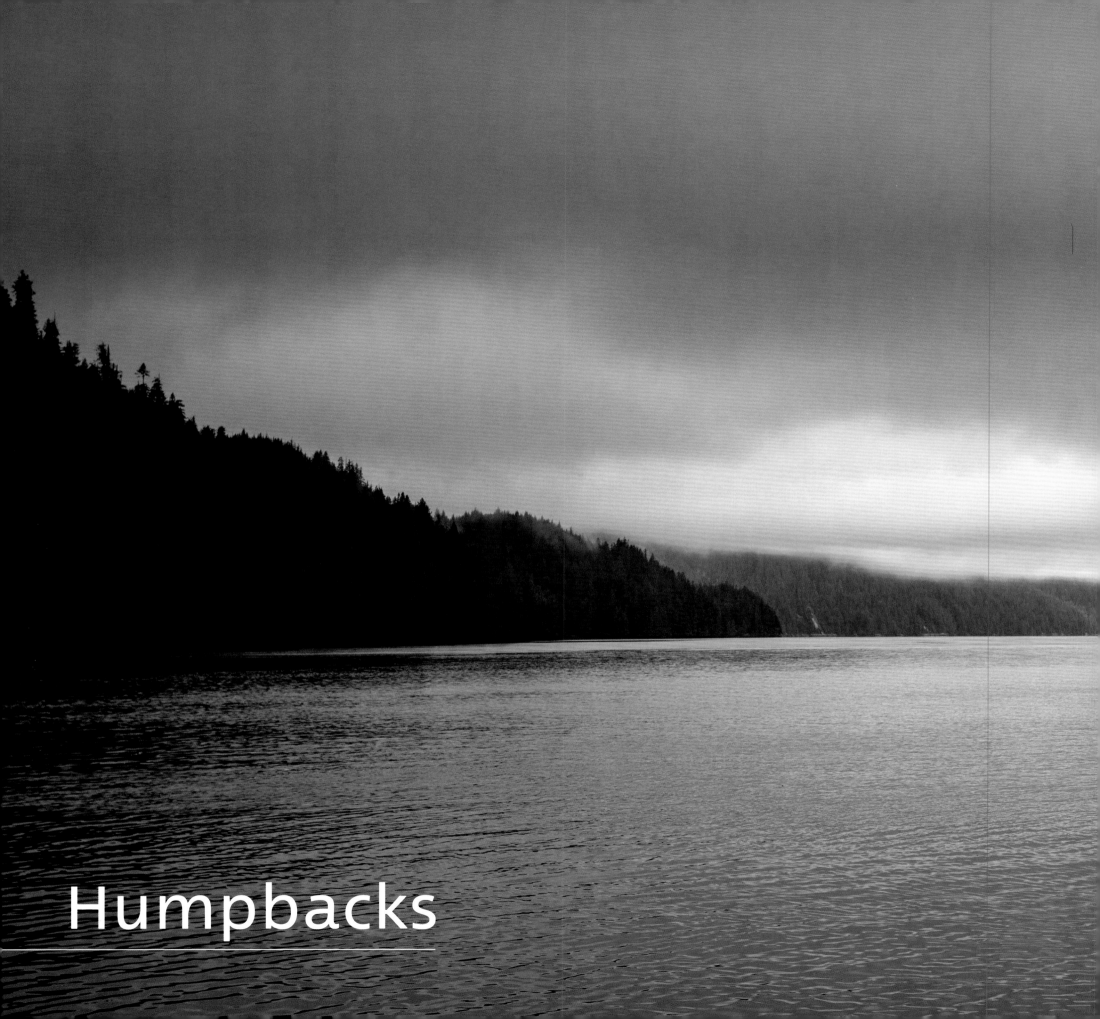

Humpbacks

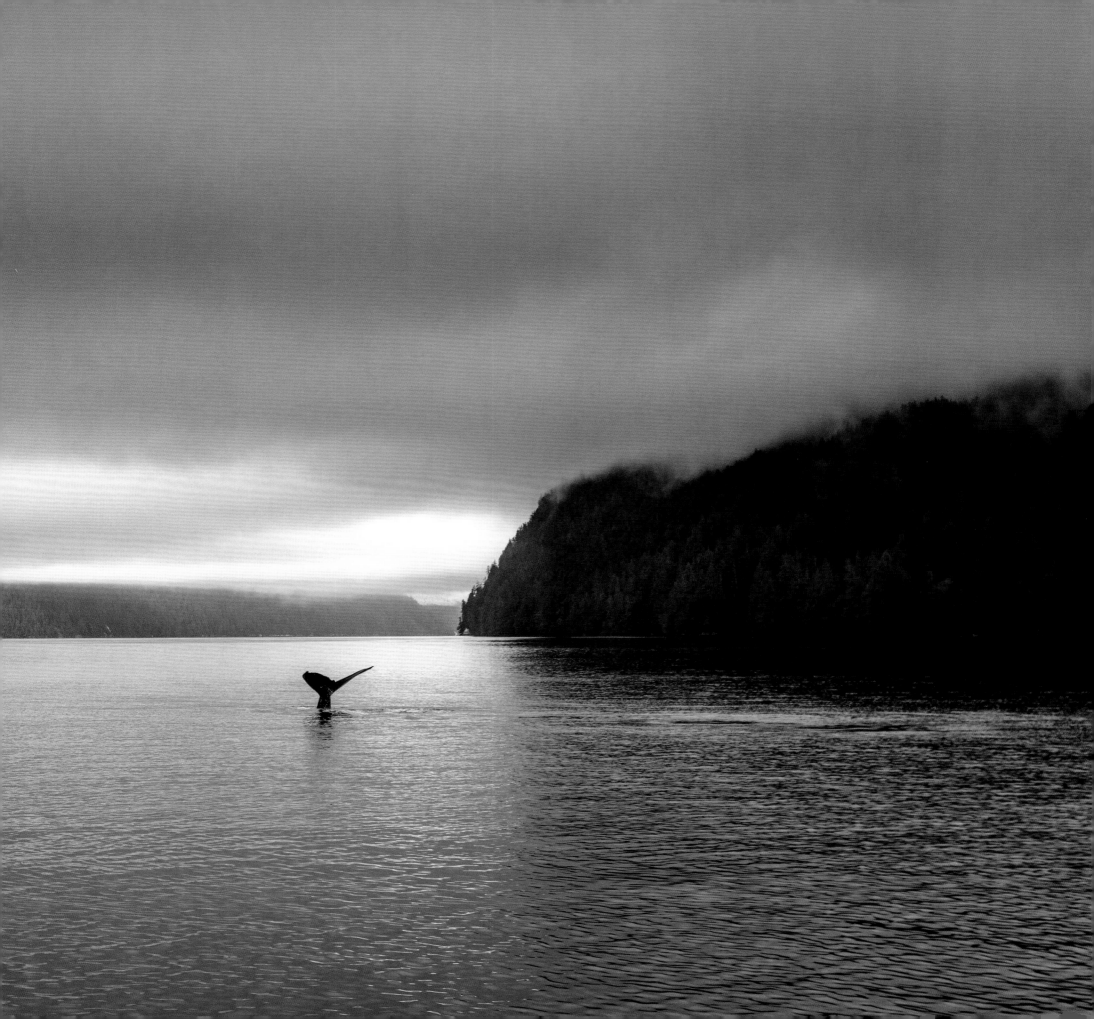

In my early days of wildlife photography, I had a discussion with a very experienced photographer about which animals he most enjoyed photographing. At one point the topic got on to whales. 'Waste of time.' he said, 'They don't do anything!'

I beg to differ. Of course, from a photography perspective, whales are a tricky subject — especially if you want to stay dry yourself. They spend most of their time underwater, and even when they finally surface, you often only see a tiny percentage of the animal.

But not all whales are the same, and among the 90 species of cetacean (whales, dolphins and porpoises), there are many diverse forms and various behavioural and photographic opportunities. Humpbacks in particular exhibit very interesting behaviour and make superb photographic subjects.

The humpback is one of the largest species of baleen whale, growing up to 16 metres (52 feet) in length and weighing up to 36 tonnes (40 tons). It is one of the most approachable and curious whales, making it a favourite for whale-watching operations. Having a 30 tonne giant launching itself from the sea is an awe-inspiring sight. The humpback's varied and highly visible behaviour is a joy to watch and a rewarding challenge to photograph. Even their breath is a spectacle. And then there's tail-lobbing, flipper-slapping, bubble-net feeding, and fluking — the list goes on and on — humpback whales do a lot!

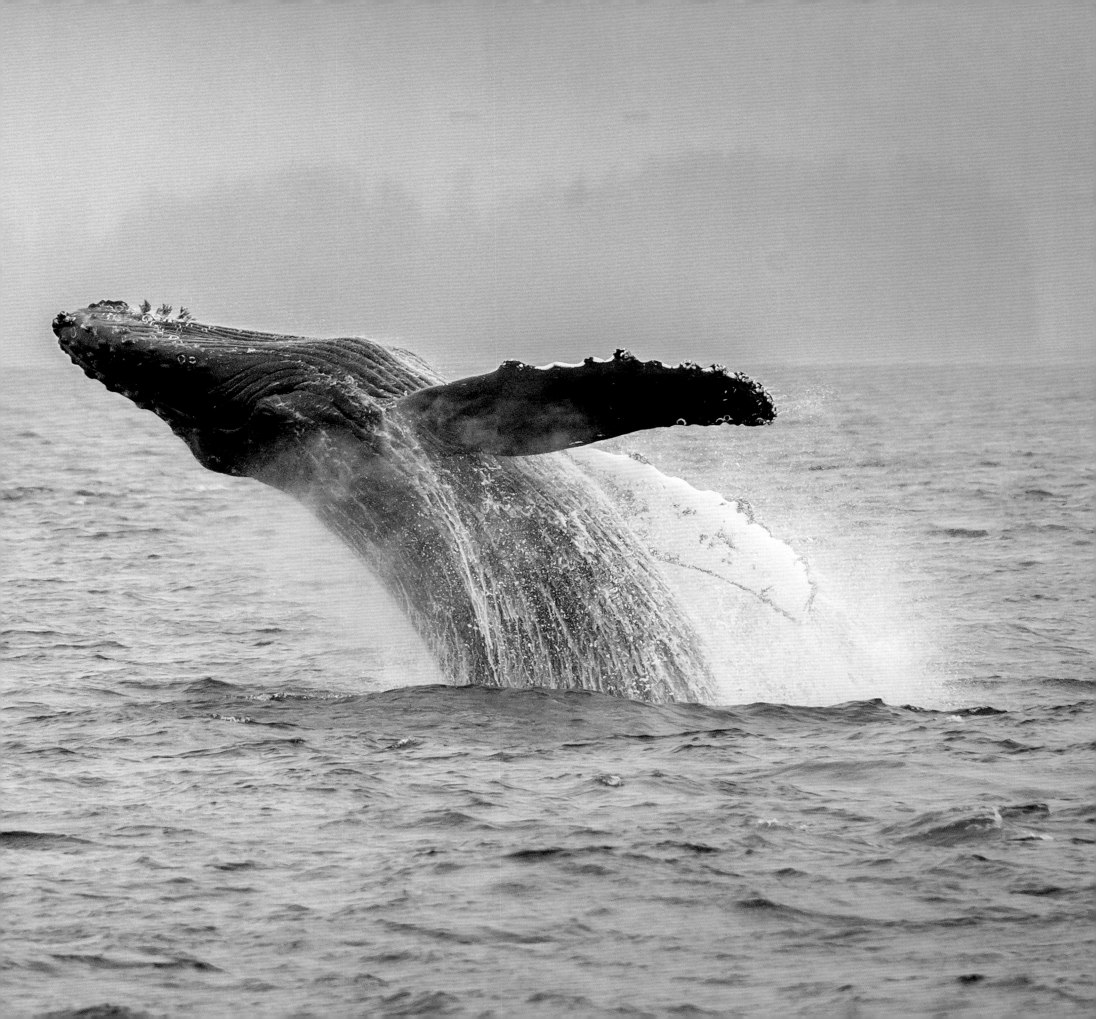

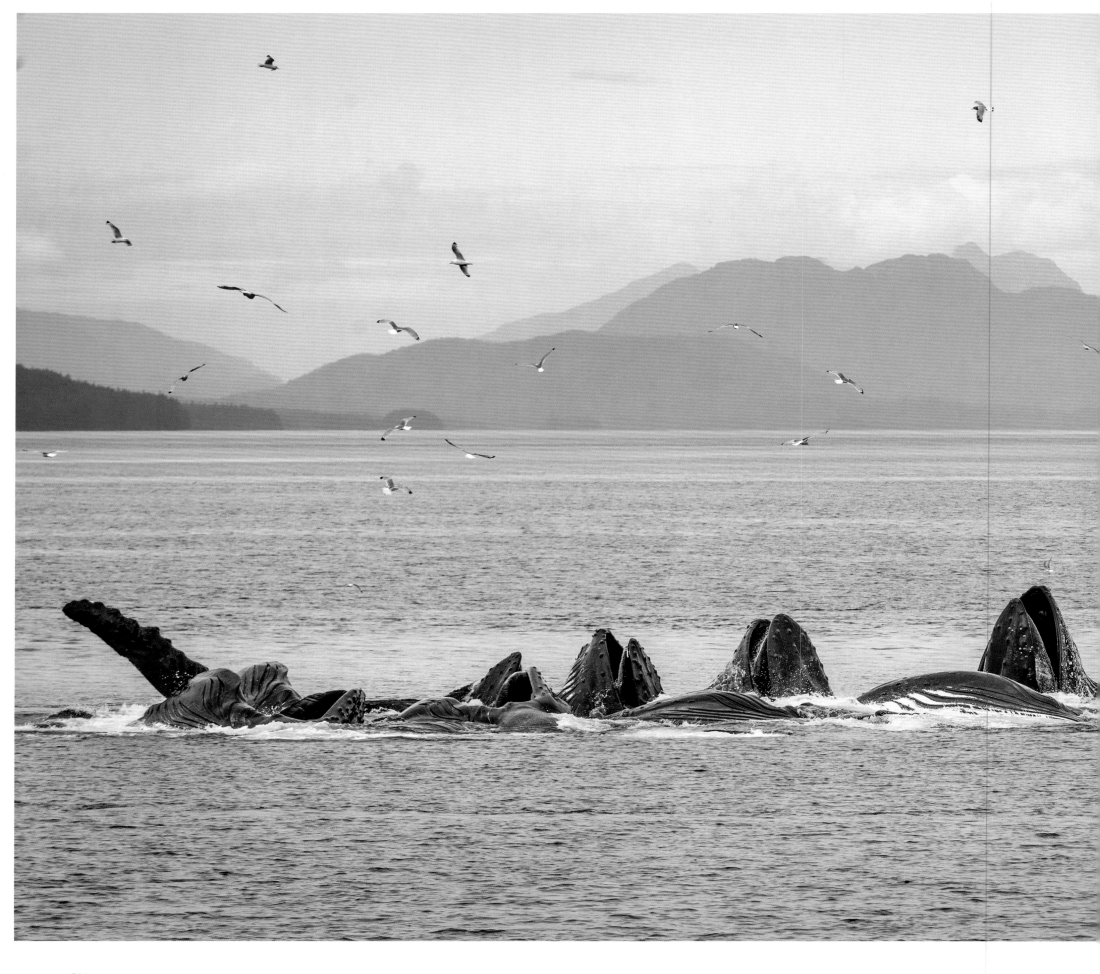

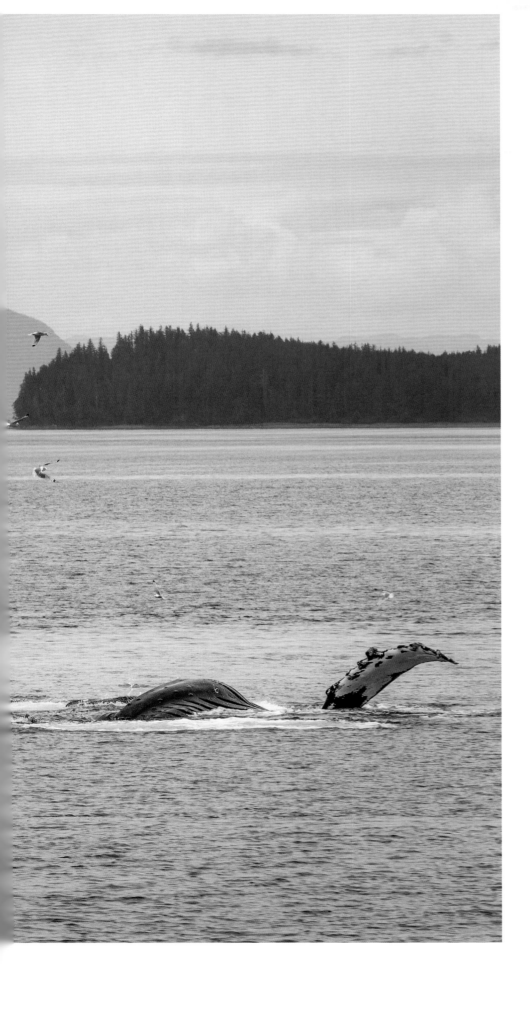

The gulls know

'We will not be stopping for these humpbacks.' The captain's words are clear, but why? Every day so far, we have seen humpback whales, sometimes alone, sometimes in small groups, known as pods.

The captain had gathered us all together for this briefing. All, in this case, means the seven passengers on our small live-aboard boat. It was a dull drizzly dawn in south-east Alaska's Inside Passage. This long thin stretch of sea is sheltered from the swell and storms of the Pacific Ocean by a string of hundreds of islands. It is a haven of calm water and abundant wildlife.

The captain goes on to explain that today is going to be different — we are on a specific mission. We are looking for 'bubble-net feeding whales'. He has reports that whales have recently been seen in the area using this co-operative feeding method, and we are going to try to find them. If we stop at every humpback we will lose a lot of time, so we will carry on until we find the bubble-net feeding group. The anchor is raised, and we're off.

Almost immediately we come across a couple of humpbacks gliding through the water. Cameras are poised, but to no avail, for the captain sticks to his word, and we sail on past them.

After about an hour we see some faraway blows, further down the channel. The captain spots something that he likes, he gives a thumbs-up, and revs the engine to full throttle. Even though we are still a long way off, we know that we have found what we are looking for.

We arrive, staying about 100 metres (110 yards) back from twelve hump-back whales together on the surface. A series of blows as they fill their lungs ready to dive. A tail fluke rises into the air as one dives, and now one after another they all dive, leaving just a series of curious circular disks of flat water on the surface, known as fluke prints.

For a while we just see lots of gulls flying around, seemingly aimlessly. We scan and scan the surface but can't see the whales. Where are they? We don't know. But the gulls know. They are flying over as a group to a spot on our right. Looking across towards them, we vaguely hear a haunting wooing noise coming from the water. Now a frothy ring of bubbles breaks the surface. Suddenly, but in seemingly slow motion, twelve huge agape mouths burst up into the centre of the ring, lunging at the school of herring they have corralled into their fizzing net of air.

It is eight o'clock in the morning, and we have already found our bubble-net feeding group: mission accomplished. But the day doesn't end with this sighting: it continues on and on. As we stand on the deck, we watch a dozen whales repeat and repeat one of the animal kingdom's most intelligent and sophisticated feeding techniques. We are the only boat here. After nine hours, when we decide it's time to leave them to it, they are still feeding and we must have watched this extraordinary act more than a hundred times. ●

Right: Zooming in close on one of the bubble-net feeders reveals the mechanisms of this lunge-feeding technique. The whale bursts to the surface with its mouth wide open, its lower jaw scooping up small fish as it does so. As it closes its mouth, the baleen plates — those hair-like strands hanging down from the upper jaw — form a sieve, retaining the fish as the water is squeezed out through them.

Right: Inside Passage, SE Alaska, USA
Nikon D3X + 300mm f4 lens;
1/1000 sec at f6.3; ISO 200

Title pages:
Inside Passage, British Columbia, Canada
Nikon D850 + 17-35mm f2.8 lens at 35mm;
1/160 sec at f7.1; ISO 250

Introduction pages:
Inside Passage, SE Alaska, USA
Nikon D5 + 80-400mm f4.5-5.6 lens at 400mm;
1/2000 sec at f9; ISO 5600

Previous page:
Inside Passage, SE Alaska, USA
Nikon D3X + 70-200 f2.8 lens at 200mm;
1/640 sec at f8; ISO 200

Photographic tip
The best from bubble-net feeding

Getting low helps to emphasise the height of the whales as they emerge from the water. However, to see the ring of bubbles and all the whales' heads, the opposite applies: you need to be as high as possible. If you are lucky enough to see a number of feeding sessions, the solution is to photograph from both perspectives.

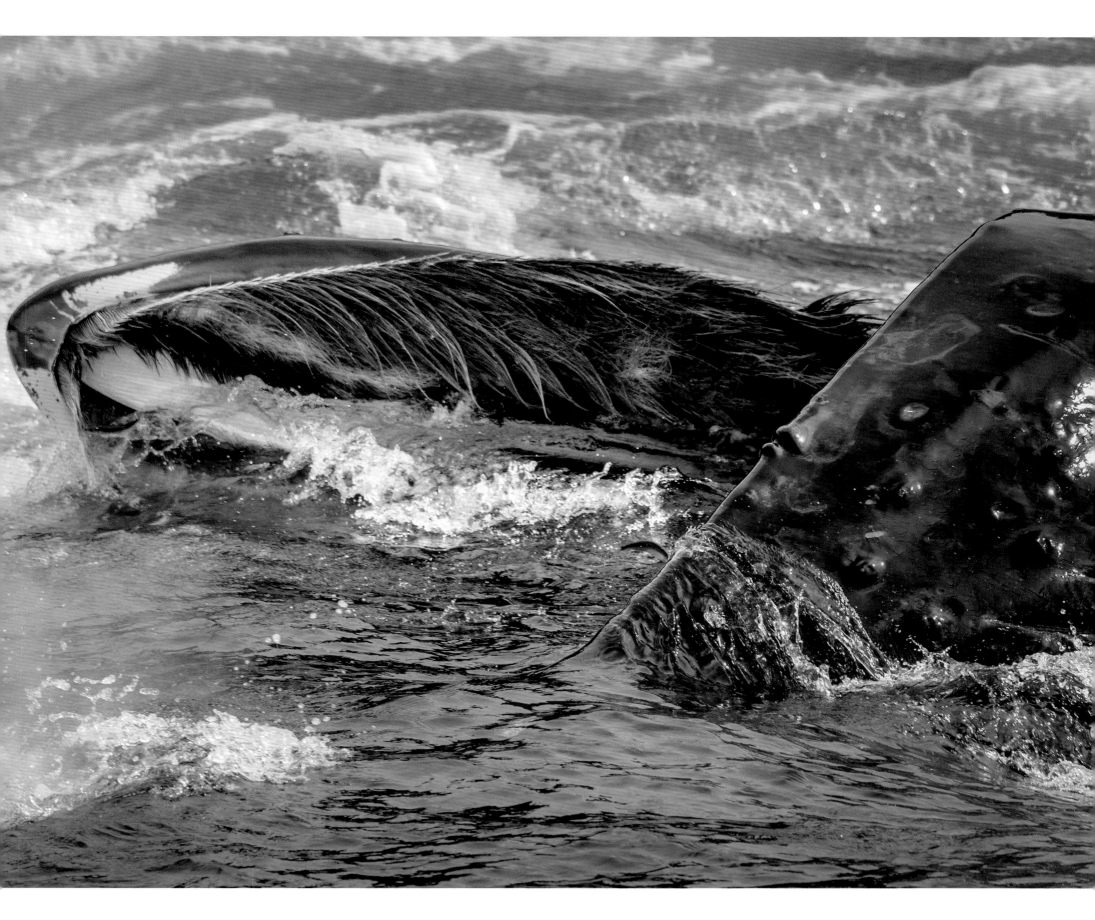

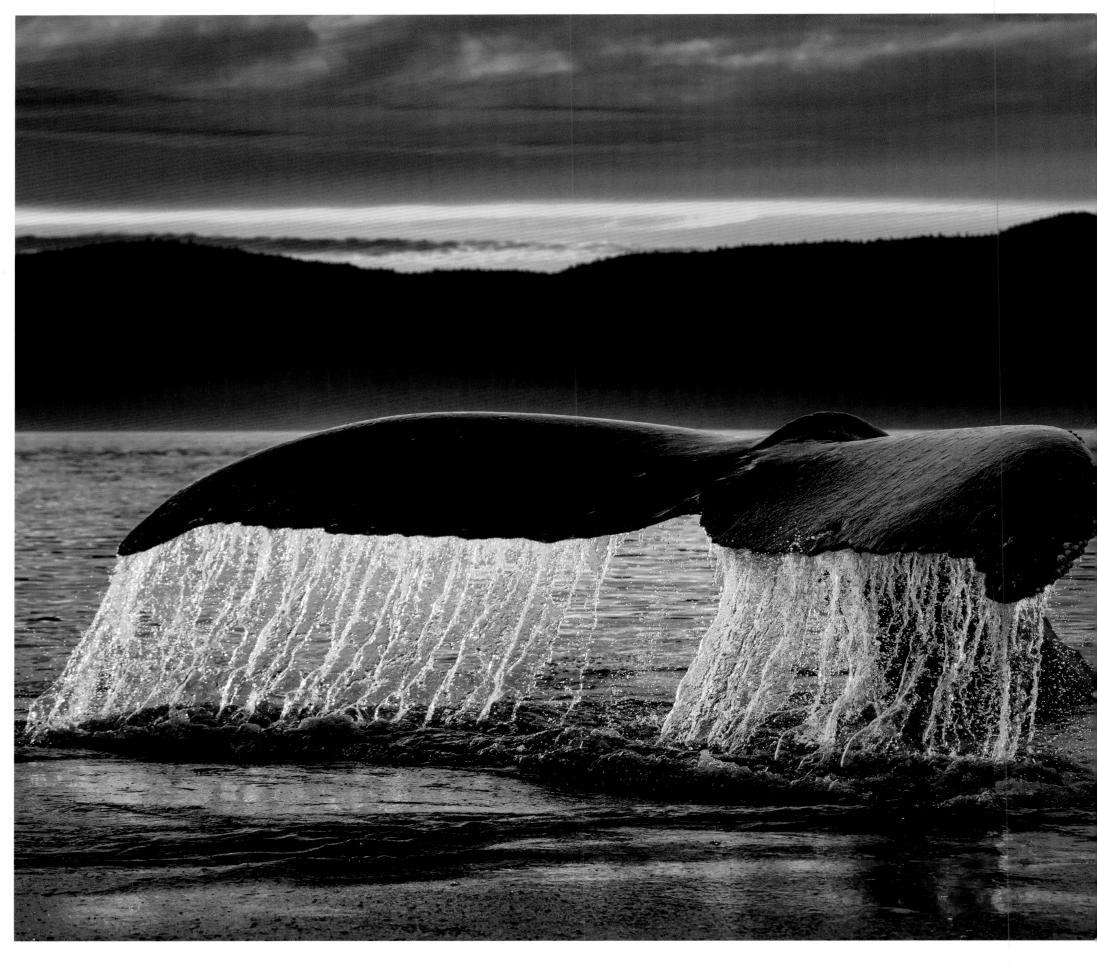

Conspiracy

We are at anchor in a small bay in Alaska's Inside Passage. Dinner is over, and we are relaxing in the lounge discussing the day's events. The captain wanders across to join us. He suggests it is a nice evening to go out and explore the area and offers us three options. Firstly, there is a small island just to our north: it is bear-free, so safe for anyone who wishes to go for a walk and look around, and he will ferry those who wish to go to the island with the Zodiac (a type of small rigid inflatable boat). Secondly, once he returns, he will take the Zodiac to explore around the bay and maybe out into the main channel, just to see what wildlife there is around. Or finally there's the opportunity to stay and relax on the boat.

Of the twelve passengers, half of us decide to take up the Zodiac cruise option. We grab our cameras, put on our weather-proof gear and life vest, and wait at the gangway for the boat. Once aboard, we head off to explore. The sun is low in the sky; it looks as though it is going to be a beautiful sunset. Along the shoreline we see a few birds pecking around, but nothing special, so we head out into the open water of the main channel.

Once there, we find ourselves surrounded by a big pod of humpback whales. There are dozens of them repeatedly deep diving. Individually they are disappearing below the surface for ten or more minutes, but as there are so many, there are always a few on the surface. One dives right next to our boat. It is a breath-taking moment as the huge tail fluke towers above us, a waterfall of water pouring off. With the golden light of the setting sun behind, it makes an incredible spectacle. Again, and again, whales come close to us and then dive. This is without doubt the top sighting of the whole trip.

Now a young calf starts to take an interest in our boat. Its mother has just dived and, left alone on the surface, it decides to visit us. As it waits for mum to return, we are a source of entertainment! This could be dangerous — for us, not the calf — as at about six months old, it already weighs many tonnes and could capsize the small boat. We keep moving away, but the calf keeps following, curious, trying to nudge the Zodiac. It's time to go.

As we head back to the ship, we realise that there is a problem. The rest of our shipmates haven't witnessed this amazing spectacle. We all had the same options and made choices, it just turned out that ours was the lucky one. How would it feel to have missed this? What should we say to say to the others? We conspire to downplay the sighting — and a strategy of circumspect understatement is quickly agreed. ●

Left: Inside Passage, SE Alaska, USA
Nikon D5 + 80-400mm f4.5-5.6 lens at 80mm;
1/1600 sec at f7.1; ISO 3600

**Photographic tip
Use a Zodiac**

The best views of humpbacks diving come from the low perspective of a rigid inflatable boat, such as a Zodiac. The whale's fluke towering above you, silhouetted against the sky, is the shot to try to get. Whenever it is safe and practical to deploy a Zodiac, try persuading the crew to launch one. Big telephoto prime lenses are not really practical to use from these types of boat, particularly with whales where you require loads of flexibility in framing the shot.
The best choices are telephoto zoom lenses such as the 80-400mm or 100-400mm.

Right: This is the moment I was waiting for, when the whale would lift its tail against the mountain backdrop, back-lit water falling from its flukes. When humpbacks come to the surface they breathe through a sequence of shallow dives — perhaps three or five times — and then arch in preparation for a deep dive. So it is possible to predict when a humpback will 'fluke': raising its tail to propel it downwards.

Inside Passage, SE Alaska, USA
Nikon D5 + 80-400mm f4.5-5.6 lens at 195mm;
1/2000 sec at f8; ISO 2500

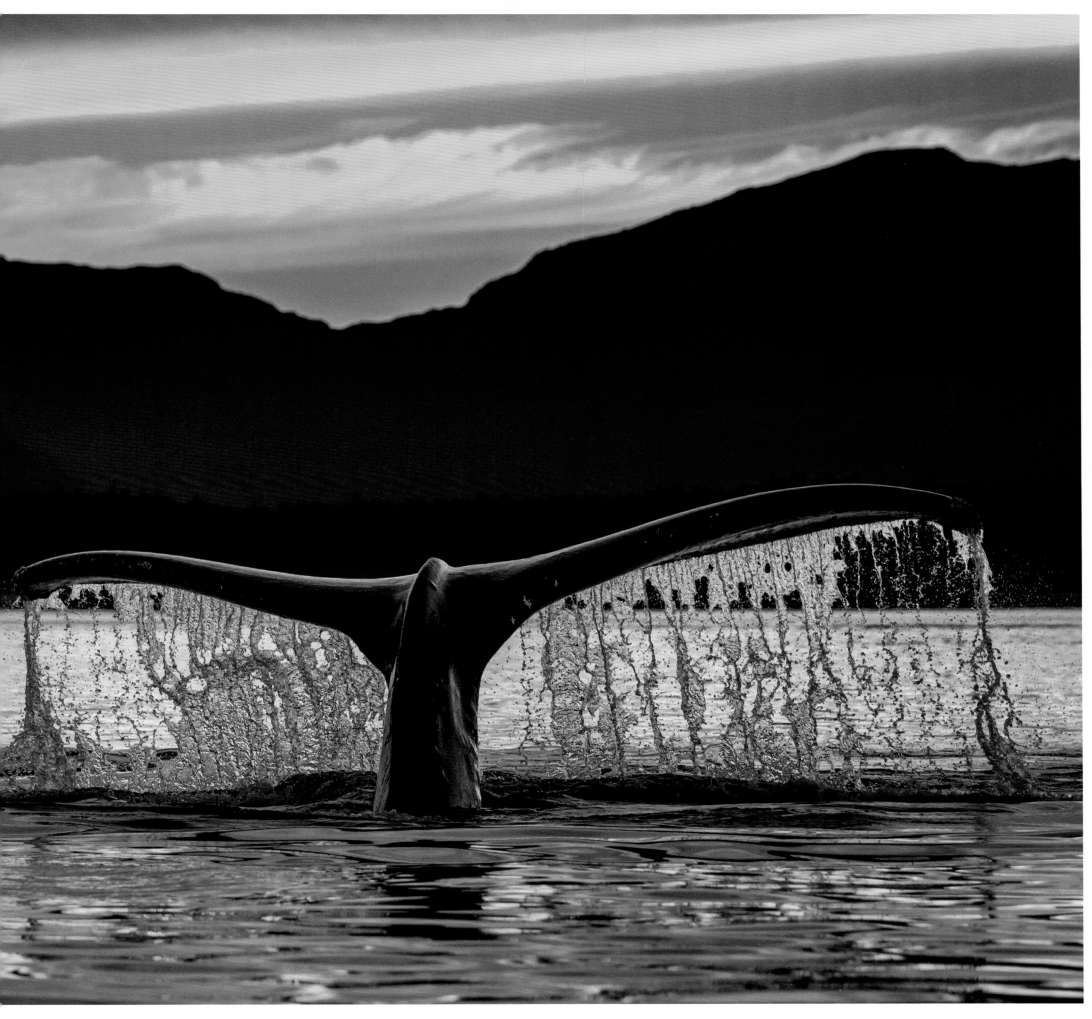

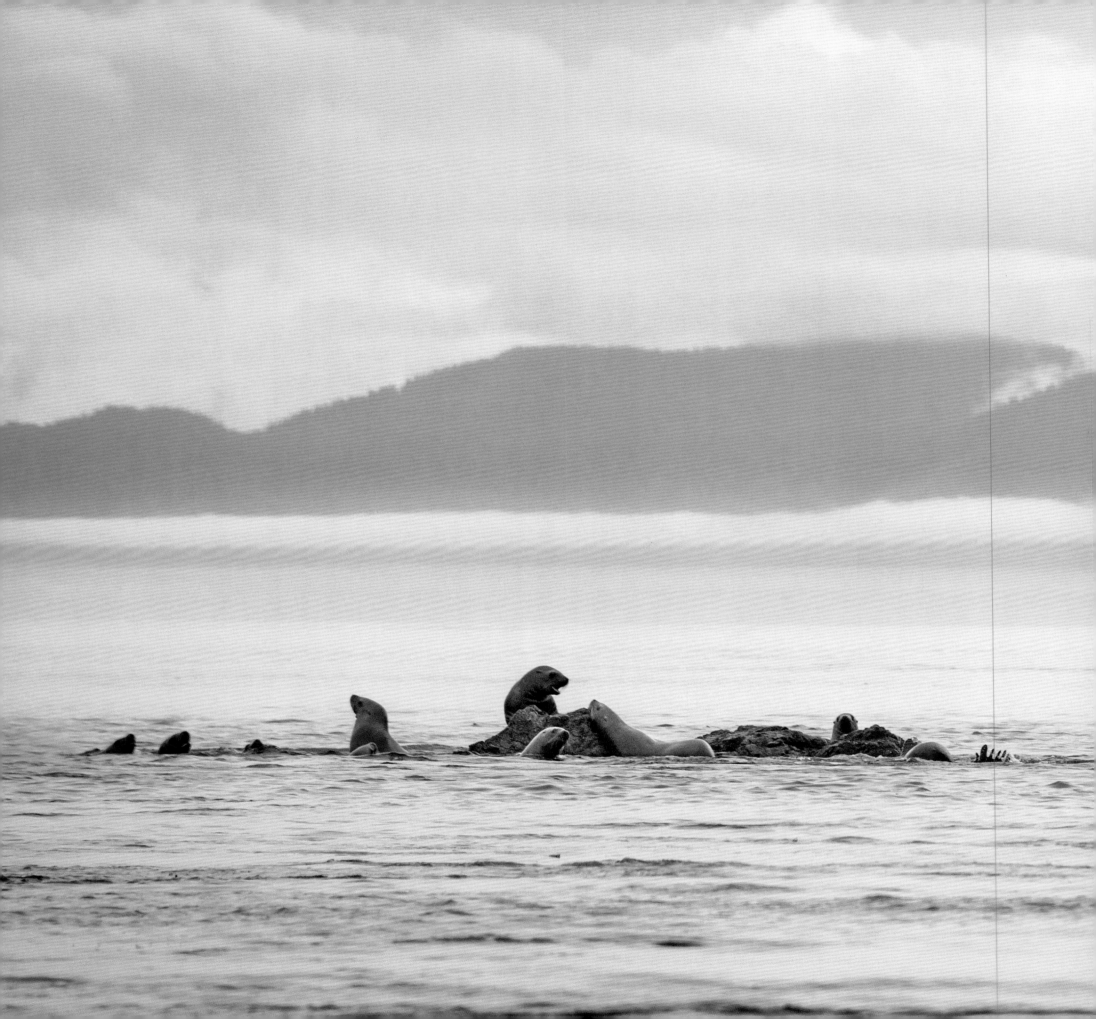

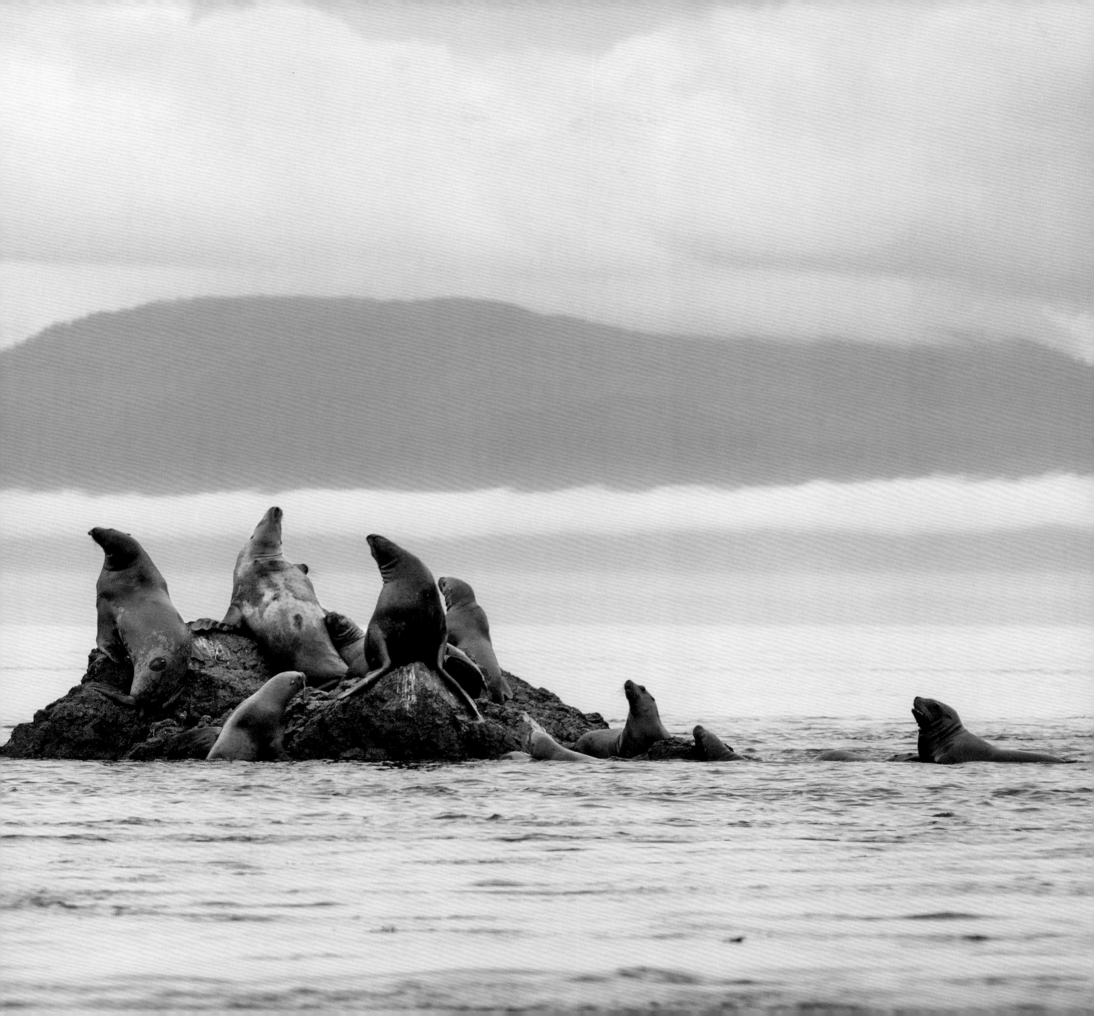

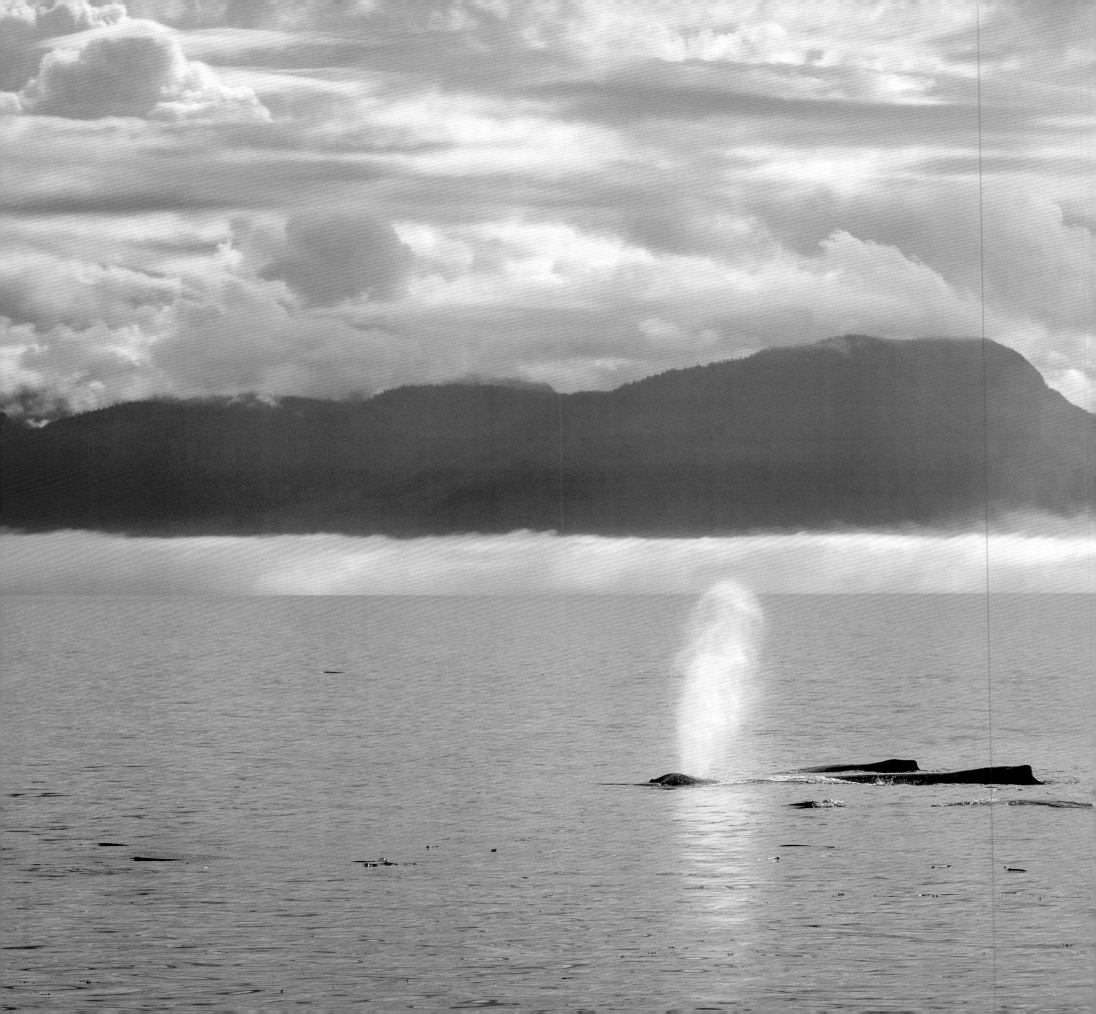

Previous spread: Steller sea lions resting on a rock in South East Alaska. This is the same location where just a few hours later I watched the whales fluke at sunset. South East Alaska is an astonishing place, with exceptional wildlife and stunning scenery. I wanted to capture the atmosphere, the expansiveness and the dreamy lines of cloud. This coastline is rainforest, and it is often cloudy or raining, which gives a softness to the light and the sky.

Inside Passage, SE Alaska, USA
Nikon D5 + 80-400mm f4.5-5.6 lens at 310mm;
1/1250 sec at f11; ISO 800

Left: It's always hard to know how many whales you are seeing at one time, as some may be underwater. I think there were about seven in this group. This is such a characteristic scene of the South East Alaskan coastline, with the whales just cruising along, their humped-backs dark against the gentle blues and greys of sea and sky, the brightness of the back-lit blow. What you can't see is the sound. From the boat we could hear the high-pitched whistling, 'whoosh whoosh' of their breath. Sometimes we'd be lying in our beds onboard at night, and we could hear the whales blow as they passed us.

Inside Passage, SE Alaska, USA
Nikon D5 + 80-400mm f4.5-5.6 lens at 165mm;
1/1600 sec at f13; ISO 250

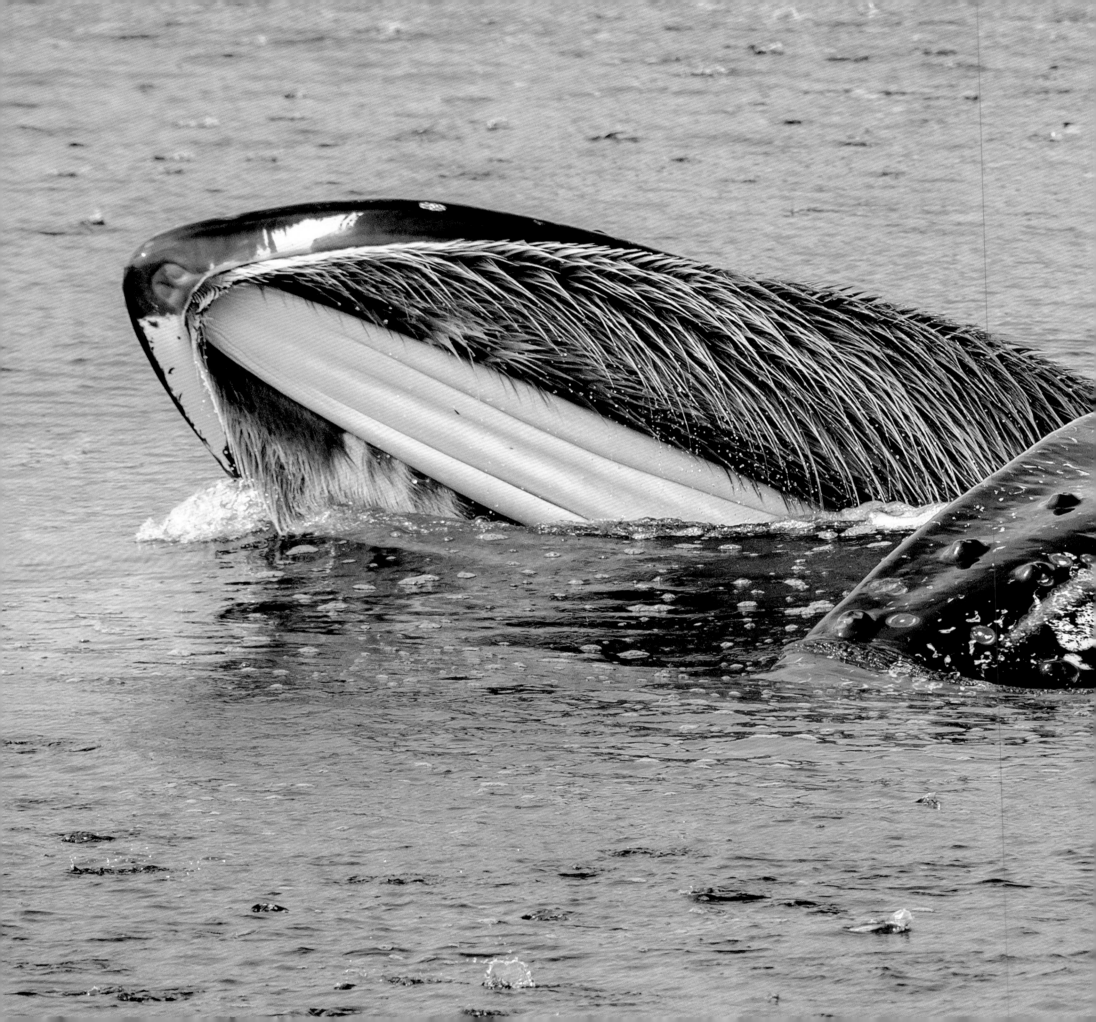

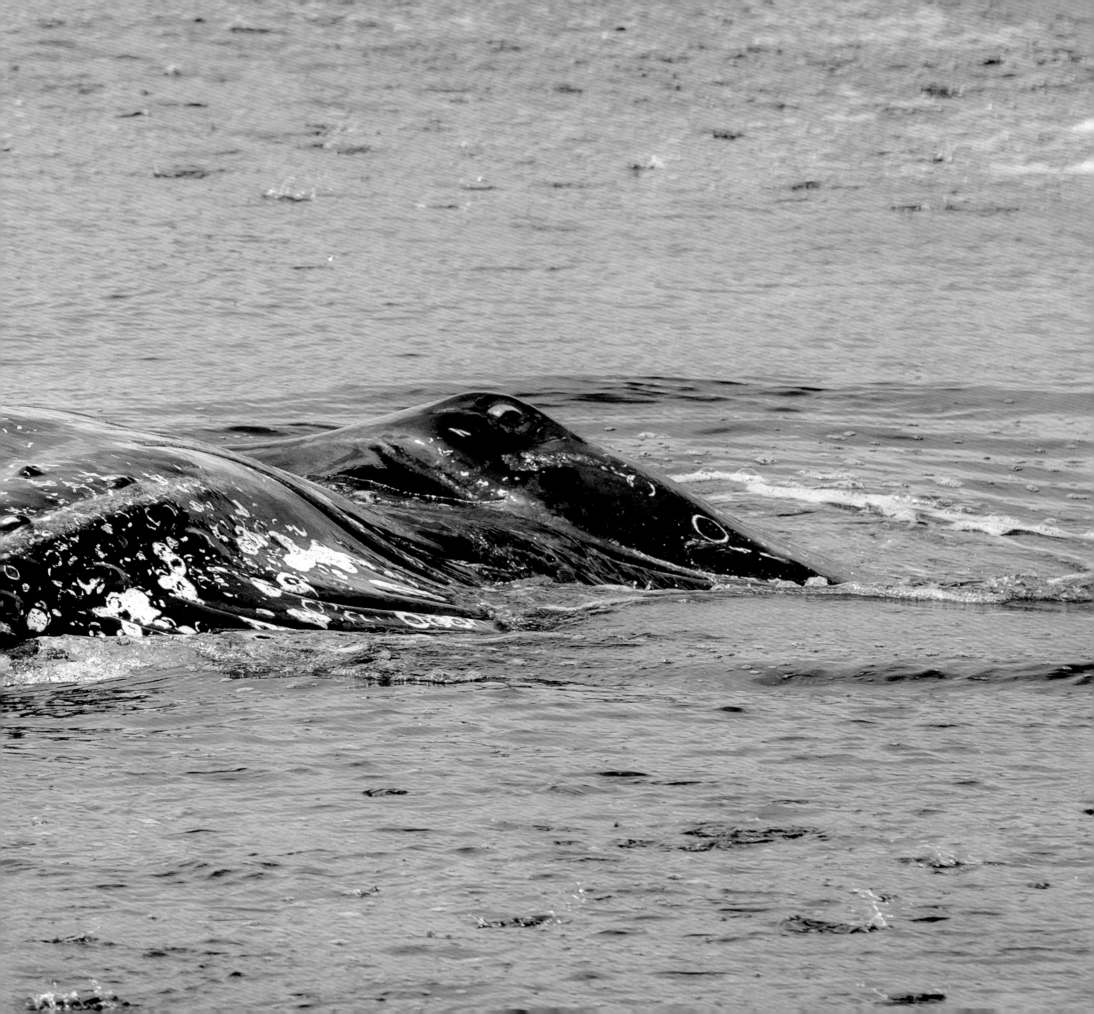

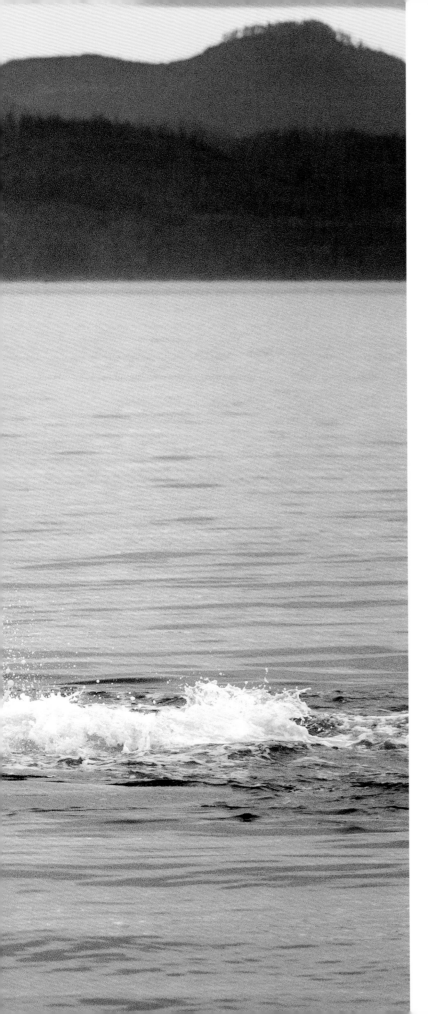

Previous spread: This whale was lunge-feeding and as it surfaced, I could again clearly see the baleen plates coming down from its upper jaw, and the pink of the palate in its upper jaw. Baleen is made of keratin, the same substance as hair and nails and turtles' shells. The raised dark bumps, seen here on the underside of the lower jaw are found all over the head of humpback whales, and are actually giant hair follicles. This unusual angle takes a bit of deconstructing to work out which bit of whale is which! For me, this photograph is all about the eye. It's really unusual to see the whale's eye. It was watching us as we watched it feed.

Inside Passage, SE Alaska, USA
Nikon D5 + 80-400mm f4.5-5.6 lens at 290mm;
1/1000 sec at f11; ISO 2500

Left: A humpback 'lob-tailing': thumping its tail down on the water's surface, creating a resounding smack which carries a long way, above and below the water. Humpbacks do this repeatedly, and we are not sure why, but it seems to be communicating something to the other whales, perhaps anger or annoyance?

Inside Passage, SE Alaska, USA
Nikon D5 + 80-400mm f4.5-5.6 lens at 195mm;
1/1000 sec at f5.6; ISO 3200

Photographic tip
Support matters

Method		
	●	Recommended
	○	Possible use
	●	Not recommended
Handheld	●	Although the light can be tricky at times, you have little alternative but to handhold on a moving ship or Zodiac. Keep the shutter speed as high as possible. Your body also helps absorb some of the boat's movement and engine vibrations.
Beanbag	●	A beanbag doesn't really work on a Zodiac, as it continuously follows and often amplifies the boat's movement.
Monopod	○	For heavy lenses, a monopod can work reasonably well on a stable boat in calm conditions, as you can still move relatively easily. Not suitable on a Zodiac.
Tripod	●	When photographing whales from a boat you need to be able to change position quickly, as they can be anywhere in a 360-degree radius. Tripods are not normally suitable.

Right: Inside Passage, SE Alaska, USA
Nikon D5 + 80-400mm F4.5-5.6 lens at 400mm;
1/2000 sec at f8; ISO 1800

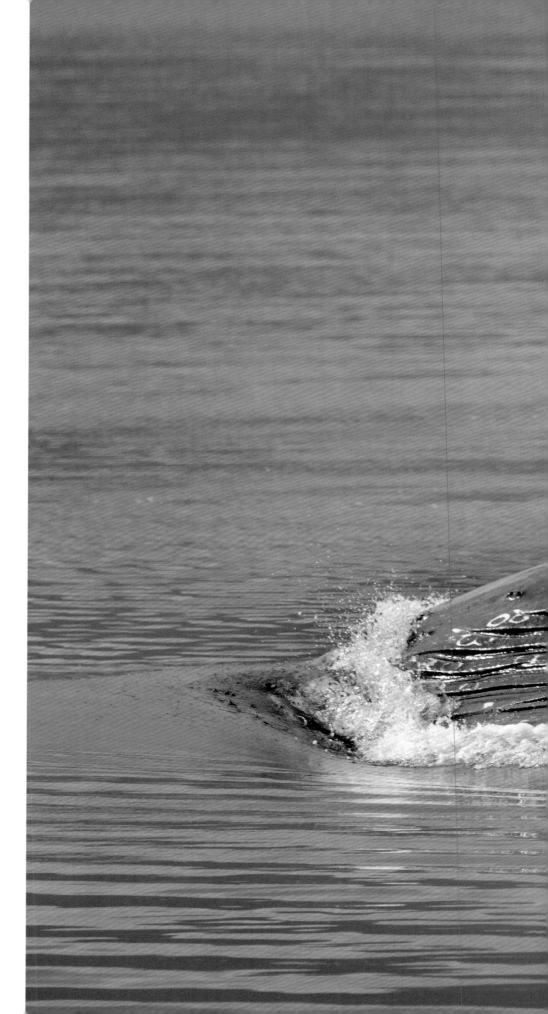

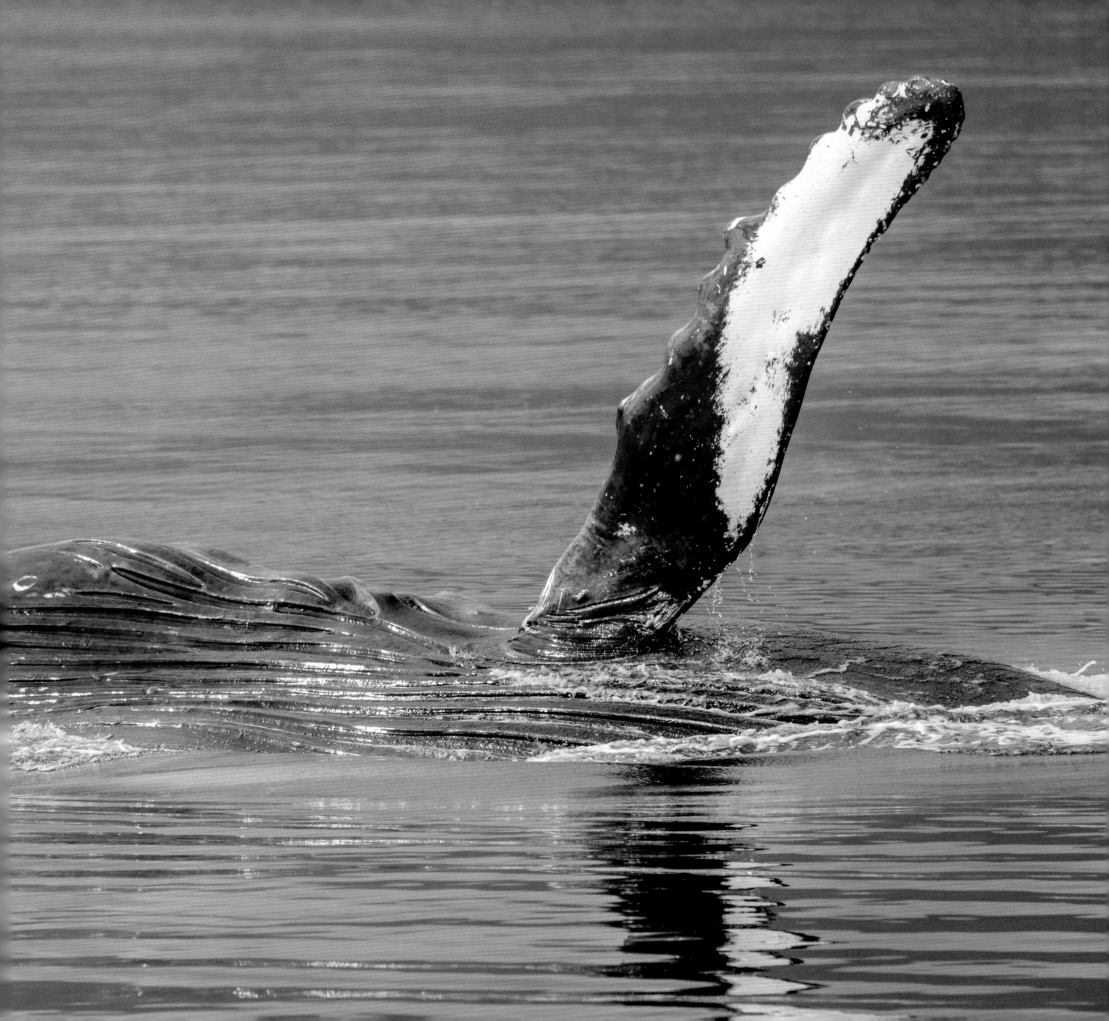

Planning your ultimate humpback safari

Where to go?

Humpback whales are found in all the major oceans, making it relatively easy to see them in most parts of the world. However, to see lots of humpbacks exhibiting many different types of behaviour in stunning surroundings there is one stand-out region — the coasts of south-east Alaska (USA) and British Columbia (Canada). Stretching over 1,600km (1,000 miles) in length, the channel known as the Inside Passage weaves its way down the coast between hundreds of islands. The islands provide calm water that is sheltered from the storms and swells of the Pacific Ocean. Here, in the summer and early autumn, humpbacks gather in large numbers to feed on the region's plentiful supply of fish and krill.

Many whale-watching operators offer half-day or full-day trips from a number of locations up and down the coast, and if time is short this is a great way to see humpbacks. Smaller boats are better for photography as they can manoeuvre more easily and give a generally better (lower) perspective.

The ideal option is a voyage on one of the small live-aboard boats that operate from a number of key locations along the coast. A typical trip is 7-10 days long. Boats of up to 50 passengers will also be an option, but I prefer smaller boats as they provide a more intimate experience. So, I recommend looking for a dedicated wildlife trip on a boat taking 10-20 passengers. There is a lot of other wildlife to see on this coast, such as brown and black bears as well as many other marine mammals and birds, but if your main interest is humpbacks, then there is occasionally a trip on one of these boats that operates with whales as their main objective. Of course, even on a specialist whale trip, you will always encounter other wildlife as you go along.

For bubble-net feeding, south-east Alaska has usually been considered the best location. Although that remains the case, in recent years this behaviour has also been seen in British Columbian waters.

When to visit?

Summer to early autumn is the main time to visit. You will have to contend with a number of rainy days, as this region is notorious for its high rainfall — indeed it is one of the world's largest areas of temperate rainforest! So it is essential to travel with rain covers for cameras and lenses. Although the peak of activity varies along the coast from region to region, the season runs from early June to the end of September. For bubble-net feeding, the best time to visit is mid-August to mid-September.

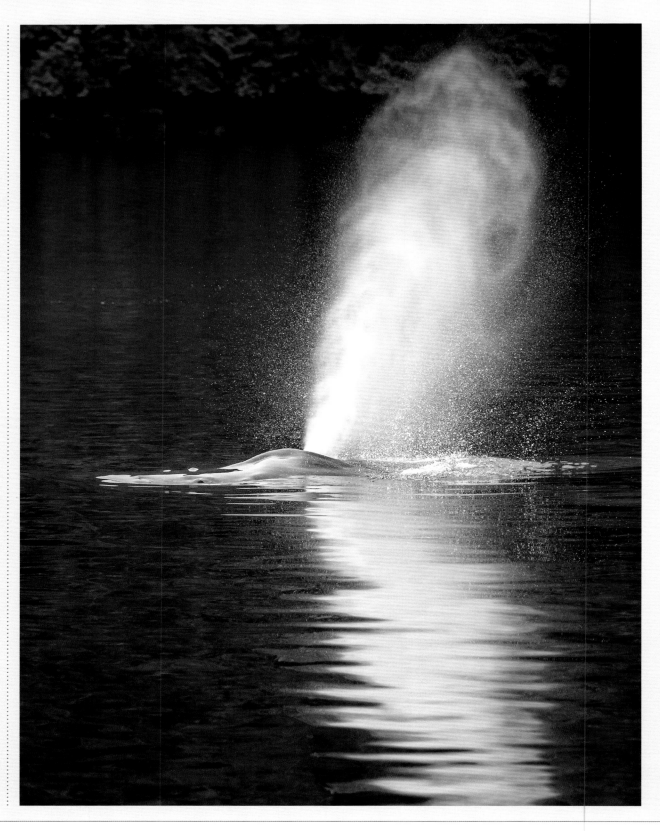

For my 'Ultimate Humpback Safari' I flew to Petersburg, Alaska and joined an 8-day humpback whale-watching cruise, on board the 12-passenger motor vessel *Snow Goose*, run by UK-based wildlife specialist Mark Carwardine Adventures.

Recommendation summary

Location: Inside Passage of south-east Alaska, USA and British Columbia, Canada

Best time to visit: mid-August to mid-September

Getting there: Fly to the relevant airport on the coast, from Seattle for SE Alaska, and from Vancouver for British Columbia

Access: Live-aboard cruise on a small ship (10-20 passengers). It is essential that it is a dedicated wildlife trip

Duration: 7-10 days

How to book: The easiest way is to find a specialist photographic tour operator offering a suitable trip. Alternatively, book through a specialist wildlife travel agency or directly with the boat operators through their website

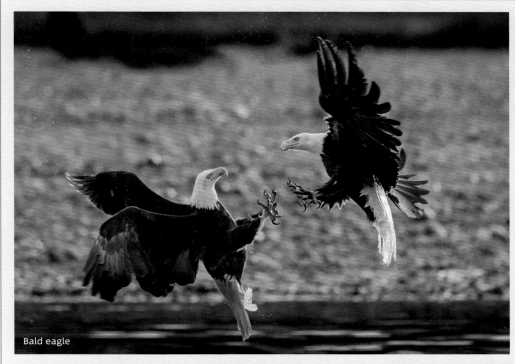

Bald eagle

What else might I see?

There are loads of opportunities for landscape photography as the scenery throughout the area is spectacular. Other wildlife includes black bears, various deer species, marine mammals and lots of birds, such as the bald eagle.

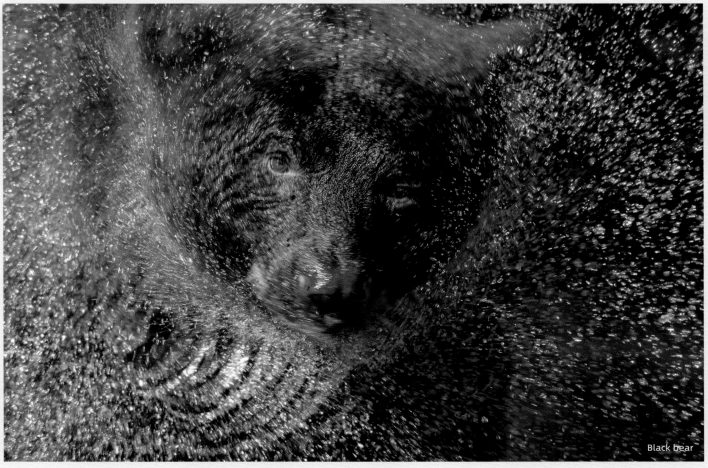

Black bear

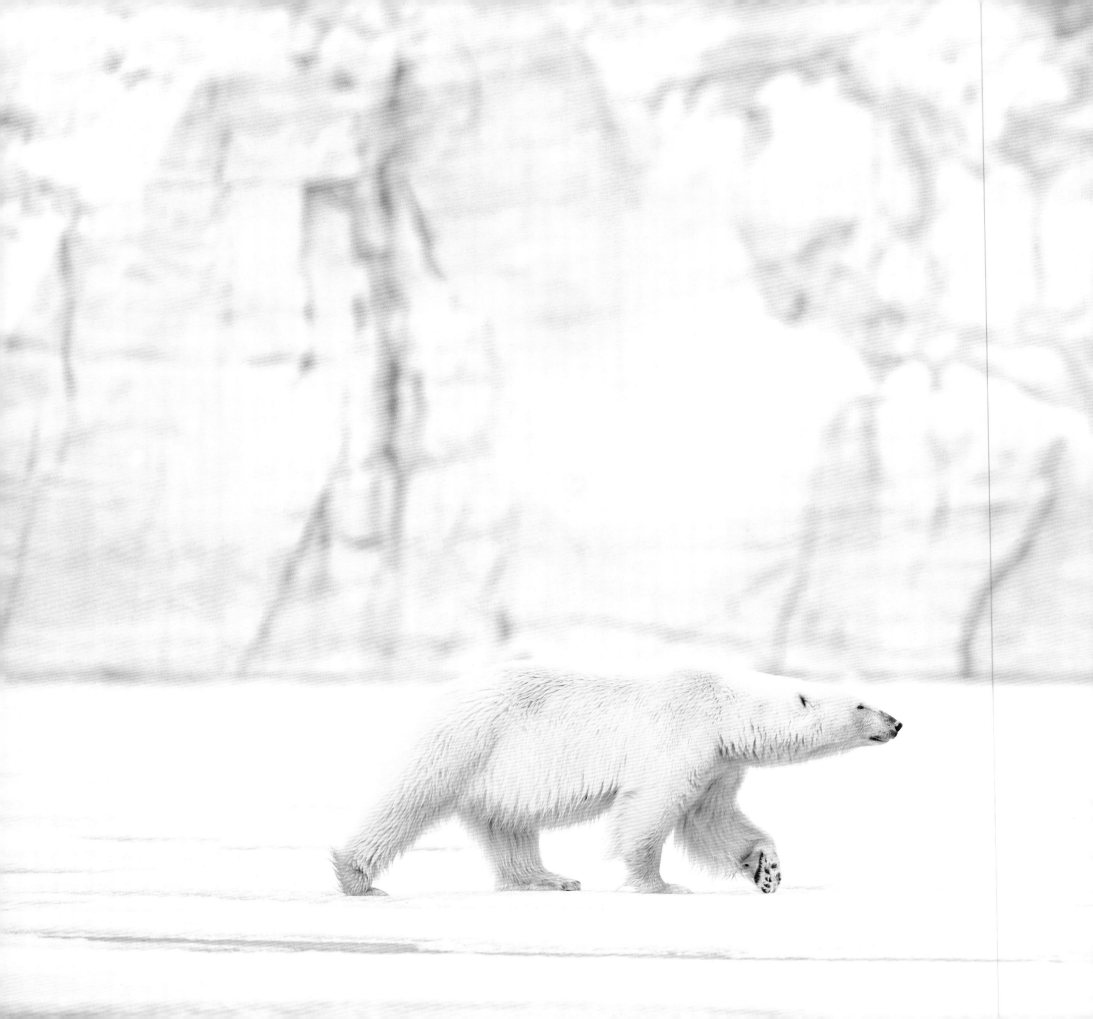

Polar Bear

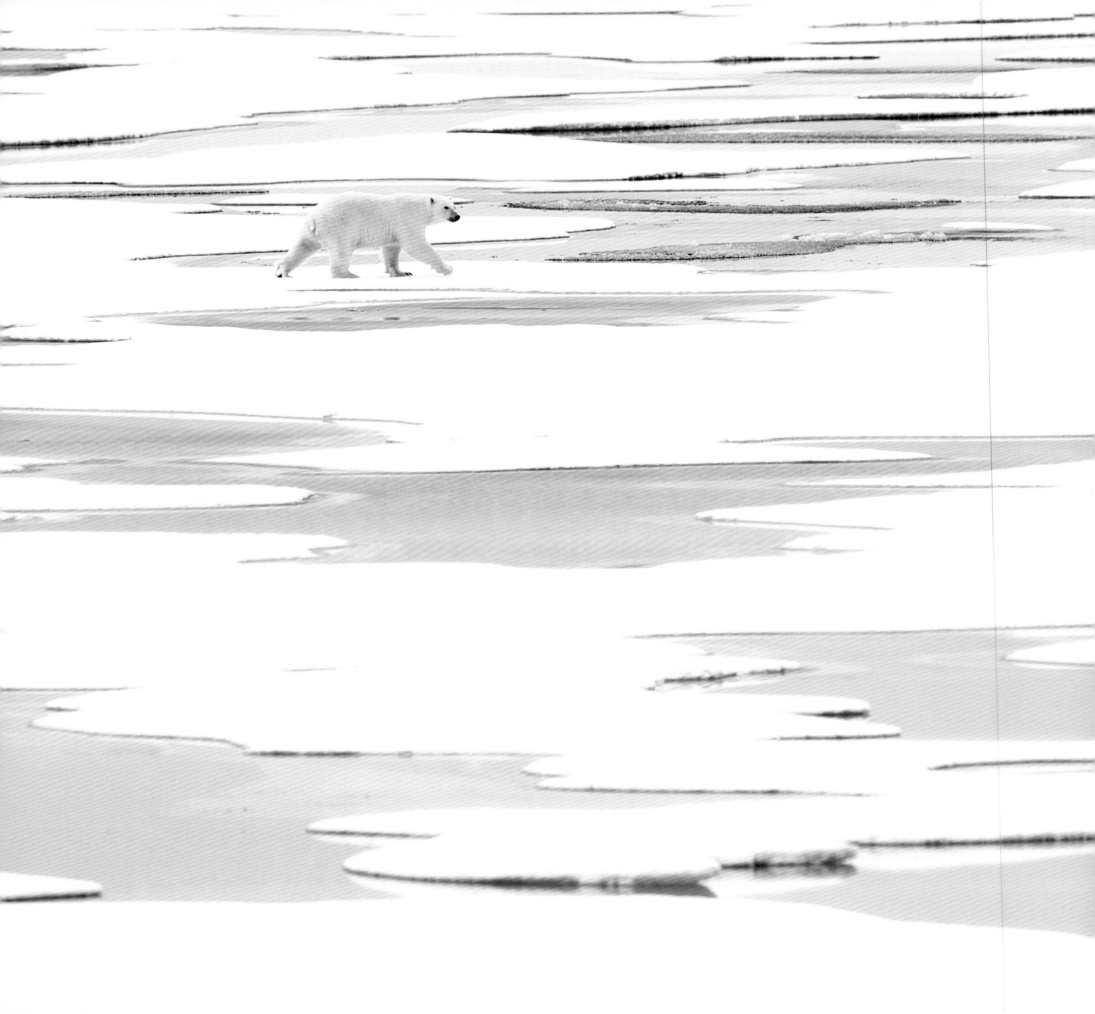

Which animal is my favourite? This is a question I am often asked. I don't think I could chose just one favourite, but the polar bear is very high on my list. I am in awe every time I see one of these bears in their natural habitat — they are so perfectly adapted to surviving in freezing conditions. A visit to the Arctic to see the planet's largest land carnivore is one of the most special wildlife experiences possible.

Males can weigh between 350-700kg (770-1,540lbs), with females around half that size. The scientific name of the polar bear is *Ursus maritimus*, deriving from the fact that they spend most of their time on sea ice. In fact, they are classified as marine mammals. They are closely related to the brown bear, but have many adaptations for surviving extreme cold temperatures, for moving around on snow, ice or in open water, and for hunting seals, their main food source.

The polar bear currently faces many threats, including climate change. They are hugely dependent on sea ice in areas where there are seals to hunt. As the planet warms up, these areas are becoming much smaller. Summer is the lean period for polar bears, when they are often forced to go on land. As the climate warms, the sea ice is melting earlier in the spring and forming later in the winter — a double blow for the bears. While the issue of climate change is high in public awareness, not many people realise that there is another urgent threat: polar bears are still hunted in places such as Canada and Greenland, at rates that appear to be unsustainable given the remaining numbers and their reproduction rate. There are estimated to be between 22,000 to 31,000 polar bears, and their conservation status is classified as vulnerable.

There may be something of interest

I love this spot! A comfy seat in this quiet corner, up here on the bridge. It's my favourite place on the whole ship. Here I have a super wide 180-degree view, but more importantly, this is the nerve centre of the ship. If anything is happening, up here we will be the first to know.

The view is spectacular; off on our right is a massive glacier face that we have been travelling in front of for hours. We are sailing along the south coast of Svalbard's second-largest island, Nordaustlandet. The huge Austfonna ice cap, which crowns most of the island, terminates here into the sea. This huge glacier front, at 180km (110 miles) in length, is the longest in the northern hemisphere. Around us in every direction are thousands of pieces of glacial ice, bits of ice that have broken off from the glacier face — all different sizes and shapes, from huge, beautiful, blue icebergs, through smaller 'bergy bits' and down to brash ice. The ship is nudging its way through and around this ice maze, as we carefully sail westwards.

Rinie, our expert Arctic guide, who as always has been outside for hours and hours scanning with his binoculars, suddenly bursts into the bridge from the upper deck. 'Captain, please can we sail over in that direction? There may be something of interest,' he says, pointing towards a distant iceberg many miles away. With that, he spins round and quickly returns outside.

As the ship changes course onto its new bearing, we all grab our binoculars and start scanning to see what Rinie has spotted. But all we can see is ice, ice and more ice. There doesn't appear to be anything special. It's a mystery.

Six nautical miles and 90 minutes later, we eventually spot what Rinie saw from so far away — it's a polar bear, and it's swimming in the sea! Marvelling at his ability to spot a polar bear in a dense icefield six miles away, I grab my camera gear, head outside down onto the lower deck and prepare for action. Slowly the ship is picking its way through the icefield, approaching the bear cautiously and quietly. ▶

Right: Svalbard, Norway
Nikon D4 + 80-400mm f4.5/5.6 lens at 400mm;
1/1000 sec at f5.6; ISO 400

Title pages:
Mohnbukta, Svalbard, Norway
Nikon D5 + 180-400mm f4 lens at 310mm;
1/3200 sec at f4; ISO 360

Introduction pages:
Lancaster Sound off Baffin Island, Nanavut, Canada
Nikon D4 + 500mm f4 lens; 1/1600 sec at f6.3; ISO 400

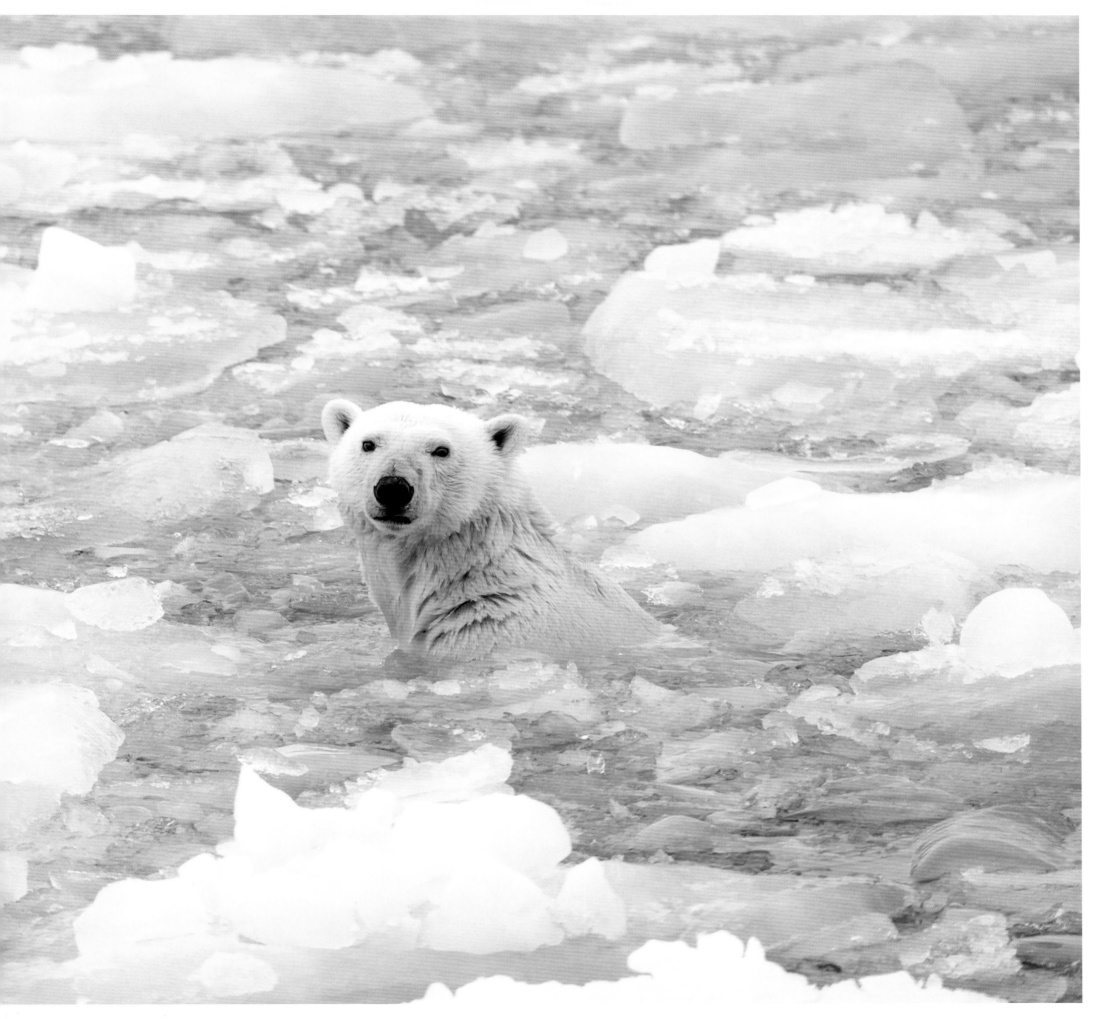

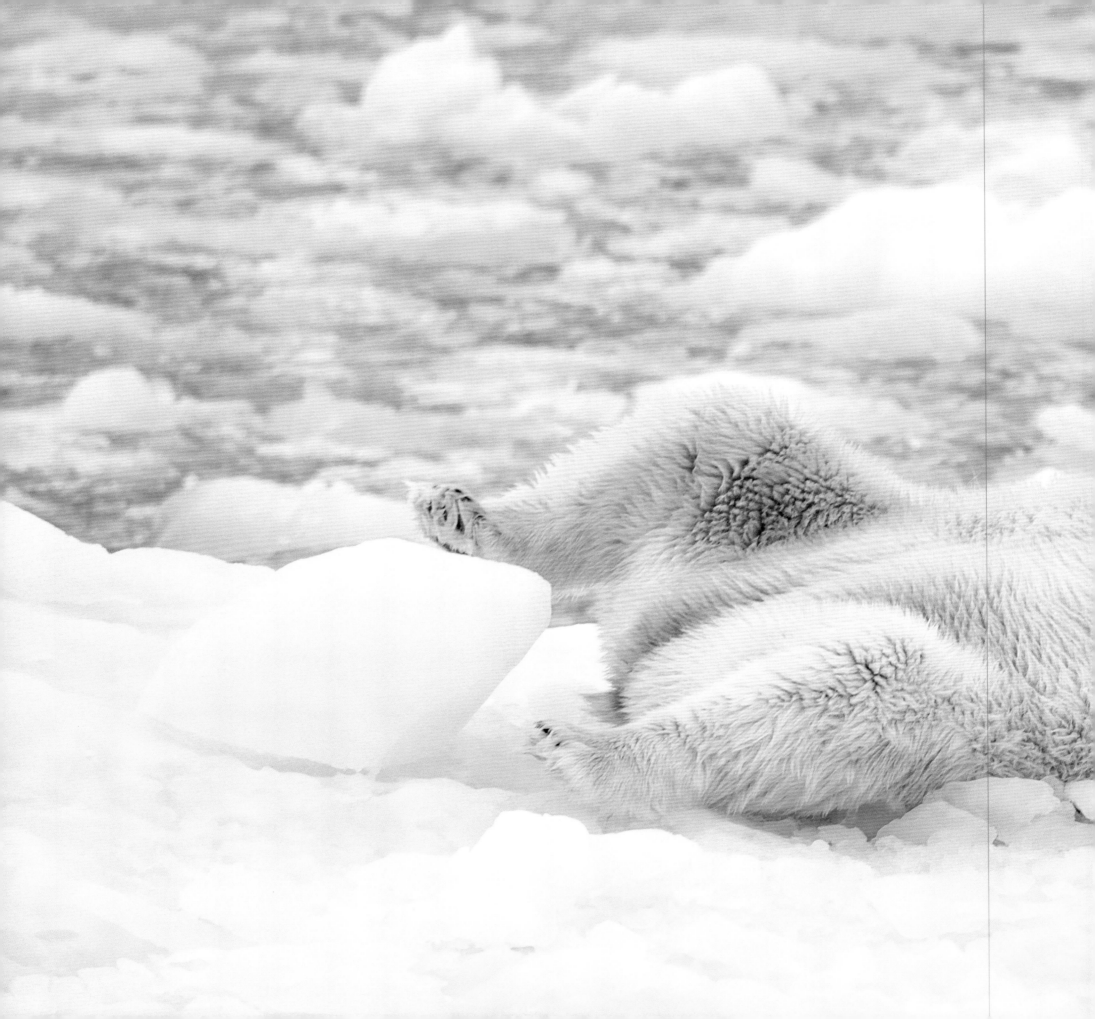

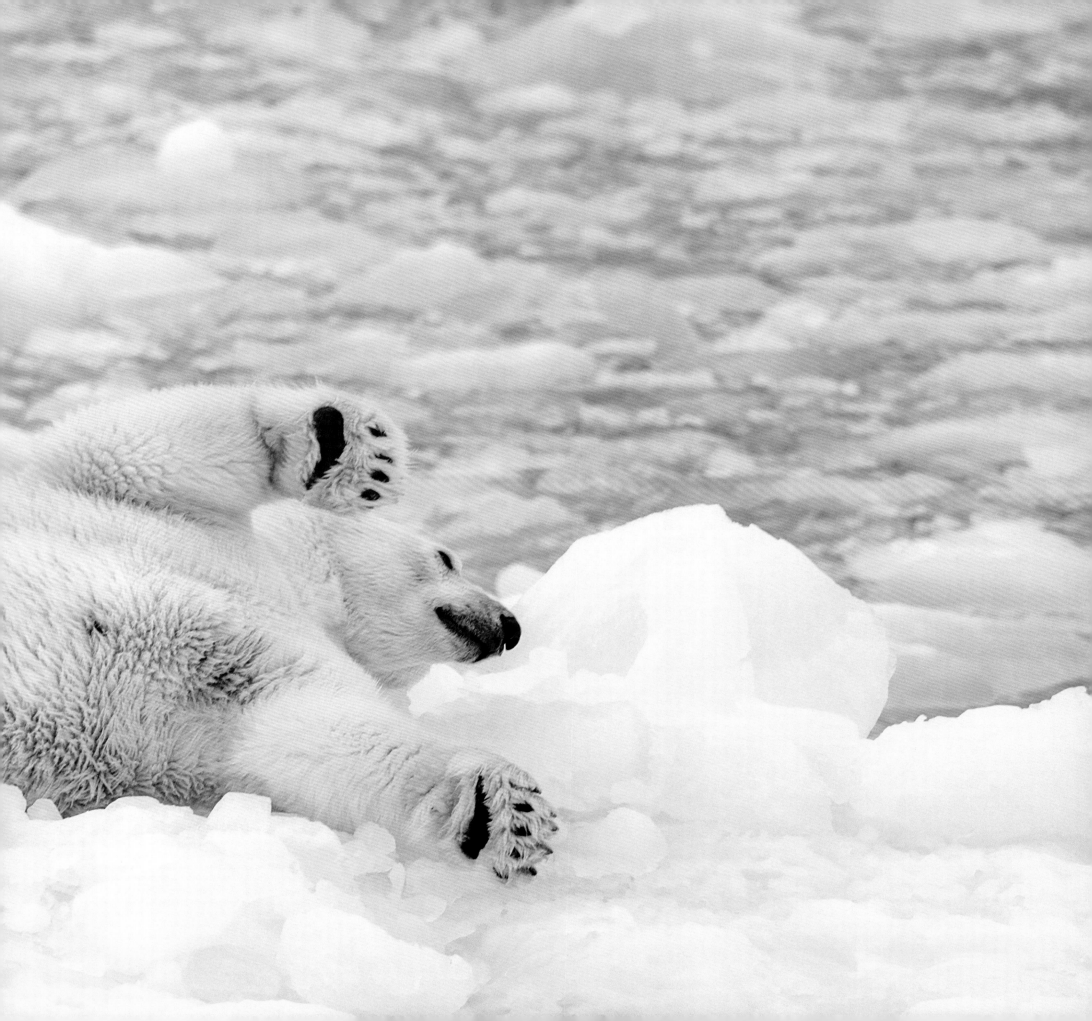

▶ Now it's swimming towards us. Clambering out of the sea onto an iceberg, it rolls around in the snow, drying its fur! It's giving us very close inspection. Intrigued by the ship — the sounds, noises, smells — it seems to want to try and get on board! Weighing up its options, it chooses a suitable iceberg close to the ship, and gradually begins a steep climb. It reaches the top, and now it is above us, inspecting the ship and the people moving about on it. Fortunately, it can't actually reach us from the iceberg: that would be a major problem. But it is giving us a fantastic show! It's incredible to be standing here on a ship looking up at this magnificent, fearless predator. ●

Right: Svalbard, Norway
Nikon D4 + 80-400mm f4.5/5.6 lens at 140mm;
1/2000 sec at f5; ISO 400

Previous pages: Svalbard, Norway
Nikon D4 + 80-400mm f4.5/5.6 lens at 400mm;
1/1000 sec at f7.1; ISO 400

Photographic tip
Using burst mode

You will notice that when polar bears are walking, they open their eyes for a short while, take in the view, then shut them again as they walk along. Probably because of brightness of the snow and ice around them, their eyes are often shut more than they are open. Looking through your camera viewfinder this is difficult to see, so it is best to use burst mode ("motor drive"), taking a burst each time of five or ten shots to increase the chances of getting photos with open eyes.

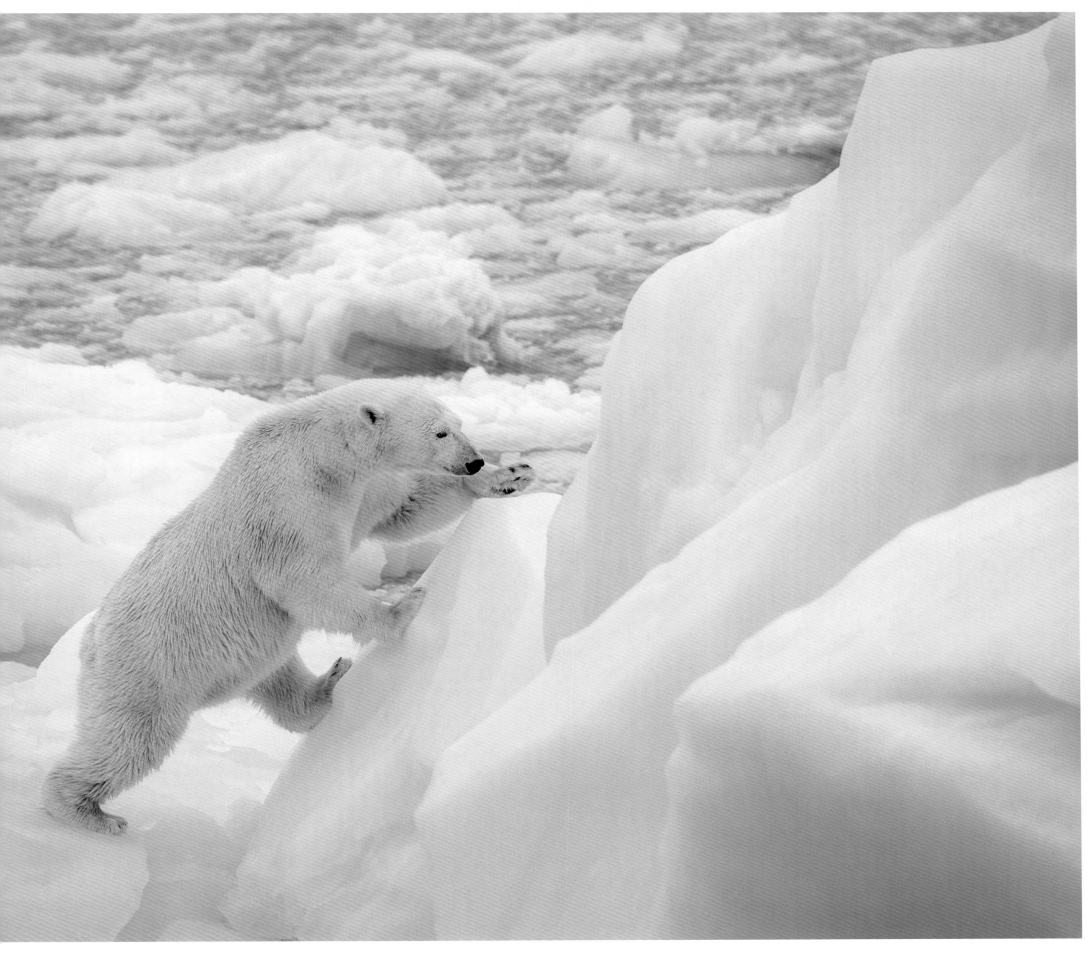

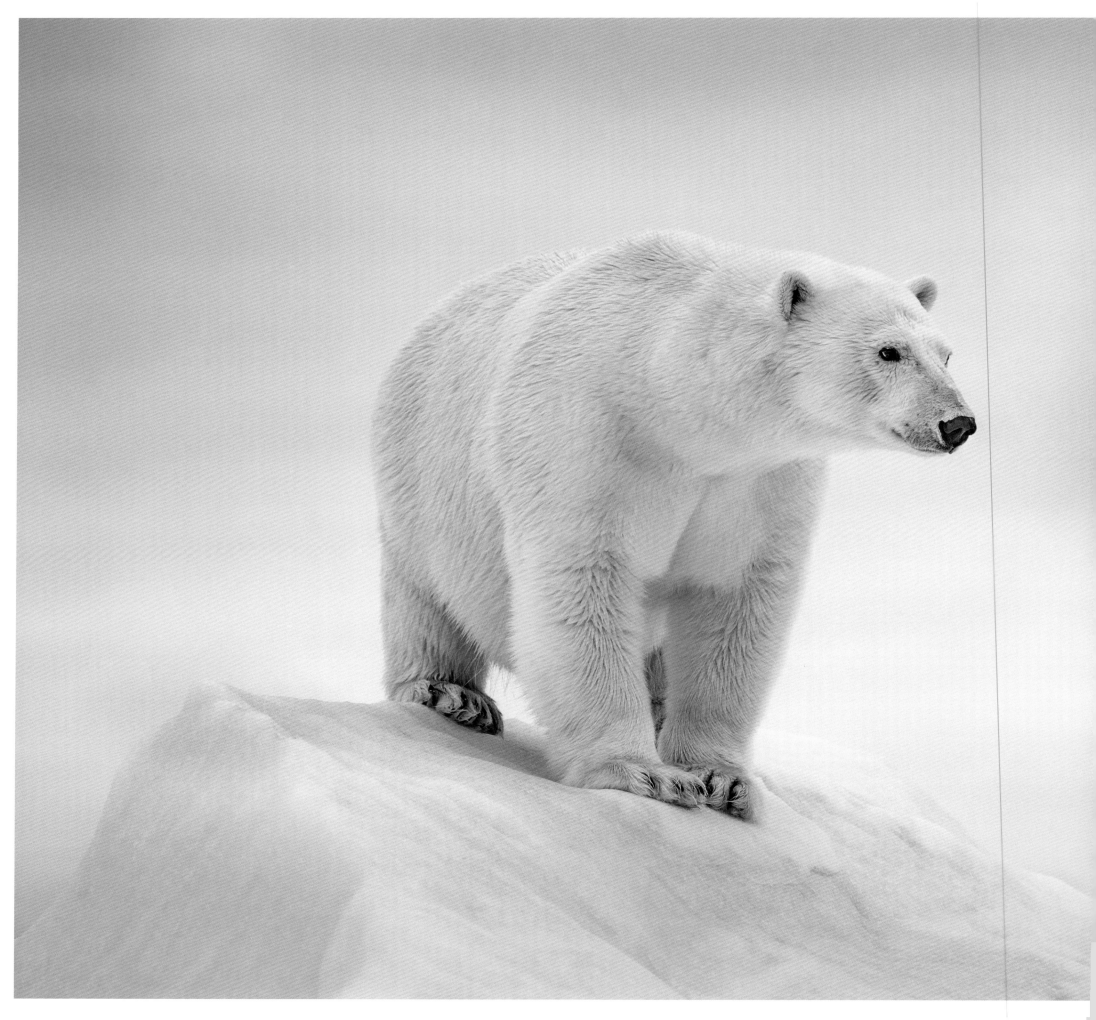

Photographic tip
Tripods on ships

To photograph polar bears from a ship, a tripod is often the best support option. There can be long periods of waiting, but because you want to be ready at all times for the action, tripods work really well. Just be careful to use a high shutter speed to eliminate the effect of any vibration coming through from the engines. There is usually loads of light, so this is quite easy to achieve without having to use an excessively high ISO. An alternative is to attach anti-vibration pads onto the tripod feet.

Left: Svalbard, Norway
Nikon D4 + 80-400mm f4.5/5.6 lens at 195mm;
1/1600 sec at f5.3; ISO 400

Completely icebound

I t all started three days ago. Svalbard can be a challenging place to find wildlife; you have to work hard, and you certainly have to be patient. We were in just this situation, four very quiet days in a row with no wildlife sightings of any great note. We were cruising along the edge of the Arctic pack ice, a long way north of Svalbard, looking for polar bears.

Someone thought they had spotted a pomarine skua (also known as pomarine jaeger). This type of skua is an uncommon bird to see in Svalbard, and conscious of the slow situation with sightings over the last few days, the captain agreed to take our small expedition ship a little way into the pack ice, in the hope of getting a closer look at this rare bird. Everything seemed relatively routine at this point. But when we were just a few hundred metres into the ice, one of the guides thought he saw a bear in the distance, much deeper into the pack ice. So far away in fact that he wasn't at all confident it actually was a bear, maybe just a piece of buff-coloured ice.

We were desperate to see and photograph something, anything in fact, but particularly a polar bear! So, the ship continued pushing its way through the ice field. It was a very slow process, the minutes became hours, and still we pushed on. Someone thought there might actually be two bears, not one. Then it was three, then five — this was getting crazy.

Five hours later, after travelling over three nautical miles through the ice, the full might of the situation was revealed to us. The captain placed the ship about 100 metres (110 yards) away from the middle of a scene that will live with me forever. At its centre was a bowhead whale carcass frozen into the ice. On top of it, around it and scattered all over the ice in every direction, we counted more than 25 bears. For the bears, it was a feast. And we had hit the mother lode! ▶

Right: An expedition ship weaving its way through gaps in the open drift ice, Burgerbukta, Svalbard.

Svalbard, Norway
Nikon D850 + 70-200mm f2.8 lens at 200mm;
1/1000 sec at f7.1; ISO 200

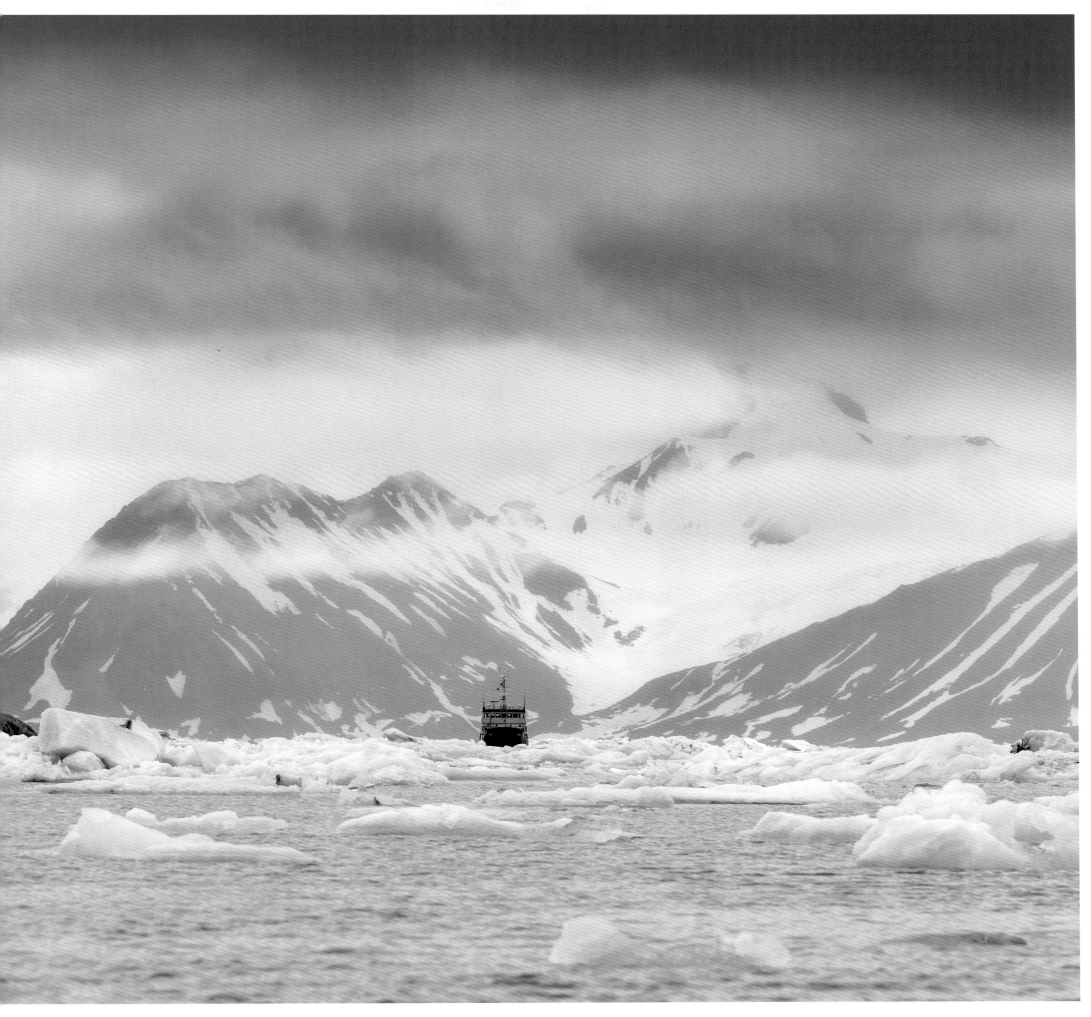

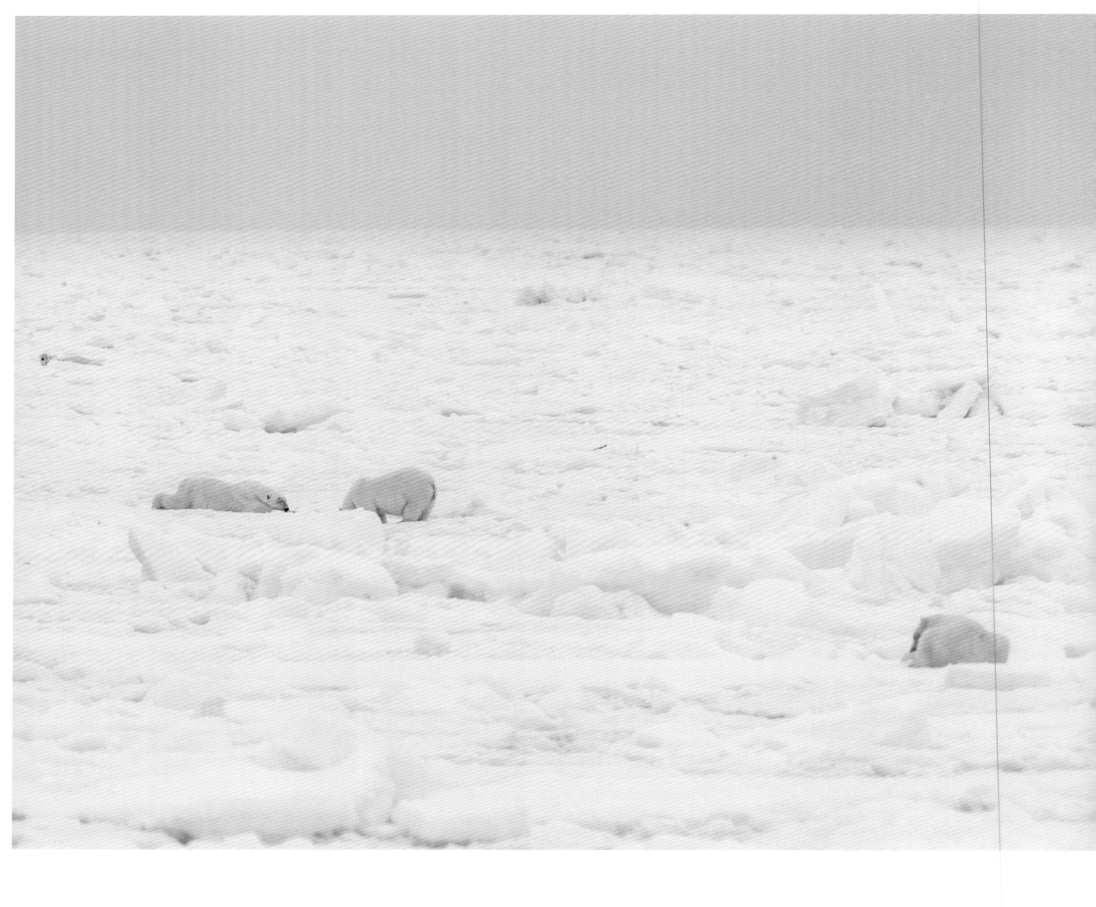

Above: Pack ice off northern Svalbard, Norway
Nikon D850 + 180-400mm f4 lens at 340mm;
1/2500 sec at f4; ISO 220

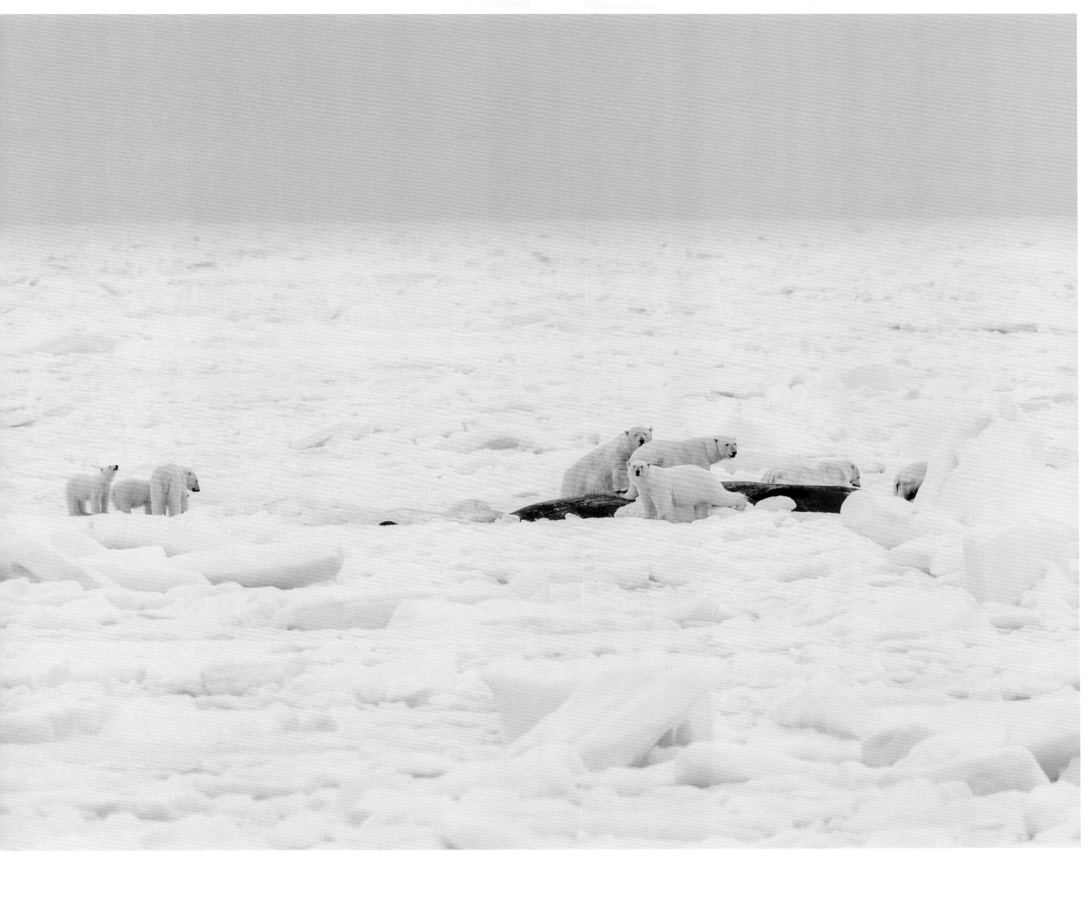

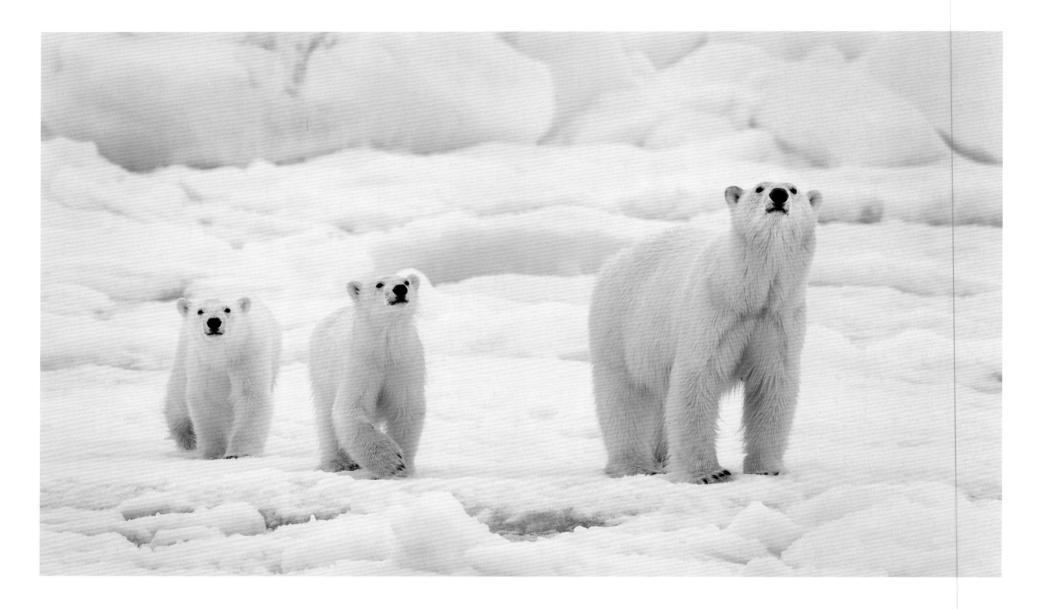

▶ Whilst there were always bears on the carcass, taking turns at gorging on the meat in front of them, it quickly became clear that the most interesting action, photographically, was away from the carcass. Bears coming and going, resting up after eating before heading back again for more. Some of the bears, probably young adult males, would spar together to pass the time, a behaviour that is not particularly common in Svalbard. Others would walk right up to the ship to have a close look at us! On one occasion a mother with two cubs gave us a very productive hour when she brought her family very close to inspect our ship. One time a large male bear settled down on the ice just 5m (16ft) off the stern and stared up at us for hours and hours. It was a great opportunity to frame close-up shots. We were in full activity mode, taking literally thousands of images! 24-hour daylight makes for very long days when you are busy photographing dozens of polar bears around you. We had to learn to pace ourselves, as it was impossible to work continuously around the clock.

Which gets us to where we are today. It is the morning of day four, and there has been a new development. The temperature has dropped markedly over the three days we have been here. The result — the loose mass of ice, through which we sailed to get here, has frozen into one huge solid lump. The captain is getting a little concerned about this situation and he announces that we need to move out of the ice before we get completely stuck. The engine fires up, and since the ship is currently facing north, the first requirement is to turn the ship around, so we can head south and out of the ice. He uses the same sort of technique that you might use to turn a car around in a tight space — move forwards turning slightly, then reverse turning a bit more. With a car this might be a three, or even five, point turn. With our ship it takes about an hour and involves dozens of turns!

Finally, we are pointing in the right direction, and we begin breaking ice as we head south. But we are not really making any progress, the ship is really

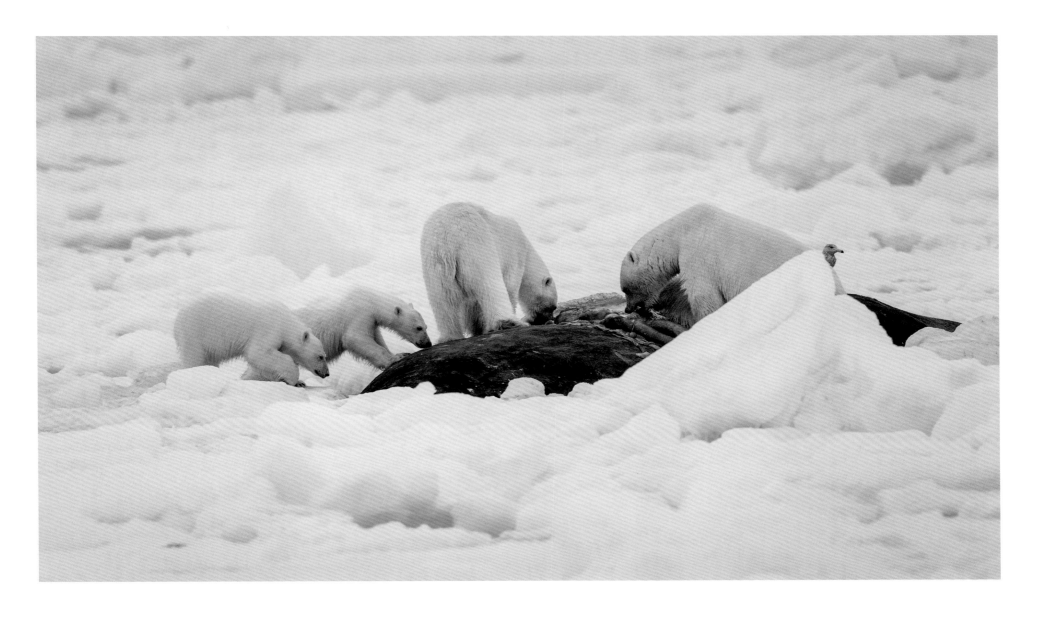

Above: Pack ice off northern Svalbard, Norway
Nikon D5 + 800mm f5.6 lens + 1.25x converter;
1/2500 sec at f7.1; ISO 900

Above left: Pack ice off northern Svalbard, Norway
Nikon D850 + 180-400mm f4 lens at 400mm;
1/1250 sec at f5.6; ISO 360

struggling. About an hour and just a few hundred metres later, the captain calls a halt. The ice is too thick, we are completely icebound. Not only are we frozen stuck, but photographically there is also a bit of a problem. We can still see the whale carcass off in the middle distance, and the bears around it, but everything is just too far away to photograph. We are stuck with nothing to do; it's a waiting game.

Day five arrives. We are making another attempt to break free. Slowly, very slowly, we begin to make headway through the ice. This involves carefully spotting a line of weakness, revving the engines to full throttle to gain some momentum, and crashing into the ice, hopefully breaking a few metres (yards). The ship tilts and groans each time as it hacks at the ice. Then we reverse and do it all again. Hundreds of times.

Ten hours and eleven nautical miles of ice-breaking later, we have reached open water. Phew — we are free! ●

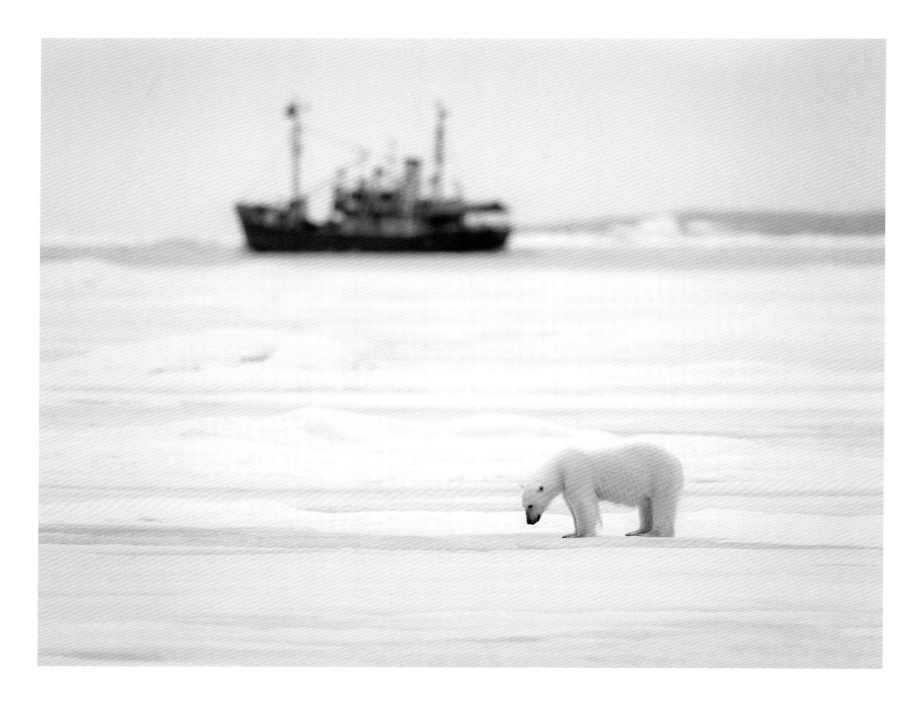

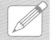 **Organisational tip**
Arrive early into Svalbard

When you are heading off on an expedition cruise, it's really important that you and your luggage arrive in time, as the boat will sail at the appointed hour, with or without you or your bags! I strongly advise booking to fly into Longyearbyen, Svalbard, at least one day before your ship embarks. That way if there are delays it gives a chance for you or your luggage to catch up.

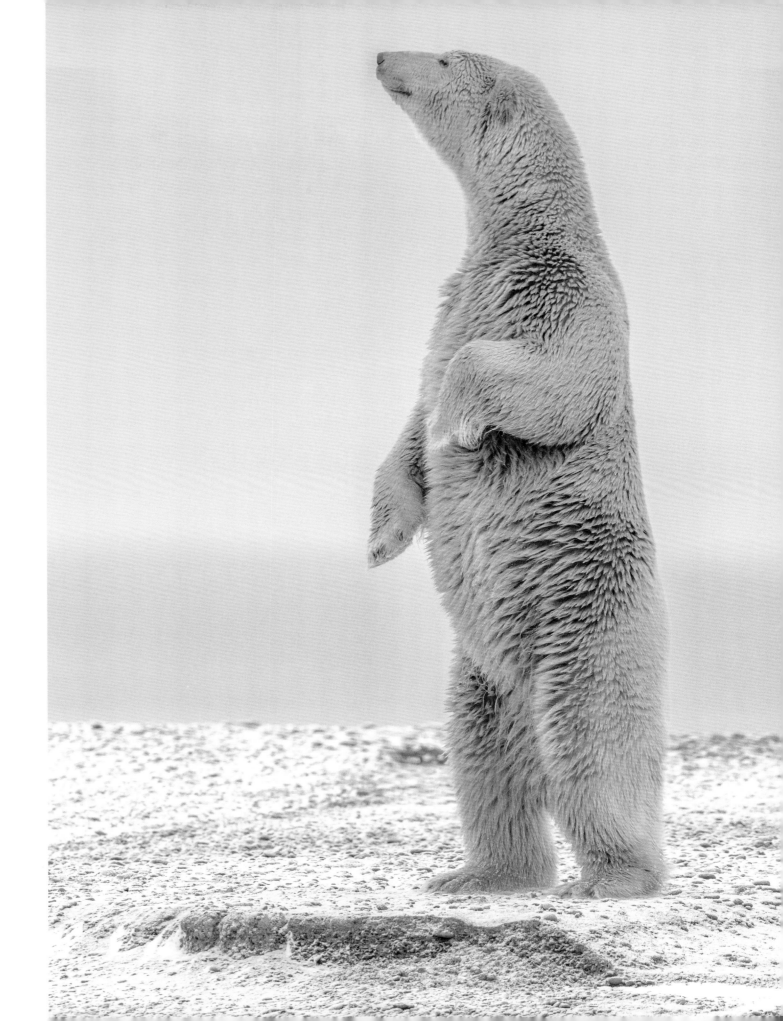

Left: This bear is 'still hunting': standing completely without movement over an ice hole, waiting for a seal to come up for air. The seals will have multiple ice holes in the area and polar bears may stand like this for hours, just waiting and hoping. Meanwhile I was watching the ship approaching, waiting and hoping that the bear would stay put until the ship moved into position to create the composition that I was looking for!

Svalbard, Norway
Nikon D5 + 800mm f5.6 lens + 1.25x converter;
1/4000 sec at f7.1; ISO 1100

Right: Polar bears have an excellent sense of smell, and this one in Kaktovik, Alaska, had picked up a scent and was standing as high as possible and sniffing the air. What it had detected was whale meat — the local indigenous people take two bowhead whales each year, and the discarded remains attract polar bears.

Kaktovik, Alaska, USA
Nikon D5 + 500mm f4 lens + 1.4x converter;
1/1250 sec at f6.3; ISO 2500

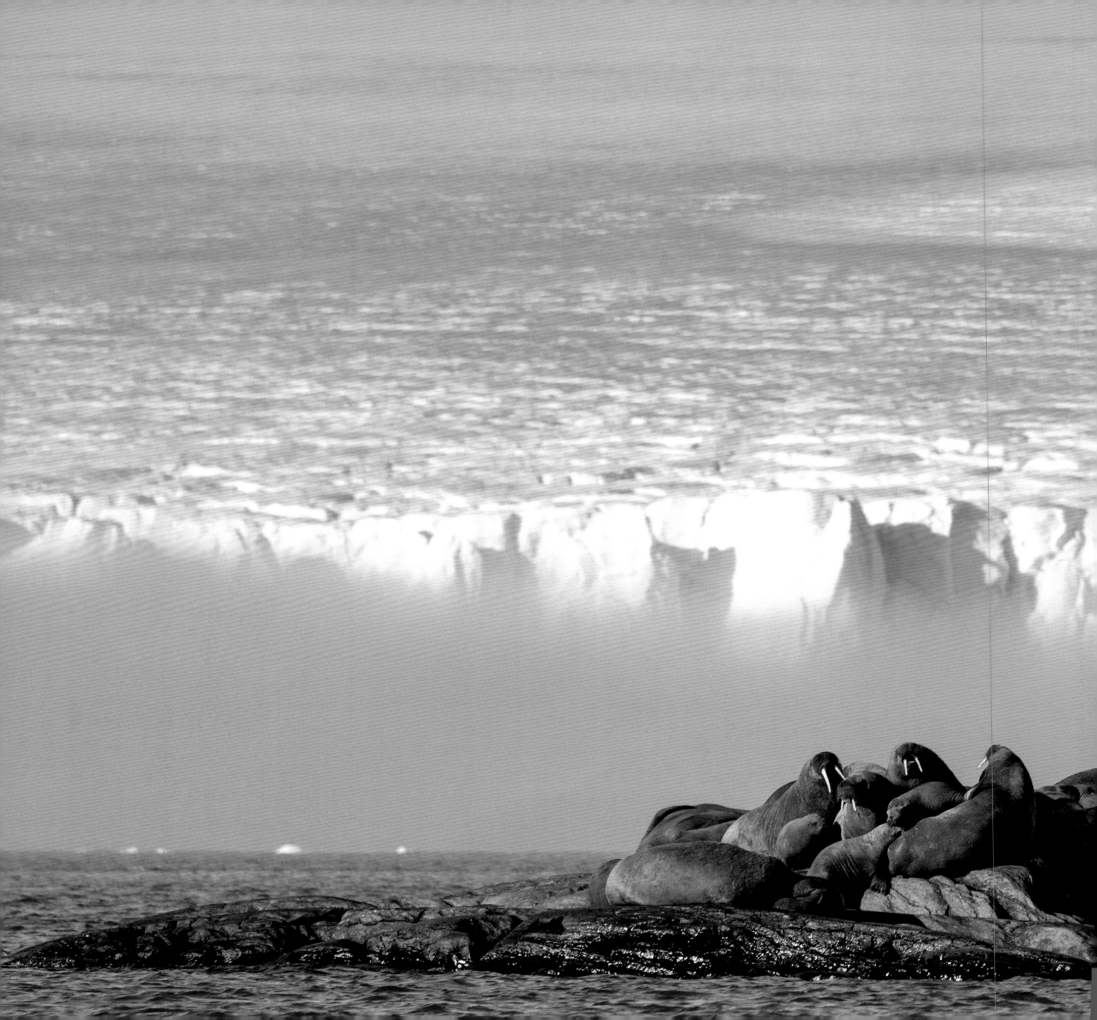

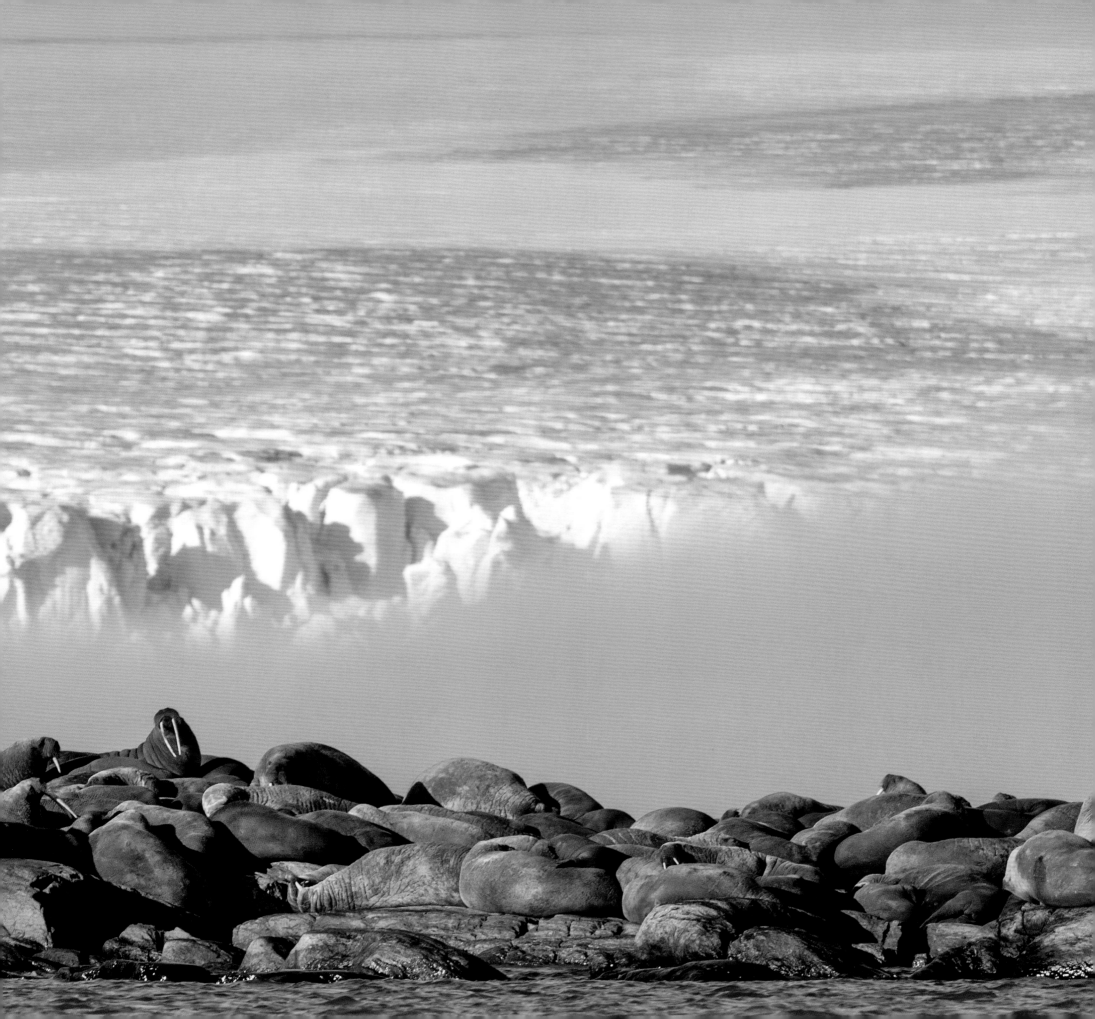

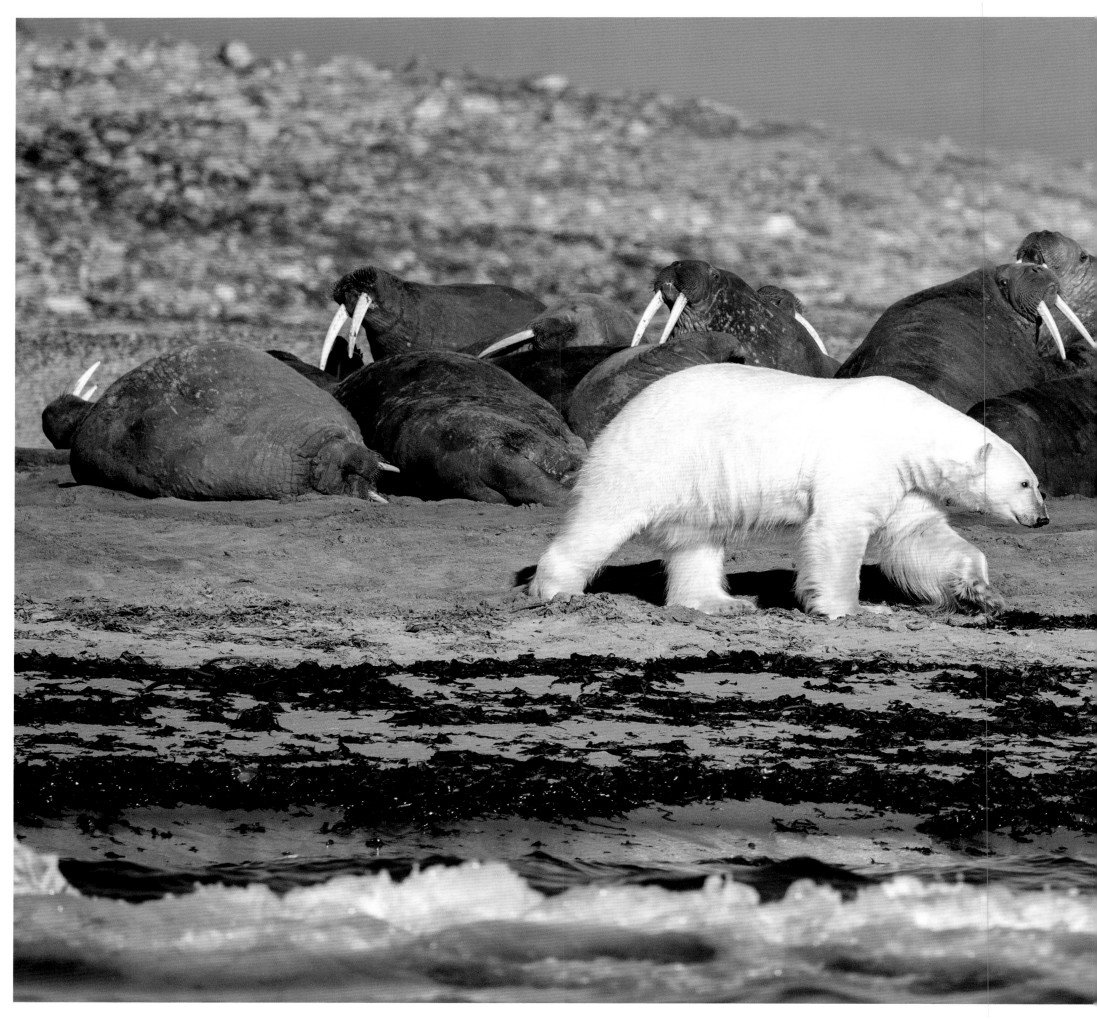

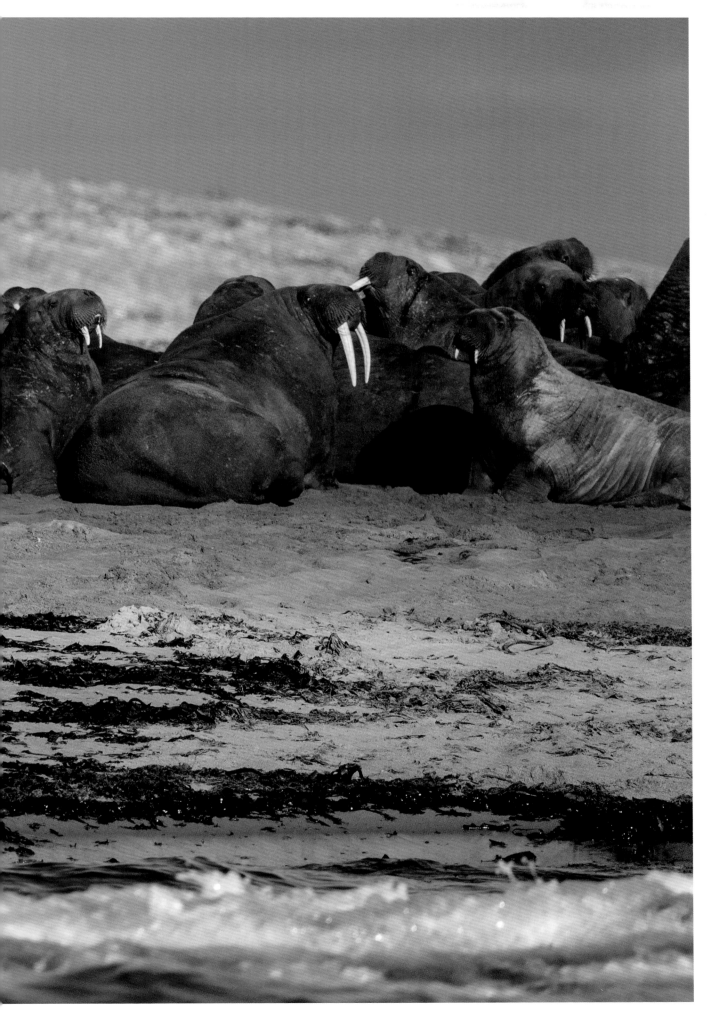

Photographic tip
Use a Zodiac to get low

When photographing bears on a ship-based trip, often you have to work from the deck of the ship. Try and choose the lowest spot and set up there. A Zodiac gives you a really nice low camera angle, but whether it is a feasible option will depend on ice conditions, sea currents and loads of other factors. On any suitable looking encounter, it is certainly worthwhile asking the expedition leader if it is safe and practical to use the Zodiac.

Previous pages: Early morning sunshine falls on a walrus colony as they snooze at the base of a glacier below the Austfonna ice cap. The bank of fog just below the glacier separated the scene, as if a frozen celestial landscape had appeared in the clouds above the colony. Just half an hour later the fog was gone.

Svalbard, Norway
Nikon D4 + 80-400mm f4.5/5.6 lens at 400mm;
1/800 sec at f8; ISO 400

Left: We had just landed on the beach to look at the enormous walruses, when a polar bear suddenly came into view over the shingle hill, and we retreated straight back into the Zodiac. The bear was clearly interested in the walruses, but they were too big to tackle. Polar bears will sometimes attempt to get walruses to 'stampede'— simultaneously lunging forward into the water — in the hope of capturing calves that get separated or injured in the crush.

Svalbard, Norway
Nikon D4 + 80-400mm f4.5/5.6 lens at 380mm;
1/2500 sec at f7.1; ISO 1000

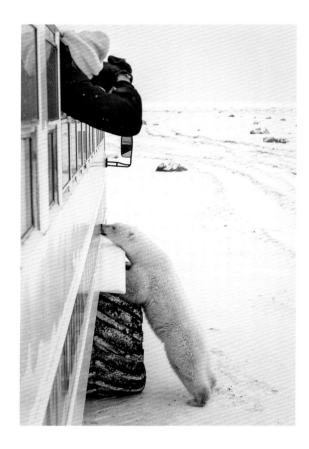

Bashing each other

We are on an almost featureless flat piece of frozen tundra. A snowy, windy expanse. There are stunted willow bushes dotted around that have grown at a permanent angle, leaning away from the prevailing wind. A few frozen ponds break the monotony of the bleak tundra. The temperature is numbingly cold, -15°C (5°F), so I am wearing heavy duty Arctic wear, consisting of multiple layers, a thick Parka coat and big Baffin boots. But right now, I am nice and warm inside this massive purpose-built machine, a Tundra Vehicle (known as a Polar Rover or Tundra Buggy), which looks like something out of a sci-fi movie. Raised high up above the uneven ground on huge tyres, this all-terrain vehicle can take up to 40 people comfortably and safely over the rough ground in these freezing conditions. It is crawling along the trails here in the Churchill Wildlife Management Area, on the shores of the Hudson Bay, in Canada.

We are looking for polar bears. Each year they gather here along the coast from the small frontier-style town of Churchill. The bears are hungry; they came onshore when the sea ice melted last spring, and they have been wandering around on land throughout the summer months. As there is precious little for a polar bear to eat on land, they are desperately keen to get back on the ice, where they can resume seal hunting. It is now early November and winter is coming. The sea water in this area is made slightly brackish with the freshwater from the Churchill River, so this section of the coastline is generally the first bit of the Hudson Bay to freeze over as winter takes its grip. And the bears know it, which is why they are here. And because they are here, so are we — trying to see and photograph them.

We can see two bears off in the distance, they appear to be quite active, and the driver is making his way towards them at top speed — about 5kph (3mph)! Eventually we get close enough and we can see they are sparring. Although it happens occasionally in other places, the polar bears here often spar. Usually it is between young adult males. Maybe they are testing each other's strength, perhaps honing their skills for real fighting, or maybe it is just an entertaining way of passing the time, playfighting? No one is quite sure why they do this.

But it is great to watch and photograph. The vehicle comes to a halt, passengers are opening the small windows at the top of each panel to photograph the bears doing their stuff. This is a comfortable way to operate, but I prefer to head outside onto the back deck. It's freezing out here, but as most people stay inside, I have lots of space, and I can conveniently support my camera lens on the handrail. Standing upright on their hind legs, bashing each other with their massive paws, the bears are really going at it. But although it looks serious, they aren't really trying to hurt each other — for polar bears, this is fun! ●

Above: Churchill Wildlife Management Area, Hudson Bay, Canada
Nikon D3S + 70-200mm f2.8 lens at 70mm;
1/200 sec at f7.1; ISO 250

Right: Churchill Wildlife Management Area, Hudson Bay, Canada
Nikon D4 + 500mm f4 lens + 1.4x converter;
1/2000 sec at f5.6; ISO 1000

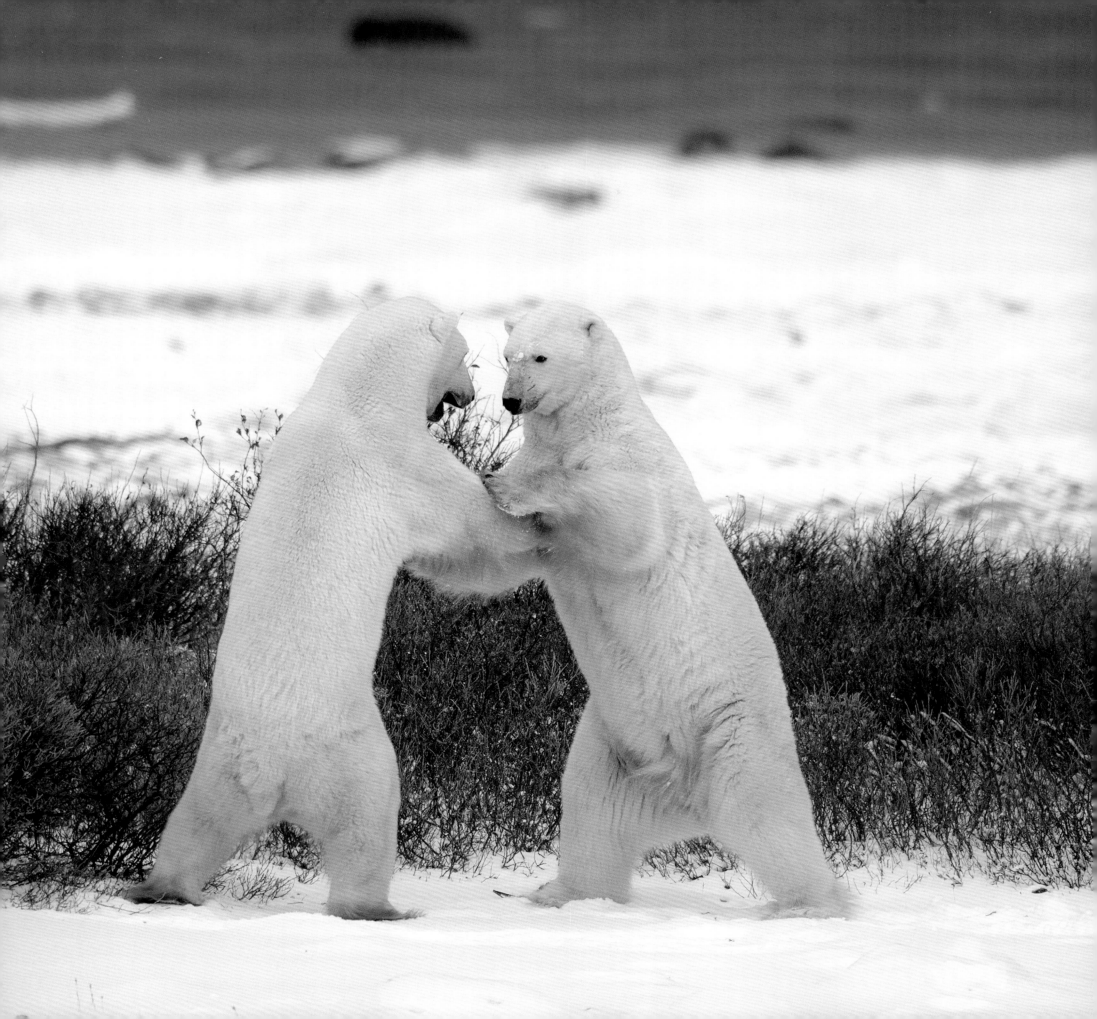

Photographic tip
Photographing from a Tundra Vehicle

One of the drawbacks of Tundra Vehicles is that they are very high above the ground, and this makes it difficult to get good eye contact with the bear without appearing to look down on it. Most people onboard tend to choose to stay inside and photograph through the small opening windows at the top of each window panel. Besides being very high, images taken this way are usually spoilt due to shimmer caused by the heat waves coming out of the window from inside the warm vehicle. I have found this to be a problem however far I push the lens out. A much better option is to brave the cold and get out onto the back deck, which has no thermals, and has the added benefit of being much lower.

Right: Churchill Wildlife Management Area,
Hudson Bay, Canada
Nikon D4S + 500mm f4 lens + 1.4x converter;
1/640 sec at f8; ISO 1000

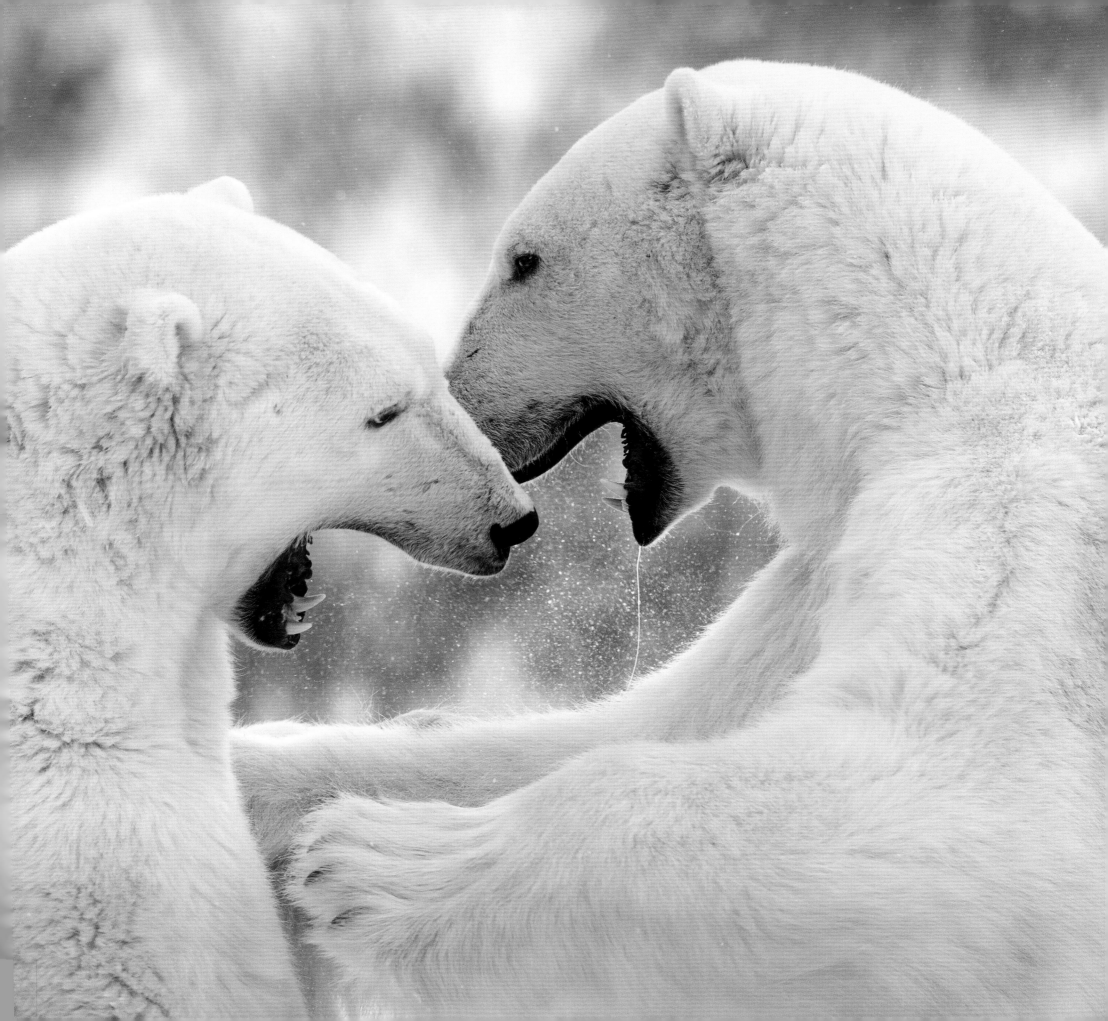

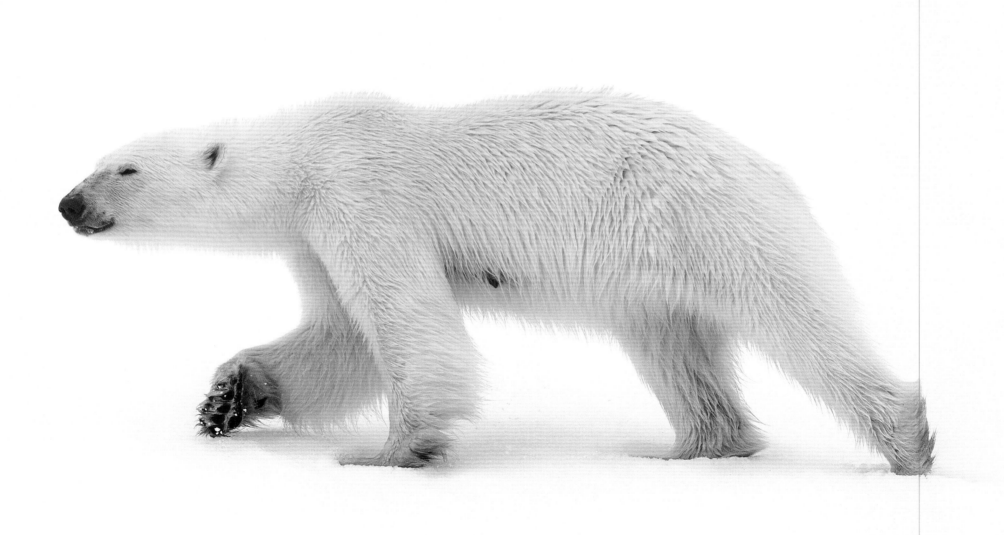

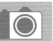

Photographic tip
Keep off the bear's shoulder

A quite frequent occurrence is that you are photographing a polar bear walking along the shore from a Zodiac. Drivers often follow just behind them, so as not to disturb the bear. In reality, this is uncomfortable for the bear, as it is aware that something is following it just over its shoulder, yet it can't see without turning. A better option for the bear, and fortunately also for the photographer, is to get quite a long way ahead and wait quietly for the bear to come along towards you.

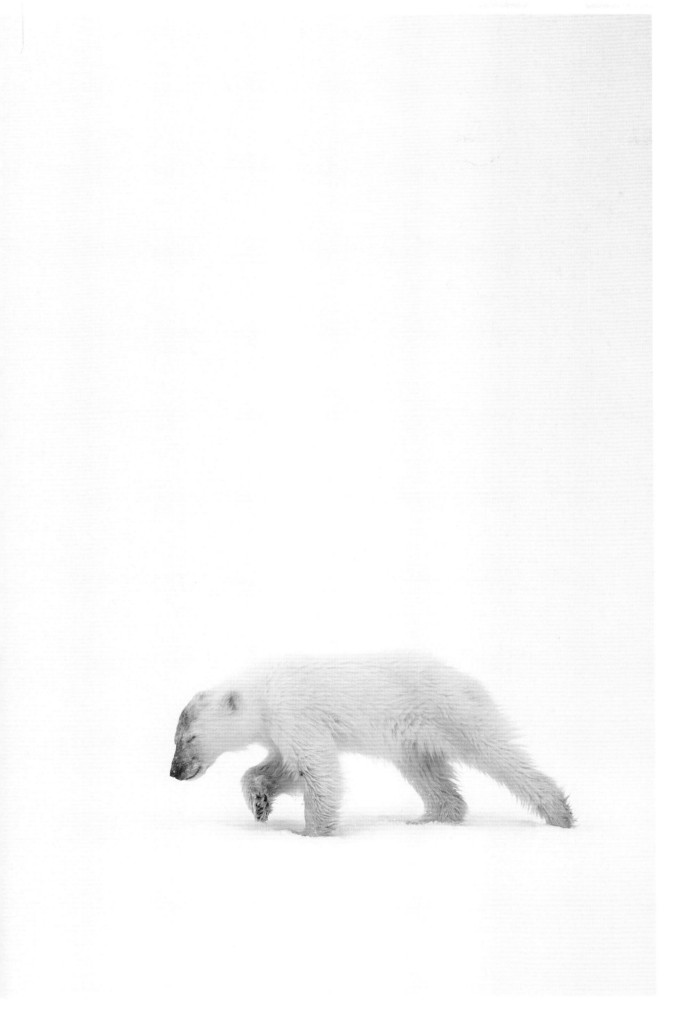

Left: We watched from a Zodiac for quite a long time as this young cub followed its mother through the snow. They walked together like this for about 10 km (6 miles), opening their eyes every now and then to get their bearings, then ploughing on with their eyes shut.

Svalbard, Norway
Nikon D5 + 180-400mm f4 lens at 180mm;
1/3200 sec at f4; ISO 280

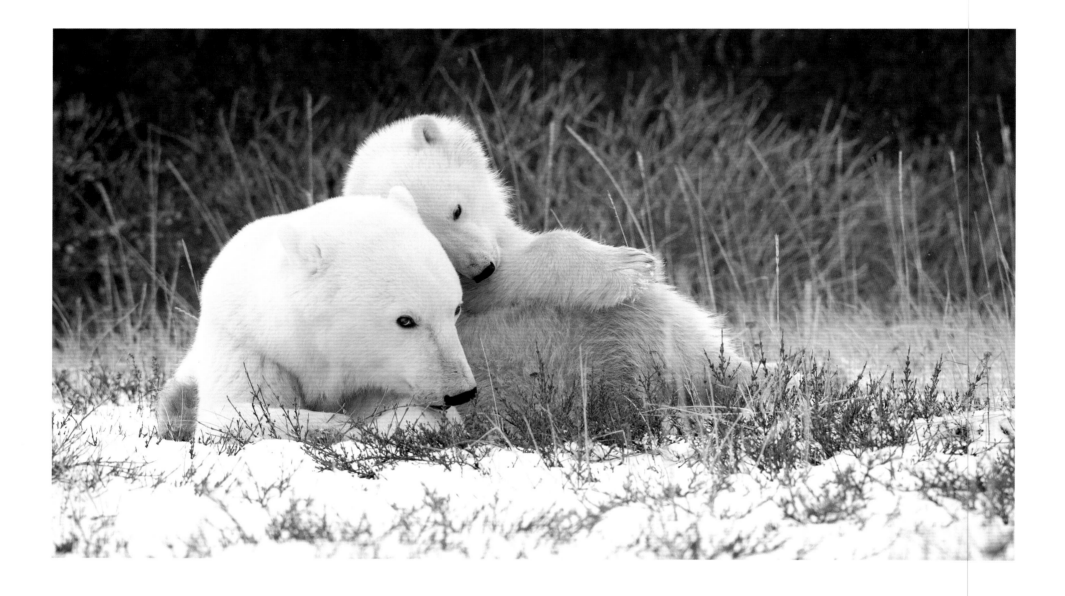

Above and right: In Churchill, Canada, we came across this mother and cub sitting beside the track. This was in November and the cub would have been nearly a year old. They were hanging around waiting for the sea to freeze. First she kept a wary eye on us, then they settled down for a snooze together. Working from a 4x4 enables photography from a much lower angle and enables more intimate portraits.

Above: Churchill, Hudson Bay, Canada
Nikon D4 + 80-400mm f4.5/5.6 lens at 370mm;
1/250 sec at f10; ISO 800

Above right: Churchill, Hudson Bay, Canada
Nikon D4 + 80-400mm f4.5/5.6 lens at 400mm;
1/500 sec at f5.6; ISO 400

Photographic tip
Support matters

Method		
	●	Recommended
	○	Possible use
	●	Not recommended
Handheld	●	Generally, with snow around, light levels are quite high, allowing for fast shutter speeds. With good technique, this is a very practical option. Essential on a Zodiac cruise.
Beanbag	●	Can be a good option on the handrail of the ship or on the back deck of a Tundra Vehicle. Take care not to lose it over the side — always tie it on. I use one with a clamp to attach it to the camera lens, so it is always there when I place the camera.
Monopod	○	Can be used on the deck of a ship, it makes quick manoeuvring possible, but can be tiresome holding it for a long time when waiting for the action to get going.
Tripod	●	Very useful on the deck of a ship. Not practical on a Tundra Vehicle.

Right: The curved horizon formed by a fish-eye lens gives a sense of the bears living on top of a frozen, icy world. I took this from the ship near Svalbard and the bears were actually very close — just 8 metres (26 feet) away — and were expertly making their way across the fragmented ice.

Pack ice off northern Svalbard, Norway
Nikon D5 + 15mm f2.8 fisheye lens;
1/1250 sec at f5.6; ISO 450

Following spread: I watched this bear walking along the spit of ice and I could see the potential for a reflection, and waited for it. This bear had been jumping in and out of the water and its fur looked perfectly groomed in the the soft evening light. 'Evening' is a relative term in the constant light of an Arctic July, but the 'night' is better for photography when the sun is lower.

Svalbard, Norway
Nikon D5 + 800mm f5.6 lens;
1/4000 sec at f5.6; ISO 1400

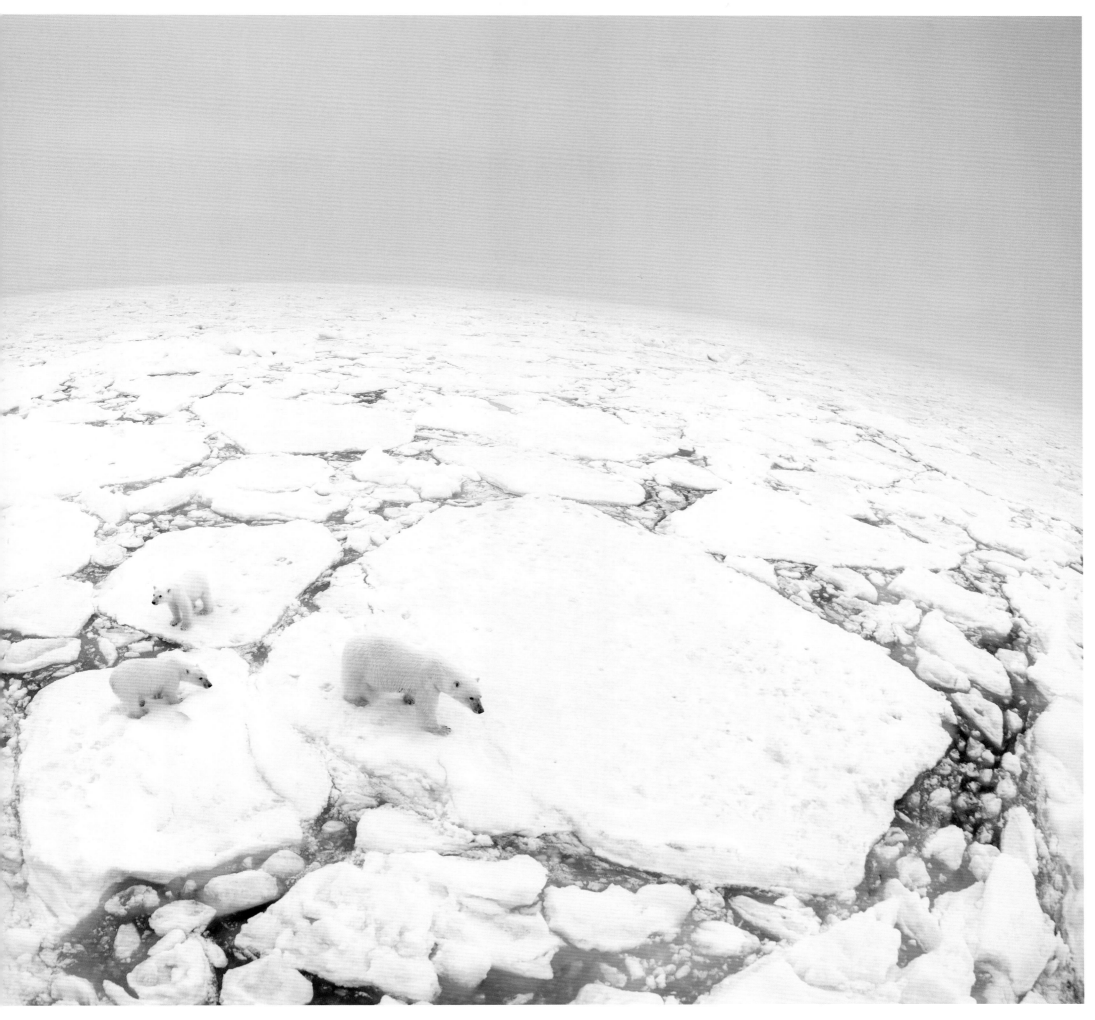

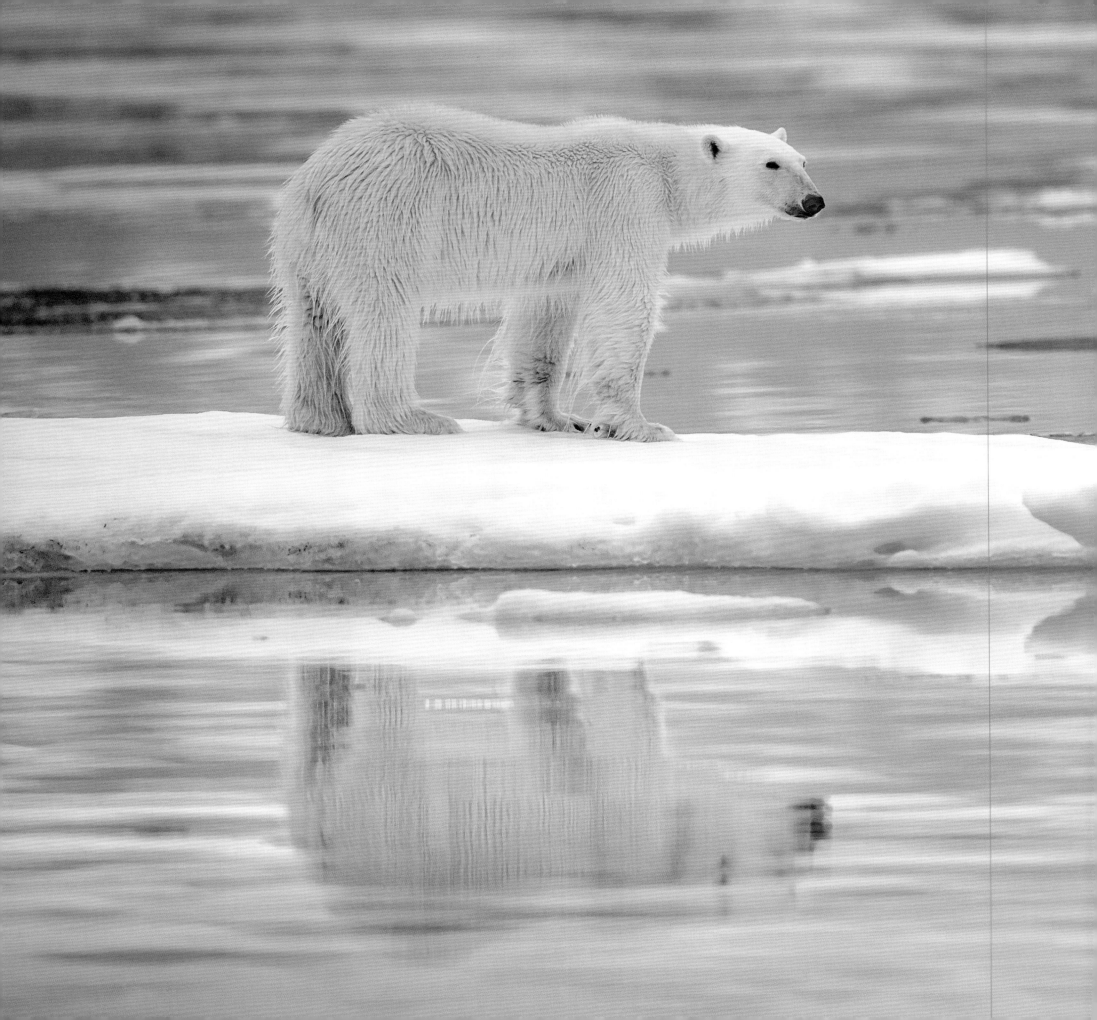

Planning your ultimate polar bear safari

There are two locations that are my favourites for polar bear photography, and because they are very different, they complement each other really well.

Svalbard, Norway

This Norwegian archipelago is in the high Arctic, between 76°N and 81°N, bounded by the Arctic Ocean and the Barents Sea. At its northern tip it is less than 600 nautical miles from the North Pole. Polar bears have not been hunted here since they were given protection in 1973. And it shows, as over this almost 50-year period bears have become habituated to ships and small boats. They generally exhibit little or no fear and are often curious enough to come closer. Svalbard offers you the tantalising opportunity to get polar bear images in stunningly beautiful, pristine Arctic settings.

How to travel around Svalbard?

Most visitors sail around the archipelago by ship. Whilst a number of big cruise ships now go to Svalbard on very short visits, these are not very suitable for photographing polar bears. The best way is on an expedition-style ship. The smaller ones have between 12-50 passengers, the larger around 100. Generally, the smaller expedition-style ships give you a more intimate and flexible experience than the larger ones, but this comes at greater cost.

How to find the best expedition cruise?

I sometimes meet unlucky travellers who have visited Svalbard and either missed seeing polar bears, or only saw a few in the far distance. Usually this is because they were on the wrong ship, or one with an itinerary with a different objective, or without expert guides.

Bears frequent the ice, and therefore it is important that you choose a ship with the highest ice class rating, so that it can safely venture into the pack ice. Many trips are more general, showing passengers as many different aspects of the area as possible, and have additional activities such a hiking, diving, kayaking, Arctic historic sites and more — all of which mean less time to focus on polar bears. To maximise your chances of having bear encounters with good photographic potential, you need to select a trip with a clear objective such as 'Polar Bear Special Cruise' or 'Wildlife Photo Tour'. Finally, it is essential that there are experienced guides on the vessel, who will spend hours out on deck scanning, and with the skill to spot bears, sometimes from many miles away.

When to go?

The main season is from the end of May until early September. Sea conditions are generally stable at this time of year. The amount of ice varies anually, making it a bit of a lottery when deciding the best time to visit. Generally, as the summer season progresses, the ice recedes. Early on there may be too much ice, later in the season, it may have receded too far north. Nothing is certain though, and it could well be good at either time. The sun is above the horizon continuously throughout most of the season, then in late August as the days shorten, it finally drops below the horizon for a while around midnight. In August and September, the light can be superb, with the sun low in the sky for many hours either side of midnight, and the possibility of photogenic sunrises and sunsets.

The reality is that the whole season has the potential for great polar bear photography. Picking a best period is tricky, but balancing all factors, the safest bet is probably to go for a trip in July or early August.

How long should the trip be?

Most expedition-style tours are for 8-10 days, sometimes as long as 20 days. When deciding on a trip, it is important to be aware that the most productive areas for polar bear encounters tend to be a couple of days sailing time out of Longyearbyen. For example, on an 8-day cruise, you should have about 4 days in the most active areas, whereas a 10-day trip will give you 6 days. As usual, if the budget allows, go for the longest trip you can find.

For my 'Ultimate Svalbard Polar Bear Safari', starting in early July on a 'Polar Bear Special', I travelled for 20 days on board *MS Malmo* with Rinie van Meurs as expedition leader, booked through US-based tour operators Nozomojo LLC.

Recommendation summary

Location: Svalbard, Norway
Best time to visit: End of May to mid-September
Getting there: Fly to Longyearbyen (Svalbard's tiny capital) from Oslo
Access: On board an expedition-style ship with a high ice class (small 12-50 passengers, large 100+ passengers)
Trip's objective: 'Polar Bear Special Cruise' or 'Wildlife Photo Tour'
Duration: 10 days, or longer if possible
Accommodation: Stay at least one night before in Longyearbyen to reduce risks from delayed travel or luggage.
How to book: Through a specialised wildlife tour company or a photo tour operator

Churchill, Manitoba, Canada

Dubbed the 'Polar bear capital of the world', Churchill is famous for its polar bear tours. Its location in the centre of Canada makes it relatively accessible to a huge catchment of potential visitors. Most tours begin and end in Winnipeg, the capital of Manitoba Province, and include return flights to Churchill. Once at Churchill, visitors can stay either at one of the hotels in town, or for the more adventurous, in one of two 'Tundra Lodges', multi-carriage accommodation vehicles parked out on the tundra.

Every autumn, scores of polar bears gather near Churchill waiting for the sea ice to form, so that they can resume seal hunting after the lean summer months on land. Visitors view the bears from a Tundra Vehicle: large all-terrain passenger vehicles designed to carry visitors safely across the frozen tundra into the Churchill Wildlife Management Area. Churchill is famous for its sparring bears, a type of behaviour that is fantastic for photography and rarely seen elsewhere.

Which operators have access to the Churchill Wildlife Management Area?

Just two companies are licensed to access the main area — Great White Bear Tours (using Polar Rovers) and Frontiers North Adventures (using Tundra Buggies). Most tours are run by wildlife travel or photo tour companies who will have block-booked with one of these two companies for their trips.

When to go?

The season is very short! Operators offer tours from around the second week of October through to the end of the third week in November. The sequence each year is similar, but the timing will vary with the weather. For photography, ideally you want snow on the ground. Normally at the start of the season there will be bears around but lying snow is unlikely. Snow normally comes around the end of October, and then at some point in November the sea freezes and the bears move out really quickly. An early cold snap can catch everyone out! I was there on one trip when the sea froze on the first day, and consequently we saw very few bears. Freeze-up dates vary; they can be as early as the second week of November but are sometimes very much later. The weather is different every year, but to give yourself the best chance of great polar bear shots in snow, a trip in early November is the best bet.

Any alternatives to using Tundra Vehicles?

A small number of tours offer a great combination for photography, with some days out in the Tundra

Vehicle, and others driving around the local road network in conventional 4x4 vehicles. Whilst Tundra Vehicles are great at getting you safely to the main polar bear areas, a drawback for photography is their height. You will probably see fewer bears from a 4x4 vehicle, but those you do see will be at a great camera angle and should lead to high quality images. That's why I feel tours with this combination give you the best of both worlds.

Where to stay?

There are two options: in a hotel in Churchill, or out on one of the Tundra Lodges. I have tried both, and my clear preference is to stay in Churchill. I don't feel you miss any bear action but have the relative comfort of a hotel room each night, and usually at lower cost. Staying in town is essential for a combination-type tour.

For my 'Ultimate Churchill Polar Bear Safari', starting 30th October in Winnipeg I stayed 11 nights in Churchill on two back-to-back tours with US-based Natural Habitat Adventures booked through UK-based Wildlife Worldwide.

Recommendation summary

Location: Churchill, Manitoba, Canada
Best time to visit: A tour that includes 5th November
Getting there: Fly to Winnipeg, Manitoba
Access: Tours include a two-hour flight to Churchill and back. Then using a Tundra Vehicle or 4x4 vehicle
Accommodation: Hotel in Churchill
Duration: Seven days (including one night in Winnipeg both at the beginning and the end)
Tour type: Consider a combination-type tour if available
How to book: Through a specialised wildlife tour company or a photo tour operator

Arctic fox

Bearded seal

Svalbard reindeer

What else might I see?

In Svalbard there are very few land mammals, but you are likely to see arctic foxes and Svalbard reindeer. At sea there are marine mammals such as walruses, bearded and ringed seals, and good chances of seeing a number of whale species.

271

My thanks to those who advised and guided me during the production of this book: Mark Carwardine, Rachel Ashton, Simon Bishop and Anna Levin. For helping with image selection my thanks to Danny Green, Peter Bradley and Rosamund Kidman Cox. For their advice and expertise I am grateful to Michele Seamark, Frederico Tavares, Rinie van Meurs, JoAnne Simerson and Brad Hill. I would like to thank Jenny Varley for her diligence and tenacity in proofreading and for providing the author photograph of me for the book.
Richard Barrett